Aldo Rossi
Buildings and Projects

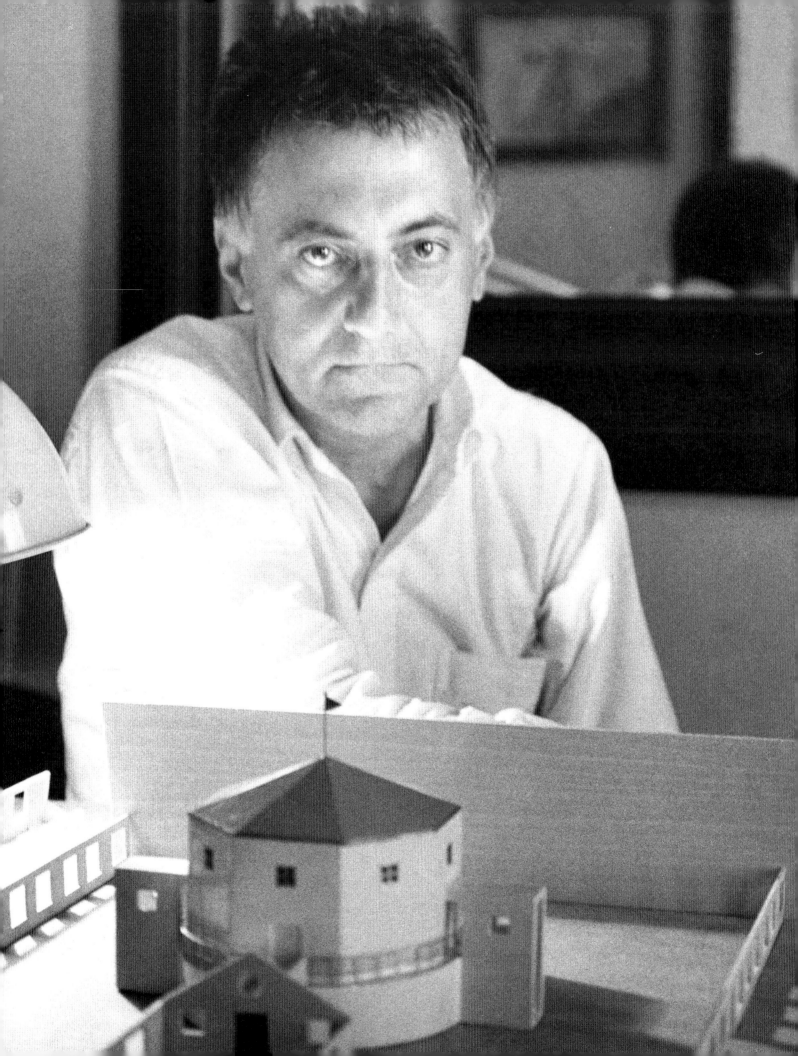

Aldo Rossi
Buildings and Projects

Compiled and Edited by Peter Arnell and Ted Bickford

Introduction by Vincent Scully
Postscript by Rafael Moneo

Project Descriptions by Mason Andrews

RIZZOLI
NEW YORK

For Valerie

Published in the United States of America in 1985 by
RIZZOLI INTERNATIONAL PUBLICATIONS, INC.,
597 Fifth Avenue, New York, New York, 10017

Library of Congress Cataloging in Publication Data
Main entry under title:
Aldo Rossi, buildings and projects.
1. Rossi, Aldo, 1931- —Addresses, essays,
lectures. 2. Architecture, Modern—20th century—Italy—
Addresses, essays, lectures. I. Scully, Vincent Joseph,
1920- . II. Moneo, Rafael. III. Rossi, Aldo,
1931- . IV. Zucchi, Cino. V. Arnell, Peter.
VI. Bickford, Ted. VII. Schezen, Roberto.
NA1123.R616A9 1985 720'.92'4 83-42923
ISBN 0-8478-0498-4
ISBN 0-8478-0499-2 (pbk.)

Reprinted 1987

Printed and bound in Singapore
Set in Garamond

Editors:
Peter Arnell
Ted Bickford

Associate Editors:
Cino Zucchi
Trent Duffy

Production Coordinators:
Dinah Coops
Leslie Alexander

Design:
Arnell/Bickford Associates
Peter Arnell
Ted Bickford
Giovanna Galfione

Cover Photograph:
Antonio Martinelli

Frontispiece:
Portrait of Aldo Rossi, Milan, 1984, by Aldo Ballo

All photographs and illustrations in this book have been
obtained from the studio of Aldo Rossi and are reproduced
with Mr. Rossi's permission, unless otherwise noted. The
photographs of the Teatro del Mondo are owned and
copyrighted by Antonio Martinelli and are reproduced
with the permission of his studio. Illustration credits can
be found on page 318.

Contents

Prof. Dott. ALDO ROSSI
Architetto

Prego di lasciare visitare
e fotografare l'edificio
ie signor Peter Arnell
architetto americano in
visita in Itala –

grazie – Aldo Rossi

13 marzo 81 –

Via Maddalena, 1 - 20122 Milano tel. 86 54 40

STUDIO DI ARCHITETTURA
Via Maddalena, 1 20122 Milano

If Aldo Rossi's mother came to me asking for a list of people who understood, cared for, and appreciated her son with undying loyalty, *and* who were capable, with professionalism, technical perfection, and unbending strength of conviction, to produce a book of his work, *and* who could do all of this while walking on water without making waves (perhaps to arrive at Teatro del Mondo?), I would give her these names: *Cino Zucchi,* who because of his infinite patience, understanding, and love for Aldo Rossi, made this book possible; *Roberto Schezen,* who broke into schools, scaled walls, and stood on rooftops in the hot Lombard sun, out of love for his profession and respect for another; *Gianfranco Monacelli* and *William Dworkin,* the Believers, without whose trust this book never would have come to fruition; *Randall Korman,* my teacher, who sparked the fire by giving me my first glimpse of Rossi's genius, the Teatro del Mondo in Venice, and *Werner Seligmann,* who made it possible for both of us; *Vincent Scully* and *Rafael Moneo,* for their generosity with valuable time, and for lending this book its soul; *Catherine Bergart, Dinah Coops, Alessandro Franchini,* and *Grant Rector,* for their support and long hours spent deep into the night to make it right; *Maurice Adjmi,* who, on the other end of many overseas telephone calls, anticipated the difficulties of this endeavor and made the time in Milan so easy; *Giordano* and *Anna Zucchi,* for being the wonderful people they are, for adopting me, and for their love; my friend *Alberto Alessi,* whose kindness will always be remembered; *Aldo Ballo, Maria Ida Biggi, Sergio Fornasetti, Ezio Frea, Roberto Freno, Alfredo Gambaro, François Halard, Heinrich Helfenstein, Giacinto Manifredi, Antonio Martinelli,* and *Leo Torri,* the photographers, always true to themselves, their work, and in turn, Rossi; *Mason Andrews,* who put her life on hold to help us out in the eleventh hour; *Jack Warnecke* and *Margo Warnecke,* who understand the need to dream; *Giovanna Galfione,* for her dedication and spirit in helping to produce a book worthy of Aldo Rossi; *Sharon Pachter,* for her love of motorcycles, skill with a typewriter, and for making me pay attention; the editors and staff of *Casa Vogue, Gran Bazaar, Casabella, Lotus,* and *Rassegna,* for their goodwill and knowledge, and for making the material available; *Antonio Martinelli,* for sharing his imagination and creativity so generously, and for capturing the essence of beauty on our cover; *Giovanni Sacchi,* the ultimate craftsman, who sheds new light on the artistry of Rossi by virtue of his own; *Italo Calvino,* for the insights he shares through his writing; *Enzio Bonfanti, Francesco Dal Co, Daniele Vitale, Giorgio Ciucci, Paolo Portoghesi, Daniel Libeskind, Francesco Moschini, Pierre Luigi Nicolin, Vittorio Savi,* and *Manfredo Tafuri,* for helping me to understand through their own understanding of Rossi; *Gianni Braghieri,* who shares the victory of beauty and brilliance represented here, for it is in part his work too.

It is a wonderful thing in life when respect and admiration for someone becomes something more. First working with and then coming to know Aldo Rossi has been the most rewarding experience of my life—he is one of the greatest writer-architect-artists of our time. One can only speak about such things generally—for they are very personal—but there is a warmth, a sincerity, and an intuition about the little twists of life that sets this man apart. And there is

another, for whom I also speak (sometimes too much), and who allows it because he trusts. So, finally, add to this long list *Mallory Samson* and *Ted Bickford,* who are really first in my heart. I will always wonder at the powerful image of men and women behind desks doing great things simply by following their instincts and dreams with conviction . . . and more dreams.

Peter Arnell
New York City
June 1984

Looking at these projects all together, it seems to me that today I could still redesign them one by one: perhaps the final result would be different, if only because of small changes and shifts in proportion.

This redesigning of one's own projects can result from personal affection, or at the same time it can be a form of technical exercise—like studying the ancients or urban topography.

I have always thought and still think that knowledge or mastery of any technique or art comes from study and practice and that this training must transcend personal preferences toward one activity or another.

In addition, I have always thought that a special stubbornness about what we do protects us from eccentricity and from passing fashions. This stubbornness, which is part of our profession, leads us to search out methods and rules of operation. There are many of these, which involve our urge to represent as much as they do the meaning we are searching for or that we wish to reveal. I refer, for example, to the way different things shed light upon one another or take on a different light when brought together—in other words, to analogy or to any other comparison that increases our capacity for understanding.

Among these methods, I have always been interested in the literary technique (we can see it as well in architecture and in the figurative arts) of purposefully making the meaning of a word or a sentence figurative rather than literal; this, of course, is what the Greeks called metaphor and what Quintilian singled out as the first and best figure of speech (*Tropus est verbi vel sermonis a propria significatione in aliam cum virtute mutatio*).

This faculty that can transform the meaning of a thing comes close to the idea of technique.

Perhaps for this reason and for still others, my projects have always aroused an unusual amount of interest among critics as well as among people with no professional background in architecture. I always welcome these interpretations with great interest, even though I think that once a work is finished there is little to add to it.

And yet I cannot hide the fact that, as the years go by, the ever greater public involvement in my work is a source of consolation to me.

In regard to form, I have always been attracted to closed and complete form as well as to the disintegration of form. This may be difficult to understand, but I believe there is no great difference between one position and the other. It is like the boundary between abstraction and naturalism: in every good architect there is a tendency toward naturalism—in other words, a tendency to reproduce what exists.

When this occurs together with small shifts or distortions, the result is of particular interest.

In the work of Henry James, one of the greatest American writers, this is illustrated very well: everything is absolutely real, even to the point of boredom, but it is always "twisted."

This different slant on things is very important.

I won't speak of my projects, even if seeing them collected here in so many beautiful images stirs up in me, against my will, a new interest.

I notice that every time I am attracted to a large public works project that is quite anonymous and impersonal, I am equally attracted to, or distracted by, individual and almost personal details. We should pay attention to the state of the architectural profession or, more precisely, the state of the architect's trade; not so much his "technical preparation" but his "workday": how he draws, how he writes, how he supervises a building project. These considerations, which we find in Vasari's biographies and in works from the past, have been ignored in the psychological-literary style of criticism. Although this style is already becoming a passing fashion, it has represented the leading edge of the avant-garde; if technique does not exist, if discipline does not exist, all that is left are "personal interests," eccentricities, and uncertainties.

But "personal expression" matters very little or not at all, unless it has a place in society and a place in history.

This is why I have always loved large public works projects, where individuality disappears, because this type of architecture must adapt itself to the city at predetermined points. I refer to architecture that we pass through in our work or where people gather in daily life—working buildings, factories, schools, and train stations. I have also loved designing residences because they are part of the city; and since they are the part that must meet the need for privacy, the architect's intervention into this realm must be brief and to the point.

The most beautiful homes are still the interiors of Carpaccio or Vermeer, of Montegna or Hopper—or of a friend's home, wherever it might be.

There is little to say about the personal side of our work. The obscure and the irrational exist only for someone lacking in reason; to try to comprehend is part of what modern man, in the Galilean sense, must always attempt.

The construction of form and its destruction are two complementary aspects of the same process, even if we would like to attach to our work those definitive valuations that only time and public sentiment can give them.

Since the architect does not choose his sites, he can build on them but he cannot give them life.

The meaning of this was clear to the ancients, and perhaps few expressed it as clearly as Martial in his book of poems dedicated to Domitian.

Qui fingit sacros vel auro vel marmore vultus
Non facit ille Deos; qui rogat ille facit.

He who models his sacred images in marble or gold
Does not make gods of them; he who prays to them does.

Yet there must be a connection between the architect and the person who will experience the result of the architect's vision. We must keep on hoping that with every project the architect is building toward a better future.

This is the sense of progress that, notwithstanding the weaknesses, deviations, and shortcomings of our work, I call Galilean: *experiri placet* (to experience is pleasing)—provided that the goal of experience, in our profession or art, is the search for truth.

Aldo Rossi
Milan, April 1984

Why is Aldo Rossi's work the most moving and haunting being done today? Why is it the most poetic, the most suggestive of feelings that other architects do not begin to attain, but by which so many have been profoundly affected? Is it because Rossi is the best painter-architect to have appeared in the later decades of this century, able to give image to shapes and places with the special gift of illusion that only the painter has? *Places* is the key. Here Rossi differs profoundly from Le Corbusier, whose paintings of the first half of this century were primarily of aggressive objects—which his buildings gradually became. Rossi makes places, piazze, stages for humanity, all illuminated by an Italian metaphysical light. He creates a theater, which by its nature is the most haunted of places. Action is imminent, suggesting some tragic splendor, perhaps an apparition unimagined before.

The colonnade of the Gallaratese is haunted in such a way behind every pier, beyond which, at last, the round columns step forward. As a stage—a setting for human life—the stairs at Fagnano Olona are even more moving. They are framed by the building, the two doors, and the clock on the wall; a stage of life, another of Rossi's theaters of the world, measured by time, given tragic stature by the simple grandeur of time. How beautiful are children in that space: the beginning of their time, which seems infinite to them. There is tragic irony in the clock. How high above the children it rides, but how close-set are the two doors in the wall below it. Two persons? Two choices? Which door? They create the aura of a stage set, which one door could not do. The stairs ascend toward them and there are also theater seats before them. The clock is a witness. That is all there needs to be. How undecorated, how artfully undesigned it is made to seem. A long generation ago, a devotee of the Bauhaus wrote a book called *The Way Beyond Art* in order to show that "design" is more relevant than "art" in the modern world and would, in the immutable workings of the zeitgeist, soon supersede it. Rossi reverses all that. For him, everything resonates art; design disappears and leaves the stairs, the walls, and time.

Rossi is able to do this in architecture because his painterly feeling for illusion and for the space of imagination is combined with another wholly architectural passion, one that is equally anti-design. This is a passion for structural and spatial types, evolved from vernacular and classical traditions, that make sense of the environment and hold it together. They offer what poetry requires: a coherent language. Rossi insists that he does not "invent," he remembers. The type is never violated by circumstance, is never "inflected" by other forms—as, for example, Venturi's very similar types will often be. Rossi's remain inviolate; they shape the circumstances. The project for student housing at Chieti creates a magical place by repeating the small gabled dwelling units. Each is emblematic of a single person. Indeed, it almost becomes the physical embodiment of a human being. Hence the meaning of the whole grouping is clear, correct, and, once more, profoundly haunting. Individuals come together in the simplest kind of community and surround the large communal building in the center of the piazza, which they define. We are reminded of Jefferson's somewhat similar evocation of an individual

and a community in the University of Virginia—partly because of a similarity of plan, but mostly because of the relation of Jefferson's small columns, which suggest people, to his large columns, which suggest the institution as a whole. Again, Rossi does this with the gabled unit. It is a language. Throughout his work, Rossi is able to employ his little pavilions from Elba very well, not only at a large scale but even at the smallest, where he uses them to shape his gentle armoire—surely the most humanly evocative of all the fine pieces of furniture that have been designed by architects in the past few years. Most unusual for him, he uses them like elegant light blue and pink wallpaper to decorate the blocky exterior of a commercial building. He seems very close to Venturi, but the analogy should not be pushed too far.

Rossi deals with an enormous tragic dimension, ranging from a kind of fatal innocence to profound melancholy and epic grandeur. He can create special, weighty masses that are without parallel today. This is where the analogies with Fascist architecture seem strongest. But it is surely fair to say that fascism had no special claim on monumentality or weight, qualities which are integral to an ancient Italian tradition. It now appears, despite the repellent aspect of fascism itself, that many of the Fascist architects dealt rather more successfully with this tradition than they have usually been given credit for. But none of them had Rossi's power. His project for a theater in Genoa outdoes them in all the *terribilità* of the palazzo block that houses the stage. Here, as elsewhere in Rossi's work, there is some echo of Asplund, but the closest analogy is with Sullivan's Wainwright Building. If we think our way past the fact that the Wainwright encases a steel skeleton, our eyes tell us that it is, most of all, a solid chunk with a clear base, strongly contained side walls, and a massive entablature and cornice. Rossi's project is much the same, but comes across as even more solid because of its tiny-windowed wall. It and the Wainwright Building are both traditional palazzo blocks in the traditional urban situation of defining the street and solidifying the fabric of the town. Seen this way, Rossi's vertical elongation of his base is an especially dramatic physical act. He has pointed out from the beginning that individual buildings have meaning only in relation to the city as a whole. This again is part of the typology that keeps Rossi's architecture strong, because he understands what its proper dimensions are. In his overwhelming group for the Congressional Palace in Milan, he arranges the individual blocks in sequence on a vast base. The effect is of urban counterattack. The old city rises with new power at a scale that is colossal and disquieting. In terms of a modern interpretation of the palazzo tradition, with its traditionally monumental, classically unified city form, the Fascists were never able to produce anything like this.

The word *modern* has to be used about Rossi, even though he dislikes it. His austerity and his fundamental avoidance not so much of decoration as of anything lush, rich, or superficially complex both put him in the family of Loos, whom he so much admires. He assigns his "purism" to an earlier stage of his career, but it continues to mark him in very positive ways. He continues to respond to what has now turned out to be a persistent modern desire for plain

surfaces, hardness, clarity, and simple Neoplatonic geometry. Some deep instinct must be at work here—perhaps a disgust for the unjustly distributed riches of the modern age, for the vulgarity of that wealth, for the empty multiplicity of choices for leisure activity, or simply for the adornment it seems to provide.

Without any doubt, one of the major sources of Rossi's strength is his own personal kind of intellectual commitment to proletarian values. With someone else, such commitment might well be personally admirable but artistically irrelevant, possibly even disastrous. Not so with Rossi. His social convictions are integrally aesthetic—the special way he uses common industrial forms and materials suggests as much. He will modify his great palazzo images by engaging them as supports for vast metal trusses, like the roofs of enormous garages. His Regional Administrative Center for Trieste does just that—opening up the block to make echoing public spaces spanned by steel. The operation of the type is again felt, hardening the form and giving it a common vernacular stance, indeed an industrial power.

At a gentler scale, similar principles shape Rossi's smaller housing groups, where vernacular types are invariably employed. But then, as always, some intense transcendence occurs, creating places not so much of dignity (which such types normally possess on their own) but of pure magic. Through its high and narrow proportions, an austere colonnade becomes as noble as those of the old Emilian farms, and indeed evokes those of Palladio. The light frame structures that shield the entries of another group take on similar qualities because they too are so high, thin, narrow, and repetitive. This is work like that of the great traditional architects or of the old masons and carpenters who built Italy's incomparable farms and towns: work in which the age-old type is respected and worked over lovingly, only slightly modified in proportion each time, like some ancient oral epic changing just a little with every repetition, but always retaining its grand structure.

Beyond all else, Rossi is thus the incomparable Italian builder, the shaper of the most beautiful, almost entirely man-made country in the world. It is hard for an Italian to build badly and without dignity, though many in this century have managed to do so, especially in luxury apartment buildings and speculative vacation homes and in response to the assault of the automobile on the countryside. Rossi turns his back on all that in order to tap the strength of the most enduring of Italian traditions—that of the urban cemetery, as at Modena; that of the baptistry, as in the Teatro del Mondo, the heart of the city; that of the palazzo and farm; and—tragic dignity—that of the factory as well. Now in his Molteni tomb, he turns like Bramante to Italy's wholly classical forms, and at a different scale he does so in Genoa, too. Out of all this, like the greatest of artists, he draws a new poetry, that of the end of this century, written in the Italian vernacular, haunted by memory and old sorrow.

Vincent Scully

Schedule of Buildings and Projects

First date is year of design; second date is year of completion.

*The ultimate meaning to which all
stories refer has two faces: the continuity
of life, the inevitability of death.*

Italo Calvino
If on a Winter's Night a Traveler

I believe I was one of the worst students at the Politecnico in Milan, although I now think that the critical comments addressed to me are among the best compliments I have ever received. Professor Sabbioni, whom I admired especially, discouraged me from pursuing a career in architecture; he said my drawings looked like those of a mason or rural builder who might toss a stone to indicate an approximate location for a window. The comment drew laughter from my friends but it filled me with joy; today I try to recover that felicity of drawing which was taken for inexperience and stupidity, and which has subsequently characterized my work.

—Aldo Rossi

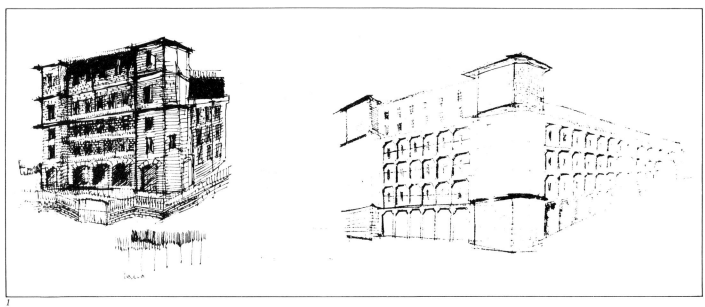

1

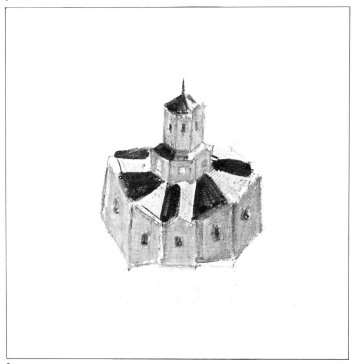

2

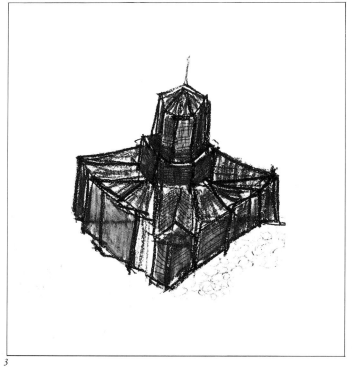

3

Prepared under the supervision of Professor P. Portaluppi, the thesis is a design for a complex that includes a cultural center and theater. Its site is at the intersection of Corso Venezia and the Cerchia dei Navigli—a ring of landfill reclaimed from the canal that surrounded the inner city. The building is designed to face the Palazzo Serbelloni. The project is an exploration of an idea about urban architecture. The act of designing is conceived of as an act of choosing from among the relatively few building types that are recurrent in the history of architecture. In the thesis, the choice of the centrally planned building type is a paradigm of the relative independence between an architectural type and both its functional features and the distribution of its program.

1. 2. 3. 4. 5. Studies for the thesis

4

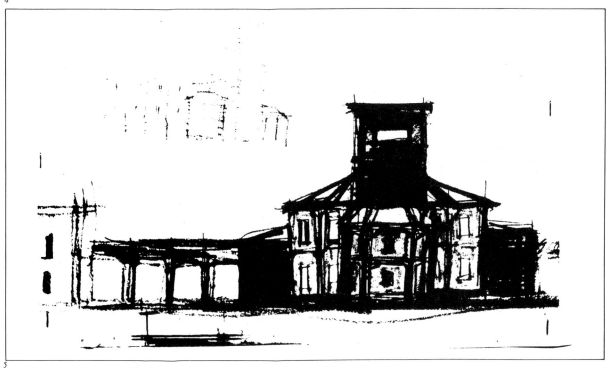

5

1

Urban Renewal Along Via Farini
Milan, Italy, 1960
With G. U. Polesello, F. Tentori

Since the mid-nineteenth century, an industrial area of factories and workers' housing has developed outside the center of Milan. Much of the area has deteriorated and the buildings have become derelict. The site chosen for a renewal proposal is an area of 800,000 square meters, encompassing a portion of Via Farini. It lies between a major highway, Viale Zara, and a large freight yard adjacent to a cemetery.

A specific theoretical strategy for building in such an area is advanced in the project, opposing both unregulated, piecemeal urban expansion and the sociological and architectural diaspora of suburbia. Instead, strengthening the structure of the existing nineteenth-century workers' housing is advocated. The plan has certain problems: the contiguity of highway, freight yard, and cemetery somewhat isolates the area from the city, and, because the economic motivation for the renewal is to locate workers near factories, there is no provision for the civic areas and buildings that constitute the focus of an urban community. Still, the relatively low blocks of the existing housing present a continuous edge to the streets, thereby creating the forms of a populous city sector.

Thus, in form and to some extent in use, the area is tied to the life of the city from which it has grown. The project proposes not only to strengthen the existing urban qualities of the area, but also to augment them by introducing the civic facilities and spaces that can serve the community and represent it architecturally. The proposal, then, is to create, both in function and in urban iconography, a civic architecture that will transpose into a fragmented area the social and architectural structure of the city.

1. Model—aerial view

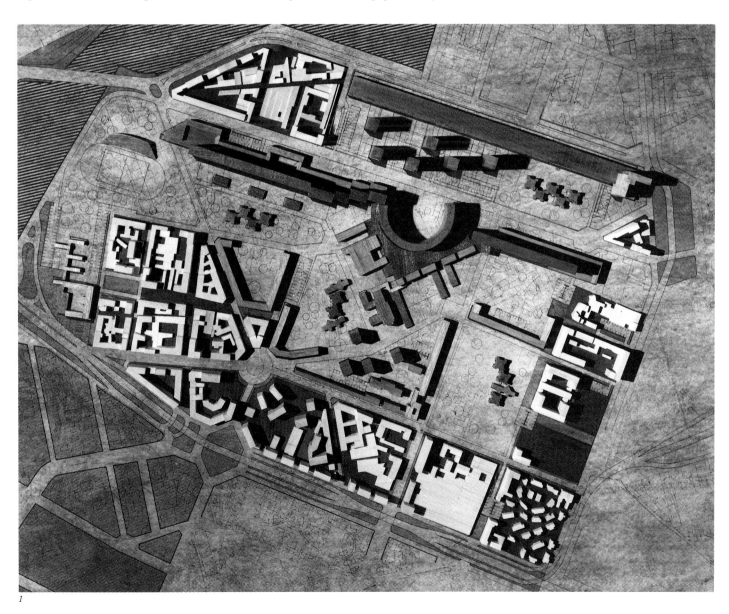

1

The new buildings, chiefly housing and a complex of community facilities, are concentrated in relation to Via Farini. A nearly continuous line of buildings flanking the length of the street on one side reinforces the urban character of the street. The towers on the opposite side of the road underscore the street's primacy in the quarter and mark a gateway to the community formed by a semicircular recession in the line of buildings opposite. A series of colonnades and public spaces promote the use of this area, which is bounded by highways, as an urban sector.

1. Model—view from south 2. Study
3. Photo of site from south 4. Entrance
level of central part of project 5. First level
of central part of project 6. Study

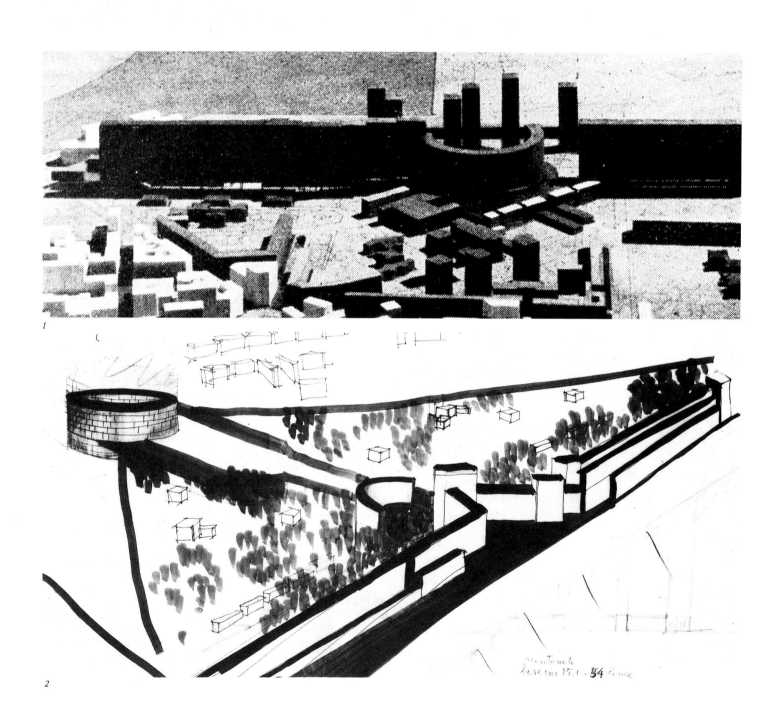

1

2

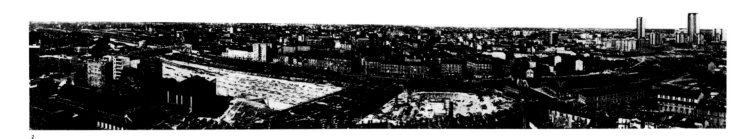

3

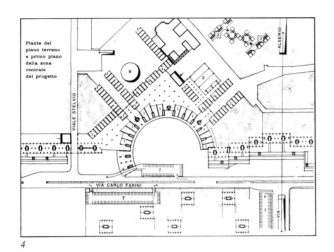

Piante del
piano terreno
e primo piano
della zona
centrale
del progetto

4

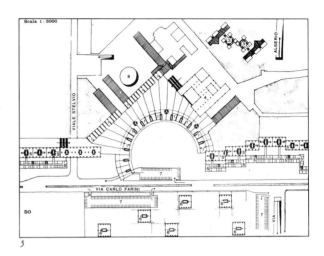

Scala 1 : 3000

50

5

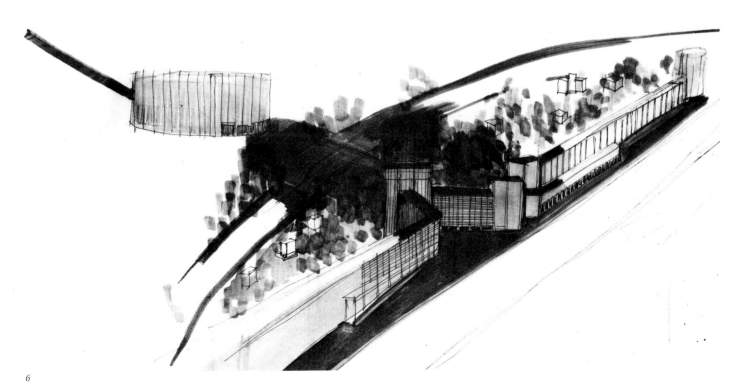

6

Villa at ai Ronchi
Versilia, Italy, 1960
With L. Ferrari

The villas in the pine groves of this area are generally built in the middle of their sites, almost concealed from the paths winding through the woods. This villa, approached through the woods from the southwest, is in a particularly densely wooded part of the grove. The building contains two independent apartments with separate entrances. Access to the second-floor apartment is gained by means of an external stair that wraps around the north corner of the villa. The top floor has a bedroom suite opening onto a roof terrace.

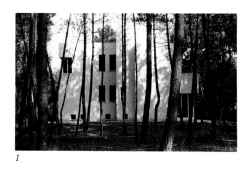

1

The walls and pilasters are of reinforced concrete, plastered and whitewashed on the exterior. Windows and door frames are steel profiles. Terraces are paired in ceramic tile, while the floors of the interior, the steps of the exterior stair, and the handrail are of white Carrara marble.

The villa has strong associations to the architecture of the white-plaster vacation houses of the Versilia. The work of Adolf Loos is also recalled: the external stair wrapping a corner of the house resembles a similar one in Loos's villa on the Venice Lido. Furthermore, there are extensive overall references to Loos's Raumplan composition.

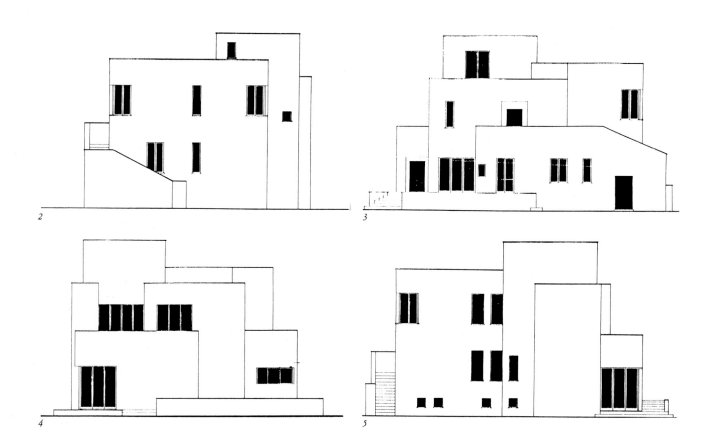

2

3

4

5

1. *View through pine trees 2. 3. 4. 5.*
Elevations 6. 7. 8. 9. Views through pine
trees

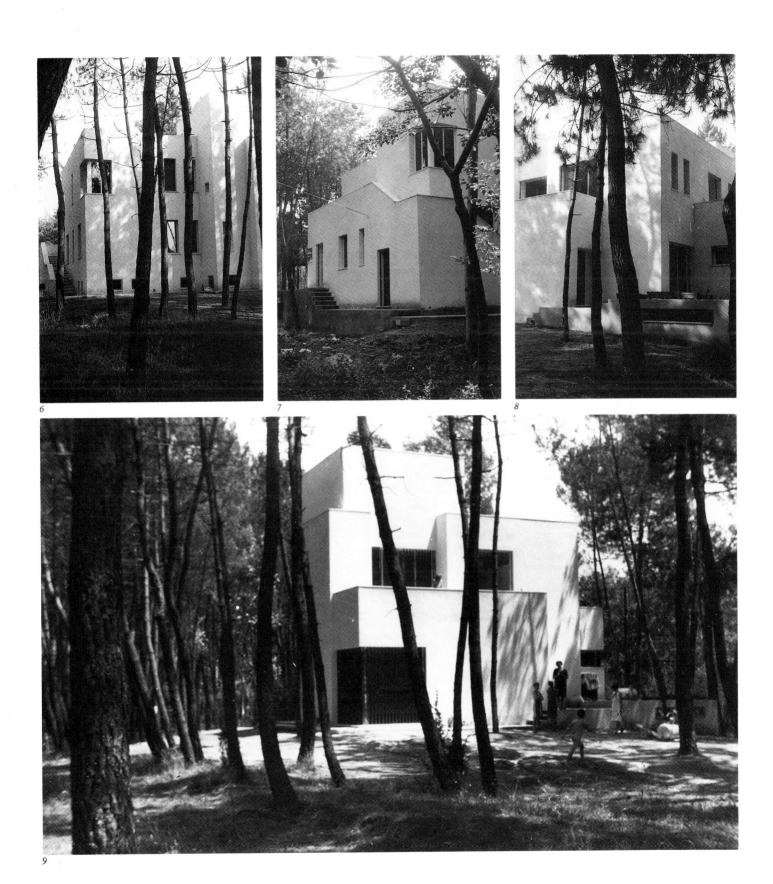

6

7

8

9

25

Peugeot Skyscraper
Competition Design
Buenos Aires, Argentina, 1961
With V. Magistretti, G. U. Polesello

The competition program solicited designs for a skyscraper that was to be the tallest building in Buenos Aires. The plan proposed is square with a square central core of elevator banks. The building is structured by steel tubes spaced regularly around the exterior, with two at each corner. The tubes' sheet-steel ribbing is offset along the length of the tube, expressing the decreasing structural stresses on the upper reaches of the building. The interiors of the tubes, which are 2.4 meters in diameter, are hollow. There is a raceway for mechanical systems in the corner pilasters and stairways, providing a secondary means of circulation between floors in some of the lateral tubes. Floor slabs are of ribbed sheet metal, providing hollow raceways for mechanical circuitry.

The strategy here lies in the clear separation of the structural components and in their formal reduction to elementary forms. According to the critic F. Tentori, this primary expression of architectural elements "creates, in the whole, almost a classical giant order: Loos's column translated from a symbol to real Architecture."

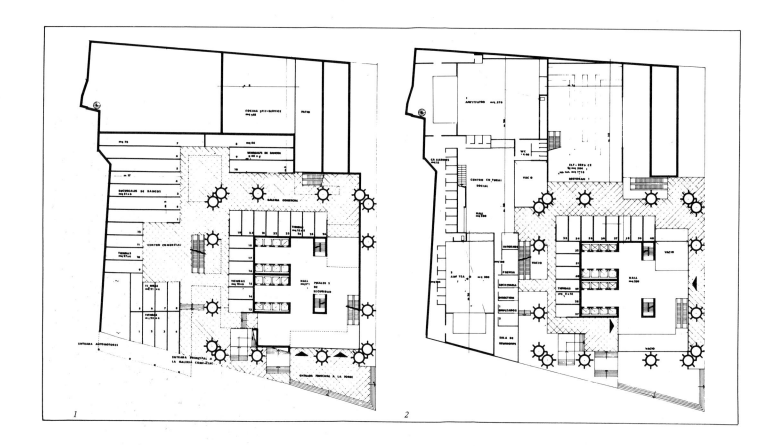

1
2

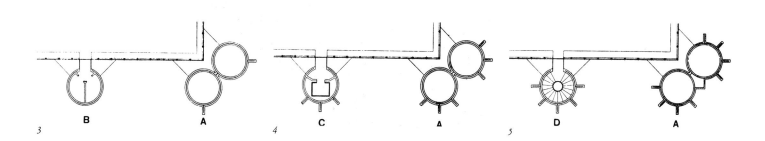

3 B A
4 C A
5 D A

1. Ground-floor plan — commercial activities
2. First-floor plan — offices 3. 4. 5. 6.
Details of corner elements used for different
functions 7. Typical office floor (2nd–64th
floors) 8. Restaurant at 65th floor 9.
Typical apartments floor (66th–68th floors)
10. Photomontage of tower, looking
southeast

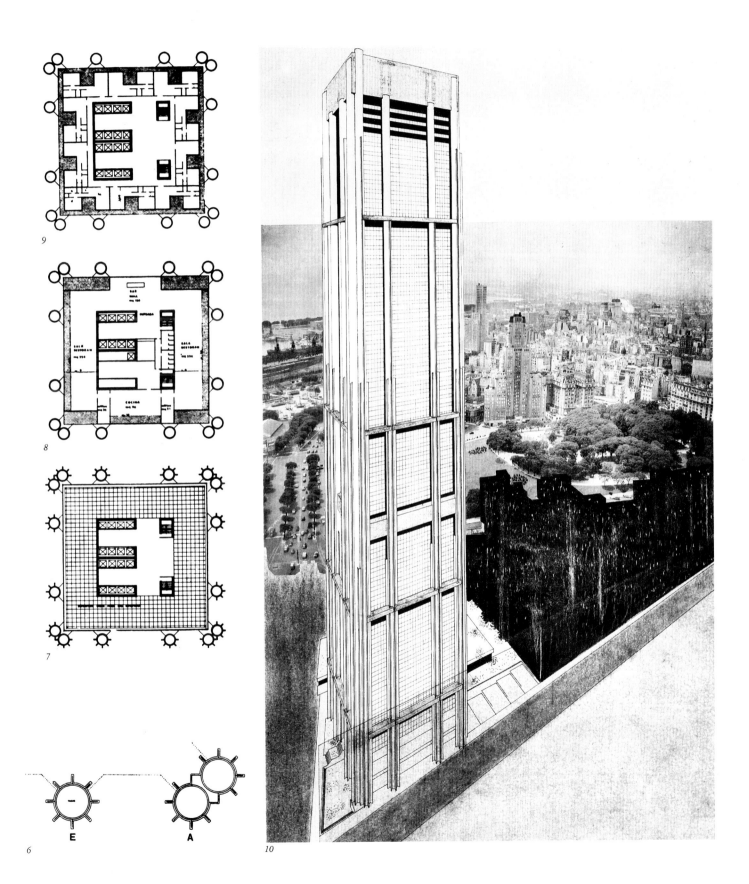

9

8

7

E

A

6

10

27

Workers' Housing
Caleppio, Italy, 1961
With G. U. Polesello

This is a proposal for developing housing and services outside a small town near Milan. A new street is proposed, to lead from the old town center; it creates a spine along which the major elements of the composition are located. The street bisects the central elements of the design—four square towers, whose outside edges define a square. The street and the view to the countryside are closed at the west by a tall, slablike building; a low C-shaped building at its foot creates a public piazza. A similar, L-shaped building closes the view to the southwest and defines a second public space. To the southeast are rows of single-family houses. The project explores the relationship between housing types and urban morphological qualities.

1. General plan 2. Perspective from northeast

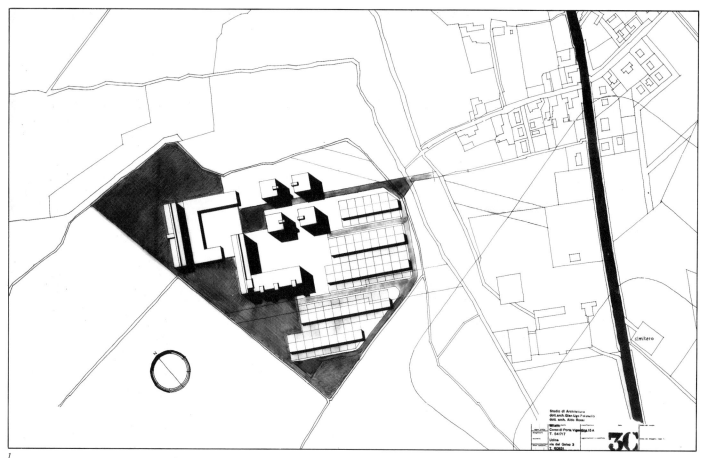

1

2

Monument to the Resistance
Competition Design
Cuneo, Italy, 1962
With G. U. Polesello, L. Meda

The monument, dedicated to the partisan fighters of World War II, is in the form of a great cube placed on the green platform of a field at the edge of Cuneo. The cube is 12 meters per side, made of concrete masonry faced with stone slabs that are 6 centimeters thick. Along the walls are arranged commemorative inscriptions and the names of partisans killed in battle. A wide flight of stairs leads to an area completely enclosed by high walls, except for the sky above and a slot at eye level the length of one wall of the cube. Through this opening a panorama of the battlefield and the mountains beyond may be seen. The monument is designed to

1. Cover of the Italian architectural magazine Casabella-continuità

1

be part of the town in which it lies, to serve
as a raised, enclosed piazza, and to be seen as
a tower or a piece of triumphal architecture
related to the fabric of the city.

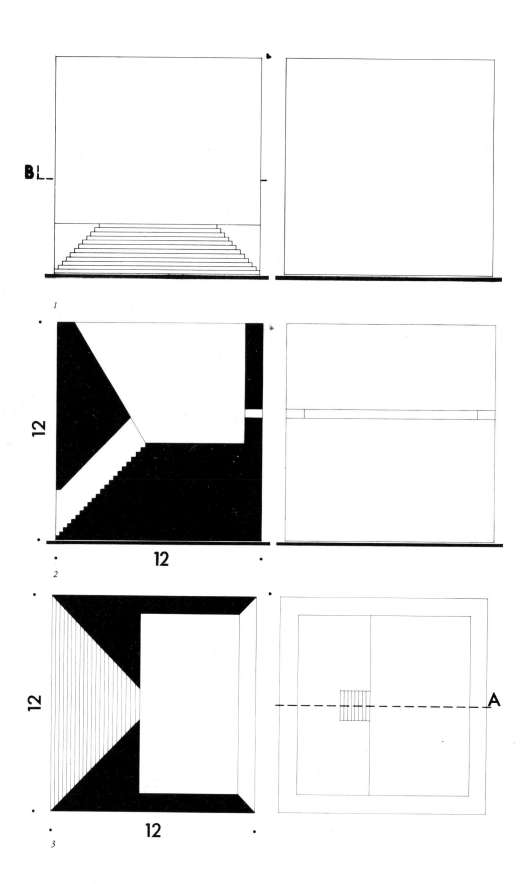

1. Entrance and side elevations 2. Section and model looking toward entrance
through stairs and panoramic front 5. Sectional axonometric
3. Section above stairs and plan 4. Site plan

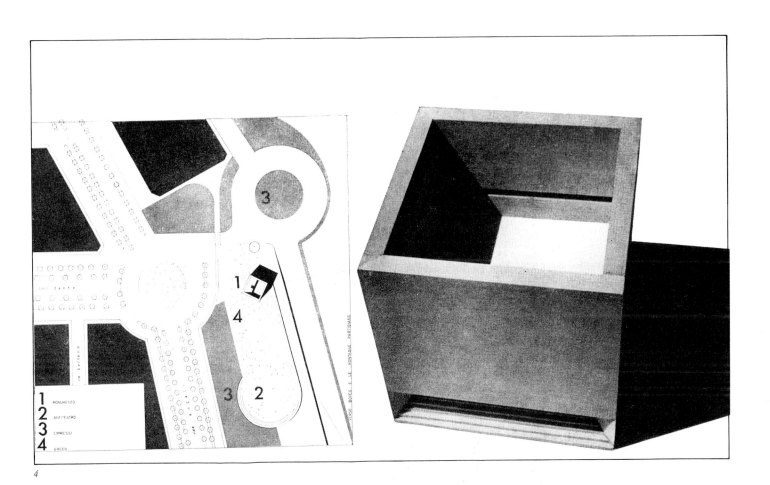

4

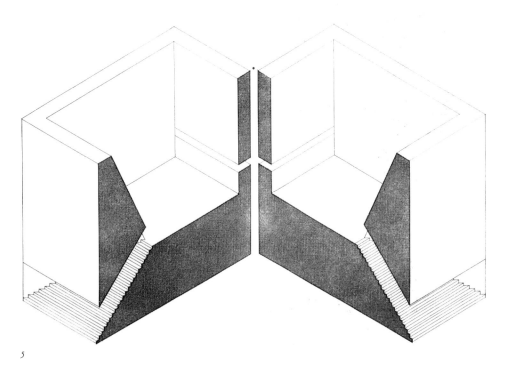

5

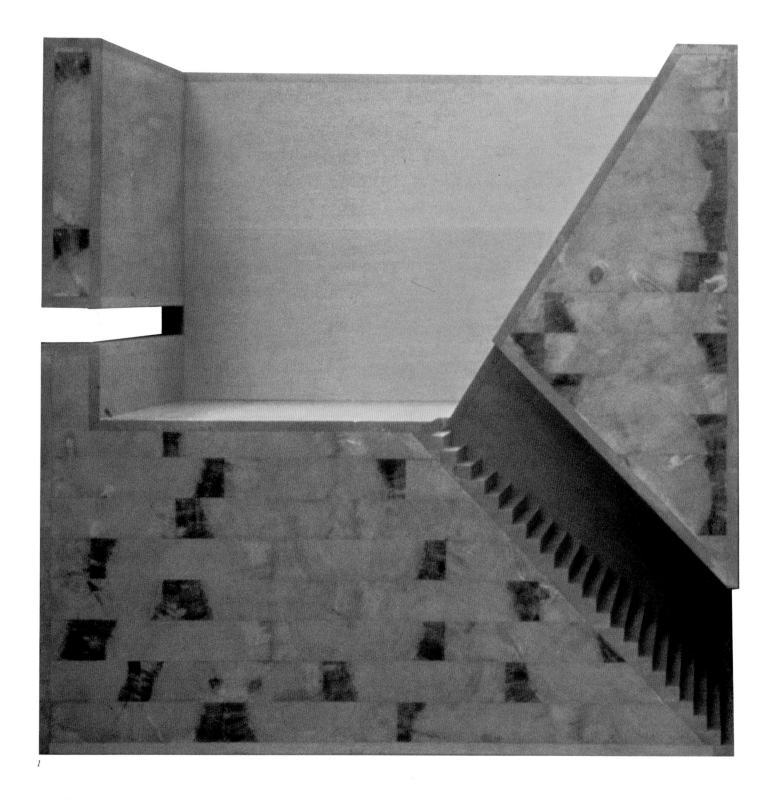

1

Monumental Fountain
Competition Design
Milan, Italy, 1962
With L. Meda

The design for a fountain at Milan's administrative center unites the uses and characteristics of squares, monuments, and fountains. The primary form is derived from a cube with parts of its volume excised. The structure is built of reinforced concrete faced with white Istia stone. Situated in a rectangular basin of water, it is accessible by a short flight of stairs. Water flows from the uppermost edges of the cube along three surfaces that slope to a narrow aperture. From the aperture water falls as a continuous sheet into the basin below. An ambulatory area is excised from the cube, offering shade and seating.

1. Sectional axonometric 2. Site plan
3. Section through stairs and back elevation

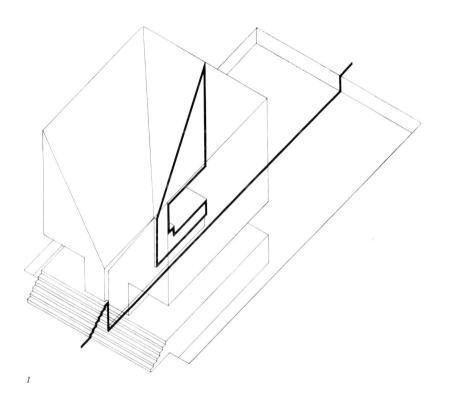

1

2

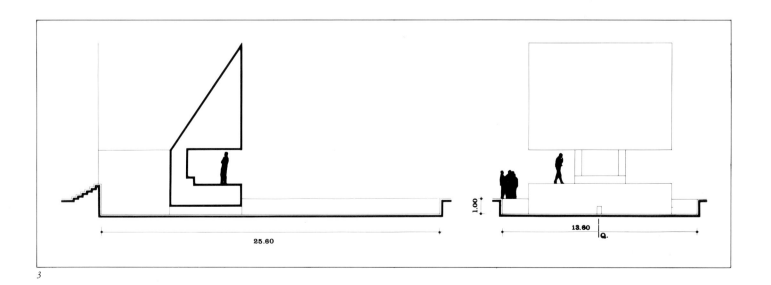

3

*1. Side view of model 2. Perspective view of
model 3. Plan 4. Front elevation*

1

2

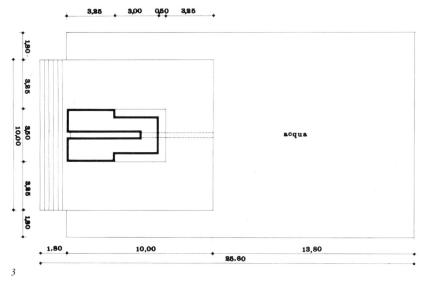

3

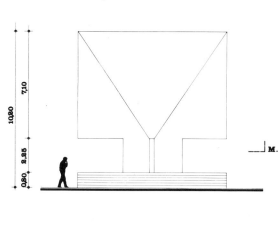

4

Country Club
Fagagna, Italy, 1962
With G. U. Polesello

The site is a hill in rolling countryside. In the design, the separation between two parts of the building—the public and the more private sections—is expressed as a topographical rather than a functional condition. The two parts of the complex are built on opposite slopes of the hill and are connected by means of a gallery tunneled through the hill. Private rooms are in the smaller of the two parts; in the larger are a restaurant and a series of salons. The main hall is capped by a spherical dome. The axis of the gallery extends through a main hall as a series of stairs, and beyond it in a long run of stairs following the hill's slope. In addition to these stairs, two pergolas on either side of the main hall extend into the hilly landscape. As well as preserving the natural condition of the hilltop, the partially submerged buildings appear as unearthed ruins, underscoring the primacy of the landscape.

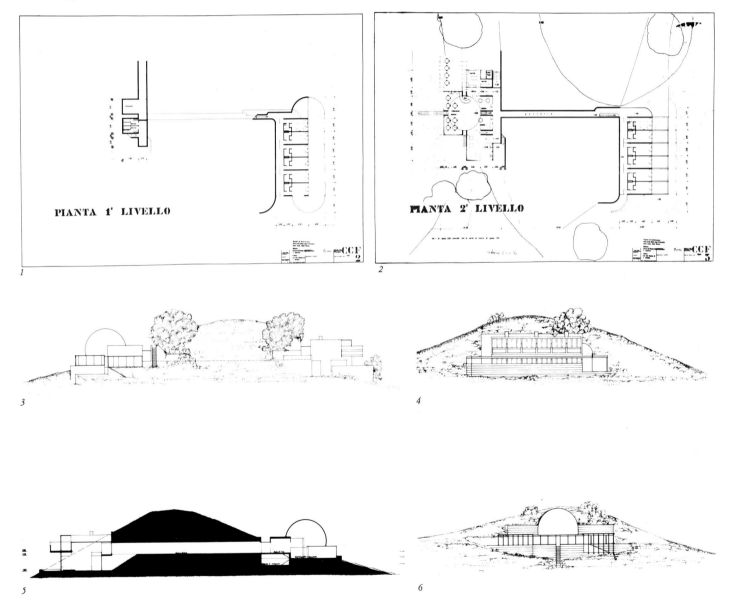

1. Ground-floor plan 2. First-floor plan
3. South elevation 4. East elevation
5. Section through gallery 6. West elevation

In the competition design for a school in the park of the Royal Villa in Monza, submitted under the name Peter Pan, the formal attributes of organization around a presumably continuous grid are explored. The grid is created by a series of glazed ambulatories that bind all parts of the project together. A distinction is made between public and private areas, the former housed in a block at the front of the school, the latter in a slightly deeper block at the rear. In the center of the school, between the two major building areas, the ambulatories enclose a series of raised open courts. In the front block, administrative offices, the cafeteria, and laboratories are arranged. The central bay of the front block is roofed but otherwise open, creating a portico and entrance atrium. The heating plant, built as a separate building in line with an edge of the

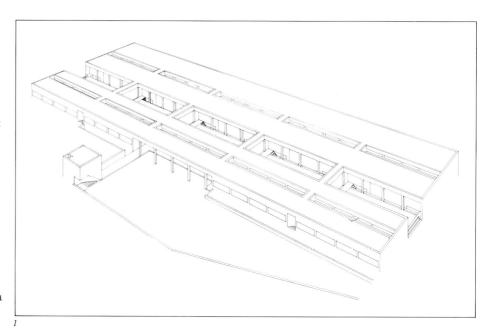

1

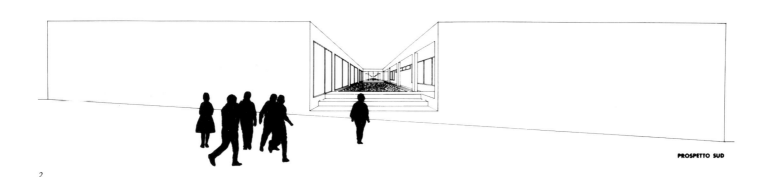

PROSPETTO SUD

2

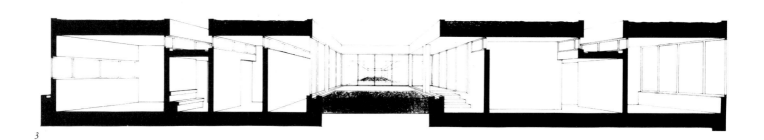

3

atrium, further demarcates the entrance. Each of the five major bays of the teaching block at the rear contains four small classrooms, a service area, a large commons classroom, and a recreation area. While the small classrooms overlook the park in which the school is sited, the commons and recreation areas of each bay give views and access to the adjacent court and, through the glazed ambulatories, to the other gardens and facilities of the school.

1. *Perspective view* 2. *Perspective elevation from south* 3. *Perspective section through courtyard* 4. *Ground-floor plan* 5. *Sections looking north (left) and south* 6. *North (left) and south elevations* 7. *East elevation* 8. *Section through the courtyards* 9. *West elevation*

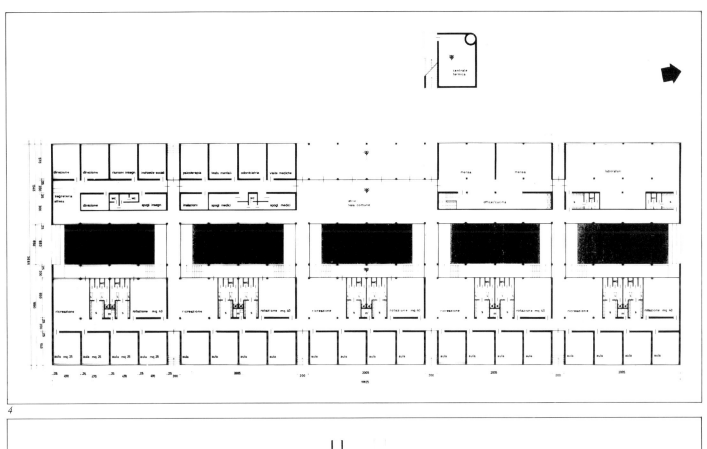

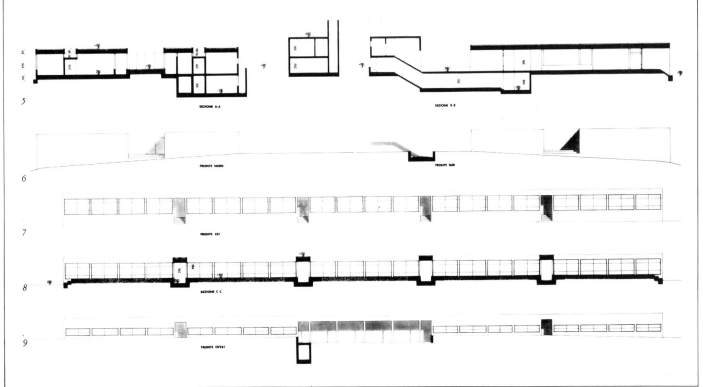

Museum of Contemporary History
Addition and Interior Design
Milan, Italy, 1962
With M. Baffa, L. Meda, U. Rivolta

Located in the center of Milan, the museum is housed in a seventeenth-century building and in an addition that extends into its courtyard. The design for the renovation and addition emphasizes the history of the building itself by organizing views through subsequent building layers; openings cut into the original bearing wall invite views through to the addition beyond. The addition is a large hall that overlooks the courtyard (through large sheets of glass). The museum displays artifacts such as war relics, newspapers, posters, documents, and flags. In the courtyard, field guns from World War I sit on a slab of white stone. Inside, freestanding panels and showcases, glass-topped display tables, and wall-mounted panels, as well as large, freestanding artifacts, are arranged simply against a background of "cold" materials—white marble, white painted wood, glass, and metal. The intent is to let the objects—each with its own rich history—stand in uncompromised isolation against a neutral background.

1

1. *Hall of flags* 2. *Hall on the courtyard —
interior view* 3. *Hall on the courtyard —* *through hall of flags* 4. *Hall on the
courtyard — interior view* 5. *Courtyard*

2

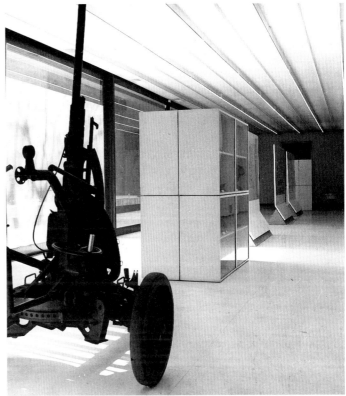

4

3

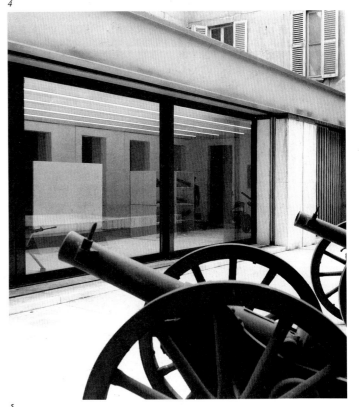

5

Centro Direzionale
Competition Design
Turin, Italy, 1962
With G. U. Polesello, L. Meda

The idea of a *centro direzionale* was advanced by many in Italy during the sixties as a solution to several urban planning problems. To alleviate congestion and reverse the conversion of housing stock to office use in center cities, the strategy proposed was to build complexes of offices and municipal administrative facilities outside historic city centers. The scale of a complex imagined as a *centro direzionale* was large enough to constitute a self-contained new district and determine the direction of urban expansion. Competitions for the design of such facilities have frequently become the ideological battlefields on which opposing ideas about land use and the future development of historic cities are advanced and criticized.

In this project, submitted under the name Locomotiva 2 to a competition for a *centro direzionale* outside Turin, the nature of the program as a large-scale intervention in the suburban landscape is emphasized: the main building masses—four blocks defining a large square—are held nearly 30 meters above ground. Beneath them, elevated highways carry traffic through the complex.

Supporting the building are equally spaced cylindrical piers. The piers house not only the structural support, but also elevators, stairs, and mechanical cores. The building blocks, each about 20 meters deep, primarily house offices. The top floors are devoted to nightclubs and other entertainment facilities. Every seventh floor is open.

The enormous open-air public square defined by the office blocks is developed from ground level with a number of facilities. A shopping street is on one side of the square. On the other is a multilevel piazza. Opening on the latter are the district's congress hall, theaters, and a movie theater. The steel dome of the congress hall rises above the square, visually dominating it.

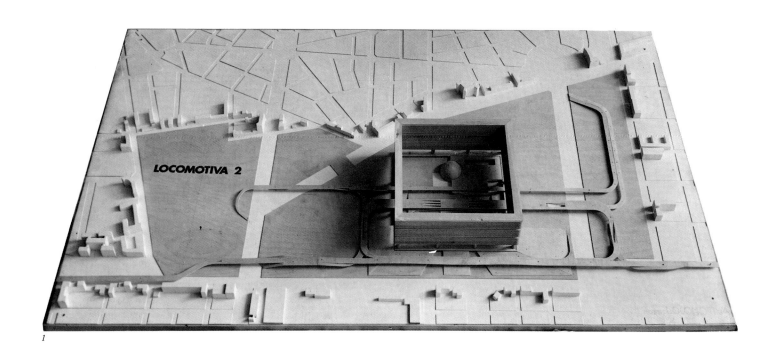

1

1. Model from above 2. Section looking
south 3. Section looking east 4. Site plan

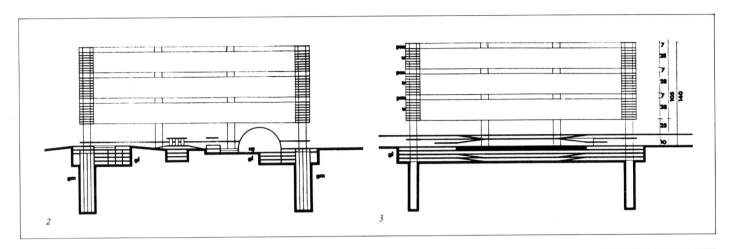

2

3

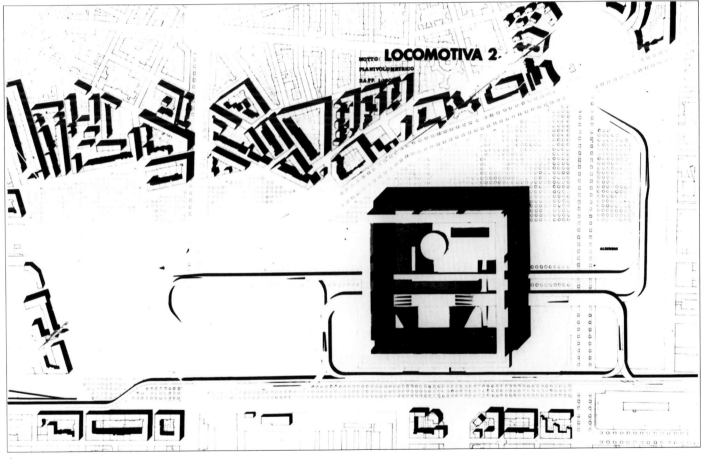

4

Iron Bridge and Park Exhibition
XIII Triennale
Milan, Italy, 1964
With L. Meda

Two projects were designed for the XIII Triennale exposition in Milan—an open-air exhibition area in a park near the main exhibition area, and a bridge connecting those two areas. There are two sections of the bridge: one leads from the park to a raised platform, the other spans a street from the platform to the second floor of the exhibition building, the Palazzo dell'Arte, built in 1933 by Giovanni Muzio. The original plan for the bridge was triangular in section and would have appeared, according to G. U. Polesello, to be of "no color and no material, as certain Ledoux entities." It was built as a reticular structure of iron tubes, screened with wire mesh. In front of the portico of the exhibition building, a cubical pylon

supporting the bridge is sculpted with intersecting arches to create a sort of triumphal arch. Elsewhere the bridge is supported by giant cylinders.
At the far end of the bridge is the exhibition in the park. From the foot of the bridge, a path leads beside a wall, which is 4 meters high and 250 meters long, into which a number of doorways are cut. The doorways give access to exterior spaces made by the placement of walls perpendicular to the long screen wall. The irregular spacing of the perpendicular walls, the variety in their lengths, and the natural rise and fall of the topography all contribute to making these exterior spaces diverse. The rooms at the farthest end of the park from the bridge are

connected by a series of doors in the perpendicular walls. Arranged enfilade, these doorways afford yet another sequential perception of different spaces. The walls are built of a tubular structure covered with asbestos-concrete sheets.
Gianni Braghieri has written of the project that it "evokes many sources, among them an archaeological section whose elements lie in a chance order or, better, in a disarray whose order can no longer be traced by excavation. This 'archaeological' section has a concrete power to perform like a deed bound directly to the imagination, not unlike that of the ancient dwellings in Pompeii, Ercolano, San Clemente."

1

1. *Charcoal drawing* 2. *Sectional*
axonometric 3. *View from inside the*
bridge 4. *Base of the bridge*

2

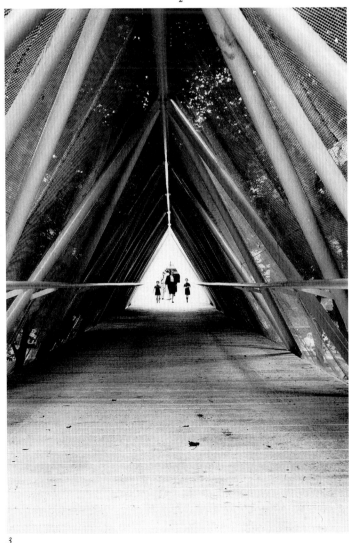

3

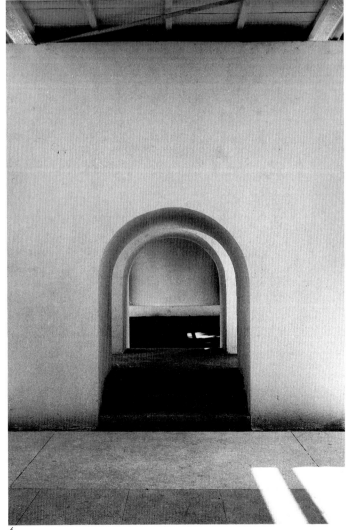

4

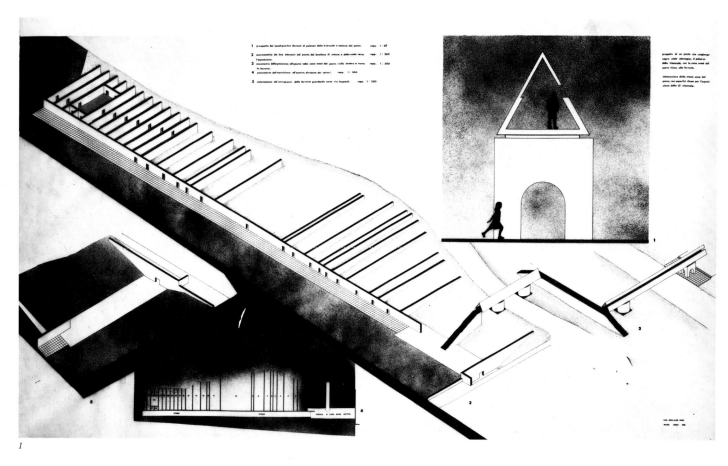

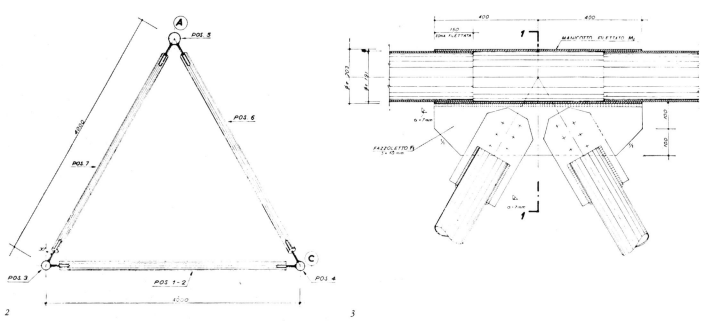

1. *General axonometric with plan and elevation* 2. *Steel truss of the bridge* 3. *Detail of the joint* 4. *The bridge and the Palazzo dell'Arte* 5. *The bridge from the street* 6. *Wall enclosing open-air exhibit in the park*

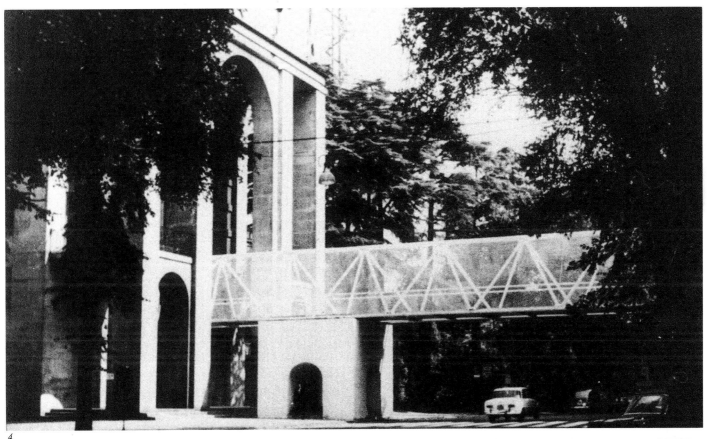

4

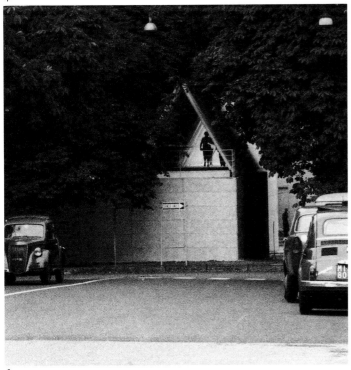

5

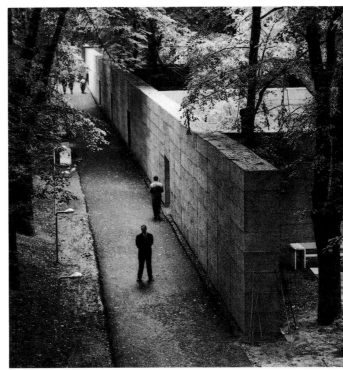

6

The site of the project is a popular summer spot—a wooded area opening onto a long riverside beach. The project's program includes a restaurant, dock, locker rooms, volleyball court, playing fields, and an elevated boardwalk, as well as upgraded access to the area, superseding an inadequate old path. In the design, a footbridge spans the lagoon at one end of the site. The lagoon itself is given regularized edges, two of which are developed as docks for small craft. Aligned with the access bridge is the boardwalk, intended to provide areas for sunbathing in summer and for promenades in cooler seasons. Its elevation also serves to protect it from the river's seasonal flooding.

Farther away from the river, on higher ground, is the restaurant, designed to be operable year-round. All the buildings were designed to be of reinforced concrete, some were to be painted; the restaurant was to be faced with white plaster.

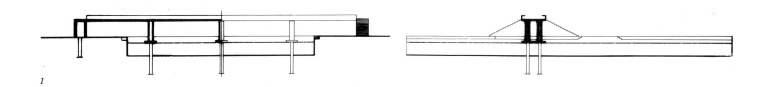

1

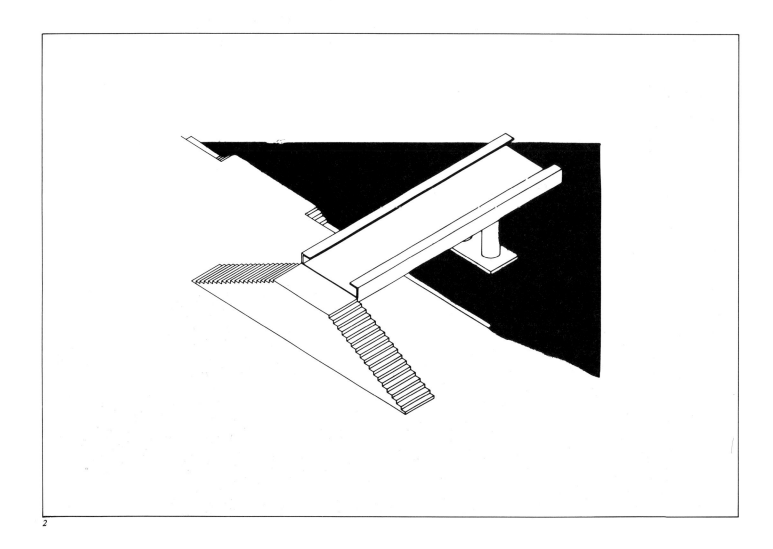

2

1. Sections through bridge 2. Partial axonometric of bridge, showing its main elements 3. General axonometric of the complex 4. General plan

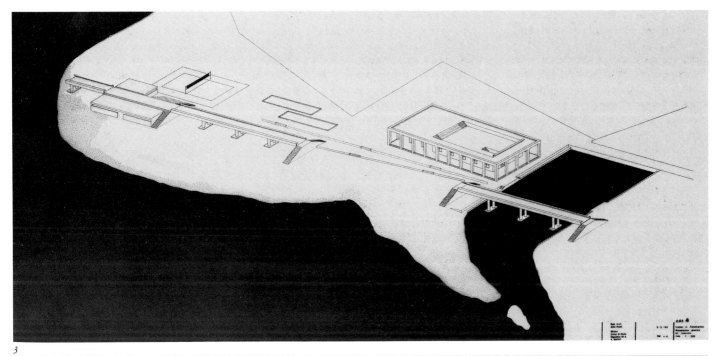

3

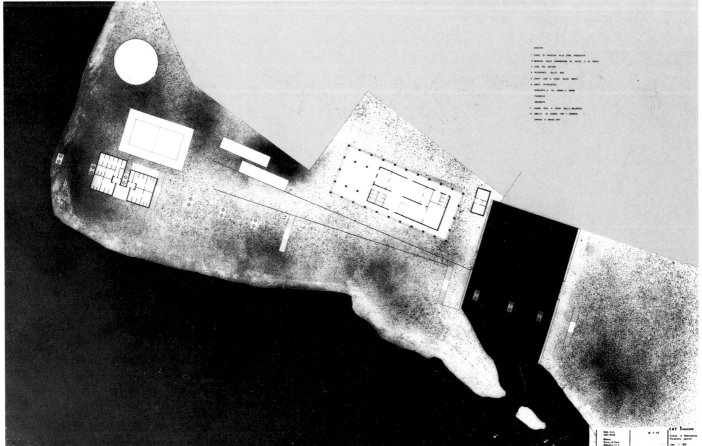

4

Pilotta Square and Paganini Theater
Closed Competition Design
Parma, Italy, 1964

The area in front of the Pilotta Palace is irregular, with one open edge. Along that edge, two freestanding structures are proposed in the design: a long rectangular building and a theater in an elliptical volume. Below grade, the two buildings are linked by two service floors. The rectangular building, with its narrow dimension to the square, has a portico of giant piers on one side. Stairs within the piers lead to rooms below and above, including one within the triangular roof. At ground level there is a continuous colonnade around the theater; farther up, a loggia, with its bays formed by slabs, wraps the building. The theater's fly-loft and curving ceiling are held within the simple form of the ellipse and a slightly pitched roof.

In the design, according to Rossi, "I wanted to construct an urban architecture, to give a public character to the building." Toward that end, "I designed cylinders and columns, line and points. . . . Here I was at the site of an Italian piazza and an exceptional monument: the Pilotta Palace. The Pilotta contains probably the most beautiful Italian theaters. The theater, however, is hidden within the body of the building, which remains unchanged and unchanging within its courts, its regular façades, and its unfinished parts."

Rossi explained that, because of the location of the theater as part of a civic urban space, "I was directly faced with the problem of the monument. I've always thought of a work of architecture primarily as a monument and am relatively indifferent to secondary functions. Only when architecture becomes a monument does it constitute a place: if one wanders through an ancient theater, spends hours in the Roman theater at Orange as the light changes, or walks through an empty eighteenth-century theater, ideas about a specific theatrical performance seem secondary. A theater may house a show, but it also presents its own architectural reality."

1. *"Study for the Parma Theater"*
2. *Sectional axonometric* 3. *Drawing for the arcade* 4. *Plan and section of theater and elevation of the arcade*

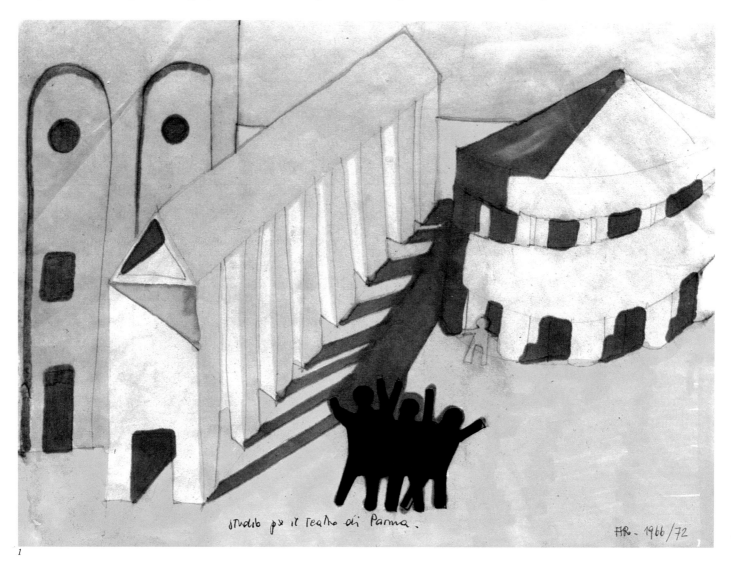

studio px il teatro di Parma.

AR - 1966/72

1

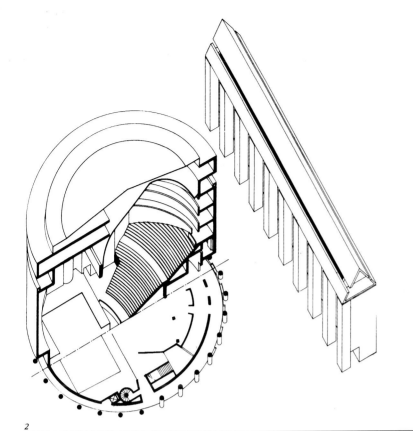

2

3

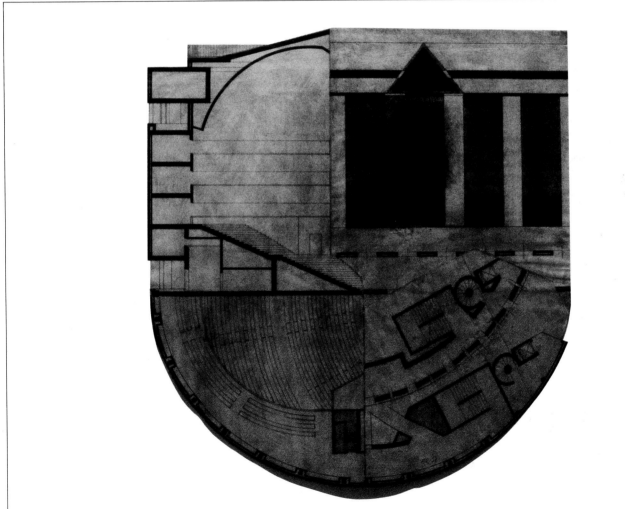

4

Given these perceptions, Rossi believes, "In the design of a theater, considerations of function shouldn't be excessive; artisans can always adapt a building; woodworkers, ironworkers, decorators, and electrical workers can always make a building usable. But it's a different case for architecture; a theater can't be designed for a particular show—it must suggest the essence of the theater." The cylindrical form of the theater at Parma was conceived of as an ideal container for many theater shapes: steps, boxes, domes, planetariums, and open-air theaters.

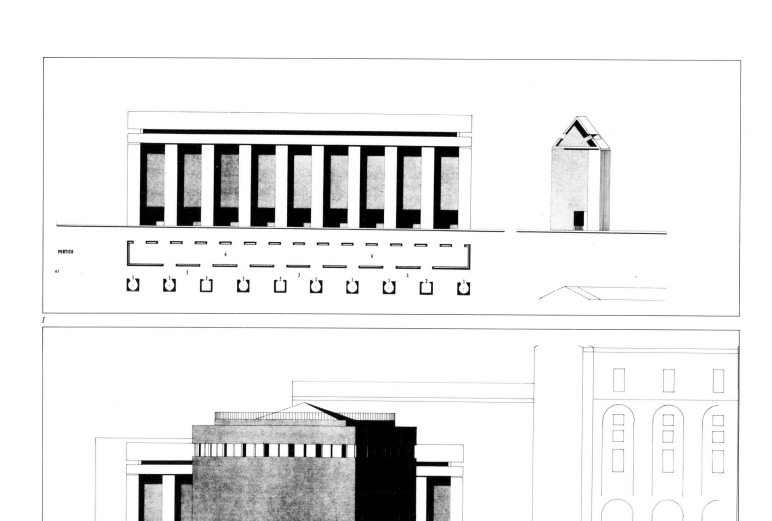

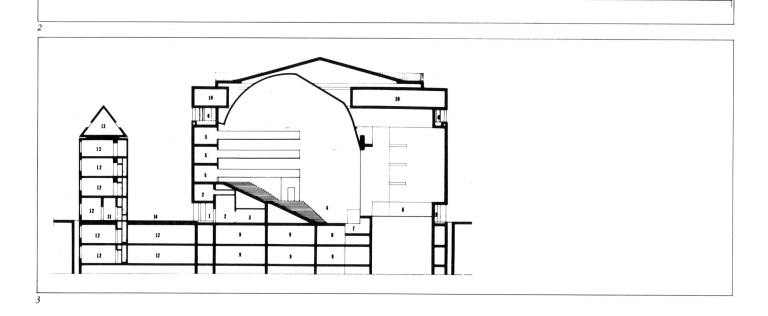

*1. Plan, elevation, and section of arcade
2. Elevation of theater 3. Section
4. Geometrical construction of plan of theater 5. Elevation from the street with
Pilotta Palace in background 6. Ground-
floor plan 7. Upper-floor plan*

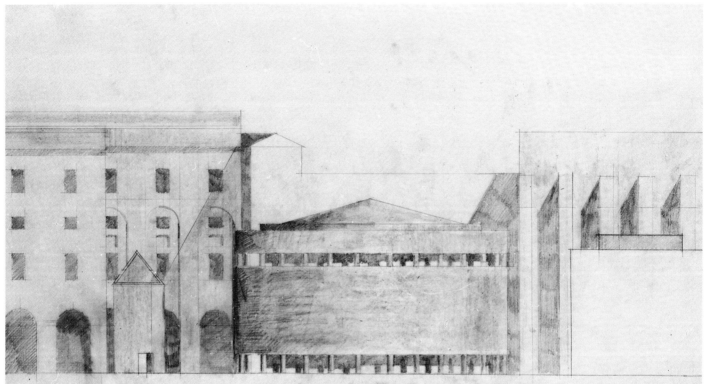

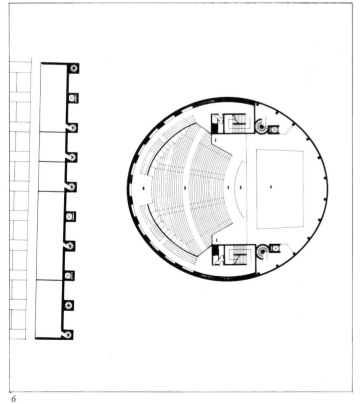

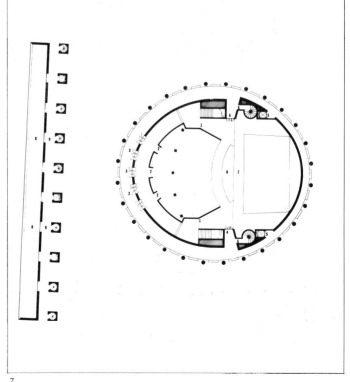

1

2

3

To define a public piazza in the area adjacent to Segrate's new city hall, several elements were designed. First, a wall was proposed to enclose the piazza on three sides, with a few arched openings providing views. A series of low cylinders on square bases provides the suggestion of another layer of built border to the square. From the city hall broad concrete steps lead down to the piazza, which is paved in cubes of red porphyry. Beside the steps, the bank is planted as a border of greenery, a border that continues along an adjacent side between the walls and the line of demi-columns made by the cylinders.

The main element of the design, however, is a monument to the partisans of World War II. Both monument and fountain, it is made by the superimposition of several primary forms. From the city hall a flight of stairs leads down to a podium, suggesting that the monument serves as a kind of bridge between the new civic buildings and those of the town beyond. Between the podium and a large cylindrical column spans an extruded triangular element that serves as the duct for the fountain's water. A basin perpendicular to the monument was built to receive the water. It was intended that the reinforced

concrete cylinder and duct be painted with glossy white enamel.

The wall and demi-columns at the edge of the piazza, neither of which have been completed, were intended (in Rossi's words), in conjunction with the monument, to "construct an architecture of shadows. The shadows mark the time and the passing of the seasons." The elements of the square were also intended to suggest fragments of earlier construction, as if a new forum had been discovered by excavation.

1. "American Cathedrals"

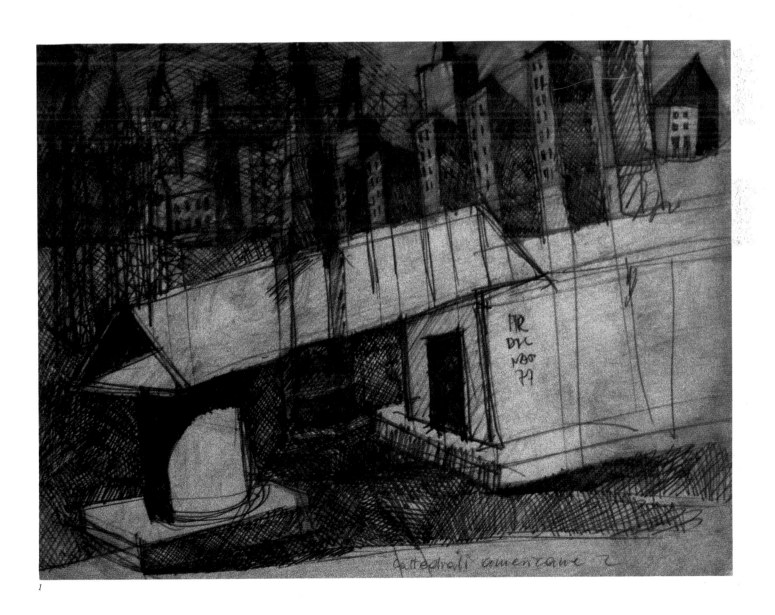

1

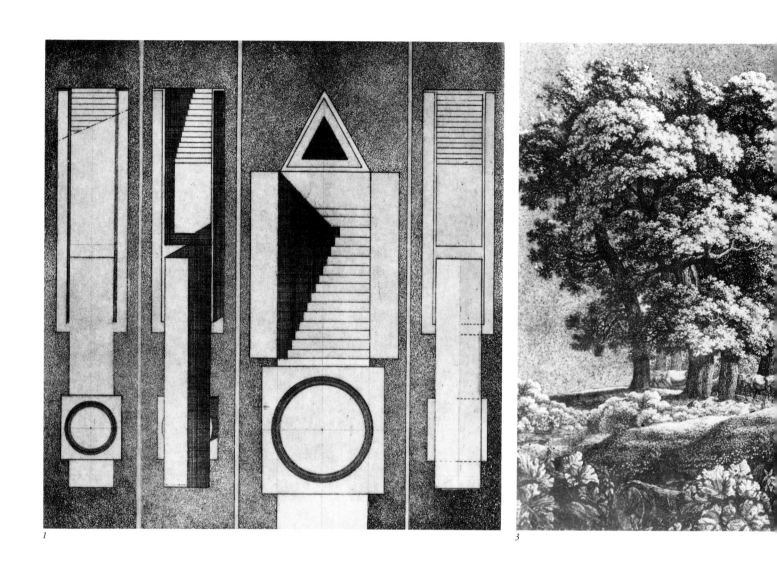

1

3

2

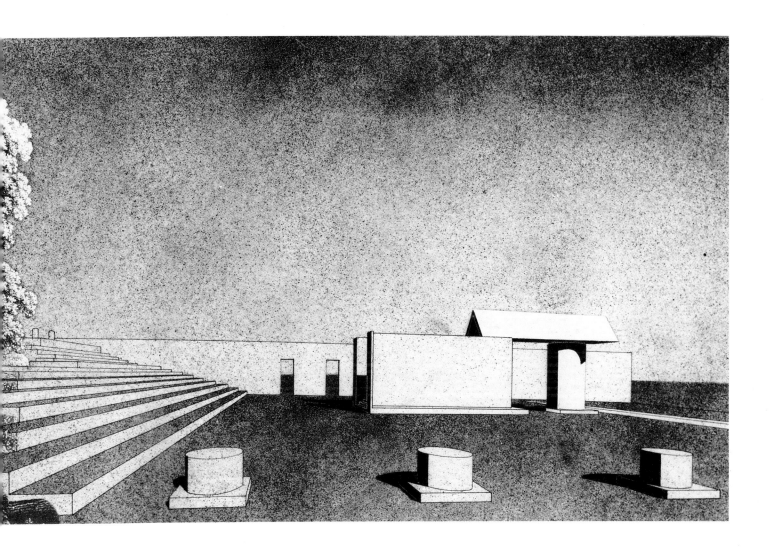

4

5

6

55

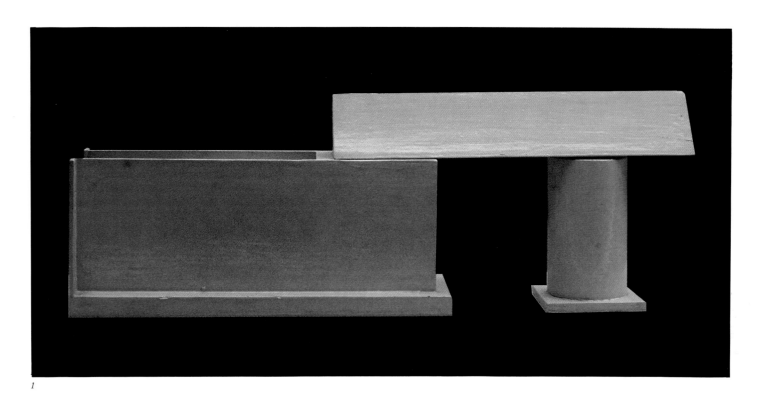

1

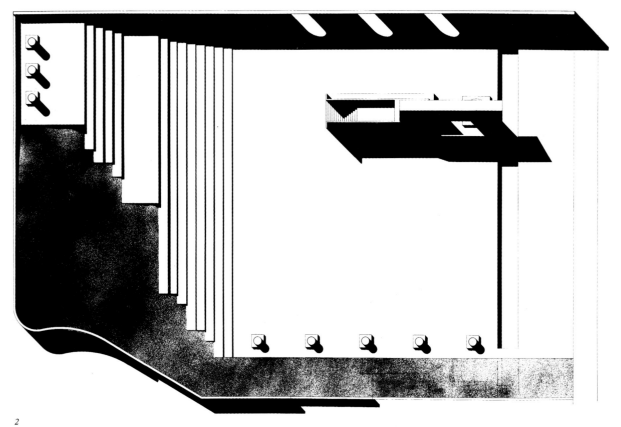

2

1. *Side view of the model* 2. *General plan* 3. *Model from above* 4. *Back view of model* 5. *Fountain under construction*

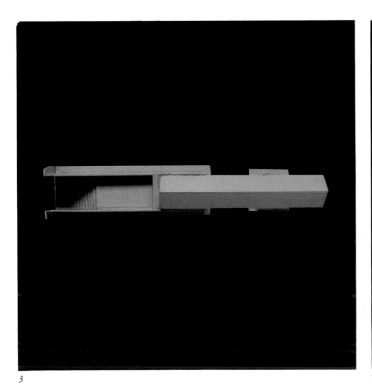

3

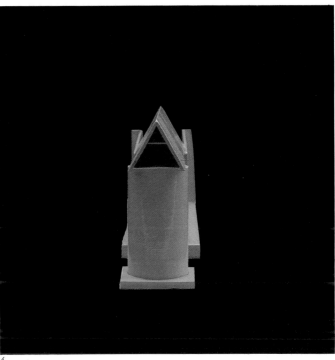

4

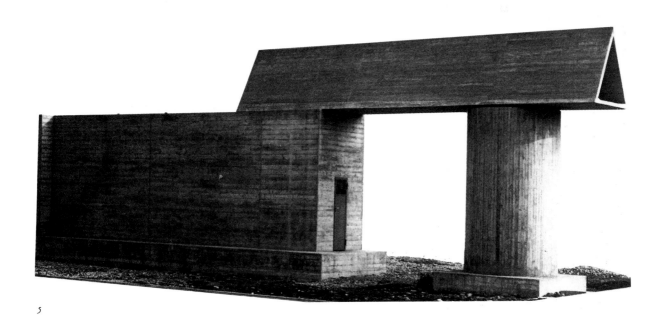

5

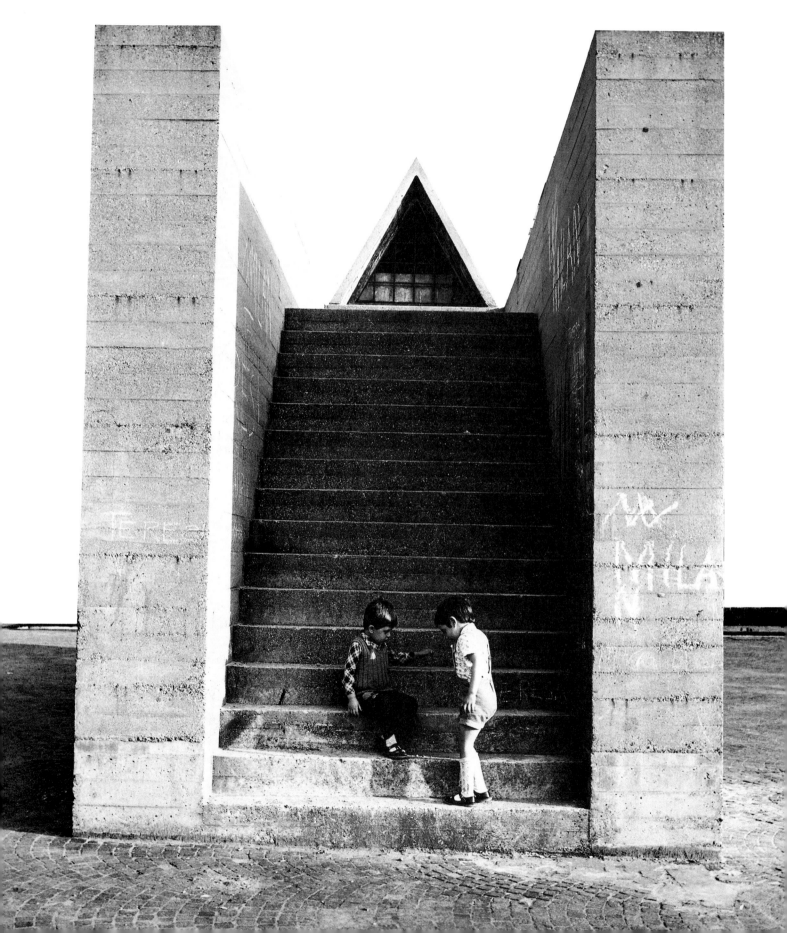

*1. The fountain today 2. The piazza today
(including back view of fountain)*

2

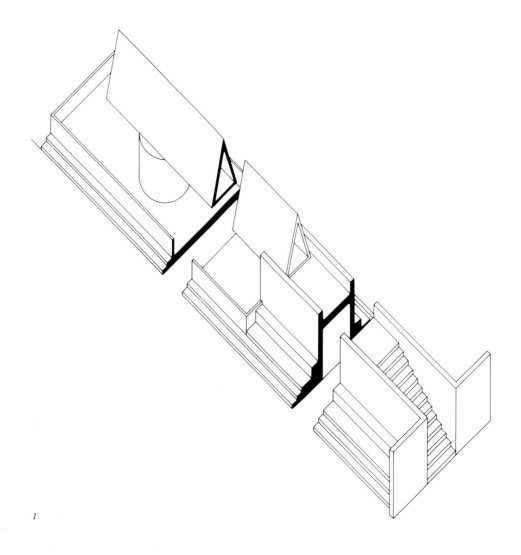

1

1. *Sectional axonometric* 2. *Elevations*
3. *Section and elevation* 4. *Section and*
cross-section

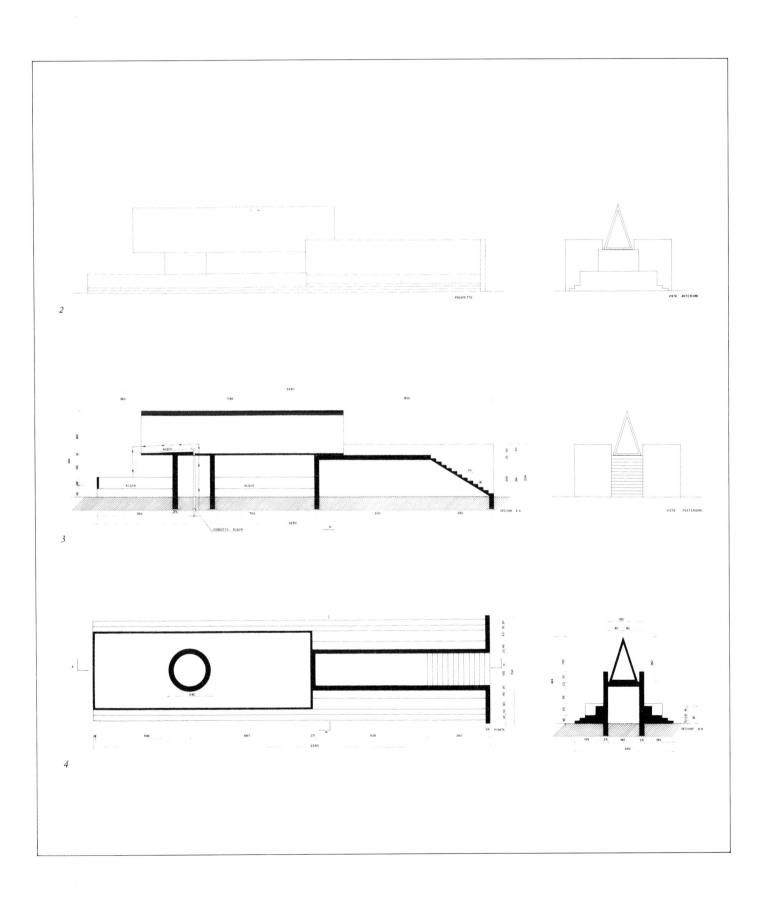

2

3

4

San Rocco Housing
Competition Design
Monza, Italy, 1966
With G. Grassi

Monza is a small city that has been subsumed by the sprawling Milanese metropolis. The area around the site is a run-down mixture of the residential and industrial buildings typical of the semiurban landscape of northern Lombardy. An existing road bisects the site roughly in half. The intent in the design is to propose alternatives both to the morphological chaos of the industrial suburb and to the standard building types of private and public housing.

The design is generated by an exploration of the courtyard building type. A grid of two-story housing blocks defines a series of small courts. There are two much larger courts near the center of the project—one sits next to the road and the other actually straddles it. Because they are four times as large as those in the two-story blocks and are surrounded by buildings twice as high, these two courts create a more public character. A third large court is set alone in the eastern part of the site.

The exploration of the courtyard building typology was influenced by a number of specific precedents: local urban and rural domestic architecture, Lombard abbeys, and early modern housing complexes like the Karl Marx Hof in Vienna and the Berlin Britz. Rossi has explained that the original impetus for the project was to achieve "absolute rationality: it was the Roman grid imposed on a piece of Lombardy. It could have been extended infinitely; there was something perfect about it, yet also almost lifeless, detached. Then I realized the two parts of the grid should be offset, just slightly. The mirror remained in its frame, yet broken in a way that couldn't be described as a desire for asymmetry so much as an accident which slightly altered the reflection of a face."

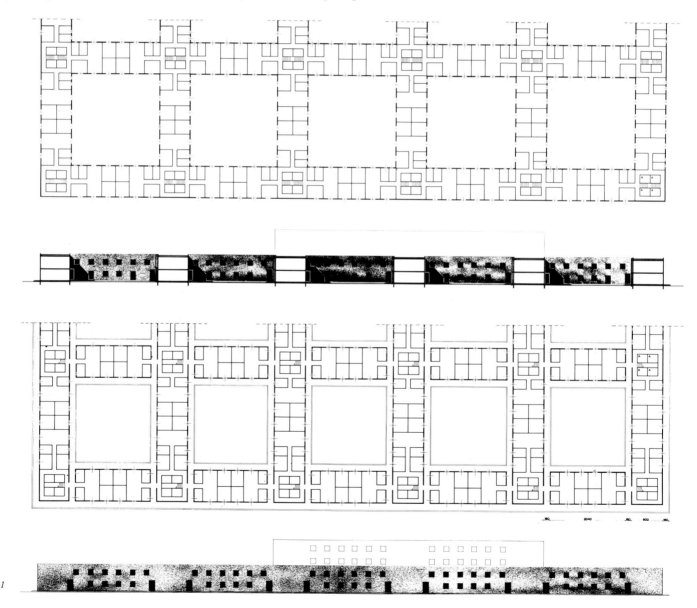

1

1. *Typical floor plans, street elevation, and*
section through courtyard 2. Model from
above

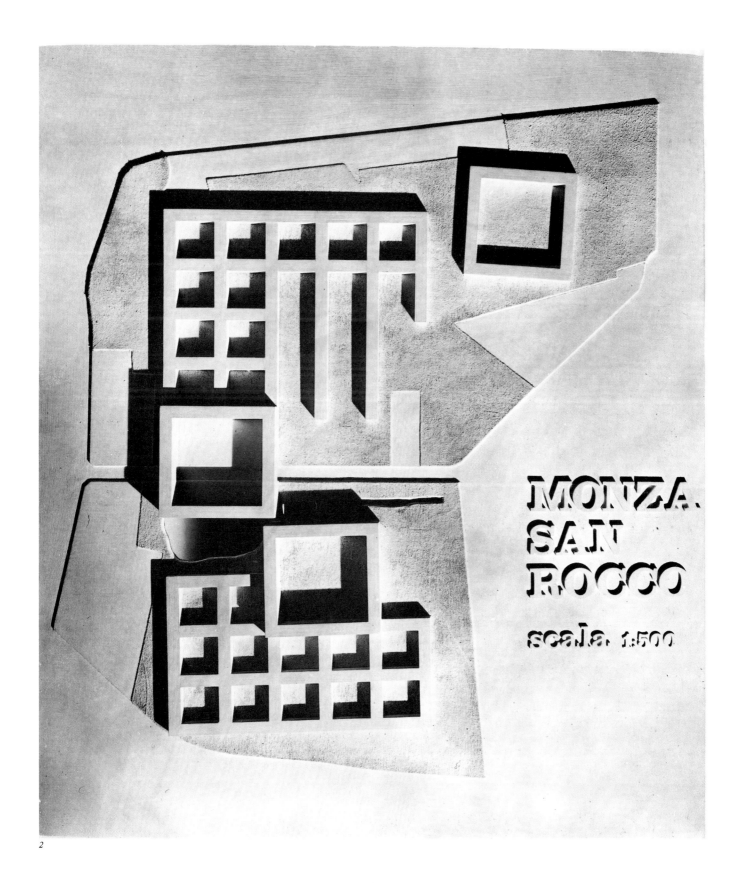

MONZA
SAN
ROCCO

scala. 1:500

2

63

Piazza
Competition Design
Sannazzaro de' Burgondi, Italy, 1967

Proposals were solicited for a competition to create a town center on a site near an eighteenth-century palace and garden, residential buildings, and a bus station. Four new buildings were proposed to define a triangular piazza. Two sides are staked by an L-shaped building of gray stone facing, with white piers and window frames. The building is completely open at ground level; its stairs lead to a lower-level department store. Along the longest side of the triangle are an open arcade, a fountain, and a rotunda. The latter, near the bus station, contains a bar at ground level and a restaurant above. The arcade, fountain, and rotunda stand in front of the palace garden, creating a sort of screen wall and gateway between piazza and garden.

1

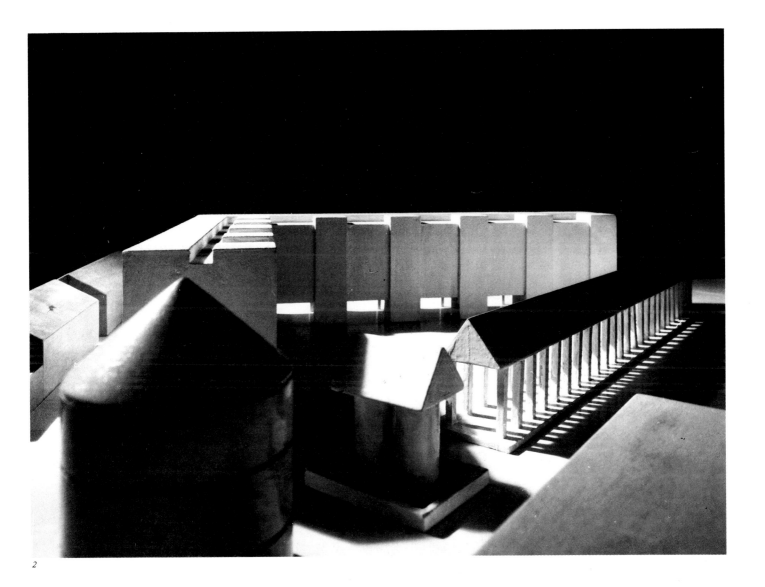

2

City Hall
Competition Design
Scandicci, Italy, 1968
With M. Fortis, M. Scolari

In the design for the city hall of a town outside Florence, a number of typologically distinct elements are connected along the axis of an elevated gallery: a square block of administrative offices arranged around a central court; a block containing the mayor's offices (which spans between the office block and a library); the library; an exhibition space; and a circular, domed council hall. The gallery/bridge is a steel truss that runs between the metal-domed council hall and the library block. Its dimensions are planned to accommodate exhibitions, with additional room in the gabled hall through which it passes. The steel beams supporting the mayor's offices rest on the library and office blocks, with four large, cylindrical steel columns providing intermediate support. The centrally planned courtyard block contains public service offices. The courtyard provides an internal focus for the office areas; the colonnaded gallery wrapping the court on each floor also serves as one of the office corridors. The principal exterior finish is an unpolished dark gray Tuscan stone facing. The galleries around the office court, however, are plastered and painted white, while the four columns supporting the mayor's office are varnished with a glossy white or light blue paint.

Rossi cites several architectural ideas and vocabularies explored in the project. Industrial architecture is a primary source—both its elements, which have proven

1. Model from above

1

iconographically influential in modern architecture, and the fantastic qualities of its pure and rigorous forms, such as smokestacks, tanks, domes, and bridges. The dome was also seen as a form traditional to both Eastern and Western architectures. More regionally specific, the use of stone and the formal rationality of Tuscan architecture were influential. Finally, the design explores organization along a linear spine of circulation, as in Rossi's Gallaratese housing. The large, cylindrical columns and the primarily horizontal organization are also related to that project.

1

2

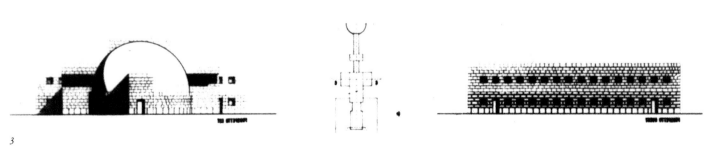

3

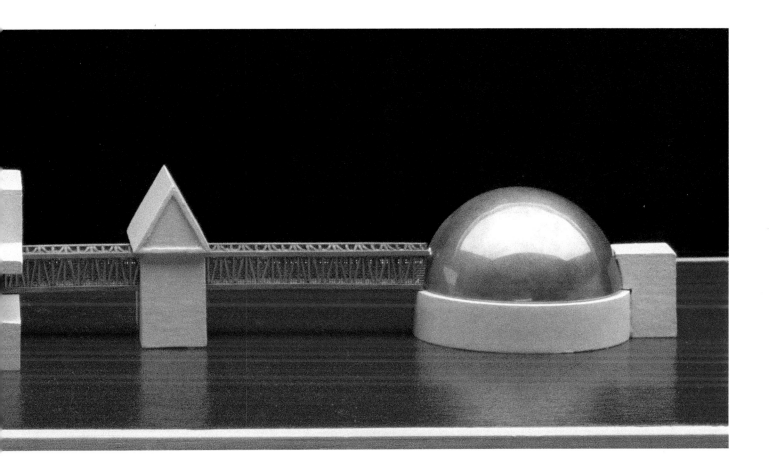

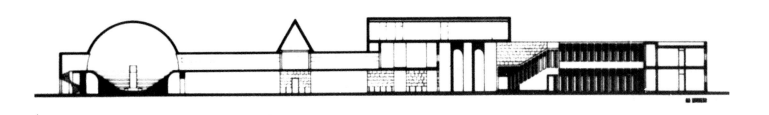

4

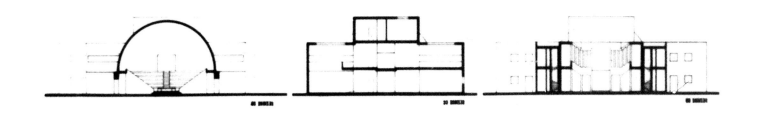

5

1. *Model — front view* 2. *Model from
above* 3. *Model — back view* 4. *Ground-
floor plan* 5. *Main-floor plan*

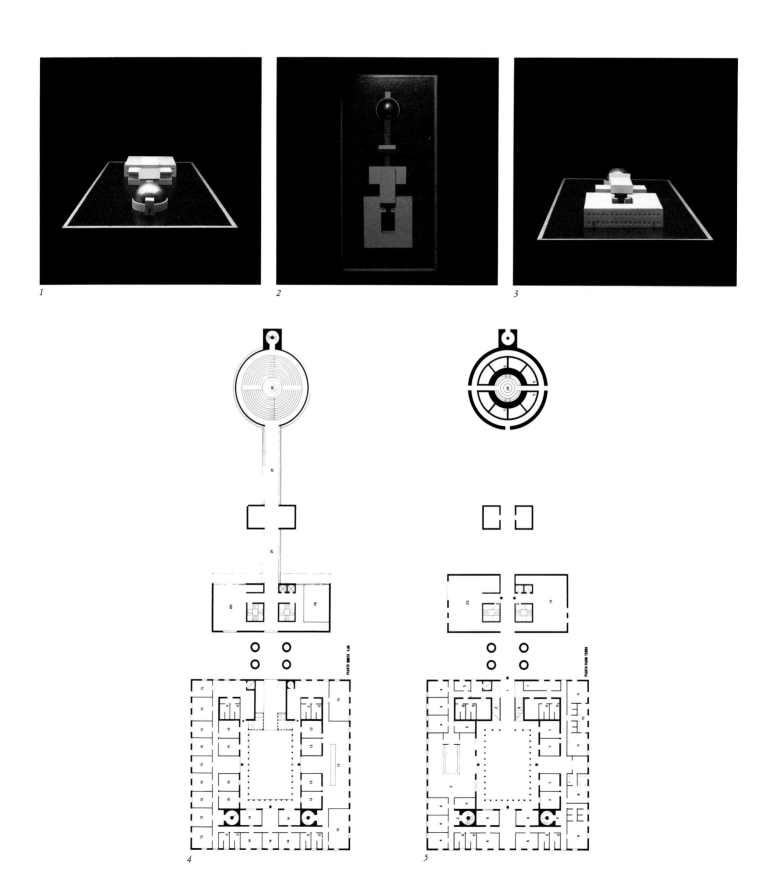

70

School at San Sabba
Trieste, Italy, 1968–69
With R. Agosto, G. Grassi, F. Tentori, E. Mattioni

The site, which overlooks the San Sabba cemetery, has an irregular shape and a slope of more than 20 meters. The longest side of the site, that toward the cemetery, is developed with the germinal element of the design: a wall that follows the slope of the site, creating a sort of rampart. The rampart lies against another wall—blank except for a line of columns marking the entrance gallery—behind which building masses containing the gymnasium and the classrooms are set. The entrance gallery off the rampart is at midlevel between the two floors of classrooms. There are two blocks of classrooms and services, each organized around a central court lit by four circular skylights. Other than the glossy white varnish on the concrete columns of the wall-colonnade, the exteriors are faced in gray stone.

1. Perspectival view 2. General plan

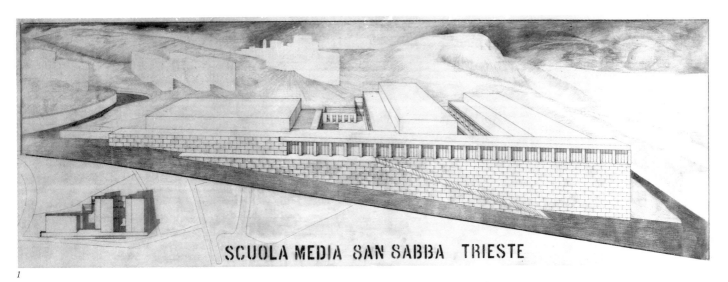

SCUOLA MEDIA SAN SABBA TRIESTE

1

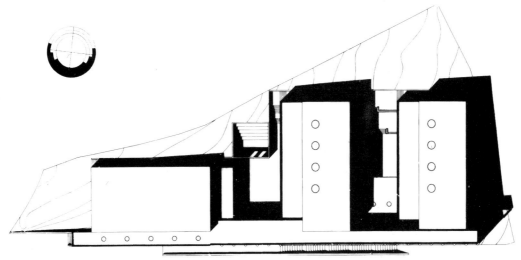

2

1. *Entrance stair* 2. 3. *Corner details*
4. *Main-floor plan* 5. *General view*

1
2
3

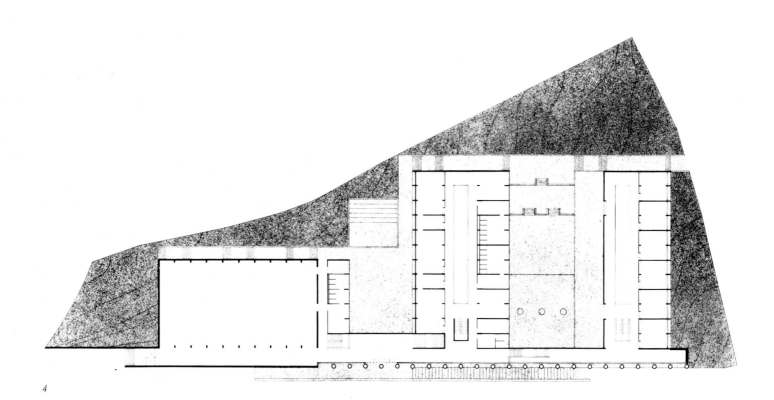

4

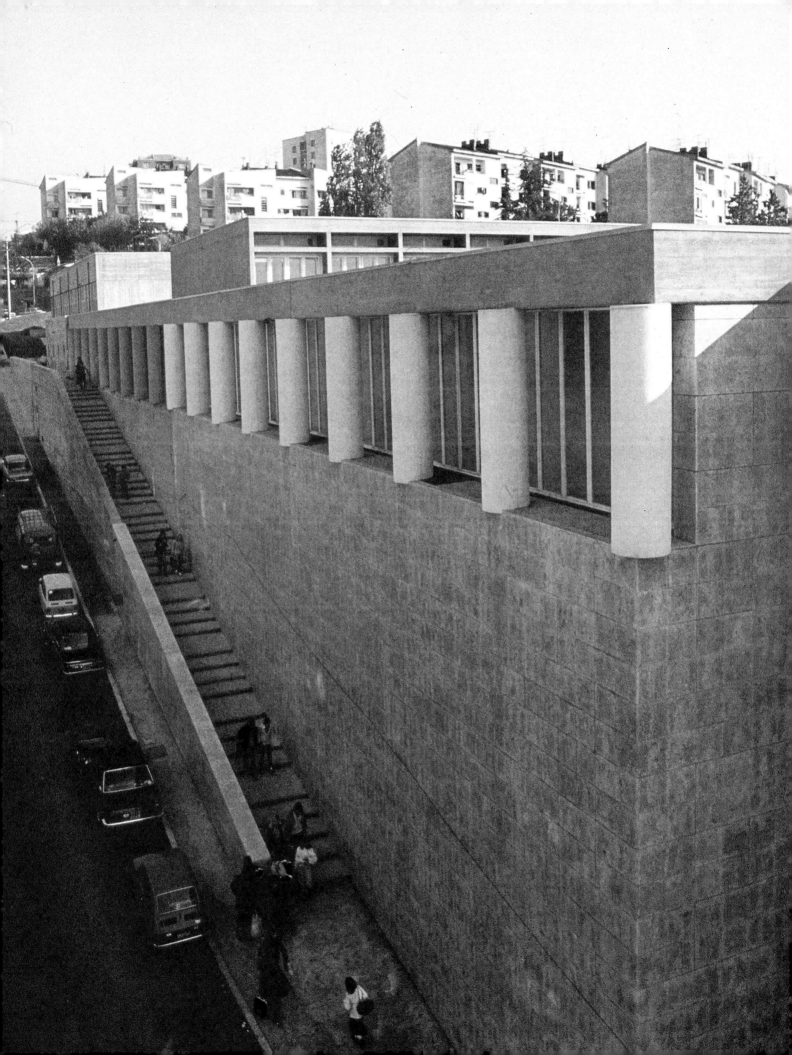

1. Interior view of decks leading to
classrooms 2. Linear section through
classroom wings 3. Linear section

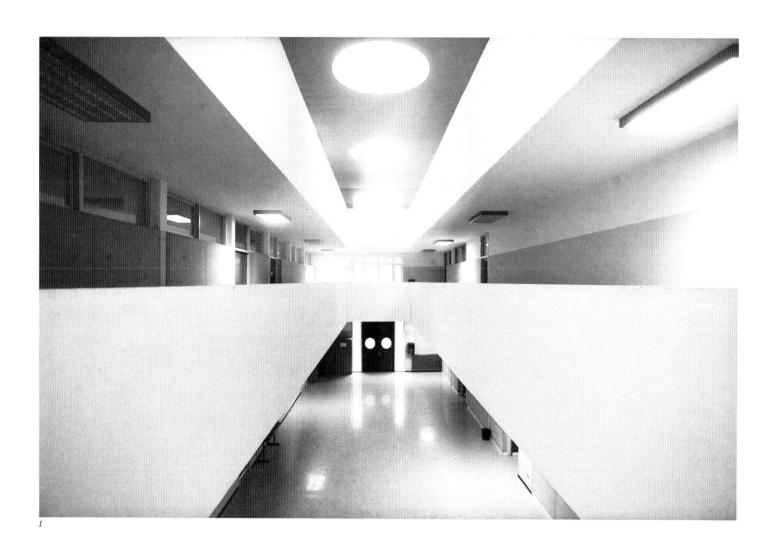

1

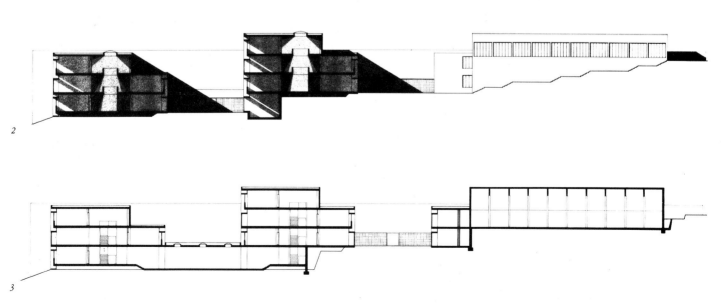

2

3

Gallaratese 2
Milan, Italy, 1969–73

The Gallaratese is a housing complex on the scale of a residential quarter, of which this building is a part. The structure, 182 meters long and 12 meters deep, is in fact two buildings separated by a narrow margin. Apartment units, organized off open-air corridors, or *ballatoi,* are on upper floors. The ground floor is an open-air colonnade-like space. On the northwest, thin piers constitute the "columns" of the colonnade; on the southeast, fins of the same thickness (20 centimeters) as the piers, but 3 meters long, are used. Near the gap between the two buildings, in the gallery of the longer building, are four cylindrical concrete columns 1.8 meters in diameter. Since the gallery of the shorter building is at a higher level, the two galleries are connected by a stair. Shops and stalls open onto the higher gallery. Stairs and elevators to the housing units above are located along the southeast side. Accessible from both the gallery and the outside, the lobby level of these cores is elevated three steps above ground level. The stair landings along the *ballatoi* are marked by pairs of large openings—2.8 meters square—screened with iron mesh stretched on crossed transverse iron bars. Other openings along the *ballatoi* are 1.5 meters square. The majority of the apartments consist of two rooms and service areas. Each unit has at least one private terrace on the northwest.

As the courtyard type was the generator and the subject of study in Rossi's housing project for San Rocco, so the Gallaratese represents a similar exploration of housing typology—in this case, housing organized along corridors. The type is associated with two important and relevant models: it is a constituent part of the vocabulary of modern architecture, conceived of as an internal, raised street; and, like the courtyard house, it is traditionally one of the most widespread housing types in Lombardy. The study of the type was followed consistently. Rossi explains, "I believe the choice of a typology in the moment of design is of decisive importance; many works of architecture are ugly because they cannot be understood in terms of a clear choice, they are, overall, without meaning."

The greatest tension in the project is created by the single interruption of the horizontal continuity: the gap between the two buildings, accentuated by the cylindrical columns and the change in level on the ground-floor gallery.

As much as for intellectual and aesthetic integrity, the consistently developed idea is advocated for its efficacy as a framework, a structure, for the incidents of everyday life. In 1974, Rossi said, "In the last few days I saw the first open windows, clothes hanging out to dry in the loggias—the first timid signs of the life it will assume when people move in. I am confident that the spaces reserved for this daily life—the big colonnade, the *ballatoi*—will bring a sharp focus to the dense flow of daily life and the deep popular roots of this residential architecture and of this 'big house' which would be at home anywhere along the Milanese waterway or any other Lombardian canal."

1. Elevation study

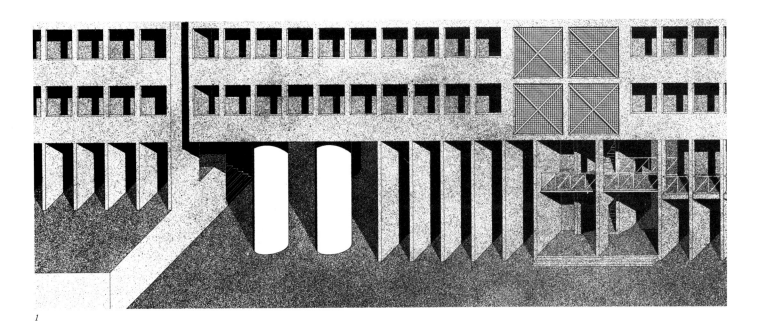

1

75

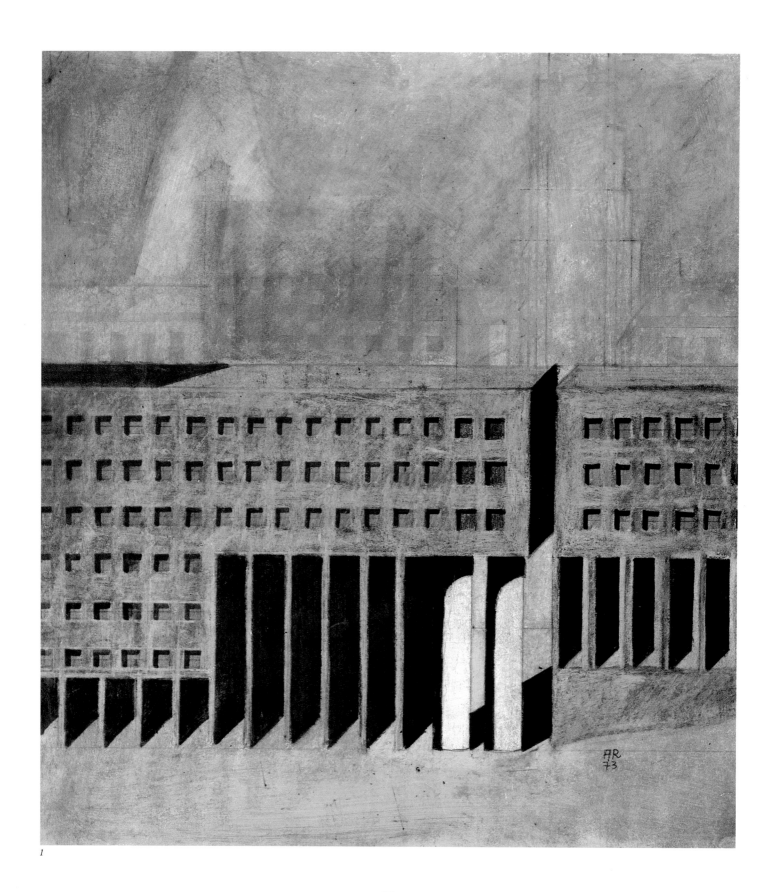

1

1. Elevation study (drawing) 2. Entrance elevation 3. Main elevation (not final façade) 4. Typical housing floor plan 5. Typical floor plan 6. Ground-floor plan

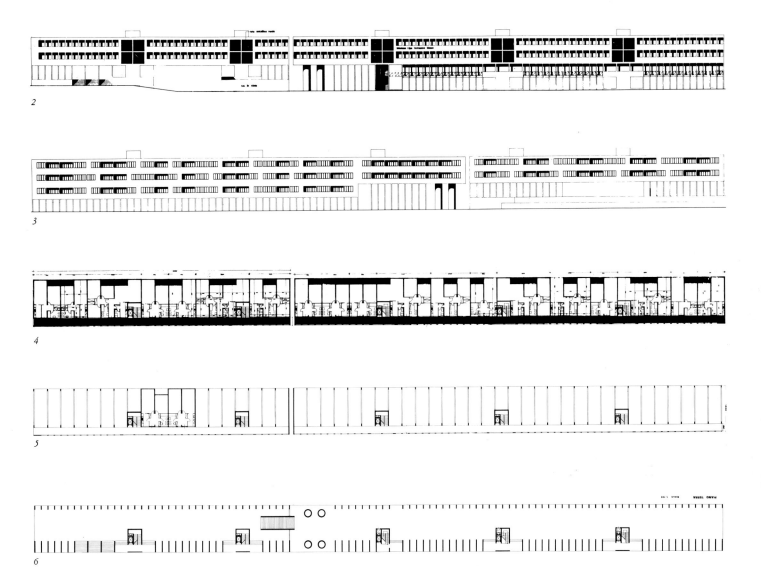

2

3

4

5

6

77

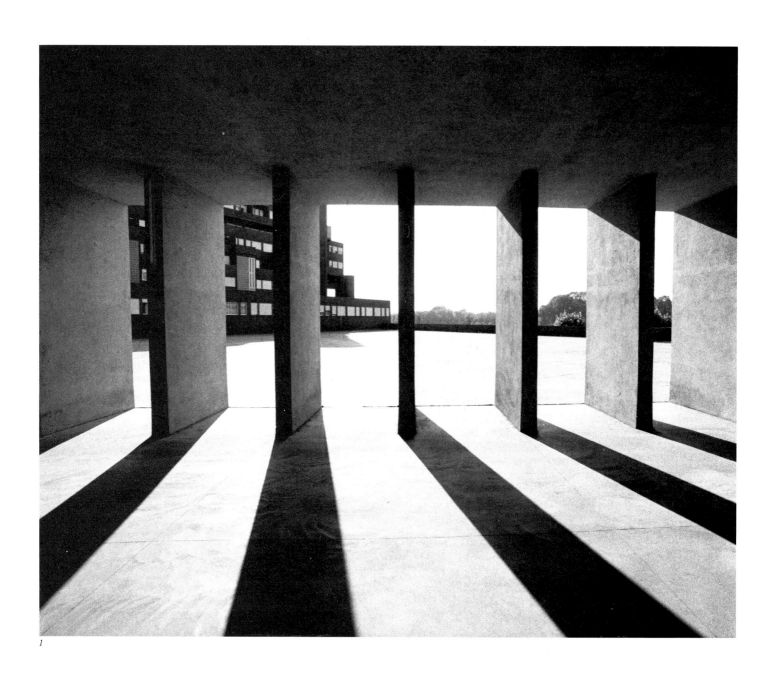

1

1. The arcade—view from inside out 2. 3.
4. 5. 6. Interior views of the arcade at the
ground floor

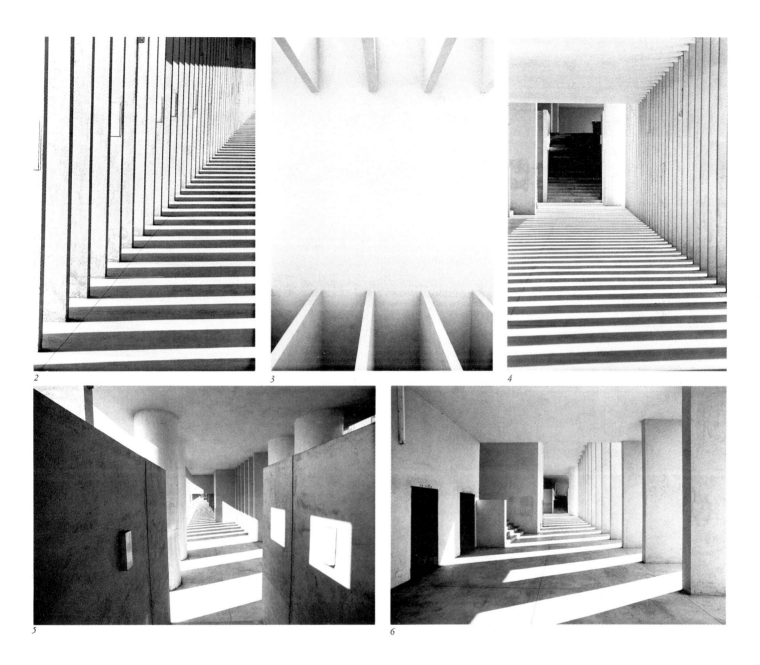

2

3

4

5

6

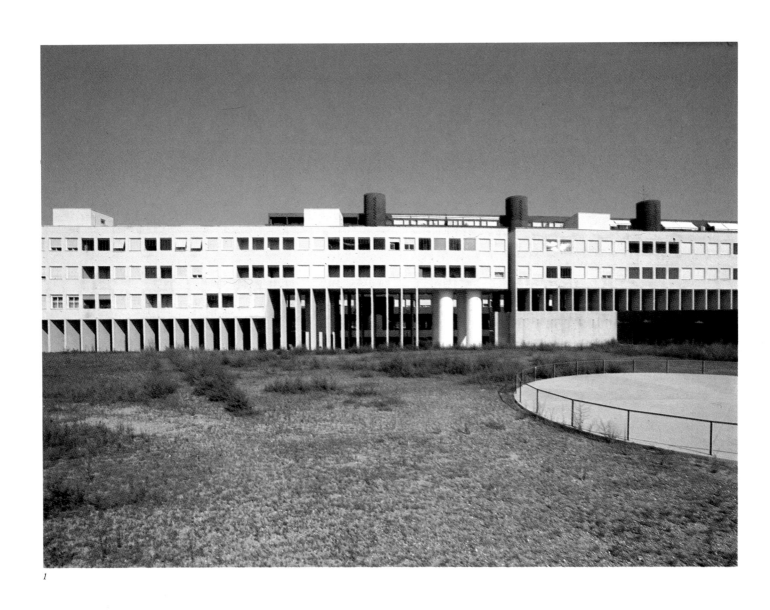

1

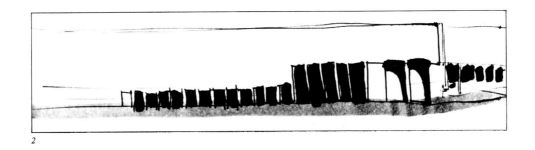

2

1. *Main façade* 2. *Ink sketch*
3. *Stairway* 4. *The gap* 5. *Ink sketch*

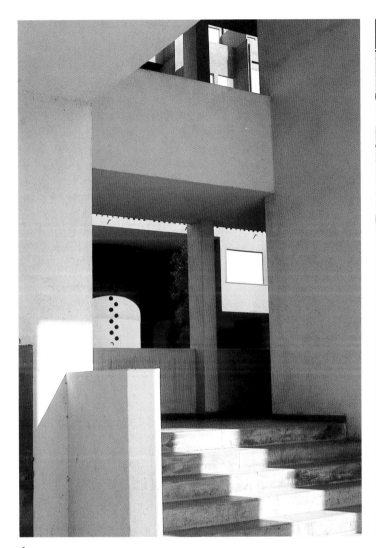

3

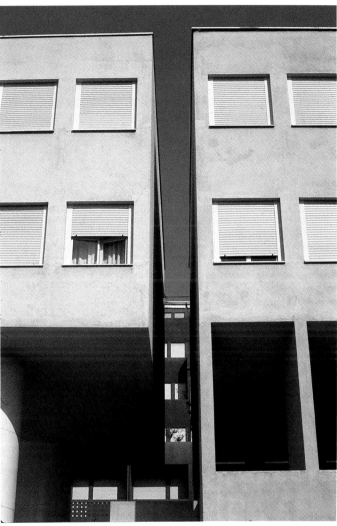

4

5

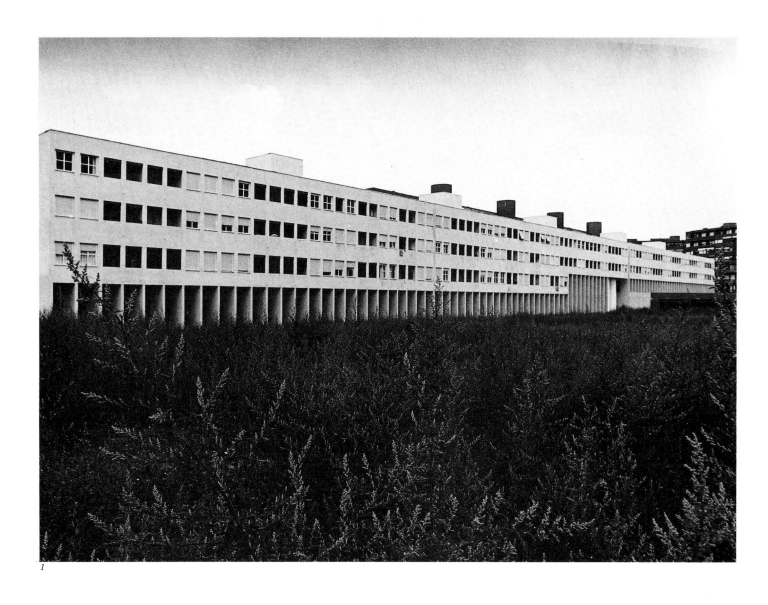

1

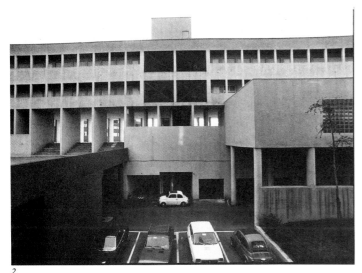

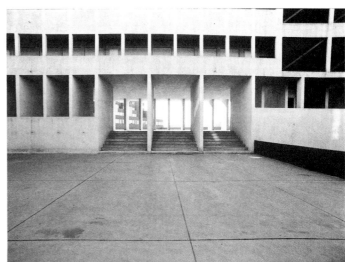

2

3

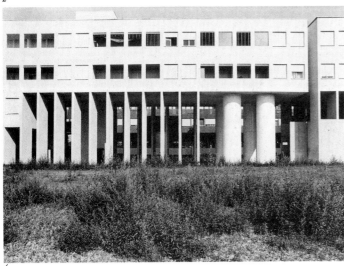

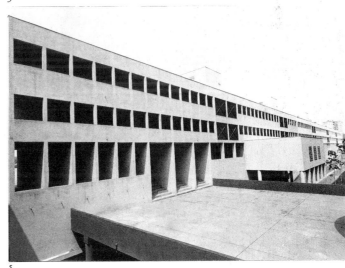

4

5

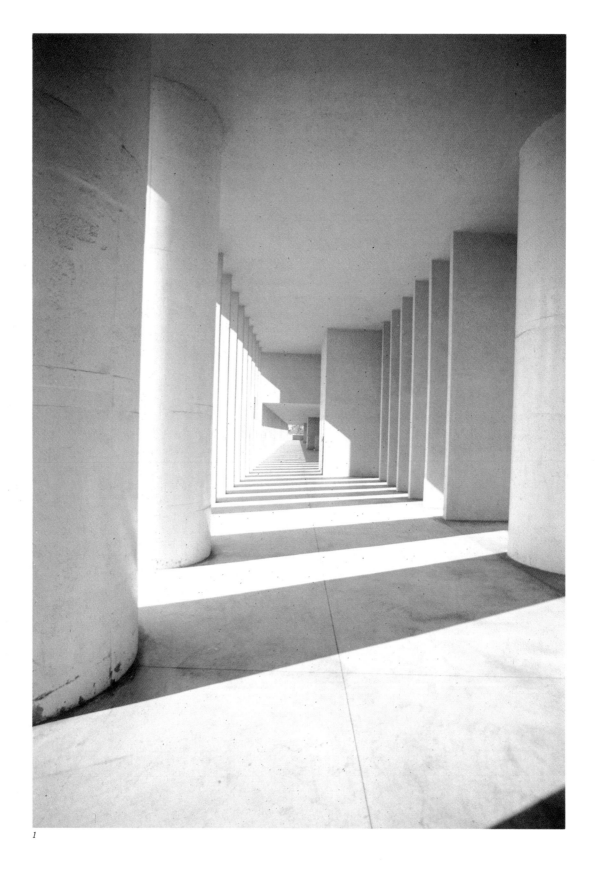

1

De Amicis School
Restoration and Addition
Broni, Italy, 1969–70

A small school built at the beginning of the century was renovated and expanded. Added were a portico, a stair hall, and classrooms. A pair of large, cylindrical columns support the entrance portico. Within the original courtyard, a colonnaded gallery was added around three sides; against a fourth is a fountain, with a triangular water source above a cubical basin. Above the fountain a large window lights—and indicates the presence of—the new stair hall behind it.
From the outset, emphasis was concentrated on setting up a sort of dialectic between the original building and the new construction. The gallery, for example, creates a partial screen through which the yellow Umbrian courtyard façade is visible. Rossi believes this approach appropriate for projects intended to preserve, renovate, or add to old buildings and historic districts. Not only is the context created by a preexisting building formally different from its addition, but, he says, "It also has its own dimension in time, which must be taken into account. To proceed by any other method in a work of 'restoration' can only signify destruction with all the sadness that destruction brings. The current popularity of environmental improvements, preservation, maintaining old façades—a sort of false embalming process—leads to the eventual decomposition of both architecture and townscape."

1. Drawing of courtyard with fountain

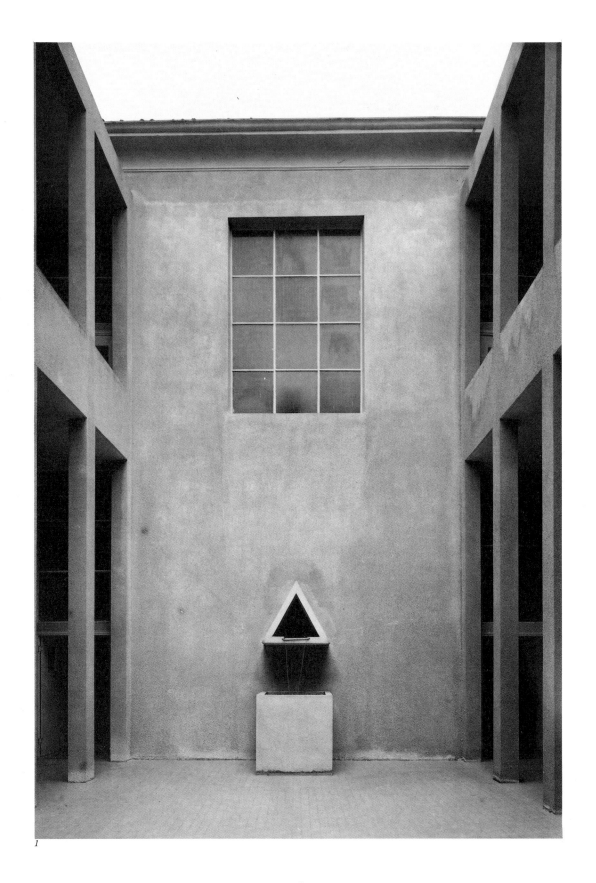

1

1. *The courtyard* 2. *Old courtyard* 3. *New*
entrance 4. *Atrium* 5. *Plan; the*
renovation is in black

2

3

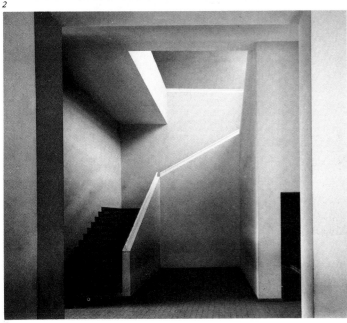

4

5

Cemetery of San Cataldo
Modena, Italy, 1971–84
With G. Braghieri

San Cataldo was designed by Costa in 1858. Along its walls is a panoply of neoclassical forms. Adjacent to it is a Jewish cemetery surrounded by a low brick wall. A major addition to San Cataldo is now being built on the other side of the Jewish cemetery. Rossi's design, which was awarded first prize in the 1971 competition, is completely enclosed, like Costa's, by continuous columbaria. The two parts of San Cataldo are connected by a colonnade, which is adjacent and parallel to the perimeter columbarium facing Costa's cemetery and perpendicular to another long colonnade that leads from the town. This colonnade is intended to shelter tradespeople associated with the work of the place, like flower vendors and stone cutters. The upper floor of this structure houses niches for urns; it is connected to the adjacent columbarium at this level by iron bridges. Additional concentric ranges lie within those of the perimeter.

A C-shaped range encloses the series of ossuaries that constitute part of the development along the central axis. The first element within the gate is a shrine—a cube with windowless openings, one meter square, and without floors or roof—a house of the dead. A stair at its center leads to columbaria below grade. Beyond this shrine are the ossuaries, designed to form a triangular shape both in plan and elevation. The terminus of the sequence is a large conical chimney-like structure over a common grave for the homeless and abandoned. This structure is also connected to the ossuaries at an upper level by a bridge.

The design is being built in stages. In the process of its realization, some functional and formal relationships have changed. The perimeter columbaria will be built on only three sides; the fourth, which faces in the direction of the parking area, will be planted with cypress on low terraces. One wing of a columbarium and the adjacent colonnaded structure have been built in sections to a current length of 175 meters. They are covered with a pinkish stucco; roofs are of sky-blue metal. The shrine has been built as an ossuary, but appears as originally designed on the exterior. It is 19.5 meters square and 17 meters high. Balconies, supported within the roofless volume, give access to the burial cells within the thickness of the red walls.

1

1. Study 2. View from the Jewish cemetery
3. The Jewish cemetery and through the
arcade of the new building

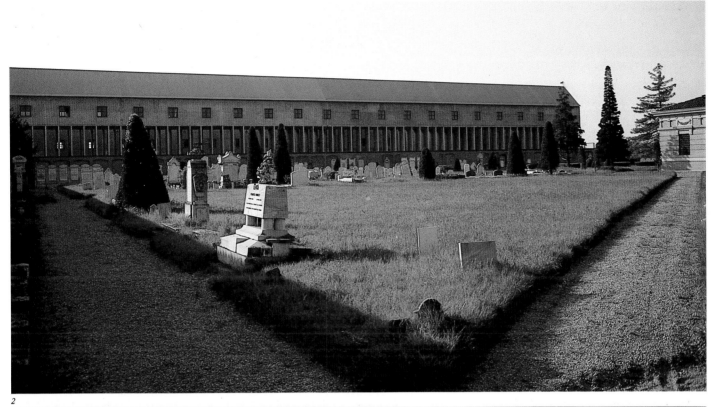

2

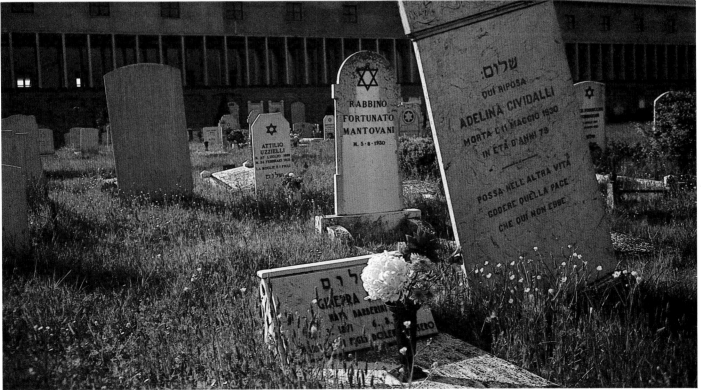

3

1. *Costa's neoclassical cemetery* 2. *General plan for the new cemetery: on the right, Costa's neoclassical cemetery; in the center, the Jewish cemetery, services, and the new entrance arcade as hinge* 3. *The neoclassical cemetery* 4. *Entrance arcade under construction* 5. *Perspective drawing of the new cemetery*

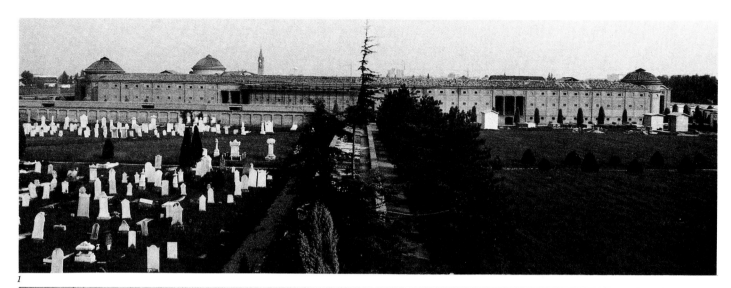

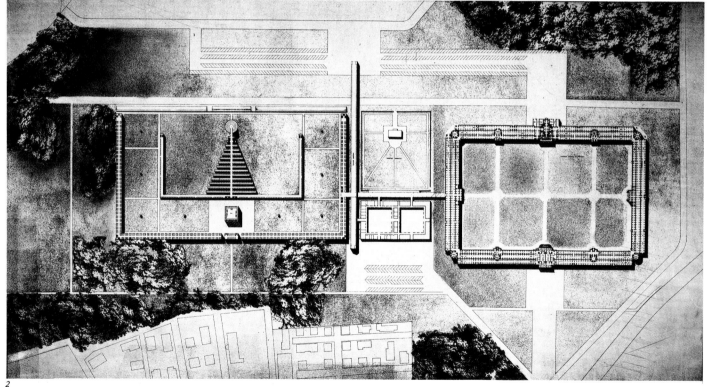

3

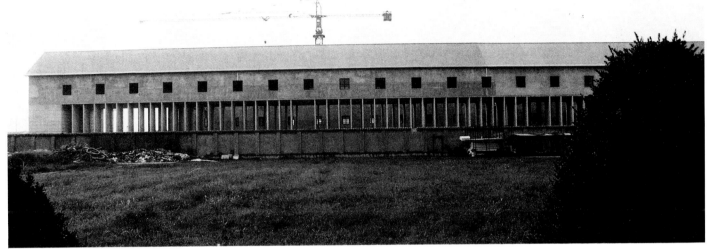

4

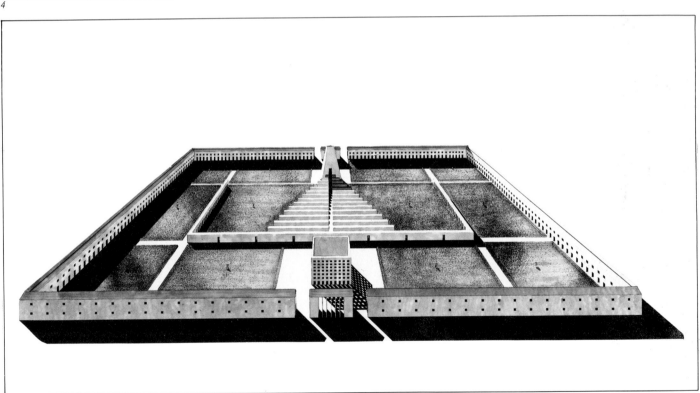

5

1

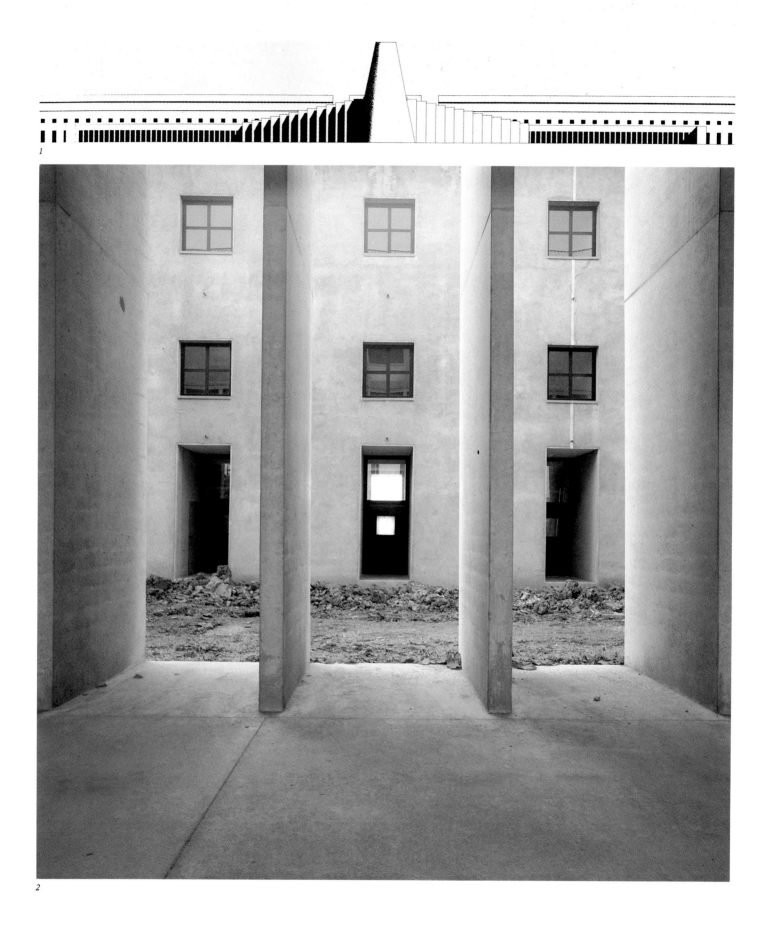

2

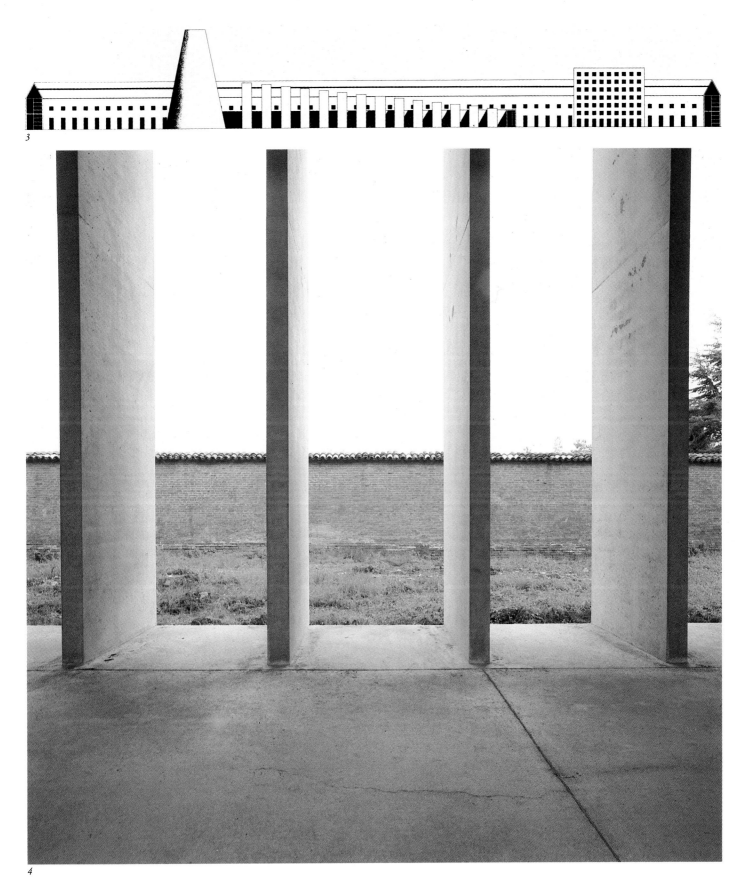

3

4

1. North elevation 2. Perimetral building
seen through the arcade 3. West elevation
4. Perimetral wall of the Jewish cemetery seen
through the arcade

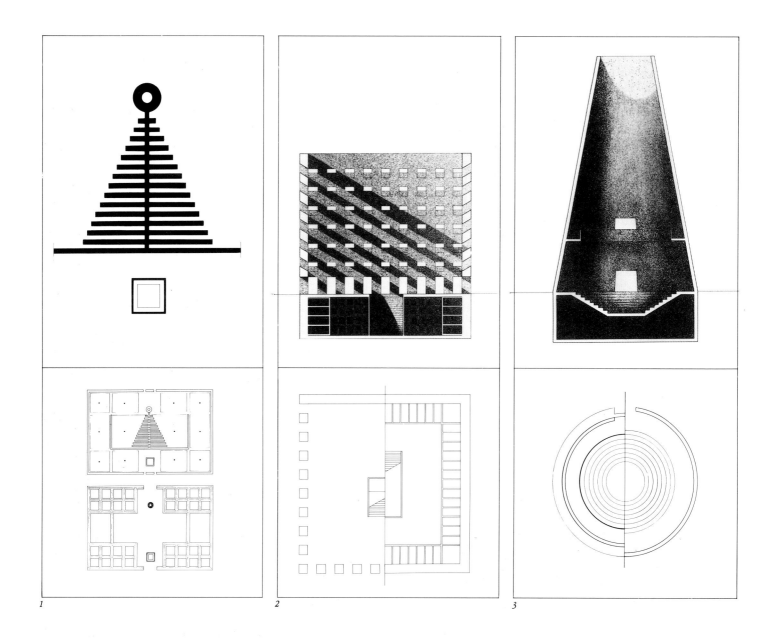

1 2 3

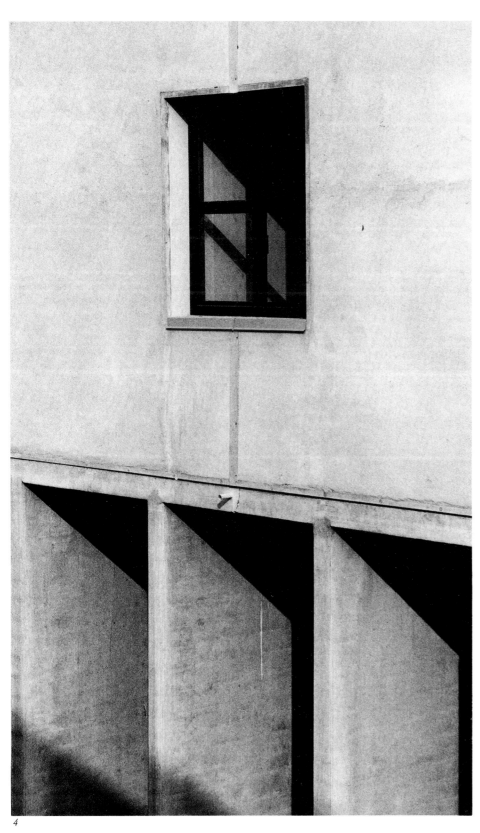

4

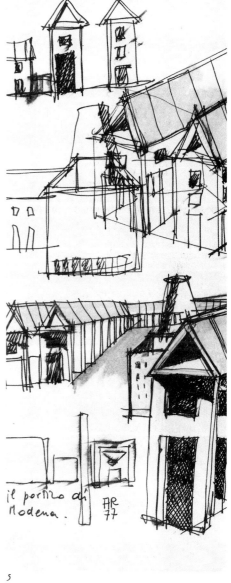

il portico di
Modena. AR
77

5

6

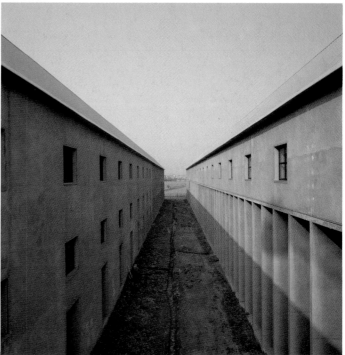

1

2

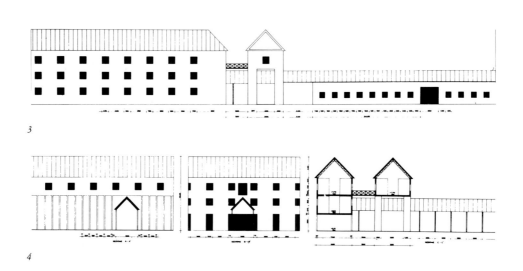

3

4

1. Bridge between hinge and perimetral buildings 2. Gap between hinge and perimetral buildings 3. South elevation

4. Section through perimetral and hinge buildings and through their connecting element at the ground floor 5. 6. Interior

views of a columbarium 7. Elevation and sections of hinge building 8. Elevation and sections of perimetral building

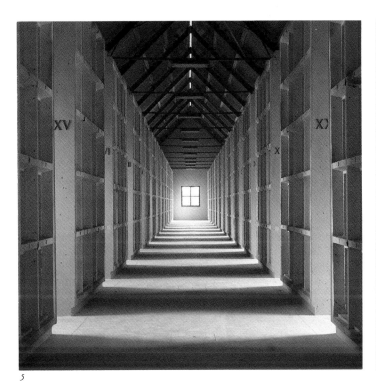

5

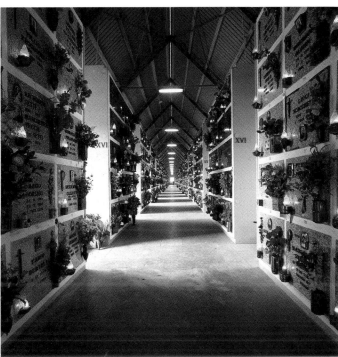

6

7

8

1. *Ground-floor door of perimetral building* 2. *The arcade* 3. *Ossuary—typical floor plan* 4. *Ossuary—roof plan* 5. *Ossuary—section* 6. *Ossuary—elevation* 7. *Plans and section of entrance building* 8. *Elevations of entrance buildings* 9. *Bridge between hinge and perimetral buildings* 10. *The arcade—interior perspective* 11. *The arcade—detail of exterior façade* 12. *View of hinge building from the bridge*

1

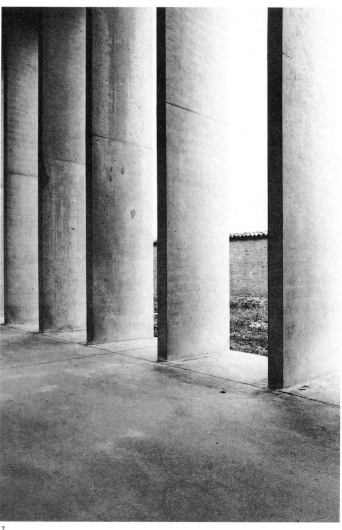

2

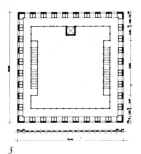

3

4

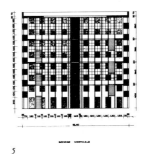

5

6

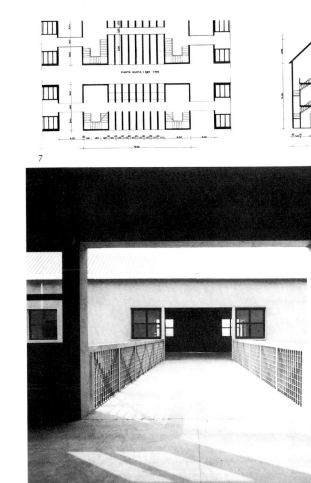

7

8

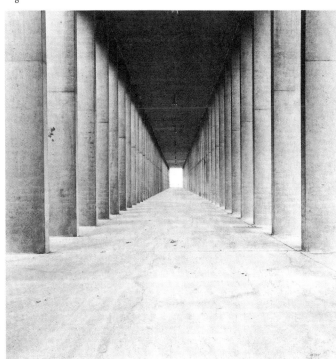

9

10

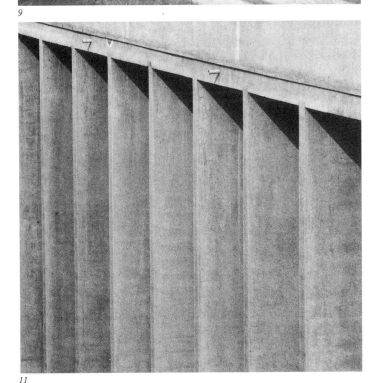

11

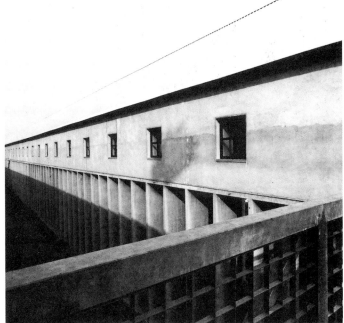

12

1

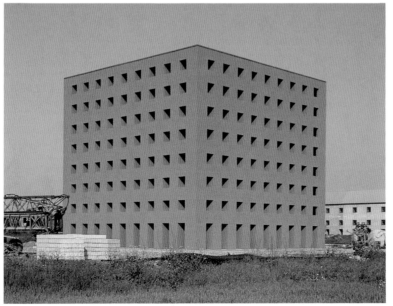

2

100

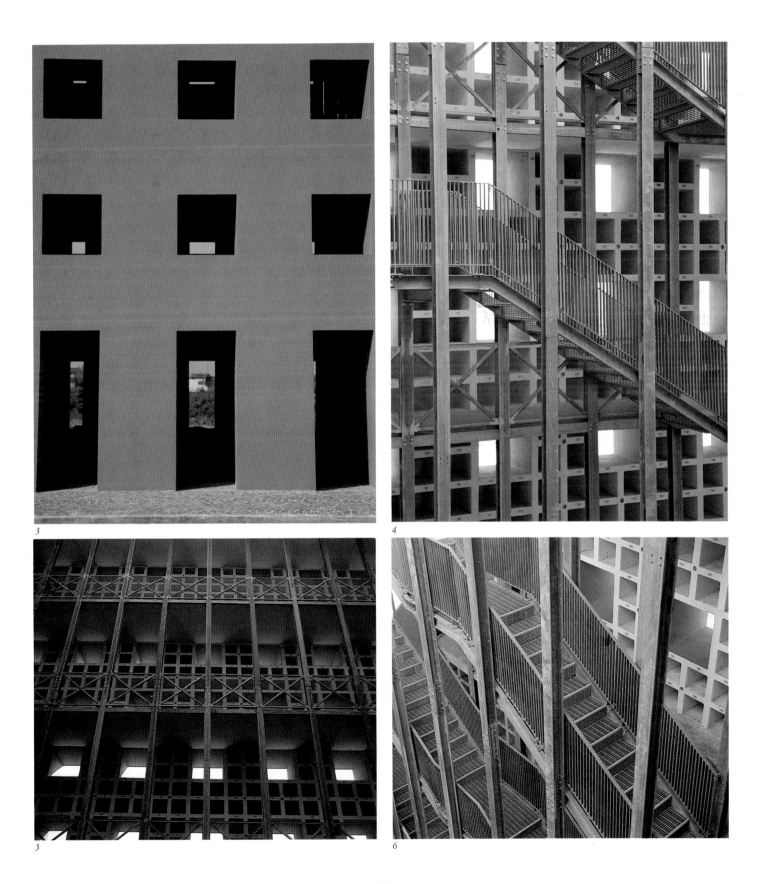

3

4

5

6

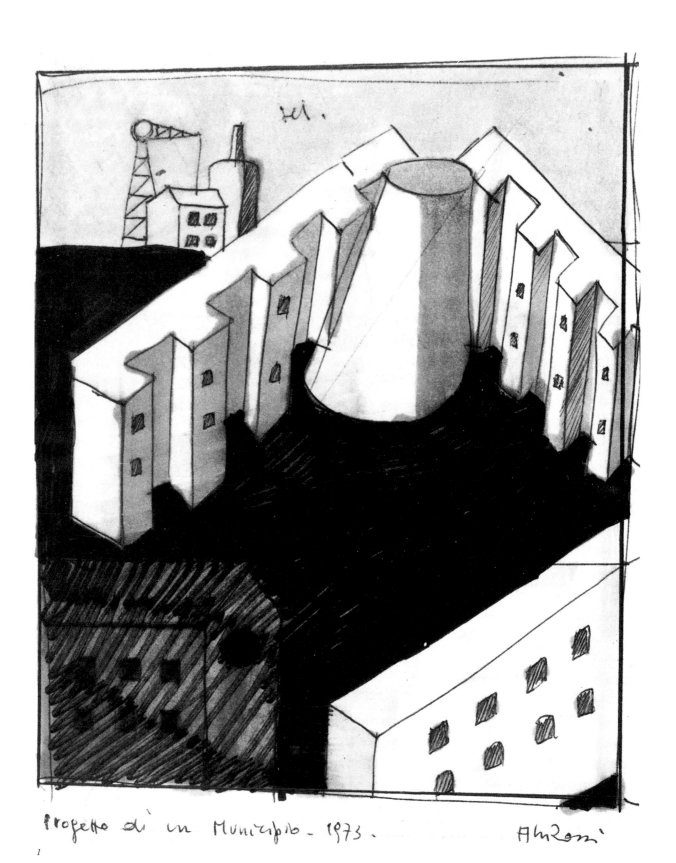

Progetto di un Municipio - 1973.

AldoRossi

1

The site lies between the traditional center of the town and a newly planted park. Two office blocks are splayed, opening a piazza toward the town center and following the geometries of buildings on adjacent sites. These blocks—long spines with shorter perpendicular wings—contain the most public offices at ground level; offices for civic and political associations and those for the technicians controlling city services are above. The four wings facing the piazza have cubic vestibules; above them are projecting triangular pediments. At the center of the complex is a conical structure that contains a simple exhibition and assembly space on the ground floor. Elevators and single-run stairs on either side of the ground-floor space lead to the city council's assembly hall above. De Chirico's *The Archaeologists,* a statue of two seated figures, is planned for the center of the piazza. The design, according to Rossi, reflected his "rising interest in the experiences offered in the work of the Surrealists, not so much from the formal point of view, as from the unexpected composition objects."

1. "Project for a City Hall" 2. General plan

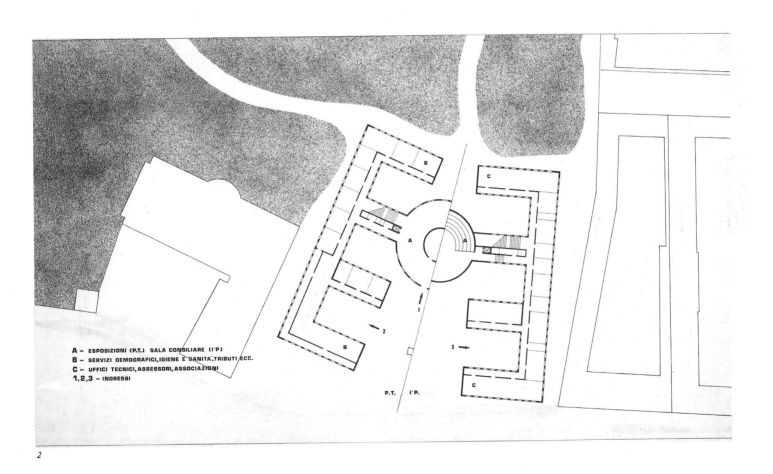

A – ESPOSIZIONI (P.T.) SALA CONSILIARE (I°P.)
B – SERVIZI DEMOGRAFICI, IGIENE E SANITA, TRIBUTI ECC.
C – UFFICI TECNICI, ASSESSORI, ASSOCIAZIONI
1,2,3 – INGRESSI

P.T. I°P.

2

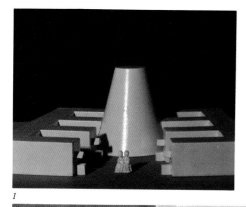

1

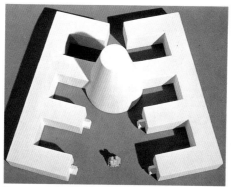

2

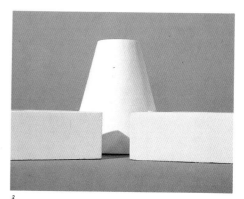

3

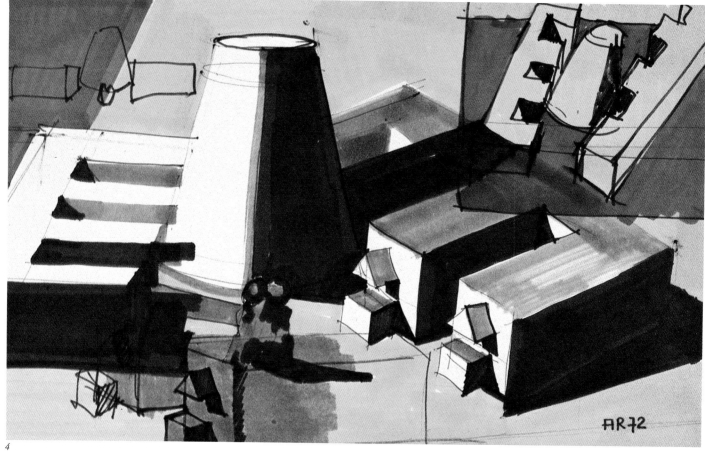

4

5

6

1. Composition with city hall, statue, and fountain

1

The school is located on the outskirts of a small town near Varese. It contains twenty-two classrooms, a number of larger special classrooms, teachers' offices, service areas, a dining hall, a gym, an exhibition hall, and a library. Originally the building was conceived with classroom wings off of a central corridor spanning from the gym at one end to the library at the other. This skeletal organization, similar to that of the project at Modena, subsequently evolved into a conception of the school as a small city focused on its central piazza: classroom wings are arranged off two corridors (rather than one), between which is an open court. The primary axis of the school—along which are arranged the gymnasium at one end of the court, the cylindrical volume of the library and exhibition hall, the extruded volume of the entrance hall, and the heating plant chimney—is nearly parallel to the street on which the school is sited. Approach to the

1. "School of Fagnano Olona"

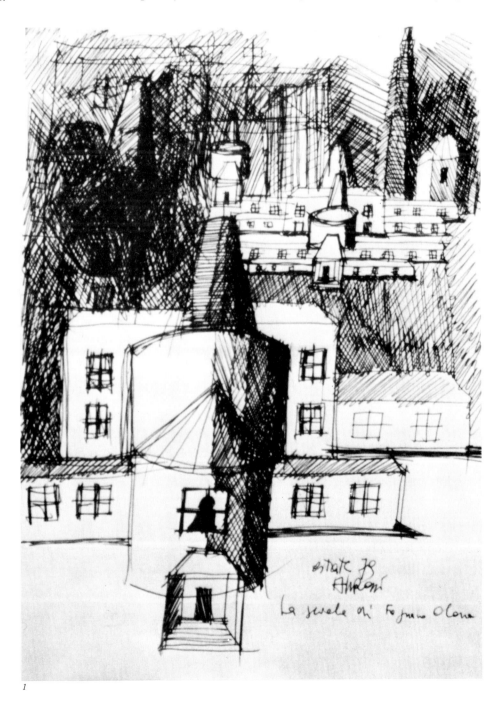

1

entrance hall is along the teachers' office wing. The chimney, made of brick like those of old factories, serves as a community landmark and marks both the entrance and the primary line of organization. Since the original construction, a blue iron pergola has been added between the chimney and a secondary gate, making the central axis more visible. Another covered pergola near the entrance shelters the children's bicycles. From the entrance hall, a corridor perpendicular to the axis leads to the teachers' offices, clinic, and dining hall and to the corridors leading to classroom wings and gym. Immediately off the entrance hall are the library and the exhibition hall, which are also accessible from the court. Both are intended to serve the community as well as the school. A balcony of metal grating is hung within the cylindrical volume under a conical skylight. The balcony and the trusses are left zinc-plated and are painted blue. The walls of the school are finished in white plaster; the window frames and gutters are

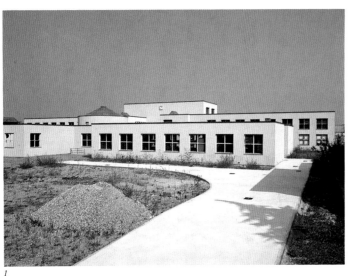

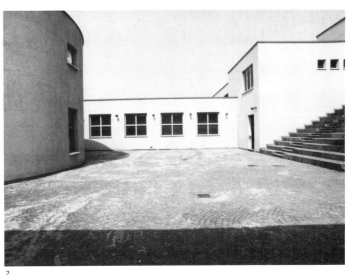

1

2

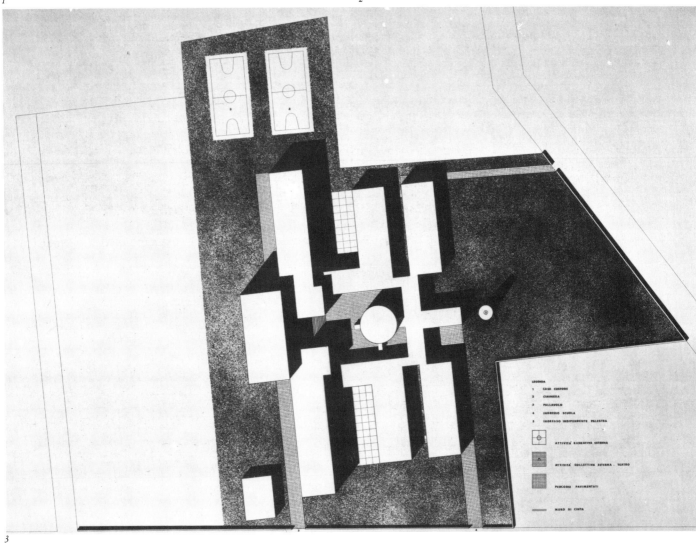

3

painted dark green.

In the court, the heart of the school, the broad flight of stairs leading to the gym adds a second level to the piazza. Porphyry blocks laid in sand pave the courts and terraces. The stairs' risers are faced in porphyry slabs. The stairs allow the court to function as theater, classroom, and place for meetings and play. Rossi has said that the photo he most loves of the school shows one of the children standing on the steps "under the huge clock, which is indicating both a particular time and also the time of childhood, the time of group photos, with all the joking that such photos usually entail. The building thus seems pure theater, but it is the theater of life."

1. *The approach from the street* 2. *The courtyard* 3. *General plan* 4. *View of library drum* 5. *The chimney* 6. *Ground-floor plan*

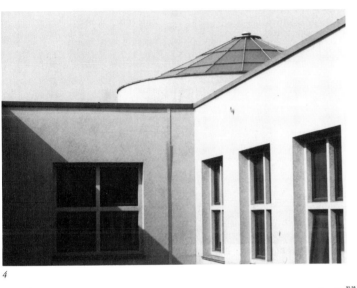

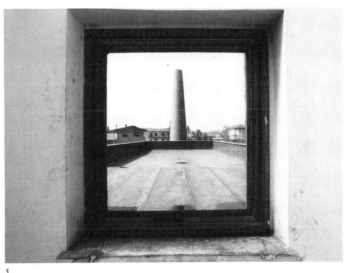

4

5

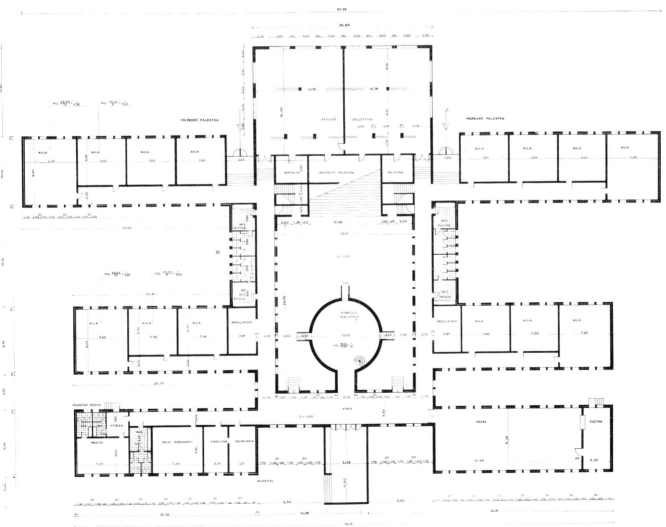

6

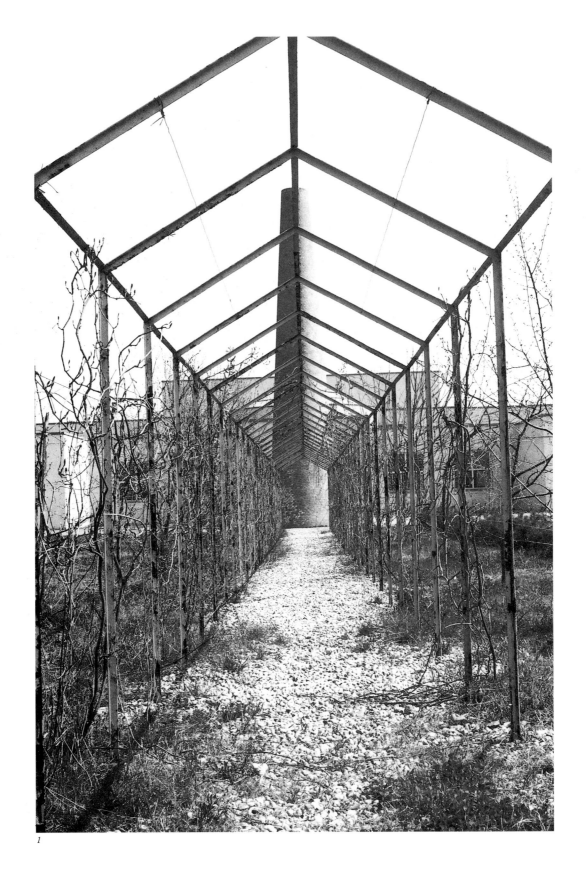

1

1. *Pergola and chimney* 2. *Pergola near the*
entrance 3. *Section through interior*
courtyard, looking east 4. *West elevation*

2

3

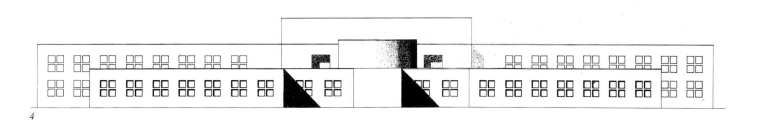
4

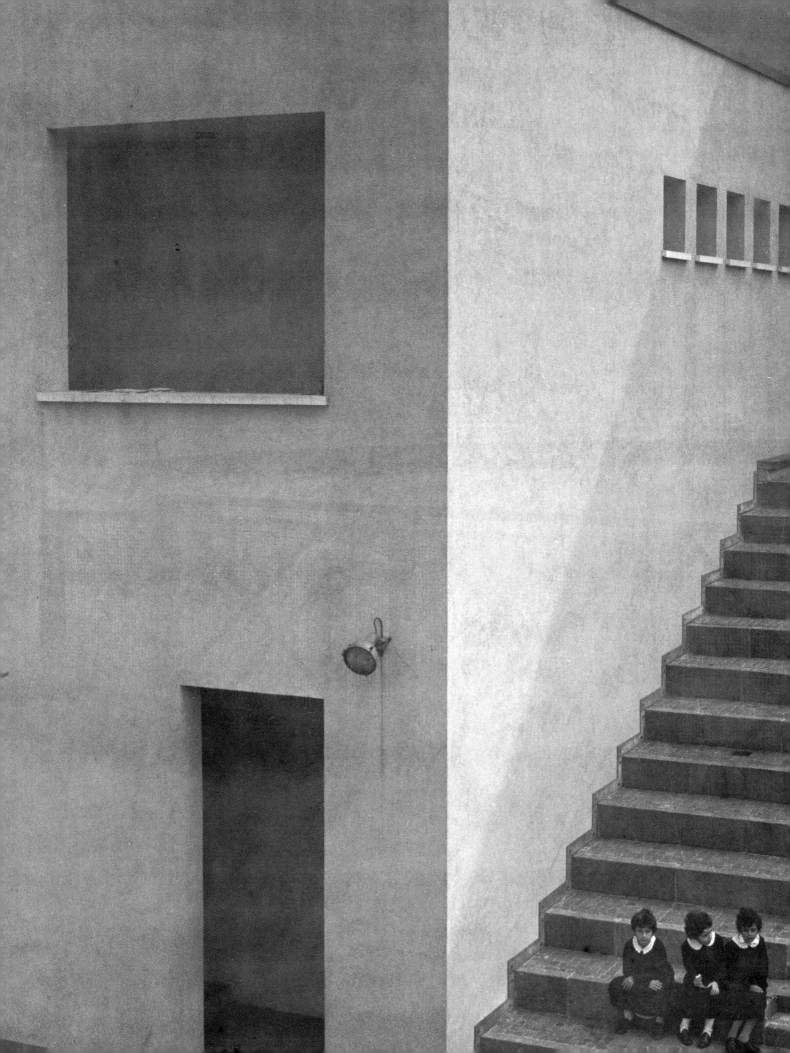

*1. Children sitting on stairway 2. Interior
courtyard, looking west 3. Interior
courtyard, looking east*

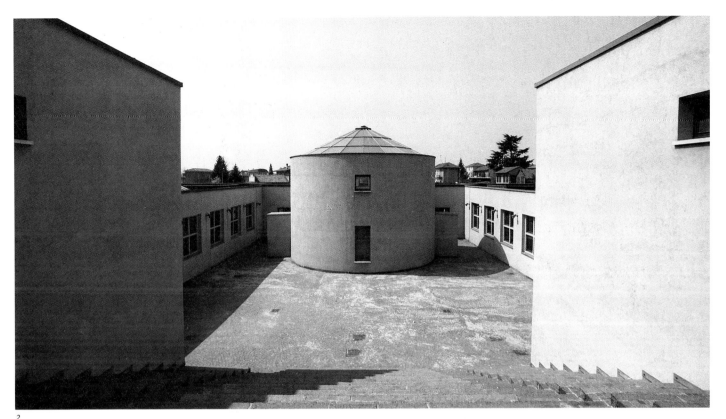

2

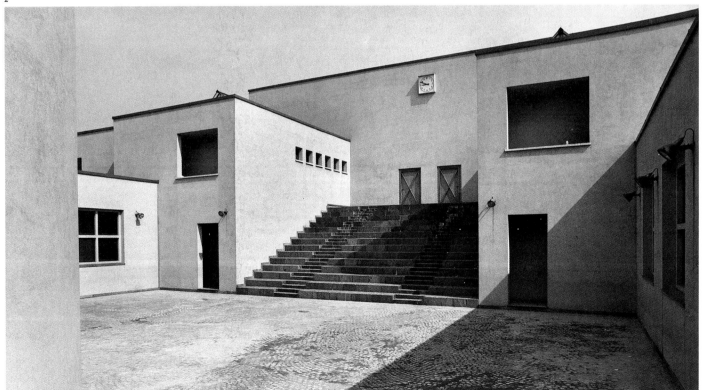

3

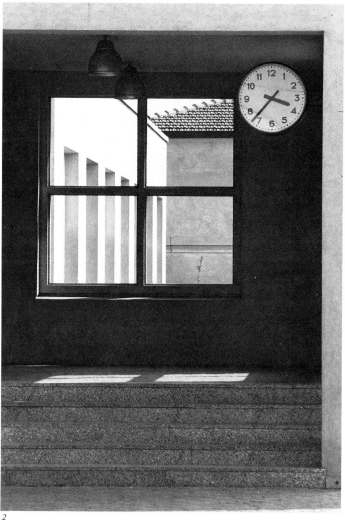

1

2

1. *Window on the front façade* 2. *Looking south into the entrance* 3. *Looking north from outside through the window at the* *entrance* 4. *Looking west from inside the entrance*

3

4

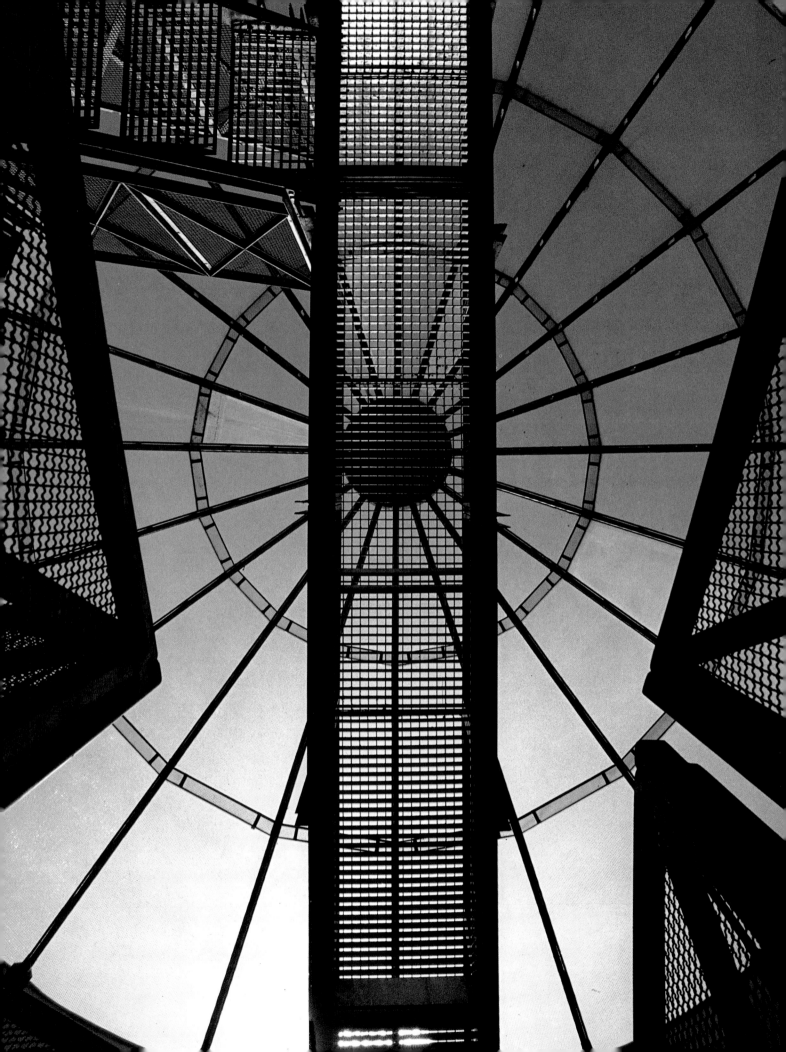

1. Interior view of library, looking up at glass
roof 2. 3. 4. The library—interior views

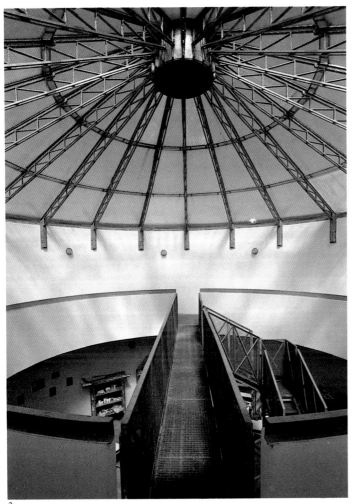

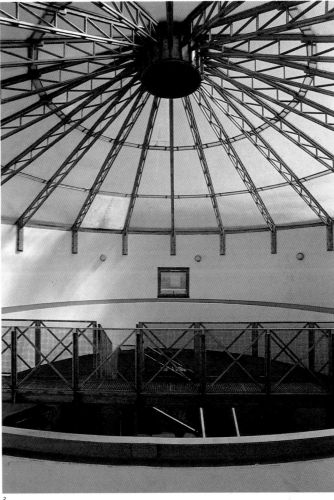

2

3

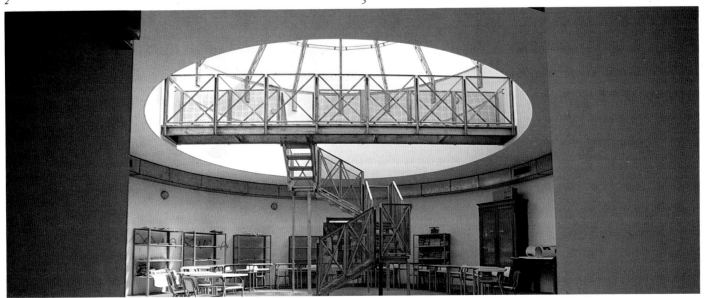

4

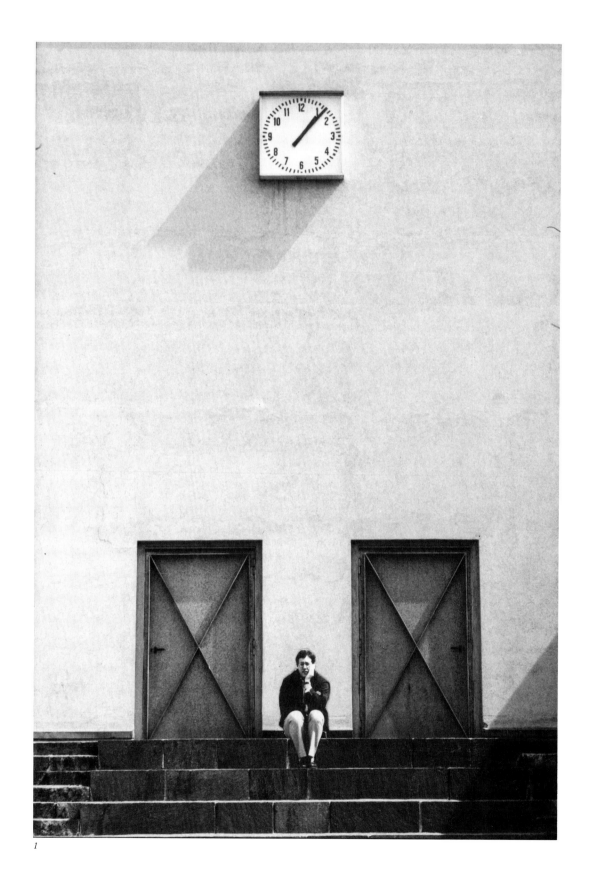

1

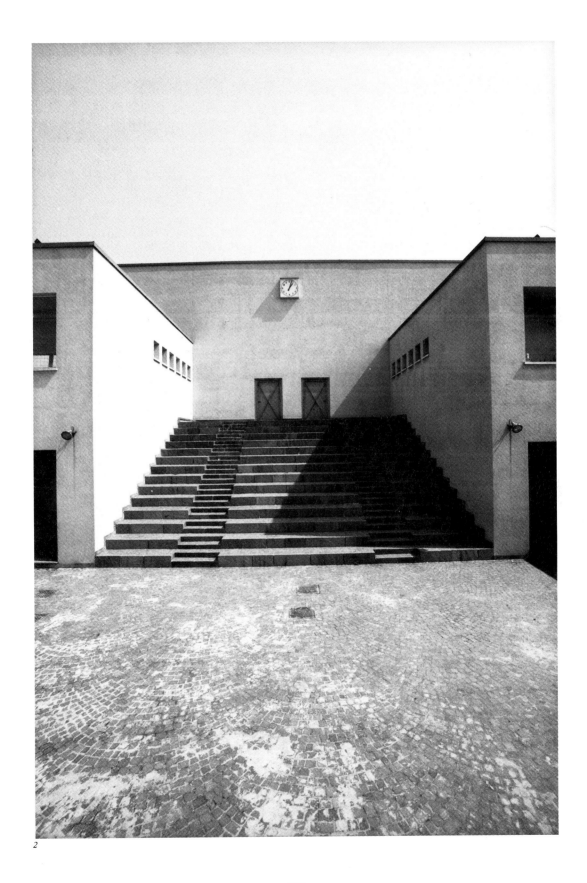

2

1

Single-Family Houses
Broni, Italy, 1973
With G. Braghieri

The public housing project is located along a main road leading to the center of Broni, a small town near Pavia. The road is the main street of a new low-income municipal housing project. Outside each three-story, one-family unit is a small kitchen garden. On the ground floor are a garage, a washroom, a kitchen, and a storage room for agricultural products. An exterior stair leads to a terrace from which the main floor is entered. Above the living room and bedroom on the main floor are two additional bedrooms.

The houses were originally intended to be orthogonal, with semicircular roofs spanning between white parapet walls; as built, the row has a slight curve and a gabled roof.

According to Rossi, "The typology of the single-family house enabled me to make a long low building overlooked by the hill and vineyards beyond. The curving roofs would lead the eye across the Po River to the countryside toward Pavia."

1. Axonometric, plans, and elevations

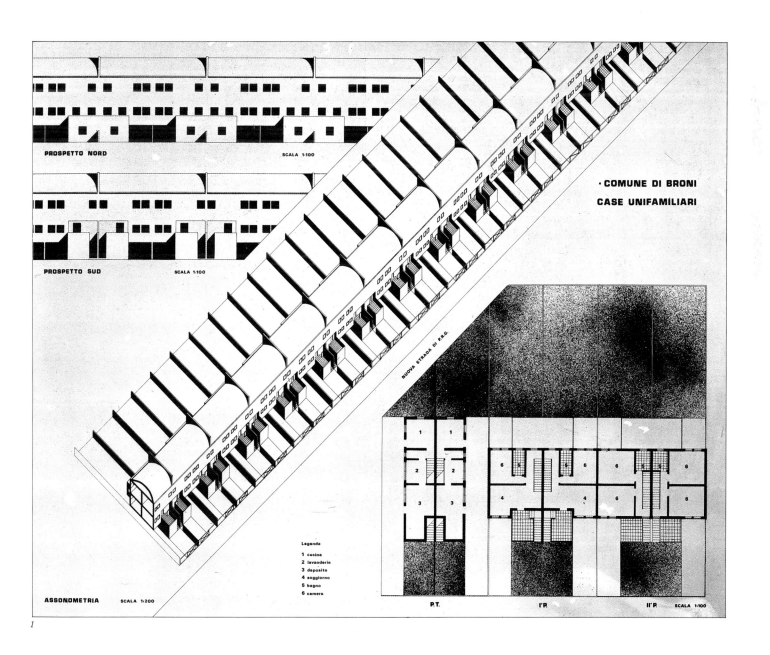

PROSPETTO NORD SCALA 1:100

PROSPETTO SUD SCALA 1:100

· COMUNE DI BRONI

CASE UNIFAMILIARI

NUOVA STRADA DI P.R.G.

Legenda

1 cucina
2 lavanderia
3 deposito
4 soggiorno
5 bagno
6 camera

ASSONOMETRIA SCALA 1:200

P.T. I°P. II°P. SCALA 1:100

1

121

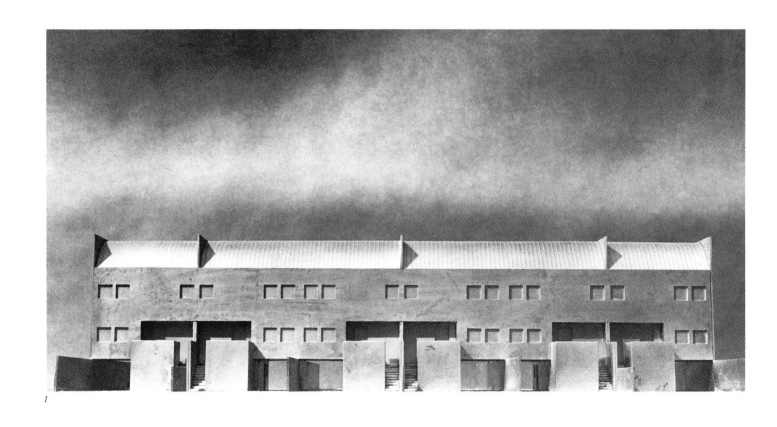

1

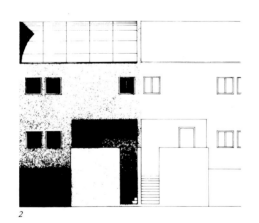

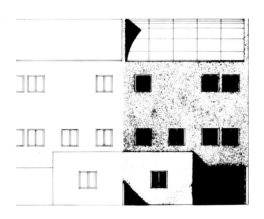

2

1. Model — view from south 2. South and
north elevations 3. Model — view from
north 4. Sections

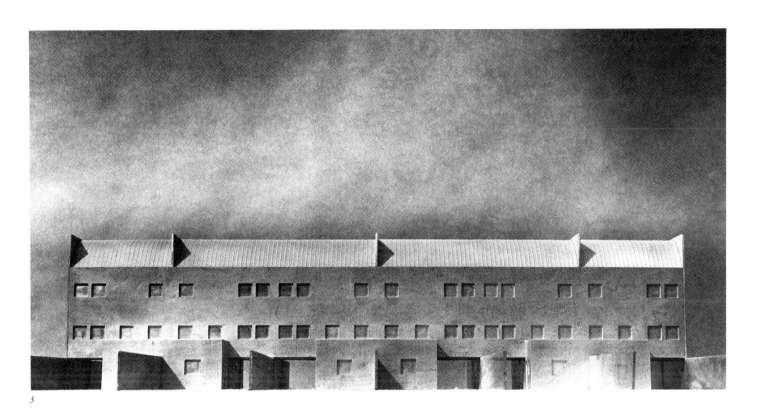

3

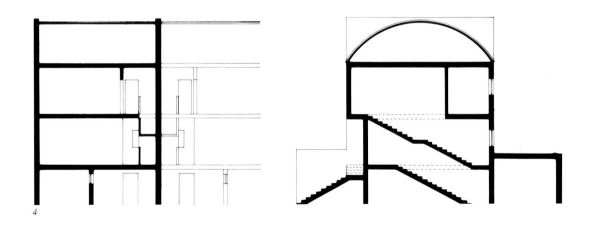

4

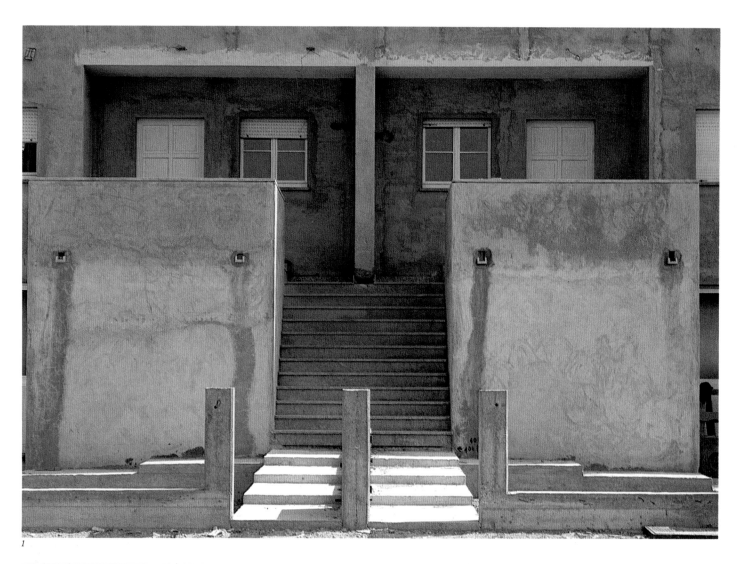

1

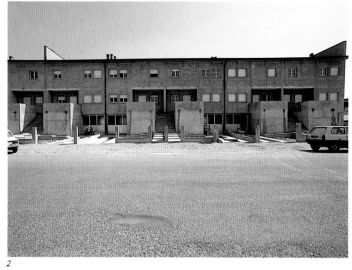

2

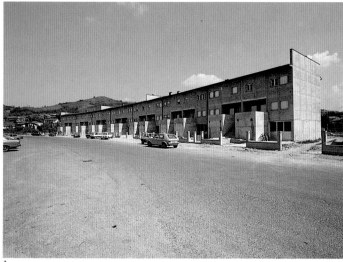

3

Villa and Pavilion
Borgo Ticino, Italy, 1973
With G. Braghieri

For a site in a thickly wooded area overlooking the Ticino River, Rossi designed what he describes as "one of my favorite projects. The first drawing shows nothing more than a forest with houses built on piers. It looks like the work of someone who was merely reporting on a day, a place, a street. . . . The balconies are like piers—the floating type—recalling those on the Ticino or on the Hudson, or on any river."

The topography of the villa's site—a steep slope dropping from a level area—was a main factor in the design. One of the five semicylindrical roofed building elements that constitute the house is placed on the level area, perpendicular to the ridge. In it are the living areas. Four bedroom wings are

1

perpendicular to it. Steel piers support the wings from the hill sloping away beneath them. Because of the hill's slope, these wings appear to Rossi "as bridges suspended in the void," which allow dwelling "in the woods, in the place where they are most secret and difficult to reach, among the tree branches." Each bedroom wing has an exterior terrace that also serves as a corridor.

Although the villa has not yet been built, a small house in the woods nearby has been completed. Between plastered-brick end walls is a semicylindrical roof of sheet metal. The trusses supporting the roof span between the

1. "Project for a Pile Dwelling" 2. Roof plan

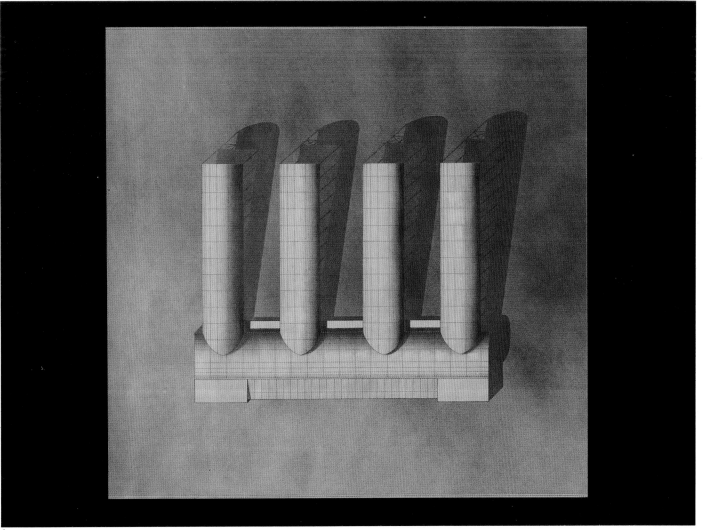

2

rear wall and a series of piers, forming a portico across the front of the house. The end elevations are identical, each with a single window and a circular attic vent above that is screened with wire mesh. The building is brick, covered by plaster with an integral yellow-gray pigment. The portico is paved with local gray stone; the window frames are wooden.

Rossi explains he is especially fond of the project because "it seems to express a condition of happiness; maybe because it is suspended in the middle of the woods or maybe because of its connection with boathouses, with fishermen's huts on the Ticino and Po rivers—because of its connection with a functional and emotional world."

1

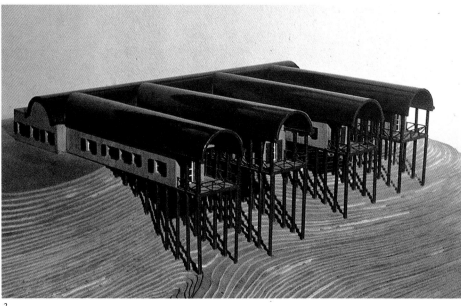

2

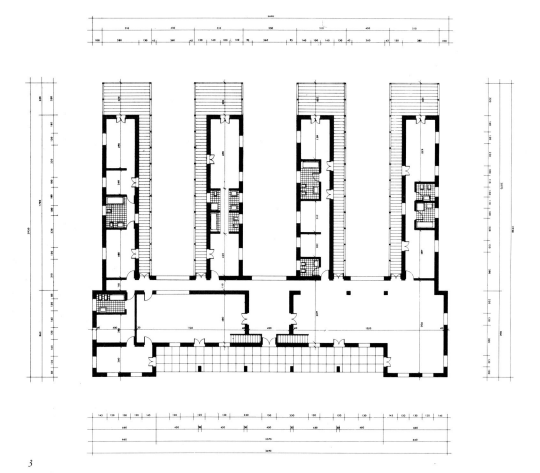

3

1. Sketch 2. Model—side view 3. Floor plan 4. "Project for a Villa on Ticino" 5. Model—view from the slope 6. Elevations and sections

4

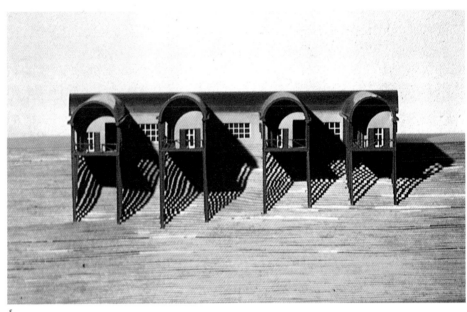

5

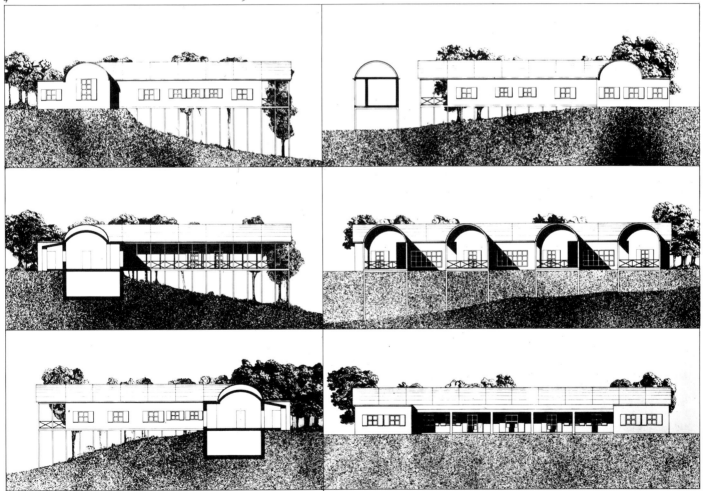

6

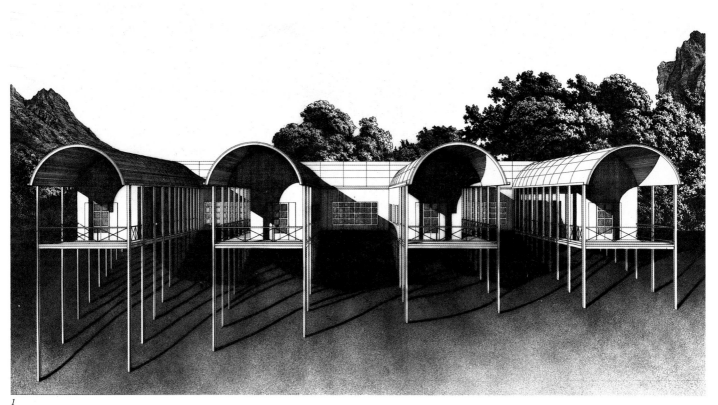

1

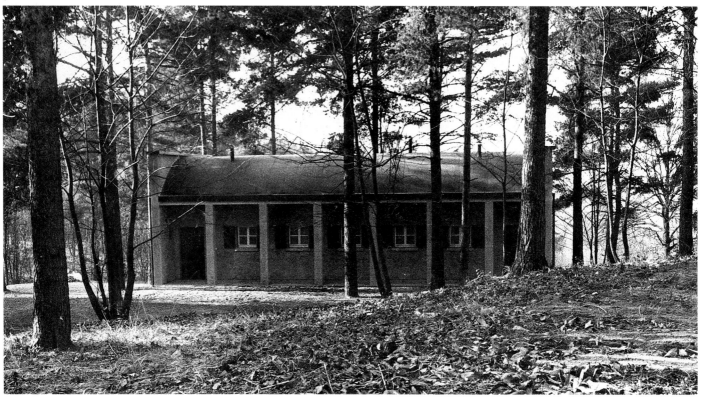

2

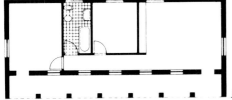
3

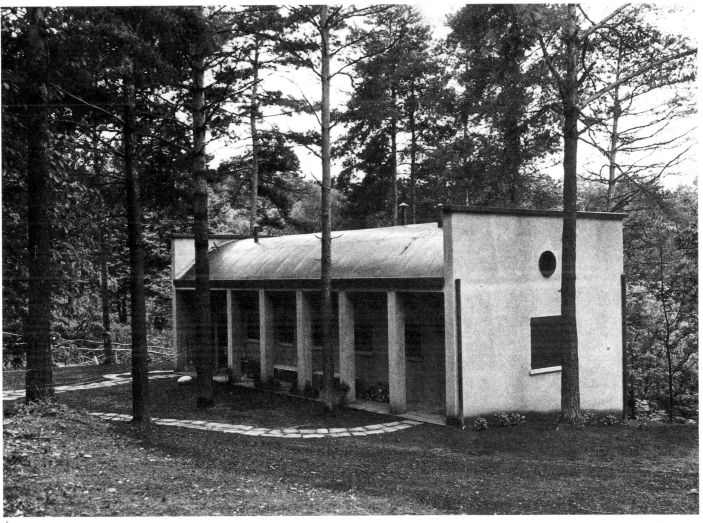
4

For the XV Triennale, an exhibit on international architecture was curated and designed for a rectangular hall and contiguous semicircle. These spaces are in Giovanni Muzio's Palazzo dell'Arte, the same building to which Rossi and Meda had joined a triangular bridge for the XIII Triennale. This installation design recalls that of the exhibition Rossi built in a park adjoining the bridge for that earlier Triennale: partitions painted white were used in the hall to create a central corridor off of which were spaces of

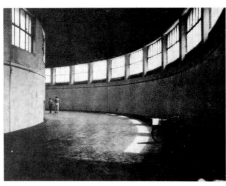

1

differing dimensions; in the semicircle, radial walls also delimit a variety of room sizes, access to which is gained through doorways arranged enfilade. Natural light in the hall is filtered through a trusslike construction of diagonal wooden bracing covered in white fabric.

1. Interior of building before intervention
2. Axonometric of the interior design for the exhibit

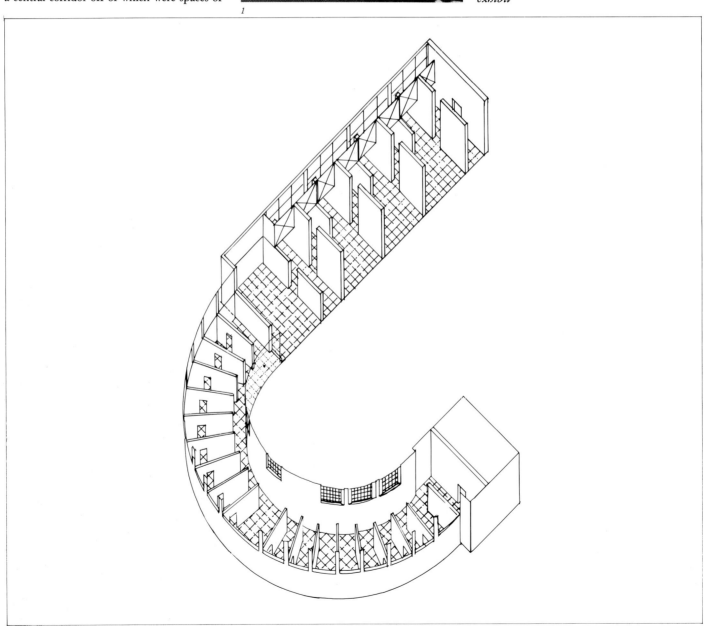

2

Bridge
Bellinzona, Switzerland, 1974
With G. Braghieri, B. Reichlin, F. Reinhart

The ancient walls and castles of Bellinzona constitute not only an embodiment of an important part of the city's history, but also are its primary topographical feature. The town's fortifications—the Castel Grande, Montebello Castle, the Sasso Corbaro, and the walls linking the three—were capable of closing off the entire Ticino Valley by controlling a main route to and from the Gottard and San Bernadino passes. The site

of the design proposal was the break in the wall at which the tower and main gate to the city stood, an area known as the Portone. The walls that cross Bellinzona were considered in the design as central streets by which the form of the city has been generated. Restoring the continuity of the walk atop the walls was therefore proposed. The new "door" into the city is made by two stair towers and the bridge they support. The blocks, of

untreated reinforced concrete, are arcaded at ground level; their stairs lead to the promenade above. The bridge itself is of zinc-treated steel tubes, screened with steel mesh and paved with pine planks, in reference to the technology of early railway bridges.

1. The old fortification seen from the outside

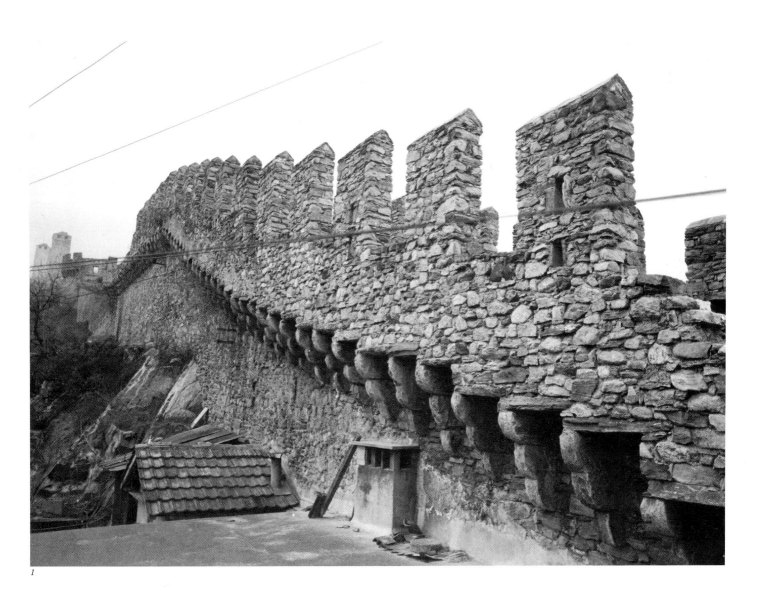

1

131

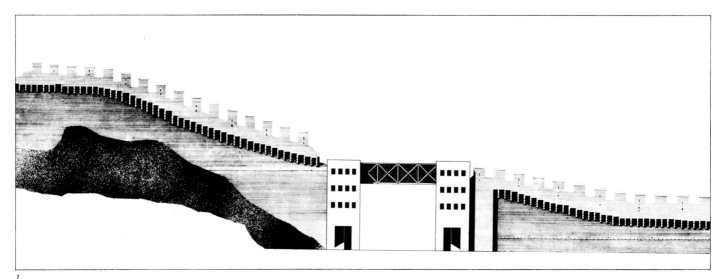

1

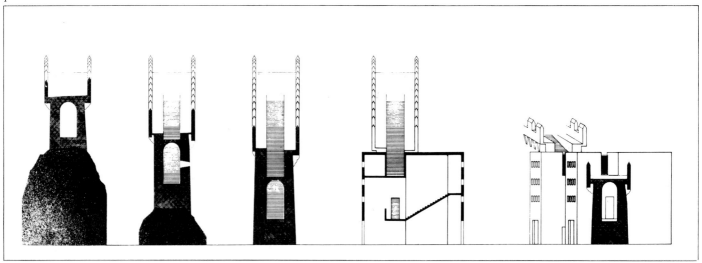

2

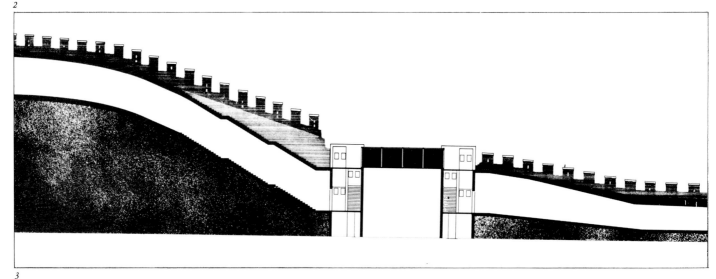

3

4

5

6

Single-Family Housing
Robbiate, Italy, 1974
With G. Braghieri

Small two-story houses are grouped in two parallel rows that are themselves parallel to an adjacent street. A perpendicular path crosses the site; where it passes through the center of each housing row, a sort of portal to the interior mews is made. The zone of the stairs in each unit is set back from the primary street elevations, visually differentiating individual units. The elevations along the mews are characterized by an apparent loggia created by the overhang of the second-floor balconies supported by extended party walls. Each unit, which has a living room and kitchen on the ground floor, can be entered from either the street or the mews.

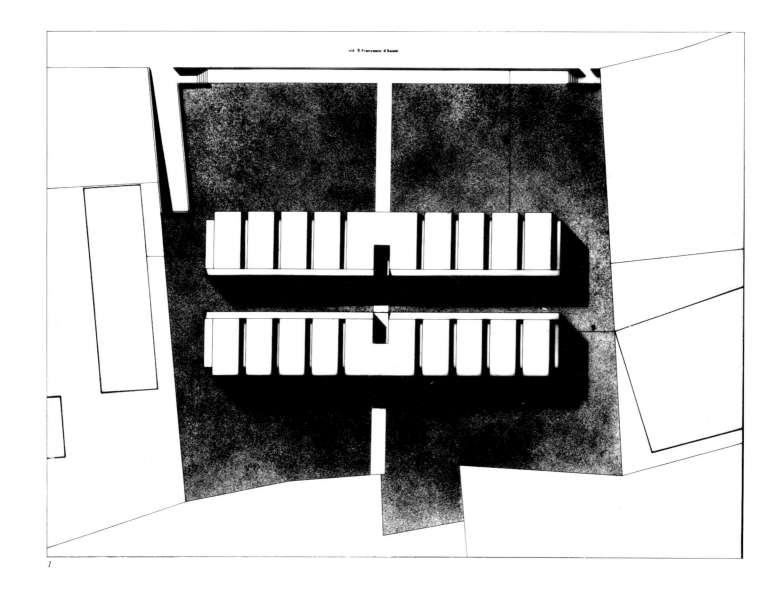

1

134

1. *General plan* 2. 3. *Study sketches*
4. *Axonometric*

2

3

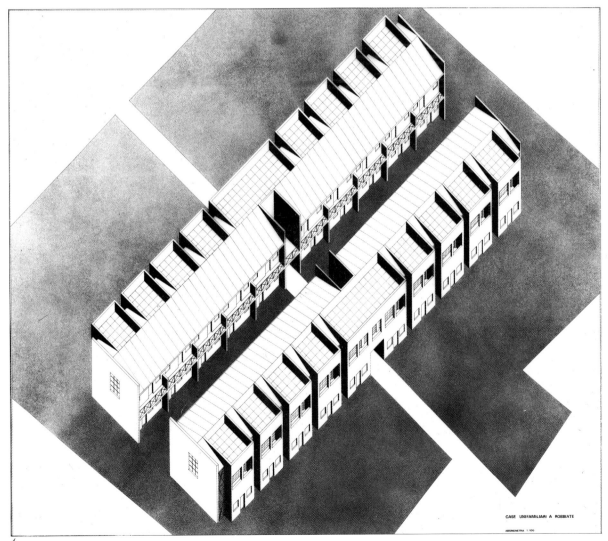

CASE UNIFAMILIARI A ROBBIATE

ASSONOMETRIA 1:100

4

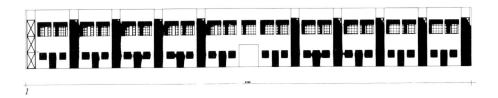
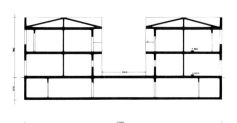

1

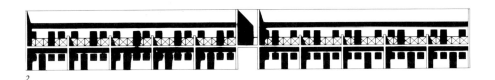

2

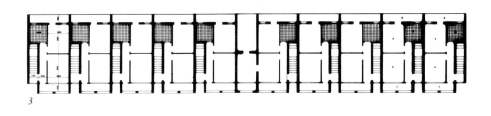

3

4

1. *Front elevation and cross-section* 2. *Mews* 4. *First-floor plan* 5. *Plans and elevations of* *and side elevations* 3. *Ground-floor plan* *one-family unit*

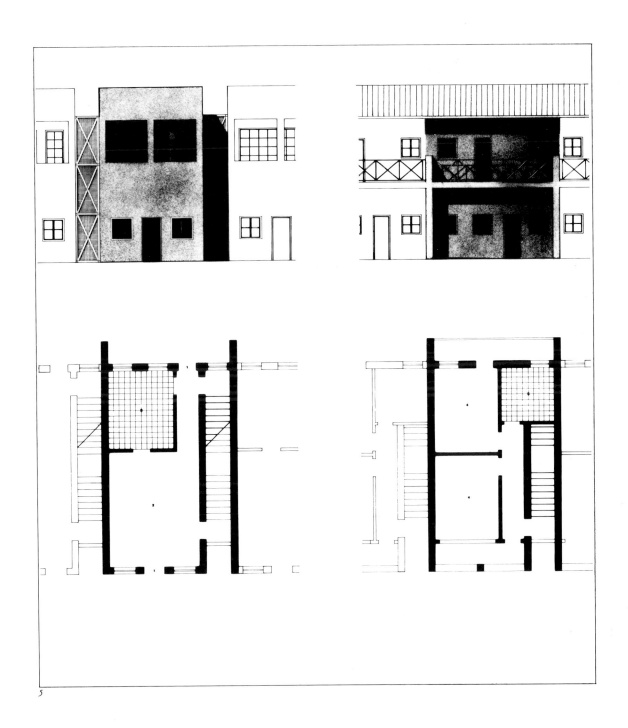

5

Regional Administrative Center
Competition Design
Trieste, Italy, 1974
With G. Braghieri, M. Bosshard

The site for the Regional Administrative Center is near the train yard in a relatively new area of Trieste. The proposed design takes as its base an old Austrian warehouse adjacent to a main street. The base is excised in places to give access to ground-floor service spaces but serves primarily as a plinth for the new construction. On this base are two long office blocks parallel to the street, between which are a trio of three-story interior courts. Each court is 14 meters square, surrounded by galleries that connect the office blocks across the courts. The three courts, open to one another at ground level, are separated on upper floors by blocks housing stairs and elevators. The building is primarily concrete,

plastered and painted white. The structures supporting the galleries and glass roofs of the courts are steel. While visibly tied to the concrete structure, the impression is of distinctly designed and built units inserted within a more generalized volume. On the elevation toward the sea and the railroad are conservatories connected to the intermediate blocks of vertical circulation. They are made of trussed elements glazed and covered with iron mesh. Like the ironwork of the courts' glass roofs, they are painted dark green.
The geometry and forms of the building are designed to establish some relationship with the regular grid of the Borgo Teresiano, the district of neoclassical buildings created when

the city expanded in the eighteenth century. An equally important source of inspiration, however, is suggested by the motto under which the competition was submitted, "Trieste and a Woman." The phrase is the title of a collection of poetry by Umberto Saba. The reference suggests, among other things, a relationship between the autobiographical nature of the poetry and the autobiographical sources of the design. Rossi explains that his childhood memories of Trieste and Venice played an important role in the design, as did his memory of Moser's glass-roofed court at the University of Zurich.

1. Model—view of stairways at the entrance

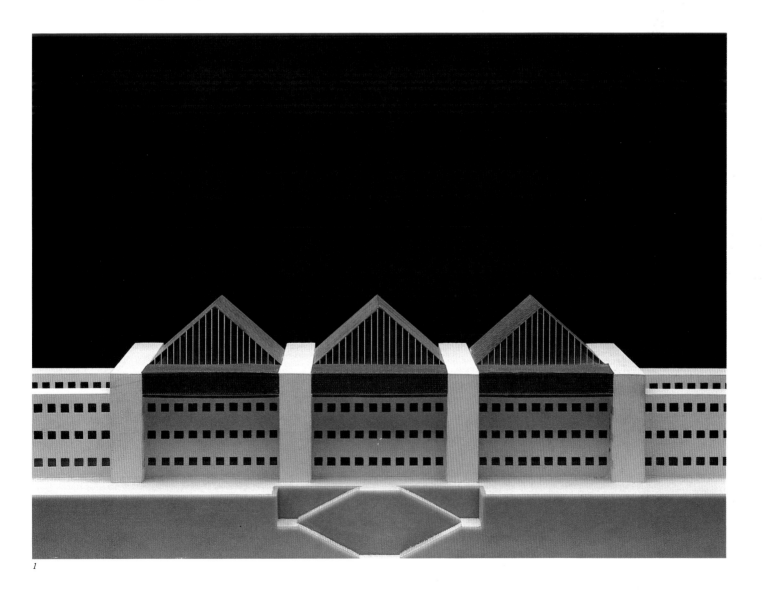

1

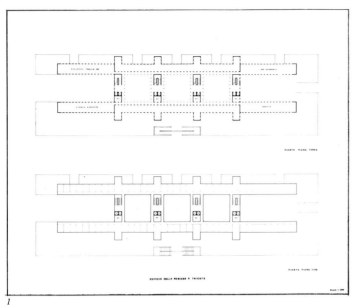

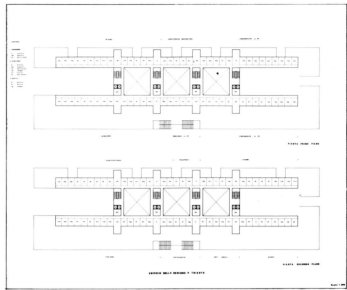

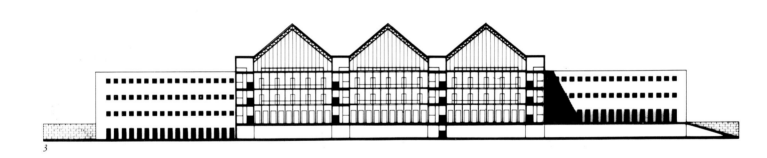

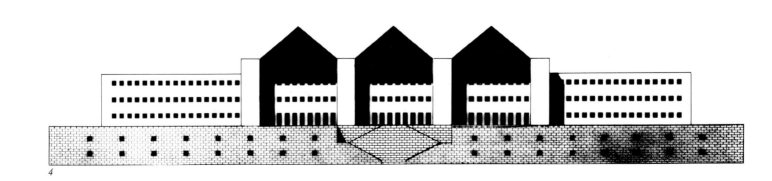

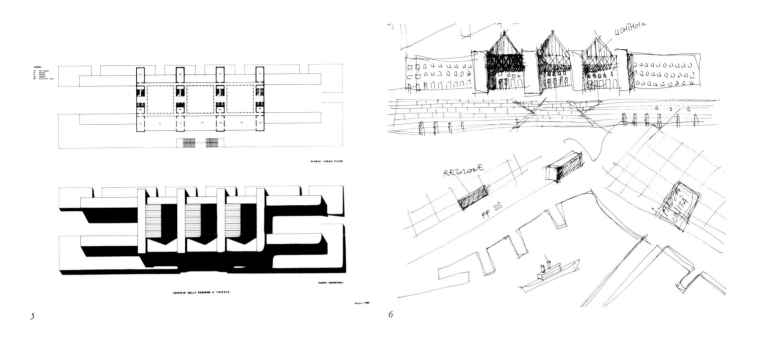

5

6

7

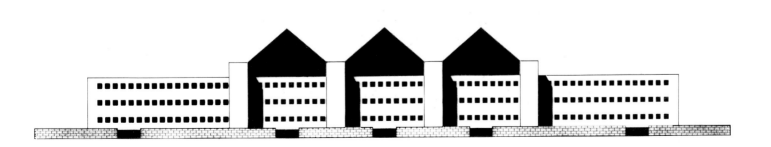

8

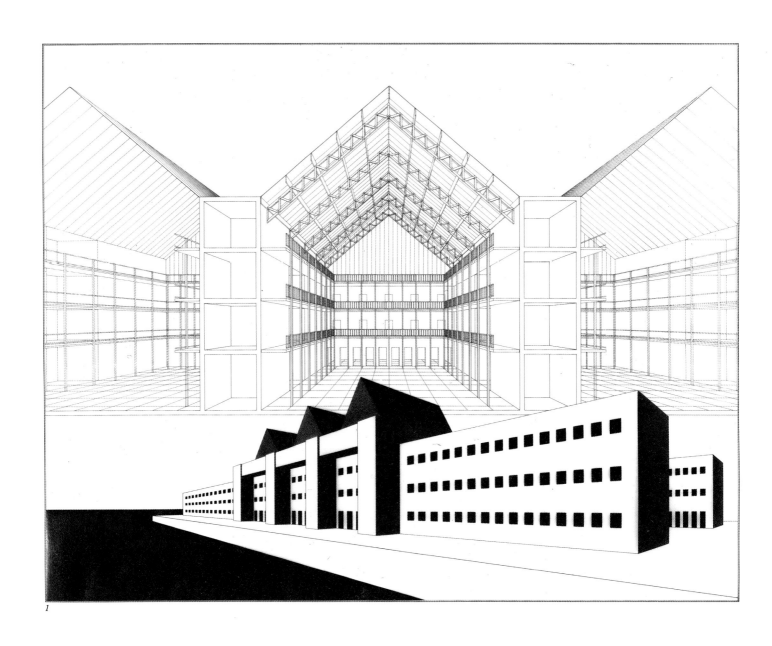

1

1. Perspective from northeast and perspectival section through the covered courtyards 2. 3. 4. Views of model

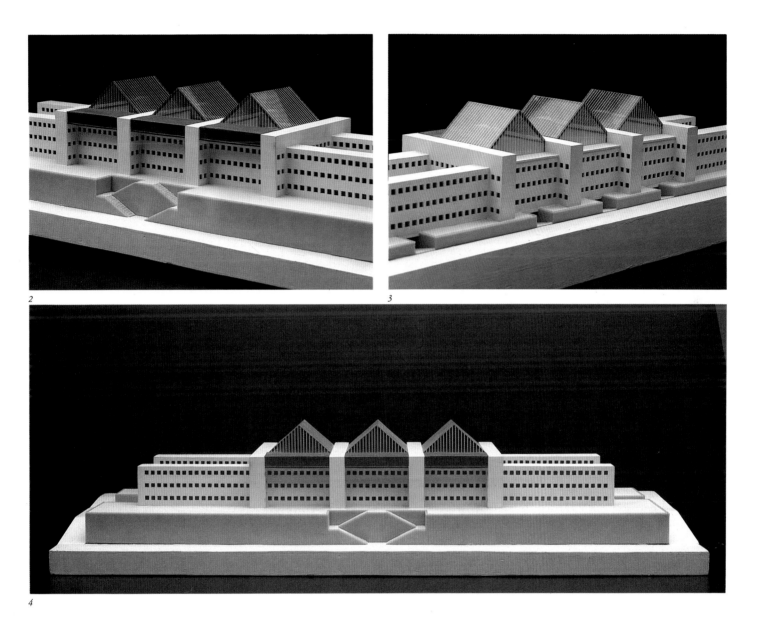

2

3

4

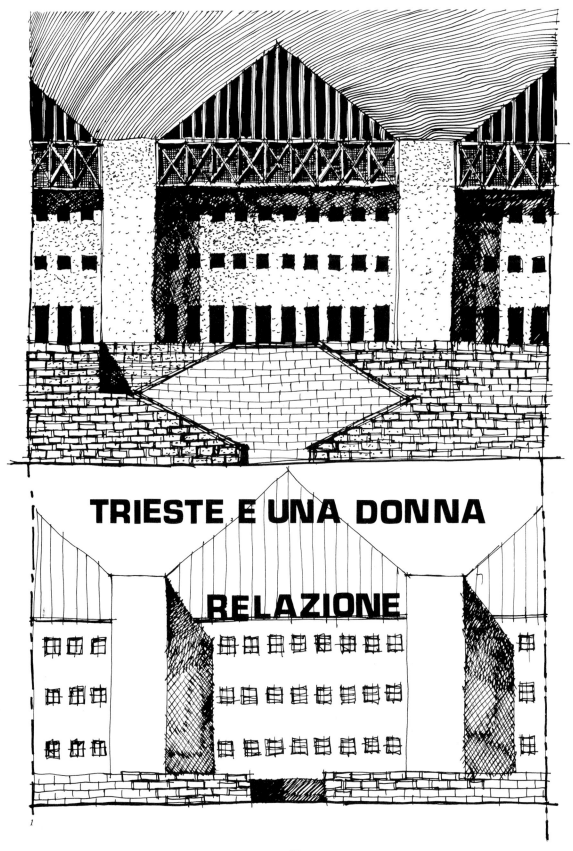

1

Student House
Competition Design
Trieste, Italy, 1974
With G. Braghieri, M. Bosshard, A.
Cantafora

The site of the student housing is on rugged terrain—a steep hillside dropping from a level promontory. There are two major elements to the complex—a student center, housing dining hall, bar, and reading and study rooms on the promontory; and wings of student rooms built off the edge of the promontory, supported on piers. The cube of the student center has an interior court open the full height of the building, over which is a glazed gabled roof, like those proposed for the Trieste Regional Administrative Center. The steeply pitched roof, visible even from the bottom of the hill, is perceptually, formally, and factually the center of the complex. Explored in the wings of housing, as in the Gallaratese project, is the typology of the long *ballatoio* housing unit. It is also related to the elevated bedroom wings of the villa at Borgo Ticino. The wings of student housing are interconnected by three transverse bridges. The two buildings are contrasted not only formally, but also in terms of materials. The student center, on level ground, is made solid, earth-bound, and massive with concrete and stone. Beyond the precipice, the housing is supported by the relatively light industrial materials of engineered steel bridges.

1. Roof plan 2. Typical floor plan

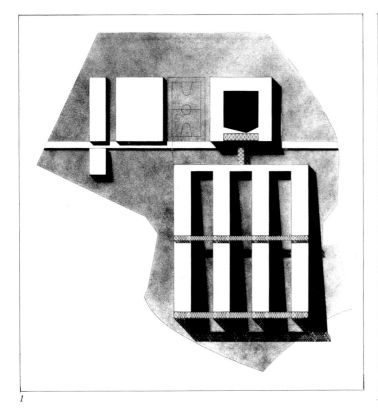

1

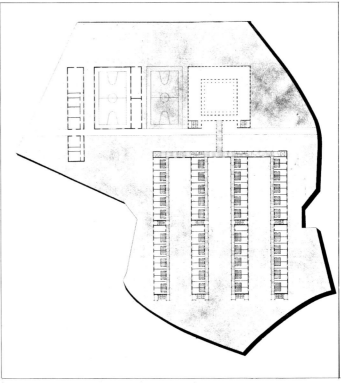

2

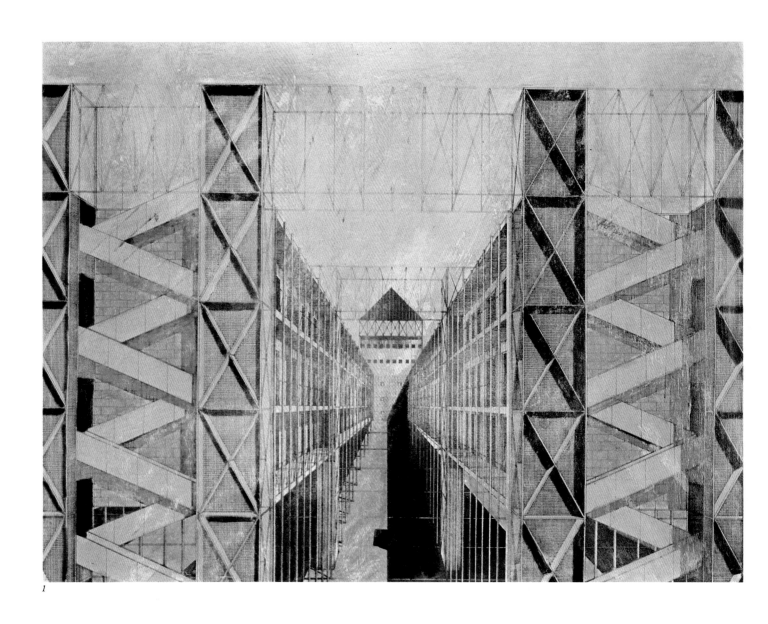

1

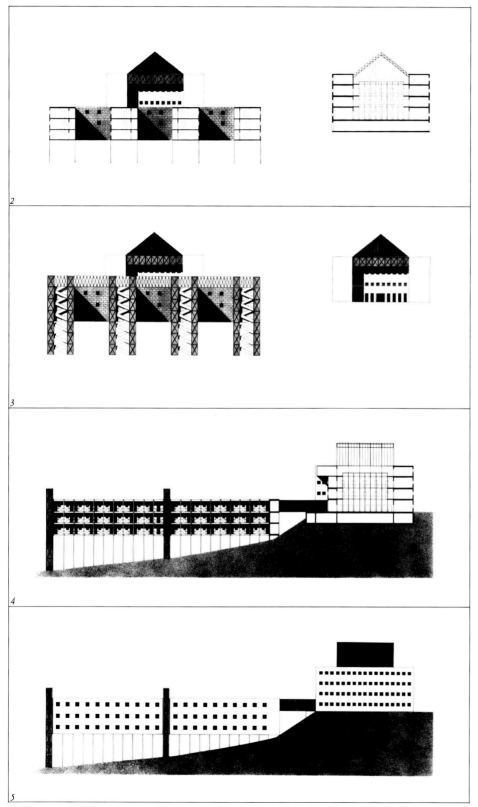

1. *Perspectival section, looking east, through basement of collective building, circulation* *hinge, and bedroom building* 2. *Study sketch*

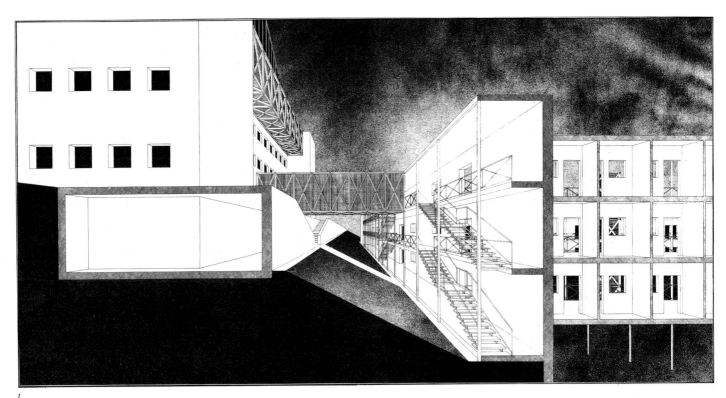

1

2

El Corral del Conde
Addition to a Courtyard Building
Seville, Spain, 1975
With G. Braghieri, A. Cantafora

El Corral del Conde is one of the oldest *corrales* in Seville. In its urban form, the *corral* is a series of housing ranges that create a shaded court at their center. Entrance to the housing units is by means of galleries open to the court. An appreciation of the history of El Corral del Conde and a conviction that the type is a vital urban structure suggested a faithful restoration of the complex, with particular attention to ensuring that it be used solely for residential use. The existing structure is retained, as is the distribution mechanism of galleries and the overall arrangement of two-room apartments.

Another aspect of the design involves creating a *calle*—a small street—adjacent to the *corral*, to connect the existing Calle Santiago and

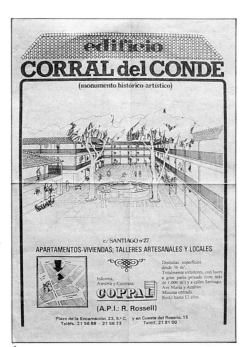

1

Calle Azafran. The new *calle* is formed by two building ranges, one of which closes a gap in the buildings of the *corral*. These buildings hold shops at ground level that are connected to maisonettes above. A row of palm trees is planned in the *calle*. That part of the new construction visible within the *corral* is a relatively bland, flat façade with small windows. Those parts of the new buildings facing the new *calle*, however, repeat the rhythm of the *corral*'s old façades by means of vertical iron elements. All new construction is faced with a plaster matching that of the *corral*.

1. Advertising for the sale of the renovated apartments 2. Perspective of the new interior street

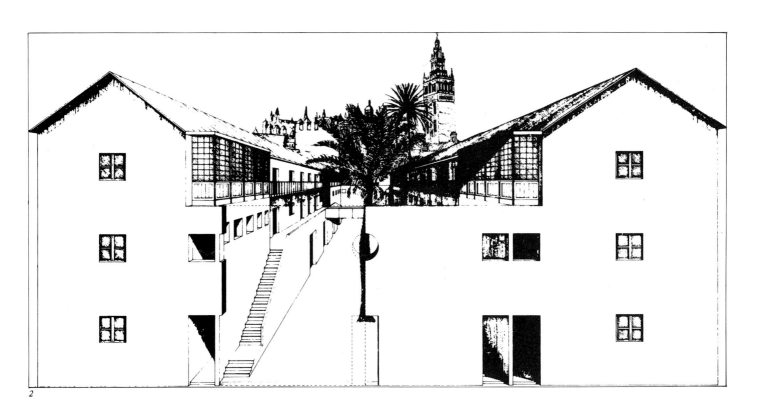

2

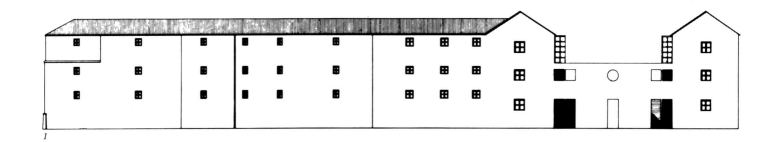

1

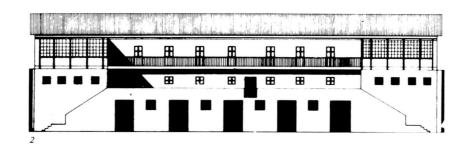

2

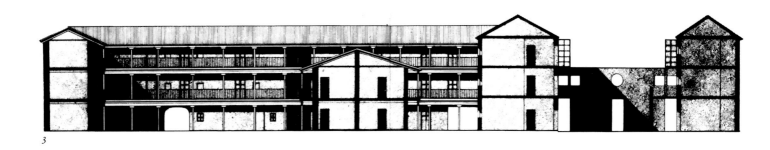

3

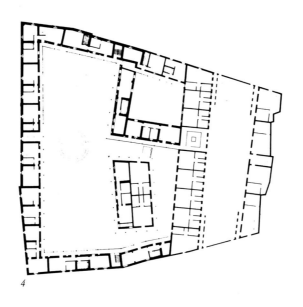

4

1. Street elevation with renovation on right 2. Elevation on the interior street 3. Section through old and new buildings 4. Typical floor plan with renovation on right 5. Street elevation with renovation on left 6. Elevation on the interior street 7. Section through old complex 8. Study perspectives

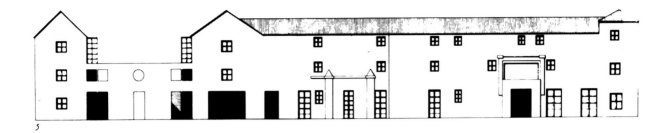

5

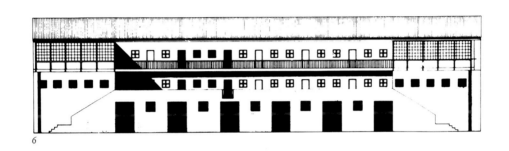

6

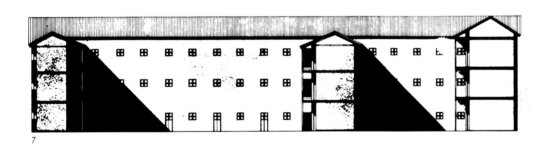

7

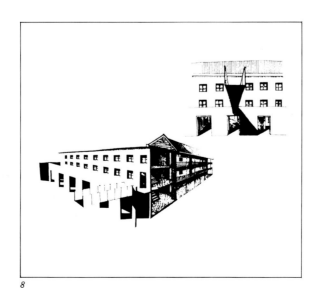

8

Housing
Setubal, Portugal, 1975
With J. Charters, J. Da Nobrega

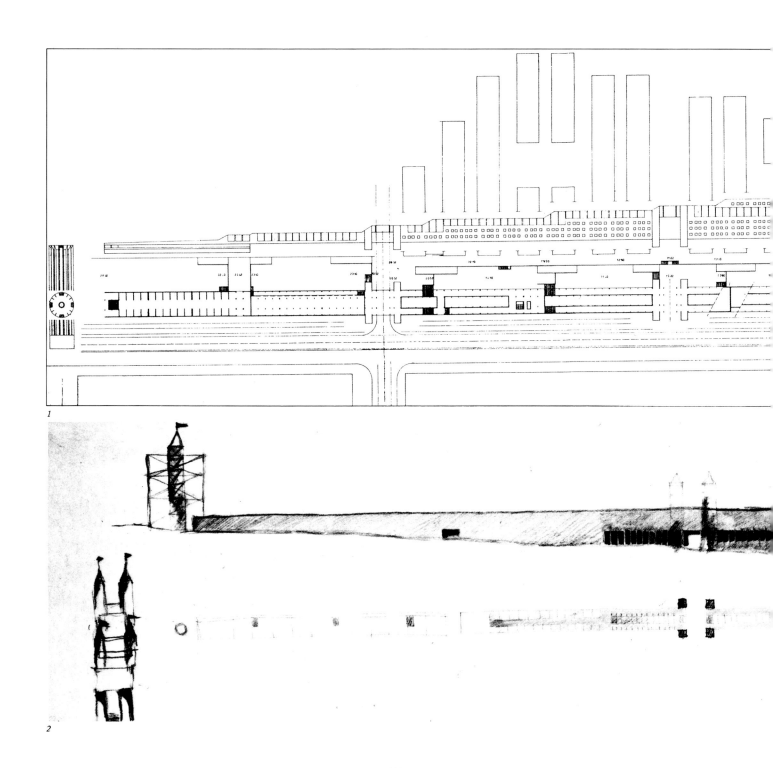

1

2

Setubal is a town in which fishing and industry are predominant. The project site slopes gently toward a major coastal highway. From an entrance marked by a cylindrical water tank at the hill's top, the overall height and number of floors increase as the hill slopes downward. The roof height of the building is stepped down at a point near its center, making the lower part of the

building, in a sense, a great terrace overlooking the sea. At the break in height are four cylindrical towers. Towers also mark the three points at which the building crosses above existing streets. Open porches are developed in both parts of the building as covered streets onto which shops and community facilities open.

The project continues Rossi's exploration of

housing typology and the relationship between buildings and sites. The premise is that both these problems can be reduced to a few solutions sufficiently generalized to be applicable at any scale.

1. Typical floor plan 2. Sketch of main elevation

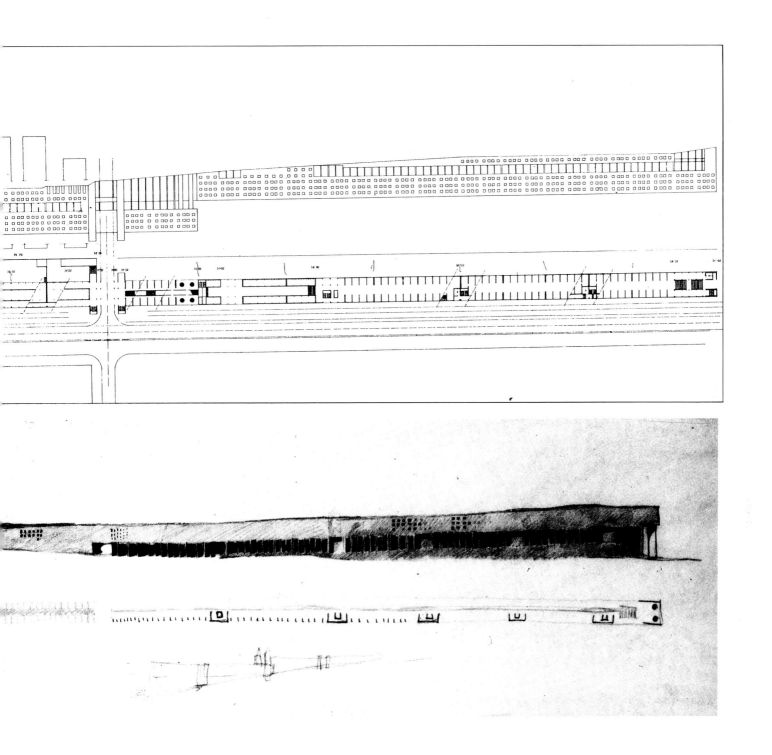

Student Hostel
Competition Design
Chieti, Italy, 1976
With G. Braghieri, A. Cantafora

The hostel design proposes ranges of individual student houses around a larger central building containing community facilities. The houses, either one or two stories, have one room and services per floor. The design of the houses is sufficiently simple and repetitive to allow for phased construction and flexibility in the choice of materials and building systems—brick, wood, metal, or prefabricated component panels could be used.

The central public building contains both indoor and open-air cafeteria and meeting spaces. A series of parallel walls defines three zones of the building, all of which have glass-gabled roofs. A central space with lateral glass walls is intended, also, to serve as a hothouse for palms and other tropical plants. The open-ended glazed space serves as both a portico for the building and a covered portion of the quadrangle. In the center of the quadrangle, in front of the main building, is the chimney of the campus thermal power plant. Creating a contrast between the central planning of the quadrangle and linear organization of the houses was a primary intention of the design. As in the houses, the central building is comprised of elemental building units. These units imply a phased construction like that planned for the housing. According to Rossi, "Among the few things that still exert a fascination for us in architecture" are those sites where buildings and intended relationships between elements have been interrupted and recommenced successively. As examples, he cites the temple at Rimini, the boardwalk area of Coney Island, and Arab constructions with successive walls. He labels these places—as well as his own hostel design—the "non-finite, in the knowledge that what is not finished can be abandoned or continued."

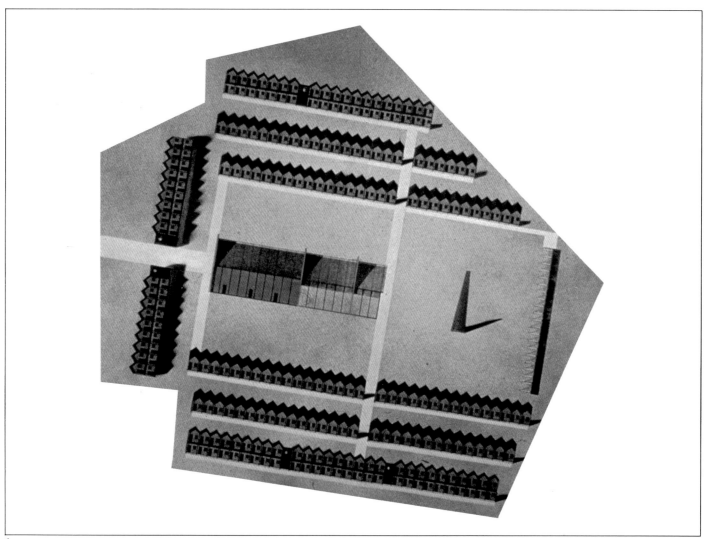

1

154

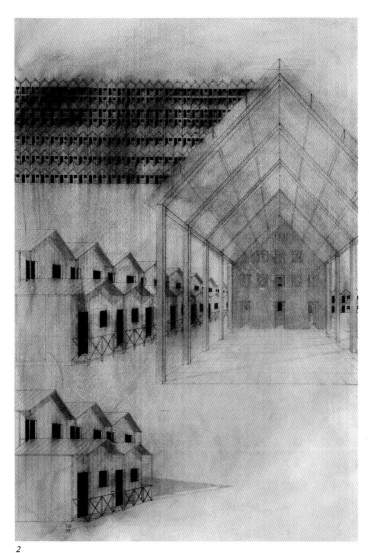

2

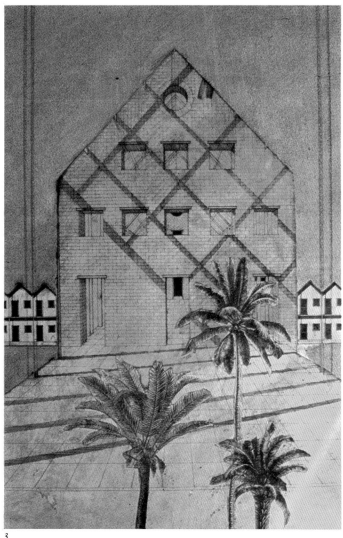

3

155

2

Portico sez A A

3

Elementi /casetta Elementi /casetta

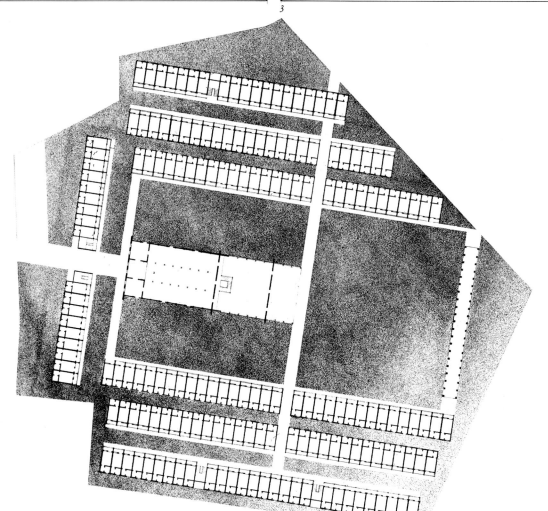

4

156

1. "Summertime" 2. Elevation and section of arcade 3. Back elevations of students' units and chimney of heating system 4. General plan 5. Front elevation and cross-section of a two-floor unit 6. Front elevation and cross-section of a one-floor unit 7. Linear section of collective building 8. Cross-section looking west and east elevation of collective building 9. South elevation of collective building 10. Cross-section looking west and west elevation of collective building

157

1

1. "Students' Housing in Chieti"
2. Model—view from south 3. Model—
view from east 4. Model—students' units
and collective building from south
5. Model—students' units and collective
building from west 6. Model from above
7. Model—view from west

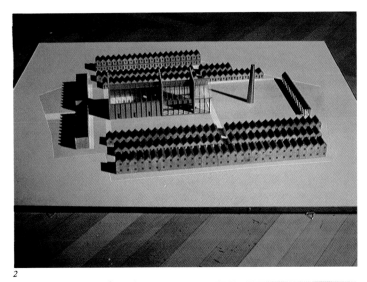

2

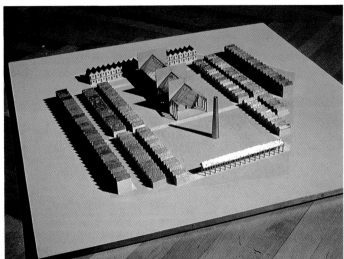

3

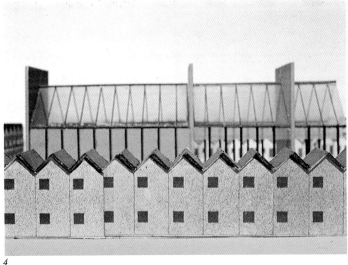

4

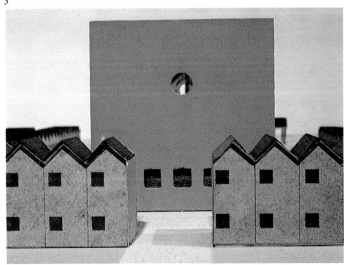

5

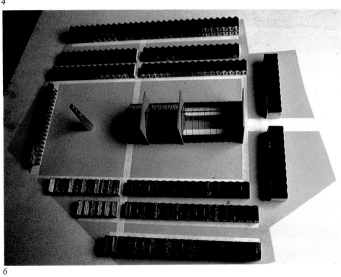

6

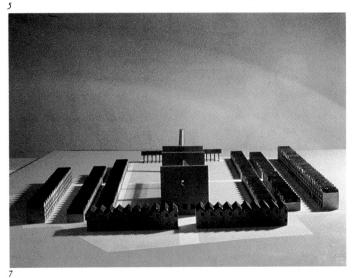

7

Single-Family House
Bracchio, Italy, 1976
With G. Braghieri

The house is designed for a fairly steep slope. The ground floor, with a continuous portico open to the valley, is chiefly open air. It contains only the living room at its center and, flanking the living room, the smaller volumes of kitchen and mechanical rooms. The central living room, marked by its fireplace's large chimney, is a double-height space ringed by a second-floor gallery. The gallery is an extension of the corridor that extends the length of the second floor. The bedrooms are arranged along the corridor and are open to views of the valley. Flanking the chimney, two steel bridges connect the second-floor corridor and gallery to the hillside.

1. Axonometric 2. West elevation
3. North elevation 4. South elevation
5. Linear section, looking north 6. First-floor plan 7. Ground-floor plan

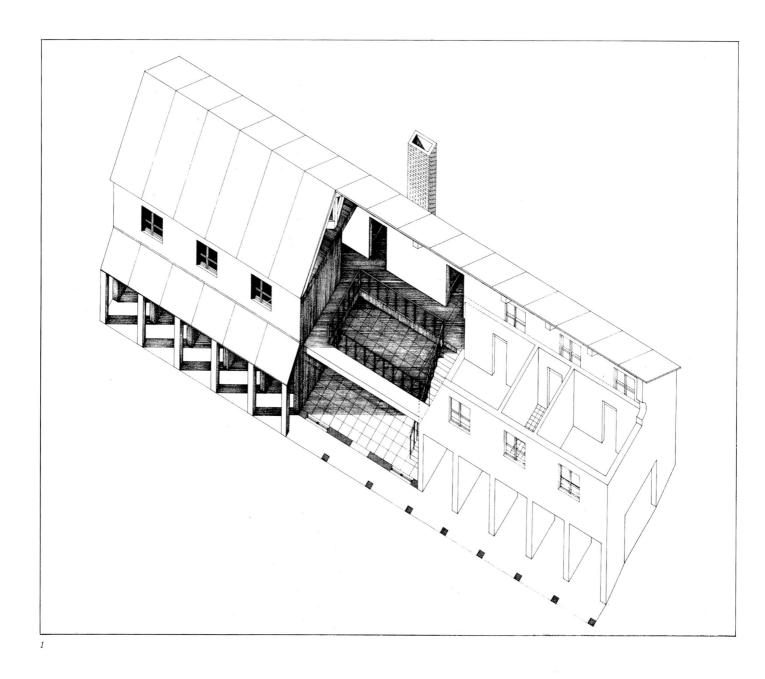

1

160

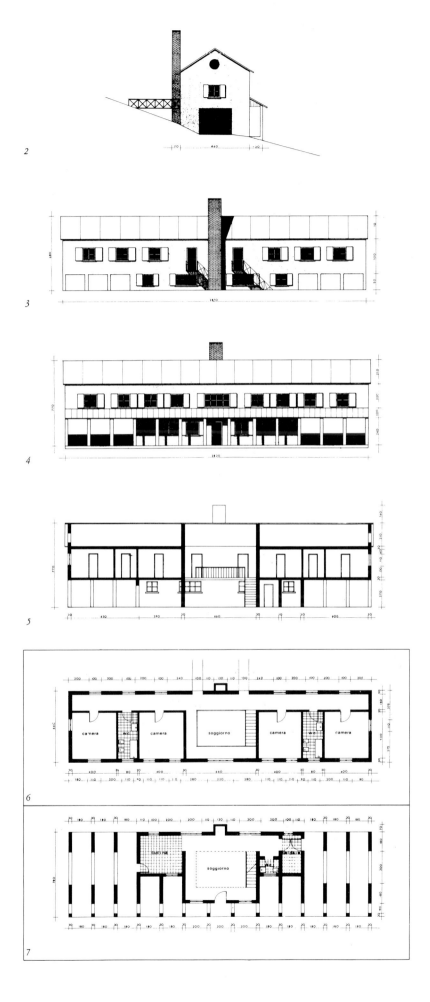

2

3

4

5

6

7

1

Houses Along the Verbindingskanal
Berlin, West Germany, 1976

The Verbindingskanal is part of a system of canals connecting the Spree River with the natural and man-made lakes to the west of the city. In the design for housing along the canal, rows of housing line both banks. On the ground floors are high porticoes. Stairs are caged in steel towers evenly spaced along the canal façades. Steel bridges cross the canal, connecting the housing blocks. Several precedents and conditions influenced the design. Complex references can be found to the work of Schinkel, in particular to his waterside projects. An effort was made to synthesize local urban form and housing types by simultaneous reference to both the Siedlungen and also to riverbanks, dams, and bridges.

1. Perspective along the canal

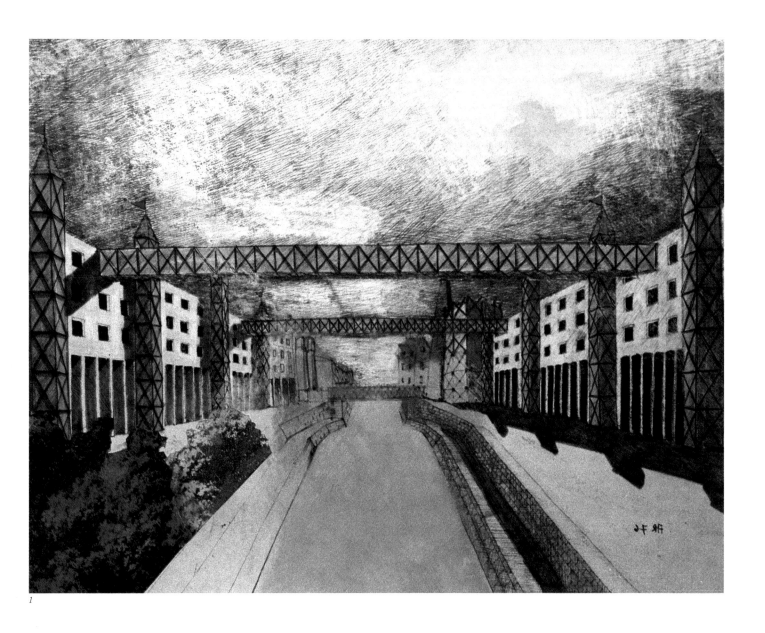

1

Centro Direzionale
Competition Design
Florence, Italy, 1977
With C. Aymonino, G. Braghieri, M.
Bosshard, A. Cantafora

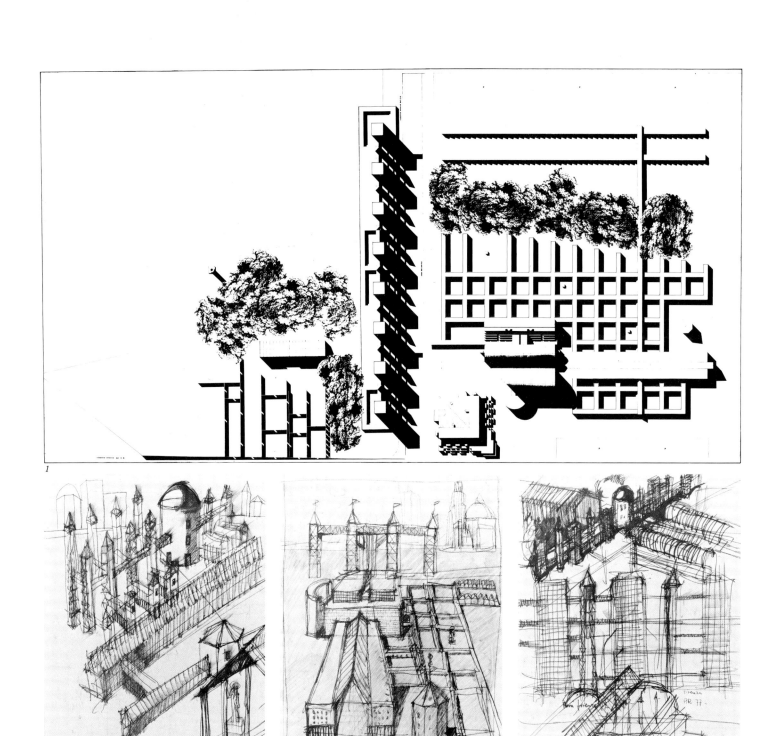

1

2 3 4

The site for a proposed business and administrative center for the Tuscan Region is outside of Florence near Prato. Although it is now a rural area, the two urban areas flanking it are growing toward each other. The site is both bounded and crossed by highways. Proposed in the project are a number of interrelated architectural and urban forms and structures. Two-story blocks of housing create a grid of courts 26 meters square, a city-like, regulating organization in which public buildings appear as individual civic monuments. The courts also provide an inward focus on architecturally made open spaces, as opposed to an outward focus on the surrounding suburban context. The housing blocks themselves are seen as ranges of repetitive, adjacent, two-story, gable-roofed houses; the courts, intended by Rossi "as places for encounters and cultural events, are seen as distinguished individually; a replica of Michelangelo's *David* stands in one,

1. General plan 2. 3. 4. Preliminary sketches 5. Map of the area 6. 7. Preliminary sketches 8. Michelangelo's David

5

6

7

8

a single tree in another, a fountain in a third."

Interrupting, and apparently superimposed on, the residential grid are two larger public buildings. The Regional Headquarters is roofed by glass vaults. Its ground-floor gallery is extended as the center of a long, four-story office block that houses offices of the Regional Administration and trade unions. Its farthest extension defines one side of a larger square on which there is an octagonal museum. A smaller gallery intersects that of the office block and leads to two long parallel rows of residential units, separated from the major, gridded concentration of identical units by a wooded area. This smaller gallery serves as a bazaar, accommodating commercial shops and artisans' stalls.

A bridge over the highway that bisects the site connects the vaulted Regional Headquarters and the buildings of the Justice Department. The courts are housed in a large, slablike building flanking the road. Above the building is a series of towers, housing the offices and archives of the Justice Department. Smaller towers with exposed steel bracing hold the stairs and elevators

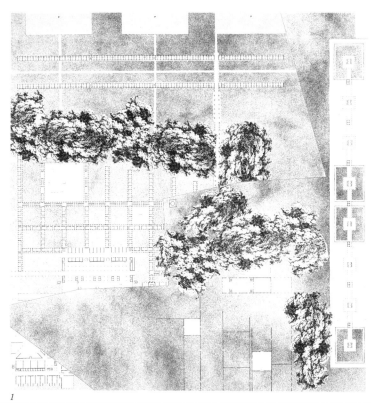

1

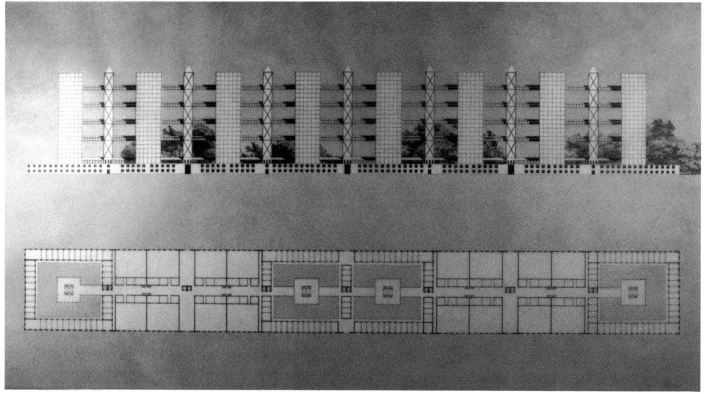

2

166

serving the offices.

Beyond the Justice complex, a segmented building of open-air and enclosed areas is intended for use by cultural associations, and is essentially similar to the center designed for the student hostel at Chieti. Another part of this area is subdivided by a series of walls with doors and is reminiscent of Rossi's design for the XIII Milan Triennale; in this case, the structure is intended to screen parking from view, while housing open-air exhibits, playgrounds, and meeting places.

1. Ground-floor plan 2. Justice Department—elevation and ground-floor plan 3. Housing blocks—ground floor plan and axonometric 4. Justice Department—axonometric

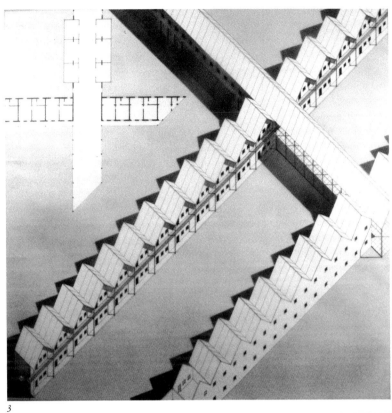

3

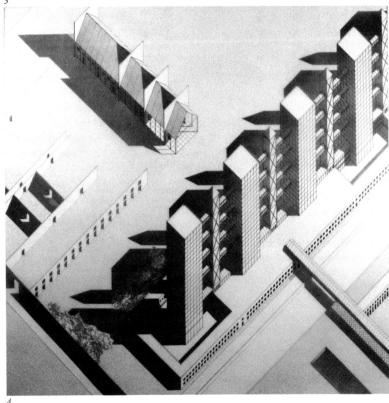

4

167

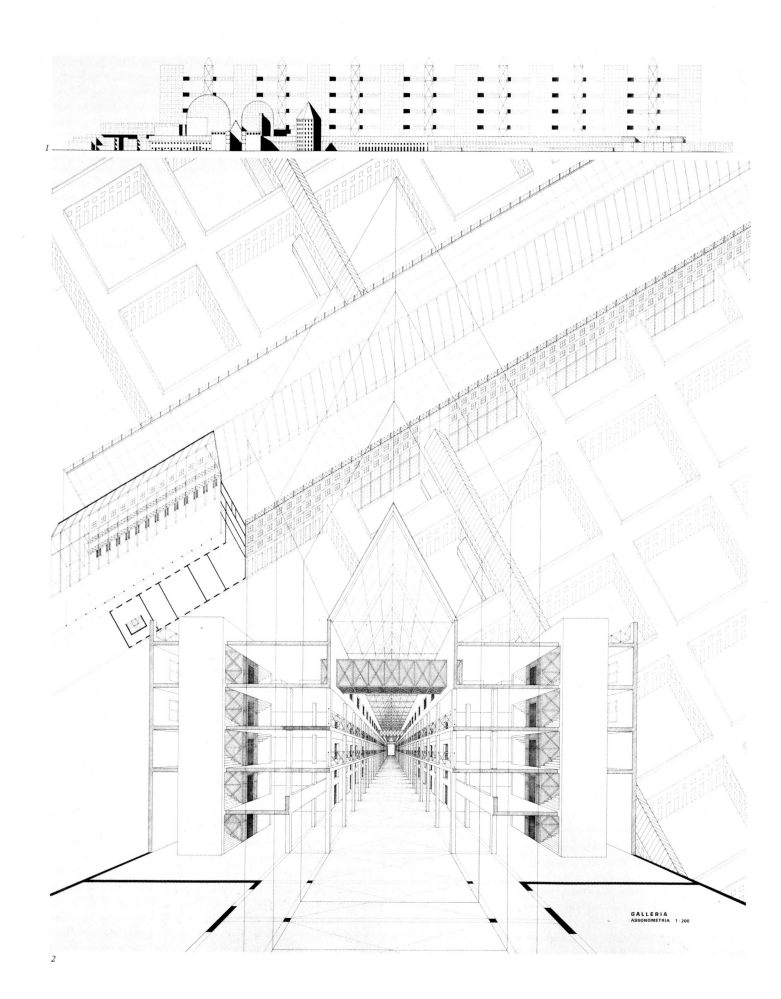

GALLERIA
ASSONOMETRIA 1:200

1

2

1. Southwest elevation 2. Axonometric section of the gallery and among the courtyards 3. The gallery—interior *elevation, floor plans, and axonometrics 4. The Regional Headquarters—plans* *5. The Regional Headquarters—axonometric from southwest*

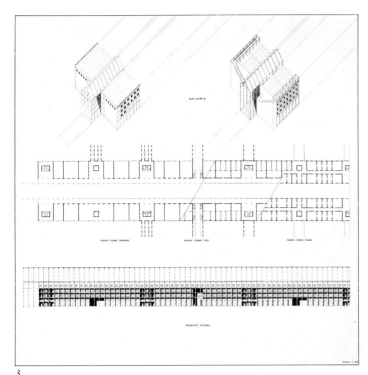

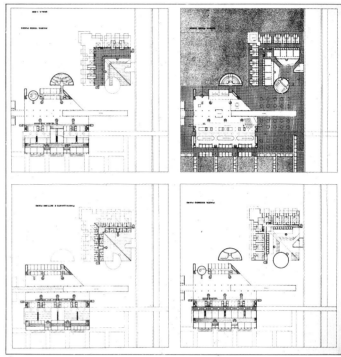

3

4

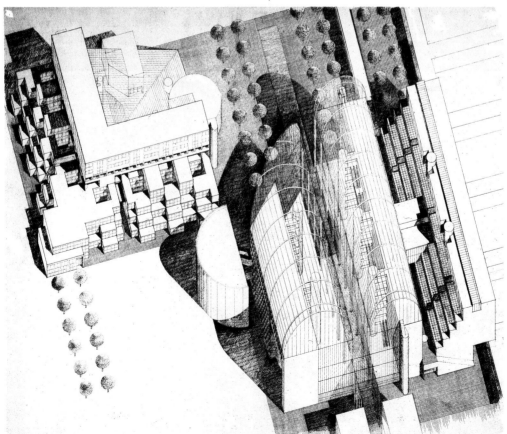

5

169

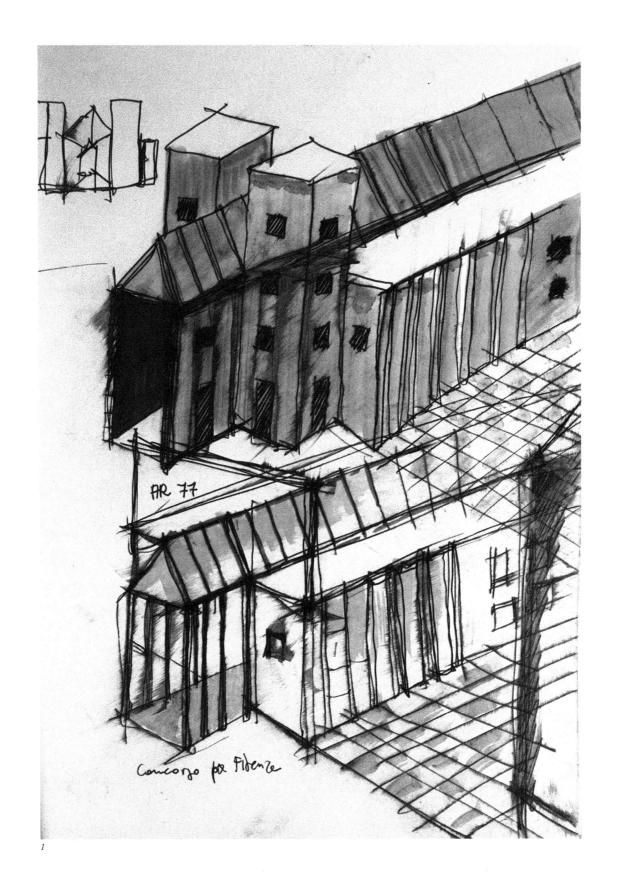

AR 77

Concorso per Firenze

1

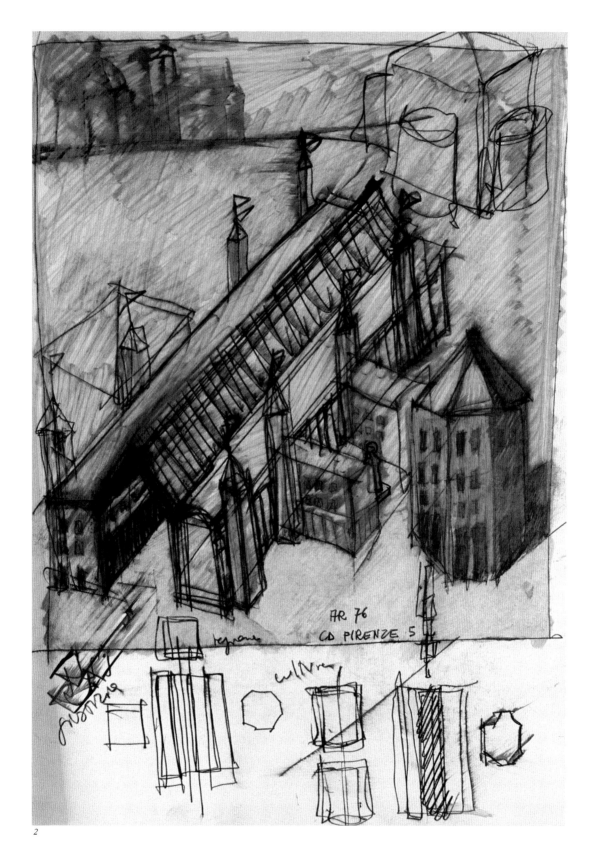

2

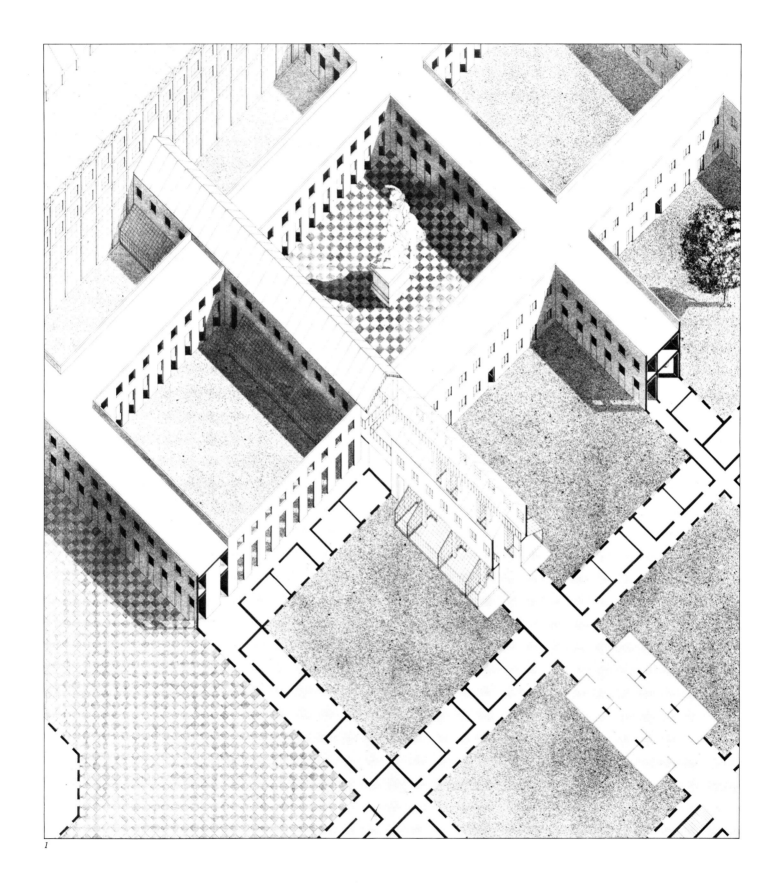

1. *The courtyards—plan and axonometric*
2. *Southeast elevation* 3. *Northeast* *elevation* 4. *Northwest elevation* 5. *The museum—plans, section, and elevation* 6. *The pavilion in the park—ground-floor plan, cross-section, and elevations*

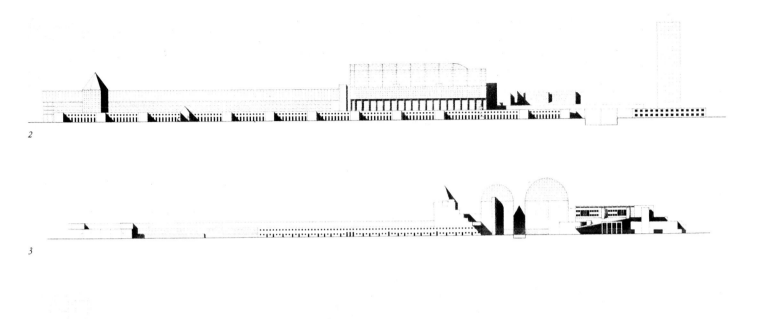

2

3

4

5

6

173

The area of Mozzo, a suburb of Bergamo, in which the houses are located is densely developed. The four row houses are under a continuous transverse gabled roof. The individual units are differentiated only by the covered, semi-enclosed entrance stairs—sheltered by a sheet-metal gable on four thin iron columns—and by gutters. The porches at the rear of each unit form an apparently continuous, two-story loggia. Each unit has its own basement. The main floor of each unit holds a living room and a large kitchen. Both open onto a paved entrance hall. From the hall, a narrow straight-run stair leads to the second floor, where the bedrooms are located. Roofs, railings, and chimney stacks are painted light green. The houses are plastered in a light ochre color characteristic of the area.

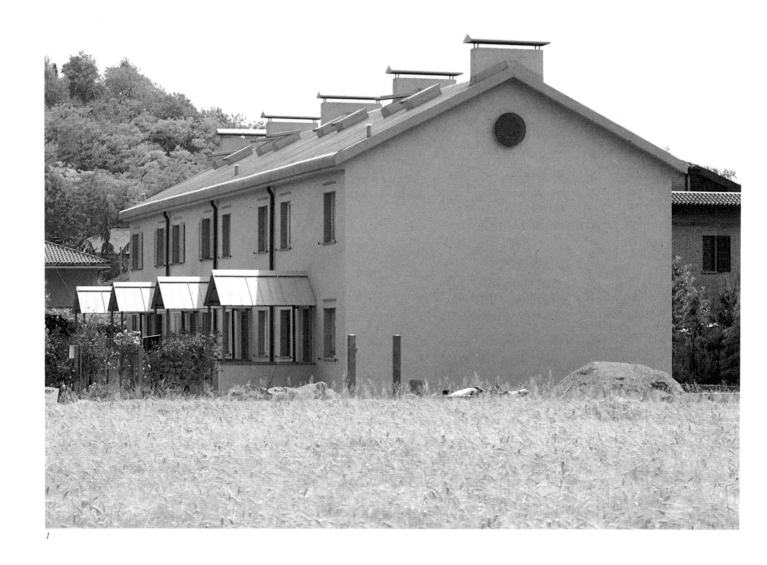

1

*1. View from northwest 2. Gate 3. "The
Houses in Mozzo" 4. View from southwest
5. Entrance to a one-family unit*

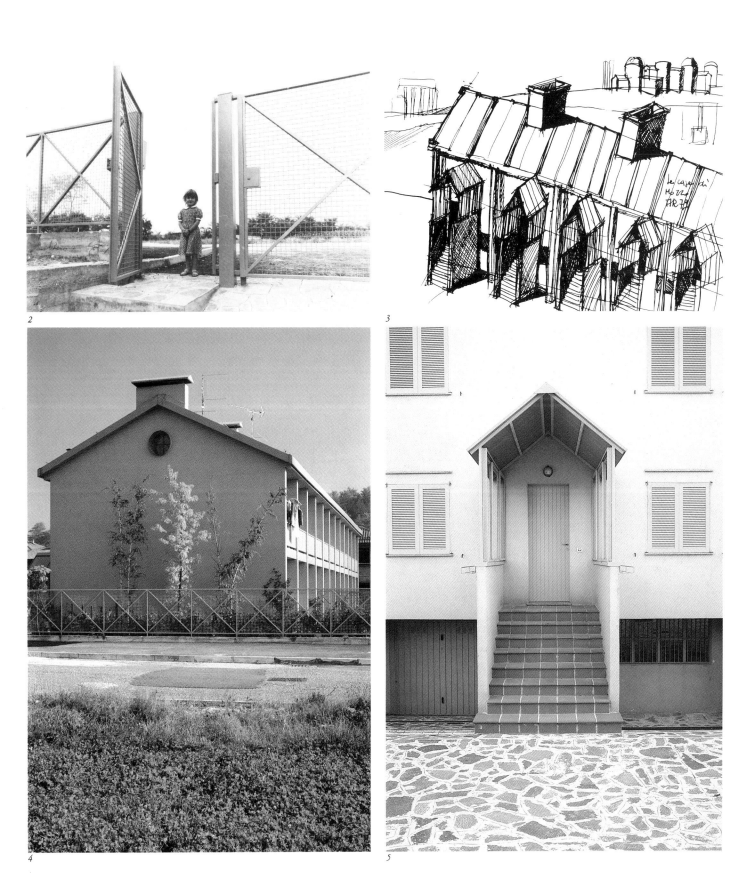

2

3

4

5

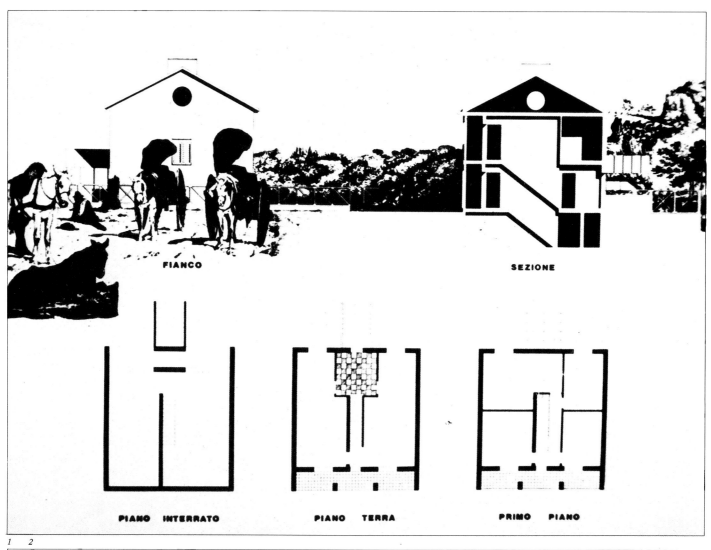

FIANCO · SEZIONE

PIANO INTERRATO · PIANO TERRA · PRIMO PIANO

1 2

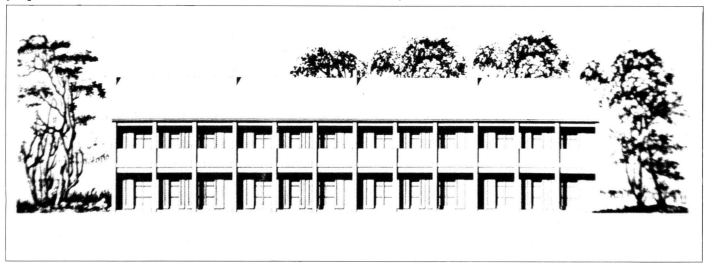

3

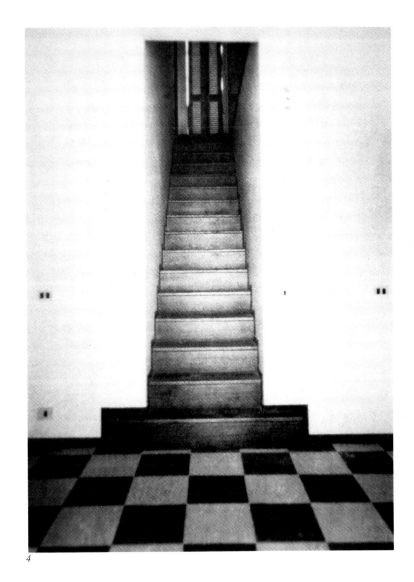

4

Twelve architects proposed changes to a section of the map of Rome drawn by Nolli in 1748 as an exercise to study what was termed "the speculative nature of urban intervention." Rossi proposed rebuilding the Antoninian Baths (Caracalla) and the ancient aqueduct to include modern heating and cooling systems. This complex would provide bathing facilities dedicated to amusement, love, and gymnastic activities, and would include annexed pavilions for eventual use as fairgrounds and marketplaces. Rossi's project description follows:

"This project does not refer to any hypothetical alternative to urban growth, nor is it affected by relationships to the city, in particular to the city of Rome or to Roma Interrotta. Any such interference would presuppose historical and psychological bonds that the authors feel unable to properly evaluate in this case.

"If this project were to have a motto, it would surely be: *ceci n'est pas une ville!* (This is not a city!) In fact, it is a bathing establishment. (Our use of French refers to a recent critical essay.)

"Instead, the project makes use of certain existing elements, such as the baths and aqueducts, restored for the occasion, as a synthetic short cut. The authors' real interest, clearly not innocent to the eye of the attentive critic, lies in thermal establishments.

"In this aspect, a relationship with Rome does exist; it is an undeniable fact that the baths used by the ancient Romans were rather singular buildings. Whether or not we like the layout of the Therms—here faithfully reproduced complete with their salons, antechambers, apses, rooms, pools, baths, etc.—it is a contamination, and not only in the syntactical and architectonic senses. There is no doubt that the relationship between Eros and gymnastic exercises—pride of more ancient civilizations— was lost in this spatial contamination, and even to the fresh eye of a purely distributive analysis, the baths demonstrate that love, even in its most elevated sense, also constituted a prosperous business.

"We referred to amusement, love, and gymnastics in this sense in our title proposal, recalling a famous work by Edmondo De Amicis [*Cuore*], which adds a note of literary suggestion without any apparent logical association. However, the history of baths goes far beyond Rome: we have personally visited some extremely old thermal constructions in the Swiss Alps where, it seems, Paracelsus the Great took his cures. (We sadly noted the serious state of neglect in which these have been left, contrary to the reputed attention paid to its monuments by this country.)

"In fact, the institution of spas reached the height of its splendor in the past century, but this is a phenomenon that can be considered

1. Revisions to the Nolli plan

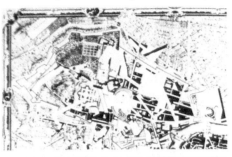

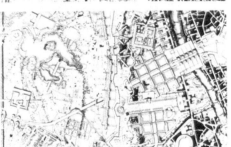

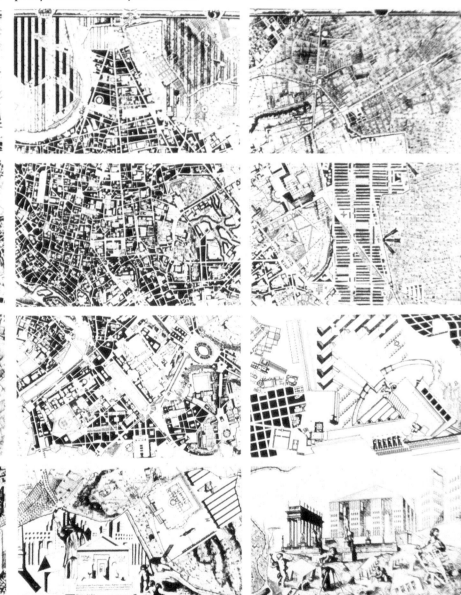

1

irrelevant to the goals of our models: we shall leave it, with its bright or dimmed lights which the French director Louis Malle tried to analyze in *Murmur of the Heart*, where he described the sociological and family-oriented abominations that seem extraneous not so much to a moral sense as to modern sensibility.

"The more positive examples to which we referred are the reconstructions made by the famous Prix de Rome architects, to the French and German romantic schools of archaeology, to those images fundamental to our classical education immortalized by Cecil B. De Mille and other Hollywood directors, as well by Fellini in *Satyricon*.

"Finally, in order to understand this project, it must be remembered that a medical objective underlies the creation of the large spaces and pools of water. They are destined to hydrotherapeutic and heliothermic cures and to all modern applications of physical therapy and chinesitherapy. Not only are the authors convinced defenders of the latter use, above and beyond any interdisciplinary ghettos, but they also agree with the most modern medical views that prefer the

1

2

abolishment of clear distinctions between the physical and psychological aspects of diseases and that favor, above all, freedom, fraternity, and promiscuity among those who use the establishment.

"For this we have planned a large, deep pool of water, to eliminate the differentiation caused by multiple tanks, which, all things considered, even if they protect the invalids from drowning also expose them to a sense of uneasiness next to the able swimmer. On the contrary, the objective danger to which the few will be submitted in the large pool (for reasons of infirmity, old age, or inability to swim) will be compensated for by a most careful attention by other bathers. Thereby a situation of continuous tension will be created, not without its spectacular elements.

"The other elements of this project are clearly legible: a fountain, a teahouse complete with a walkway and diving board, dressing rooms destined also for protecting oneself from the sun or for other purposes, and finally, the water-house. The water-house, thanks to its

1. Original plan of the sector 2. Proposed plan 3. Axonometric of proposal

very name, is perhaps the best invention this project has to offer; of course it contains the heating and cooling equipment, but the name *water-house* seems to us quite fantastic and emblematic, fresh and mysterious. This building can be crossed by boat like a gully stream, or directly, by swimming. Swimmers and scuba divers can explore its foundations and pipeline systems in a sort of scientific-engineering exploration that was unavailable before.

"In any case, an iron gangway permits the less daring to cross the water-house by walking around its entire perimeter.

"The buildings to be used upon occasion of fairs, markets, and art exhibitions (whether they be biannual, triannual or quadrennial) are located at the top of the general planimetric map.

"The form of some of the buildings has been freely borrowed from other projects, others have been converted, and still others have been invented.

"In the general planimetry an invented urban complex, composed of various buildings and a small stage on whose platform household objects have been placed, replaces the

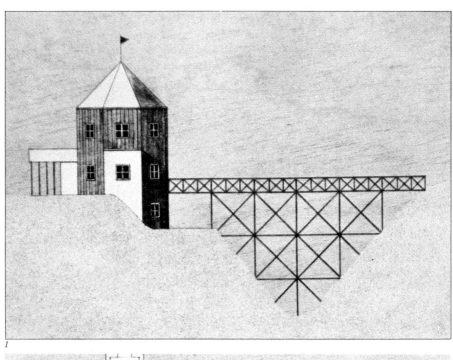

1

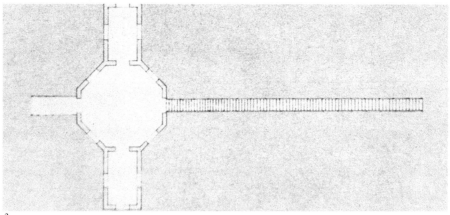

2

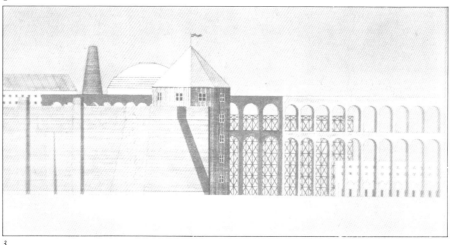

3

original dedication. The statue of San Carlone di Arona predominates this composition. The authors intended to create a rebus around this statue, based on San Carlina a Roma and San Carlone di Arona, but were unable to wind it up properly. "This weakness on their part must not be allowed to detract from the study of this great project, which we and others are convinced (on the basis of concourse results and the future of Italian and world architecture) will soon be realized and taken into consideration by some intelligent public administration."

1. Teahouse—side elevation 2. Teahouse—plan 3. Section of the Aurelian Wall, with view of the baths, the teahouse, and the aqueduct 4. Section of the water-house 5. Perspective drawing of the pavilions, overlooking the bathing establishment

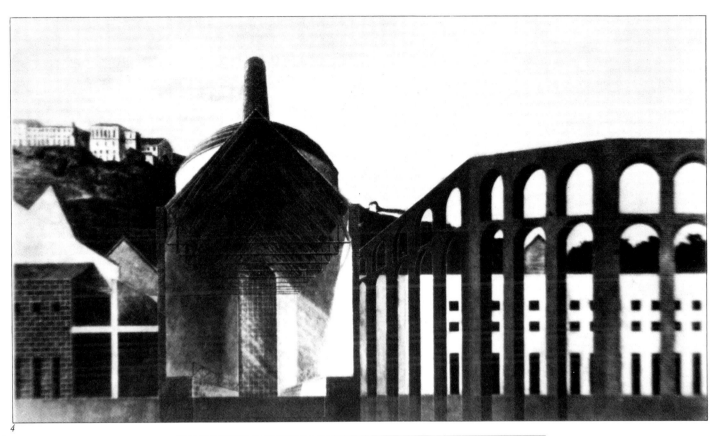

4

5

Jung once wrote to Freud: "Logical thought is 'thinking in words.' 'Analogical' thought is sensed yet unreal, imagined yet silent. It is archaic, unexpressed, and practically inexpressible in words." To Rossi, this definition explains some of the influences in his own work and also his fascination for work like Canaletto's painting of Venice in the Parma Museum. Three Palladian designs are in it as part of the city, but two are in fact in Vicenza and one was never built. Rossi says it is "an analogue of the real Venice composed of elements related to the history of both architecture and the city itself that

could not have been expressed in words." One of the first studies of the idea was a collage created for a Venice Biennale. The collage, according to Rossi, "showed aspects of memory, a memory circumscribed within north Lombardy, Lake Maggiore, and Ticino canton. History and geography are merged in Tanzio da Varallo's painting and in the stone houses, inside which the projects are arranged. A discreet private life runs through the places and gives a sense to the architecture—and perhaps it is this alone wherein the humanity of architecture lies."

Little Scientific Theater
1978
With G. Braghieri, R. Freno

The small construction was conceived of as a machine for studying architectural elements. The theater has a fixed scene, with interchangeable architectural elements and a series of painted backdrops. Its skeleton is built of steel sections paneled with wood staves, the sides of which are painted alternately pink and light blue. The term *scientific* refers to the scientific and anatomical theaters like those at Mantua and Padua. The source of the idea sprang both from their models and also from those of puppet theaters. Of the project Rossi has written, "The invention of the Little Scientific Theater, like any theatrical project, is imitative; and like all good projects, its sole reason is to be a tool, an instrument, a useful space where a definitive action can occur. The theater, then, is inseparable from its sets, its models, the experience of their combinations; and the stage can thus be seen as reduced to an equivalent of an artisan's or scientist's worktable. It is experimental like science, but it casts its peculiar spell on each experiment. Inside it, nothing can be accidental, yet nothing can be permanently resolved either."

1. Front perspective

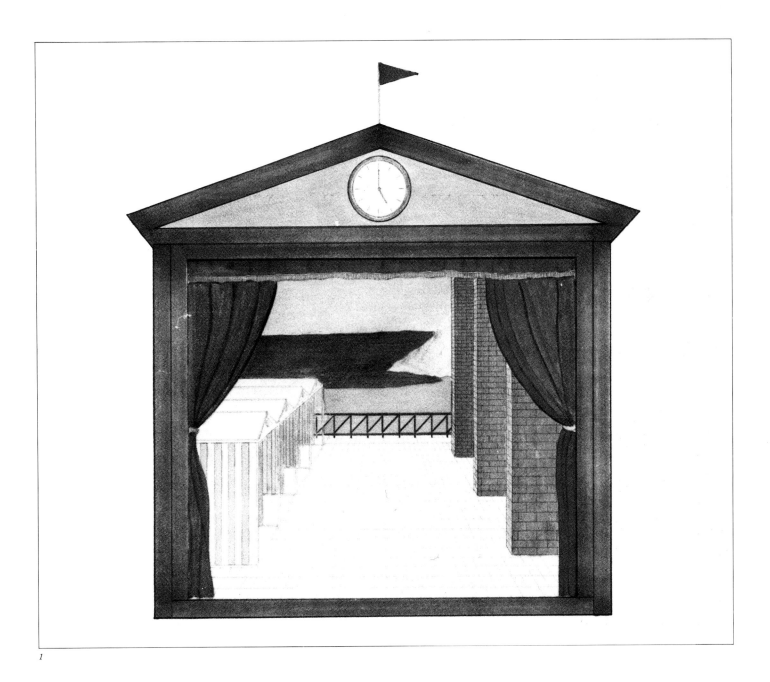

1

185

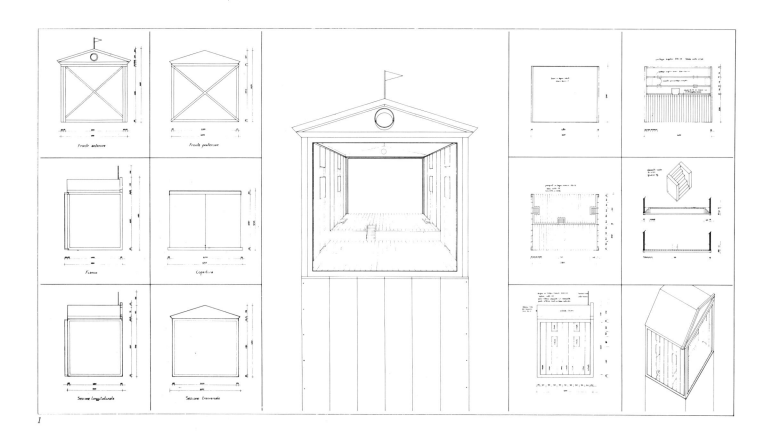

1

2

3

4

1. Constructive table with interior perspective
2. 3. 4. Studies 5. "Theater"

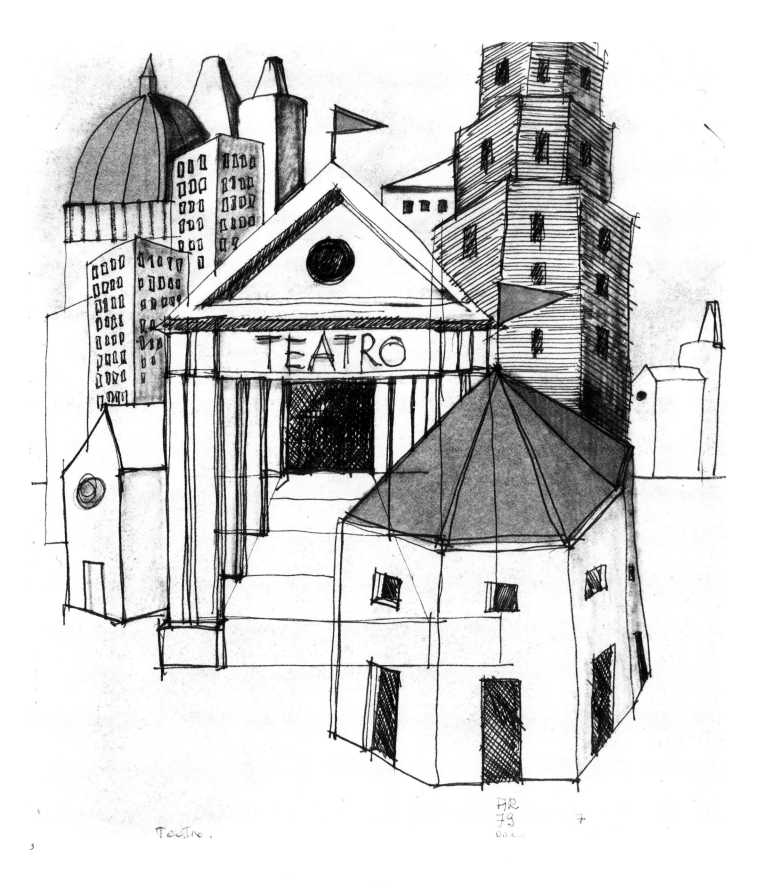

5

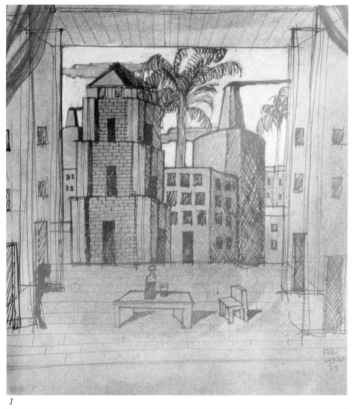

1

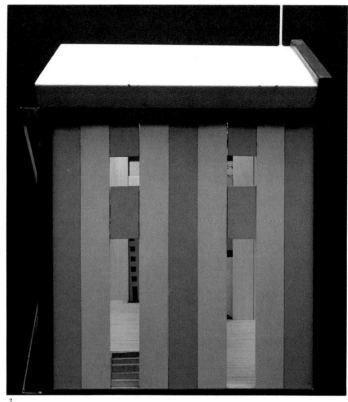

2

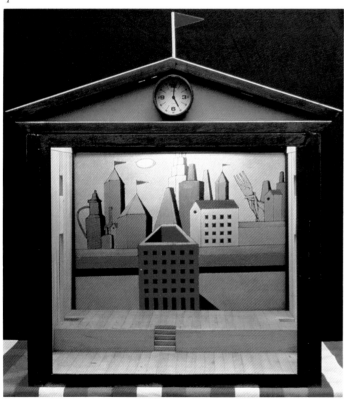

3

4

188

1. Study 2. Model—side view 3. Model—
front view 4. Model—perspectival view
5. "The Architecture—the Prologue"

5

Single-Family Houses
Zandobbio, Italy, 1979
With A. Pizzigoni

Two types of houses were designed for a site in Zandobbio, near Bergamo. One type is sited perpendicular to the access road, the other parallel to it. In the former, an entrance stair covered with a gabled entrance porch leads to the ground floor, and then almost immediately to the straight-run stair to the second floor. On either side of the stair on the ground floor are two big workrooms, each with large windows to the east. At the top of the stair a glazed corridor, which projects slightly from the east façade, leads to the second-floor rooms.

The houses sited parallel to the street are nearly entirely open on their ground floors: each has only a central hall enclosed, reached by an exterior stairway under a gabled roof. On the second floor at the top of the stair is a balcony under a projecting gable. Structural piers are visible on the second-floor façades as pilasters; as a consequence the plaster walls appear as panels set into a continuous structure of piers supporting the roof.
The project is rural in character. The houses' plans recall the combined working and living spaces typical of Italian farmhouses. The

porticoes, the long, low-pitched roofs, the rustic pediments, and the plastered façades are also recurrent elements of local architecture.
The buildings are of reinforced concrete and concrete block plastered and painted white. The gabled roofs and other metal components are painted light blue.

1. Elevations, sections, and plans—house A 2. Elevations, sections, and plans—house B

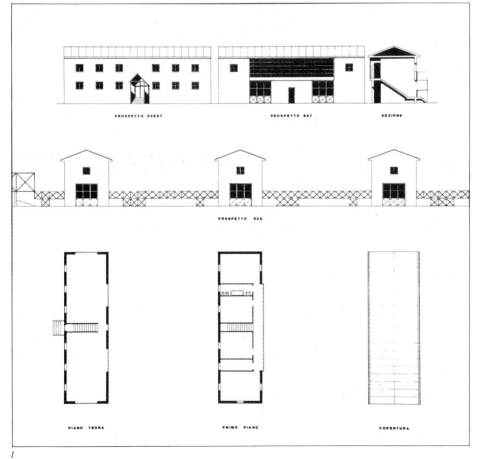

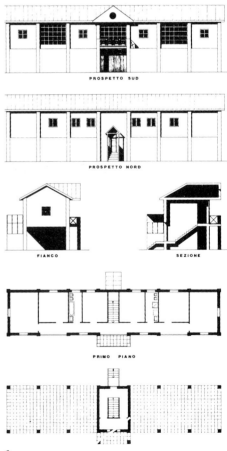

Secondary School
Broni, Italy, 1979
With G. Braghieri

The site is in a densely developed area. Immediately adjacent are a mixture of housing types, industrial buildings, and two relatively new prefabricated schools, one of which shares its cafeteria and athletic facilities with the secondary school. The latter is sited with no formal relationship to the buildings around it. Instead, it is an independent entity, focused on its internal garden courts. Linear building blocks delimit the perimeter of a square and form an internal garden courtyard. These blocks present an essentially continuous façade on the exterior; only an entrance portico and a break in the building at the rear (the latter opening to the grounds behind) are differentiated. Internally, these perimeter buildings contain twenty general classrooms, four special classrooms, a small library, professors' offices, service areas, and dressing rooms, all of which are arranged along a corridor wrapping the courtyard. At the entrance, an atrium is formed by an elongation of the building into the courtyard. This atrium is extended to provide access to the theater building at the center of the court. The theater building is an octagon on a circular base. In addition to the enclosed walkway from the atrium to the theater,

1. Model—general view 2. Roof plan

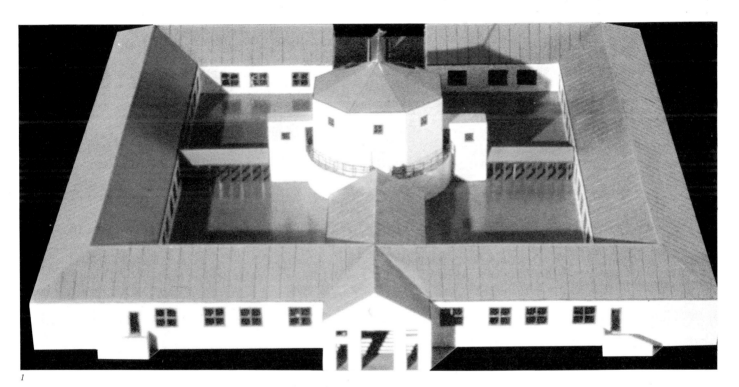

1

2

three covered colonnades also lead to the
theater; these paths divide the courtyard into
four smaller areas. The colonnades lead to
semi-enclosed stairs, which offer access to an
ambulatory around a circular base of the
theater and to the theater itself.

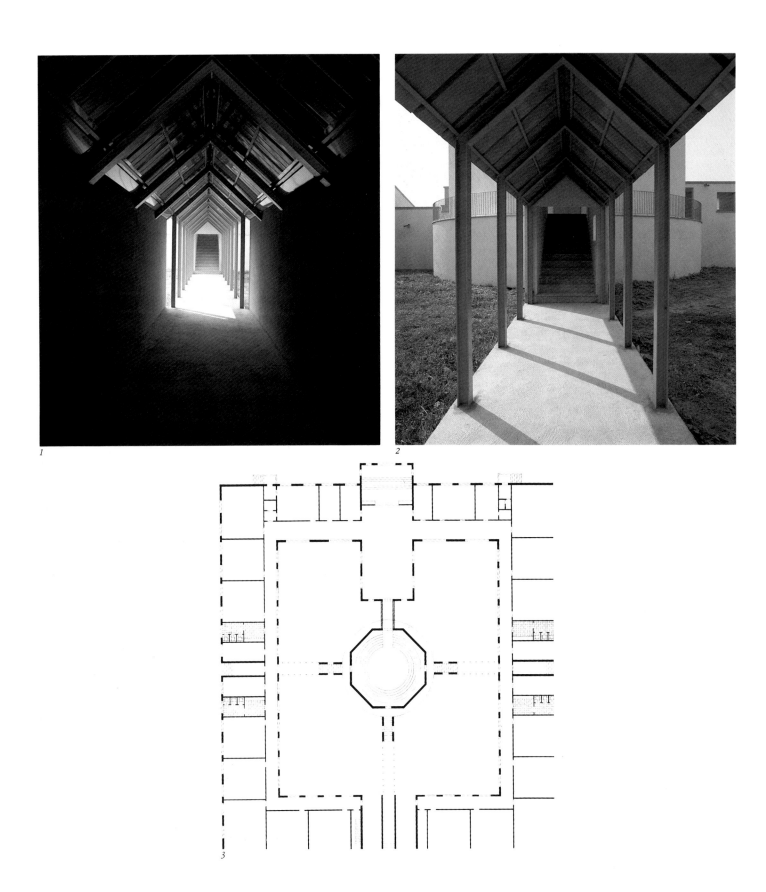

1

2

3

1. 2. *Covered walkway leading to theater*
3. *Ground-floor plan* 4. *The theater in the*
courtyard

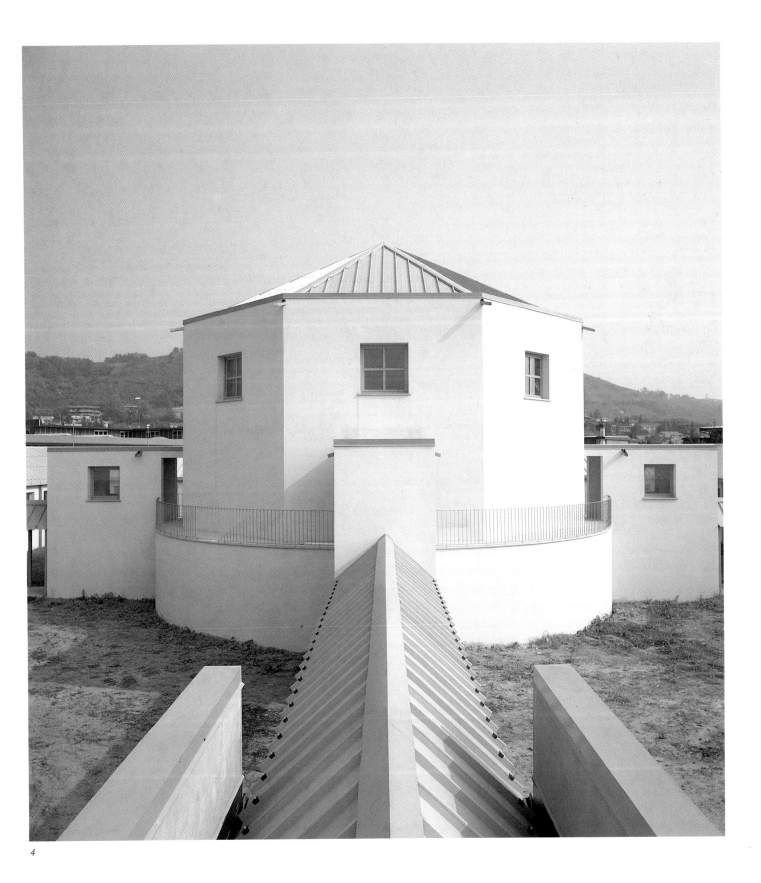

4

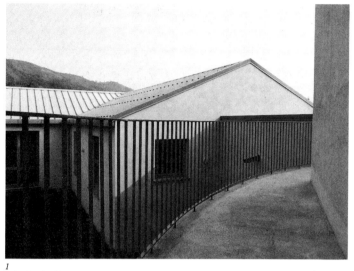

1

2

3

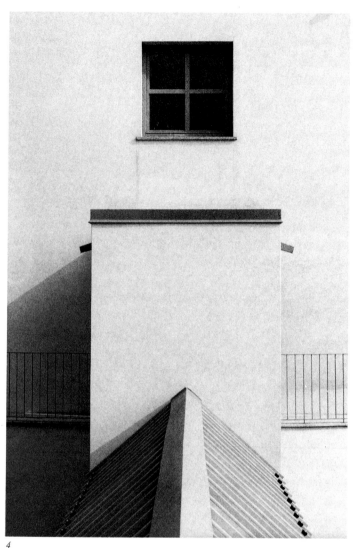

4

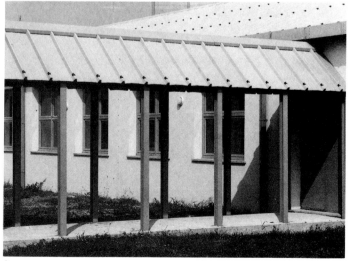

5

1. *Terrace around the theater* 2. *View of*
perimetral building from the terrace
3. *Perimetral building façade on the*
courtyard 4. *Theater—detail of east, south*
and west façades 5. *Covered walkway in the*
courtyard connecting classrooms and theater
6. *Covered walkway and stair enclosure as*
seen from the terrace 7. *Top of staircase*
and entry to theater

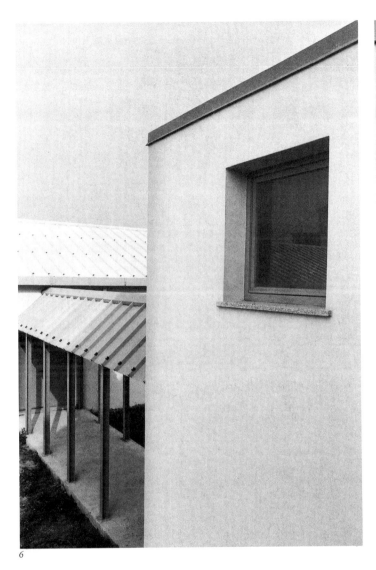

6

7

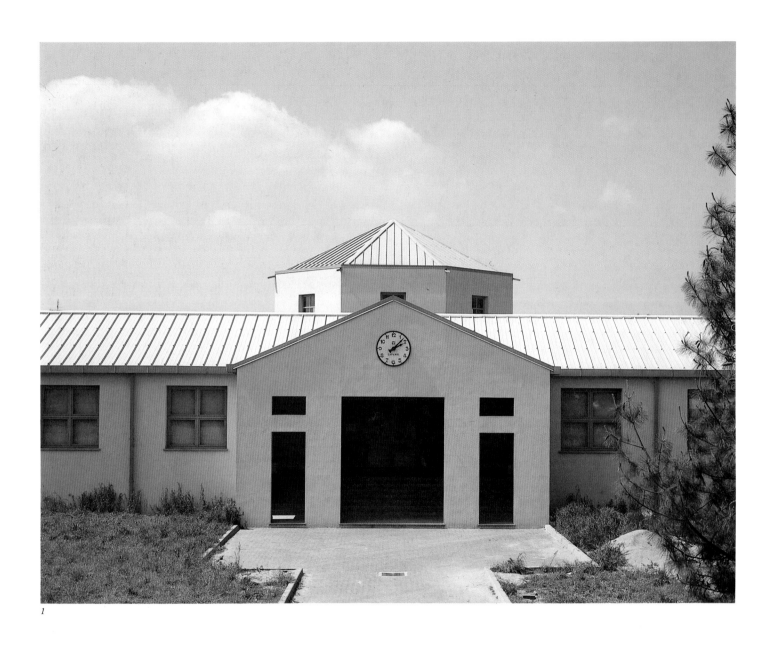

1

1. *View of entrance* 2. 3. 4. *Exteriors*
5. 6. *Interiors of theater* 7. *Ceiling of*
theater

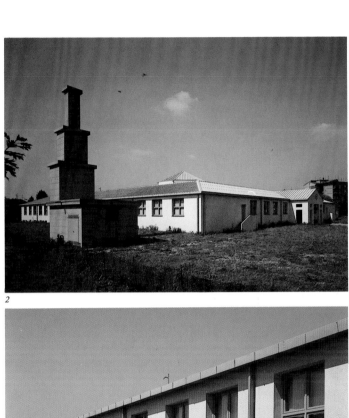

2

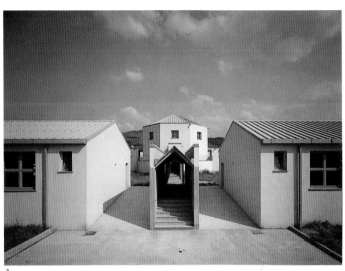

3

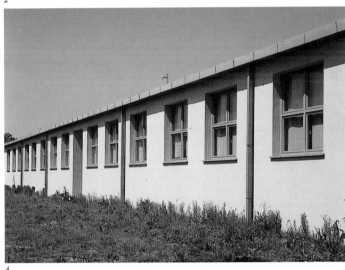

4

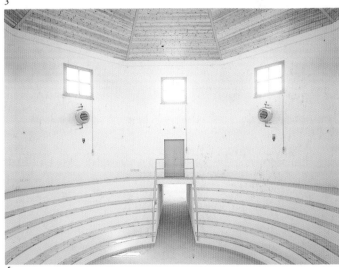

5

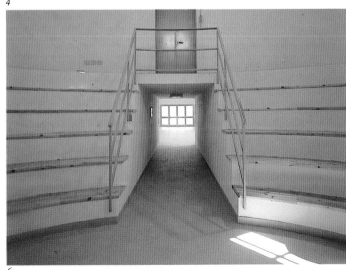

6

7

1

2

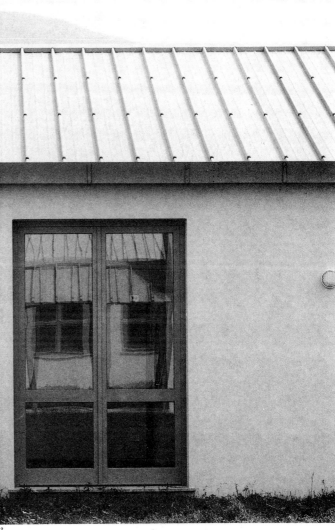

3

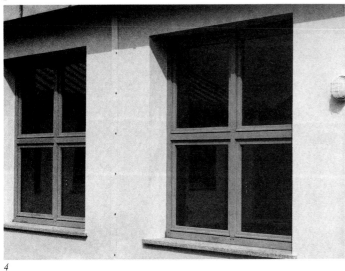

4

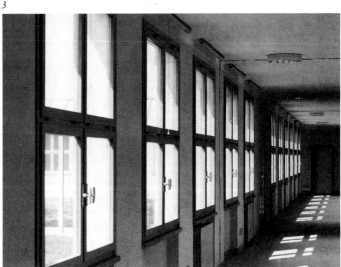

5

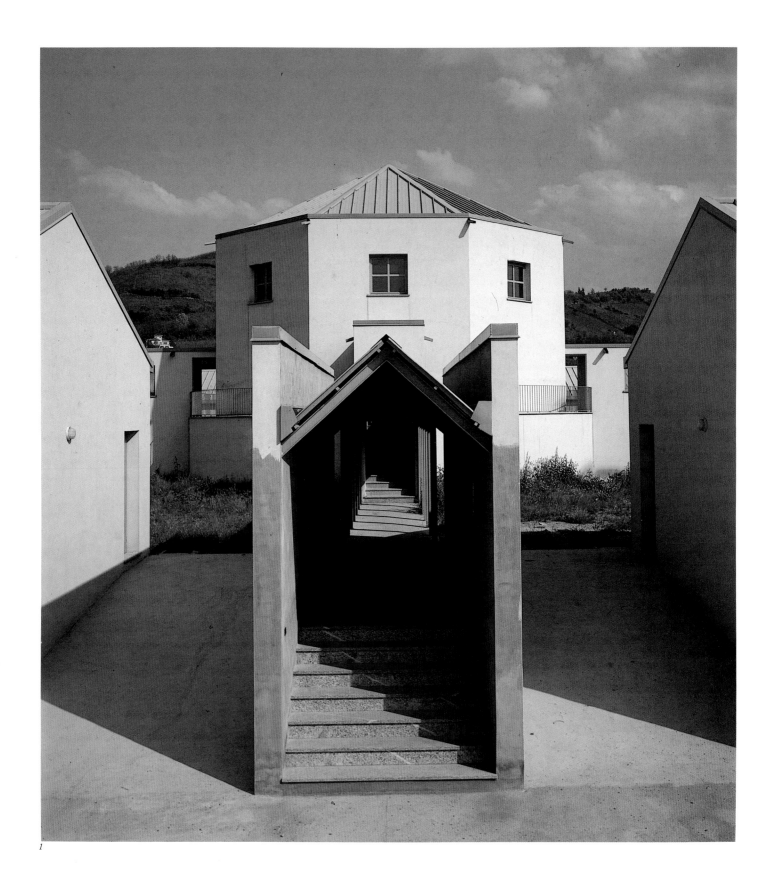

1

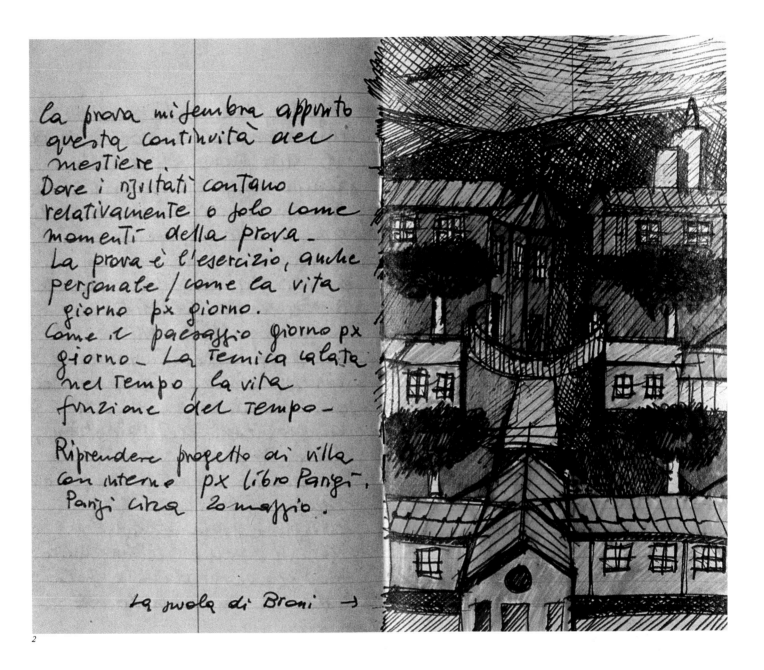

La prova mi sembra appunto
questa continuità del
mestiere.
Dove i risultati contano
relativamente o solo come
momenti della prova.
La prova è l'esercizio, anche
personale / come la vita
giorno px giorno.
Come il paesaggio giorno px
giorno. La Tecnica calata
nel Tempo, la vita
funzione del Tempo.

Riprendere progetto di villa
con interno px libro Panzi,
Panzi circa 20 maggio.

La scuola di Broni →

2

1

Karlsruhe, the capital of Baden, was laid out during the eighteenth century on a radial plan. The center on which the radiating streets focus is the tower of the Karl Wilhelm Castle, which was built in 1715 and stands in a radially planned garden. In transforming the castle into a public library for the city, several diverse elements were emphasized: the rare example of a rationalist architectural idea

1

being directly translated into a structure of urban life, the forced perspective of Friedrich Weinbrenner's plan for the Kaiserstrasse, and the Germanic urban tradition of sharply vertical elements such as steeples and smokestacks. The library design reinforces the perimeter and original scale of the city block,

1. The Stefankirche 2. Model from above

2

preserving or restoring existing buildings along the street edge and confining major new construction to the interior of the block. An iron, steel, and glass gallery, lined with shops and urban amenities, crosses the block to create a covered city street that is also the spine of the library. Four blocks around the gallery hold stacks, reading rooms, archives, and storage. Library administrative offices, as well as the offices of various civic organizations, are located in the building at the perimeter of the block. The reinforced concrete structure of the four square blocks of the library is covered with a plaster mixed with ground pinkish sandstone, to suggest the color and character of the city's old stone architecture.

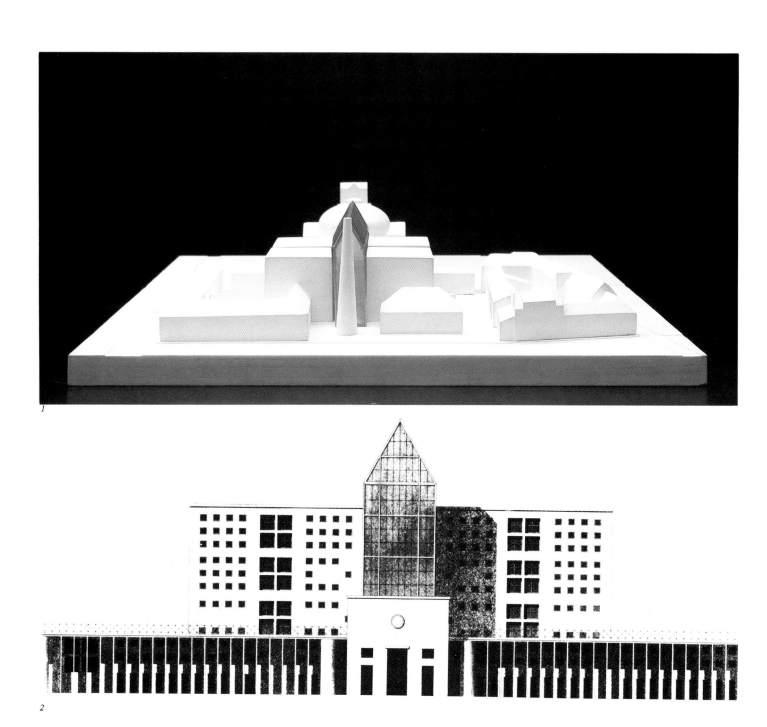

1

2

1. Model—view from south 2. North
elevation 3. Model—view from northeast
4. Model—view from southeast 5. Linear
section looking east

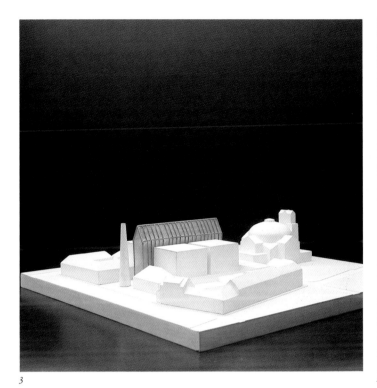

3

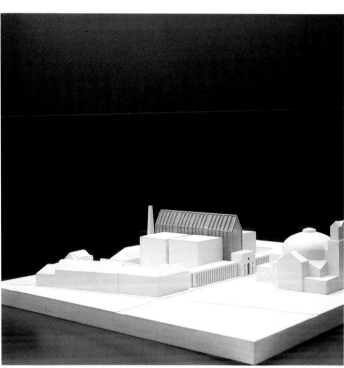

4

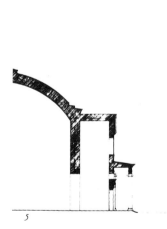

5

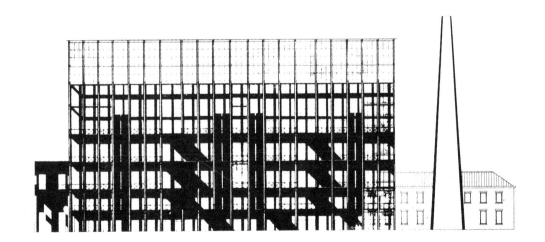

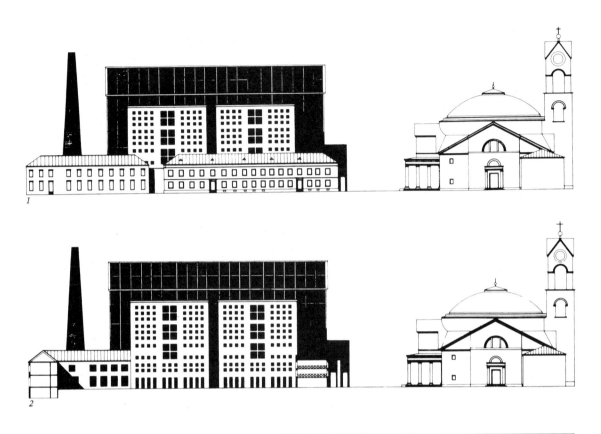

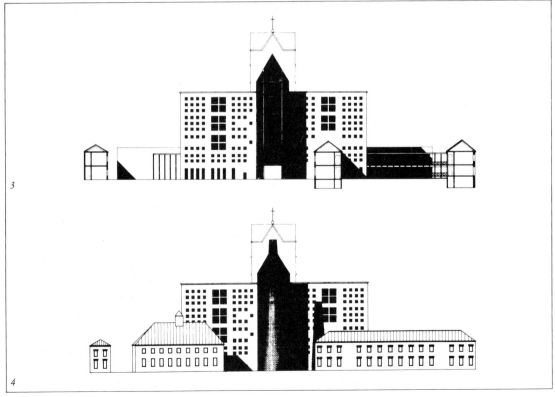

1. East elevation from the street 2. Section elevation from the street 5. Model—interior
through courtyard looking west 3. Section view of the gallery
through courtyard looking north 4. South

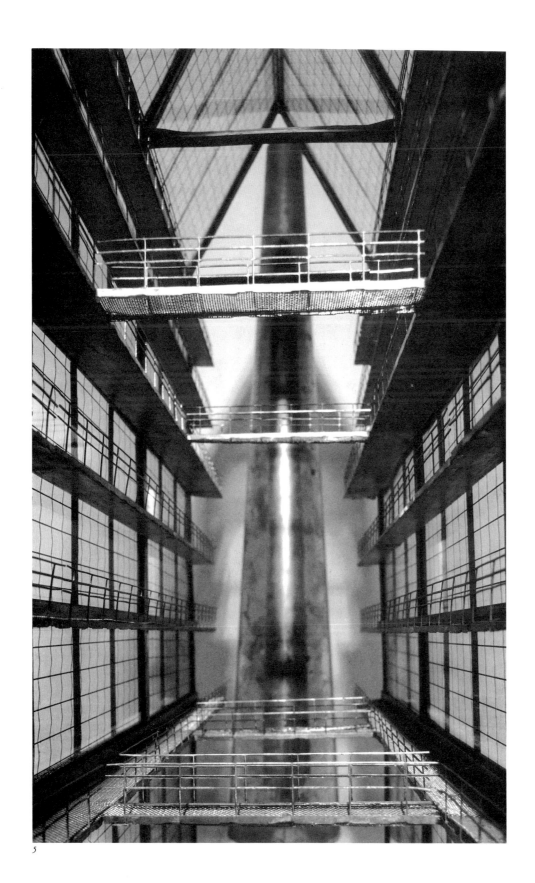

5

207

LANDESBIBLIOTHEK, KARLSRUHE, 1980
(con Gianni Braghieri, collaboratori: Christian Herdel Christopher Stead)

Questo progetto deve essere giudicato come edificio e come parte di città; esso si relaziona alla realtà del centro storico di Karlsruhe la cui particolarità consiste nell'essere nato da un'idea dell'architettura illuminista, e di aver tradotto questa idea nella vita della città. Karlsruhe può essere considerata un modello nel suo disegno originario e nella sua vicenda storica; al modello appartengono diversi progetti tra cui principalmente l'intervento nella Kaiserstrasse di Weinbrenner. La prospettiva del Weinbrenner è intesa qui come un riferimento e un simbolo; ad essa si accompagna la guglia della Stefankirche, la tensione verticale delle città tedesche nelle costruzioni religiose e industriali.
Il progetto della Landesbibliothek segue i contorni dell'isolato origi-

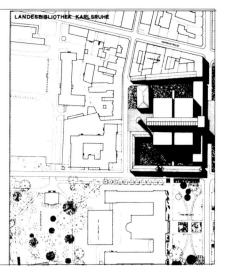

1

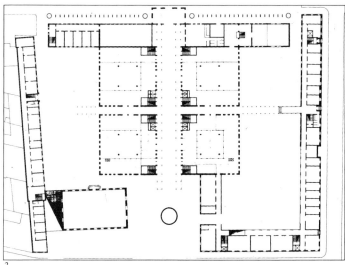

2

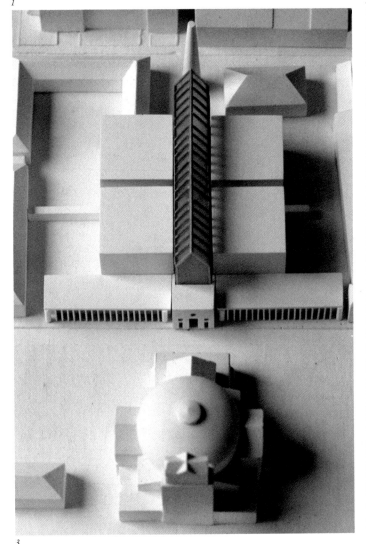

3

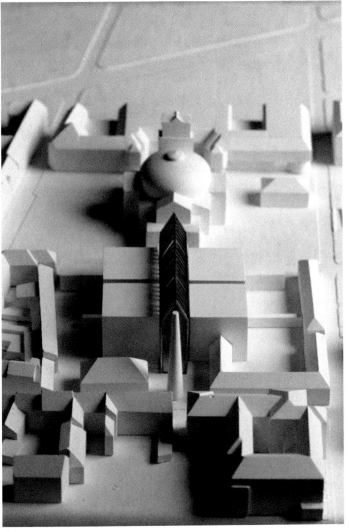

4

1. *Site plan* 2. *Ground-floor plan*
3. *Model from above (looking south)*
4. *Model from above (looking north)*

5. *Model — north façade* 6. *Model — view
from northeast*

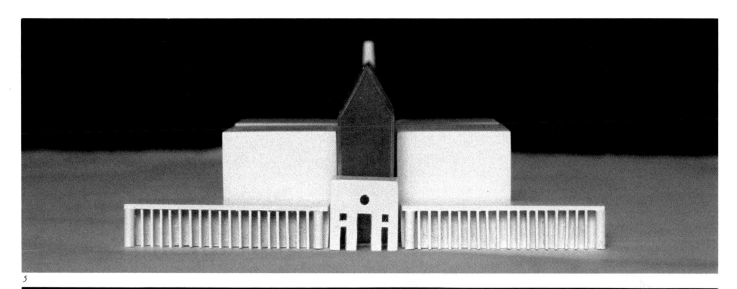

5

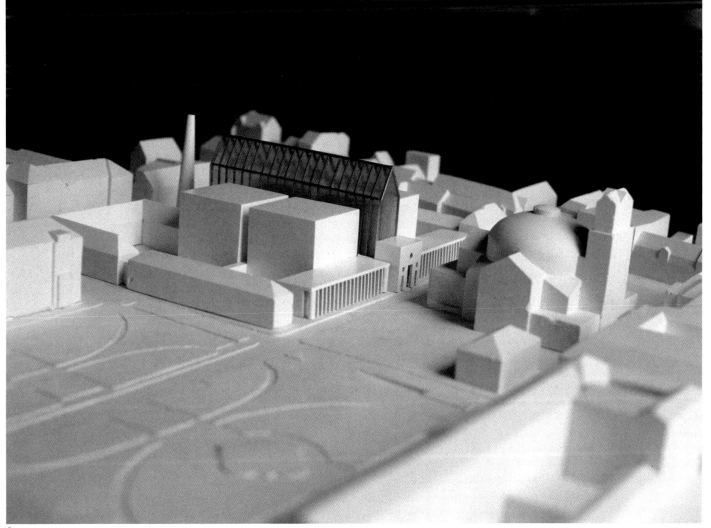

6

Housing Cooperative
Goito, Italy, 1979
With G. Braghieri, COPRAT

For a workers' housing cooperative, a series of single-family houses was designed to create a small residential quarter along a central street of Goito, near Mantua. The two-story housing units are grouped in pairs on either side of a central *allée*. All but one of these duplexes are linked by garages, which create a kind of continuous base. Entrances from the central street are through vestibules in a gabled volume. The gabled forms create silhouettes of houses along the street elevation of the housing rows. The entrance to the first house in the row is rotated 90 degrees in respect to the others in order to face the open space in front of the rows, helping to make a "front" of the side elevations. The plans of the units are simple, with bedrooms above the living areas and smaller bedrooms on the ground floor. The houses are constructed of reinforced concrete plastered with a mixture traditional in Lombardy and the Veneto: cement and ground brick are mixed into a thick paste with a red-ochre color. The roof is sheet iron, light blue in color.

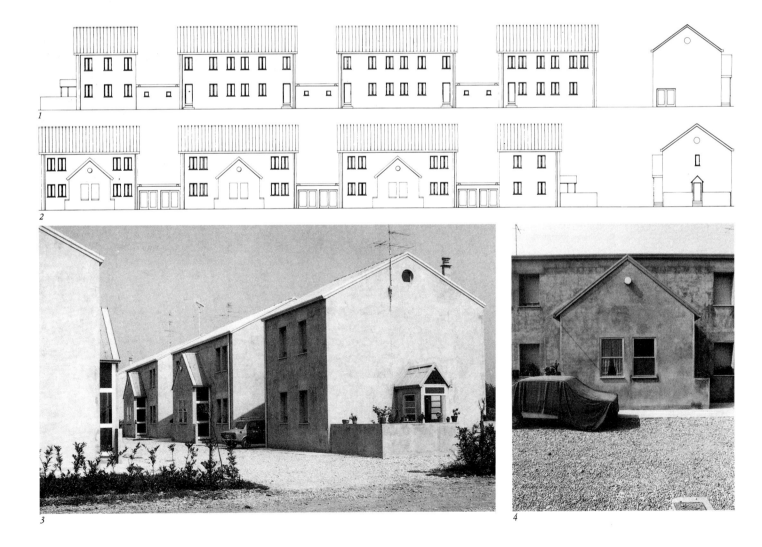

1
2
3
4

1. Back and side elevations 2. Street and
side elevations 3. Central street
4. Entrance to two houses 5. 6. Details of
street façade 7. Side view 8. Entrance
doors on the street 9. Sections through the
street 10. Linear section through central and
last unit

5

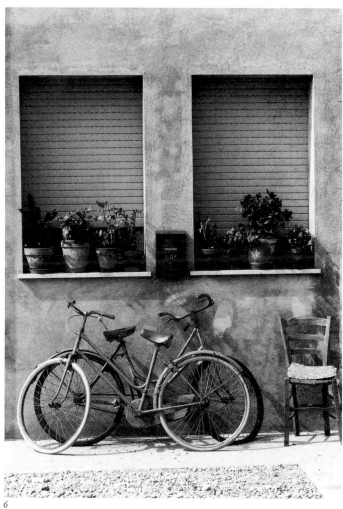

6

7

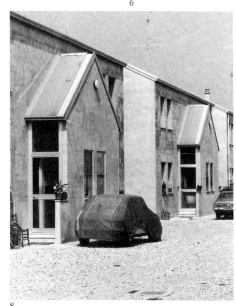

8

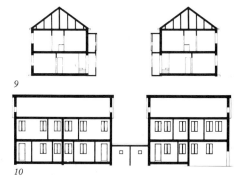

9

10

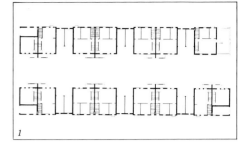

1

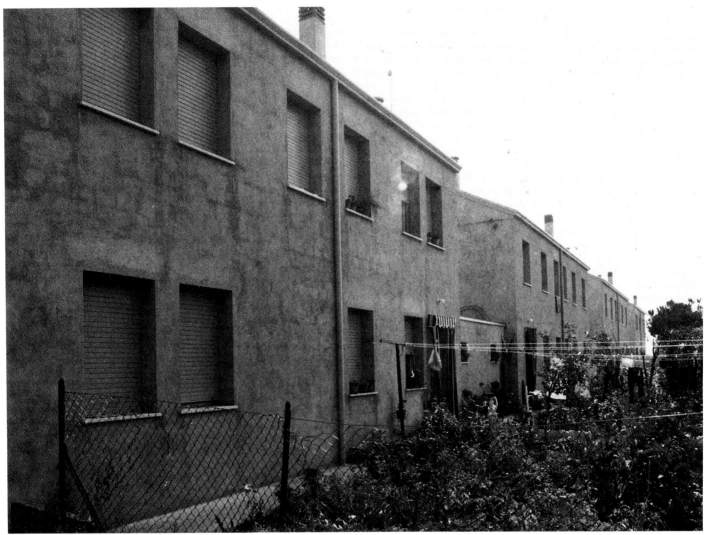

2

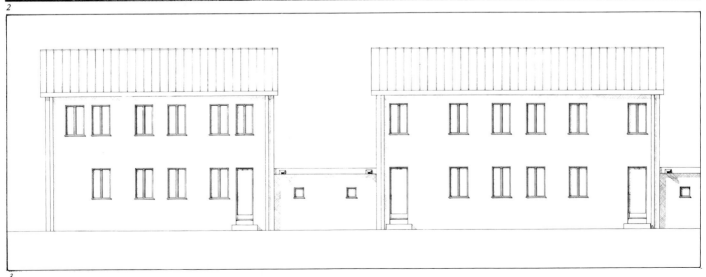

3

212

1. Ground-floor plans 2. View of back façade 3. Back elevation—central and last unit 4. Side elevation—detail 5. Street façade of one unit, with two houses 6. Street elevation of central and last unit

4

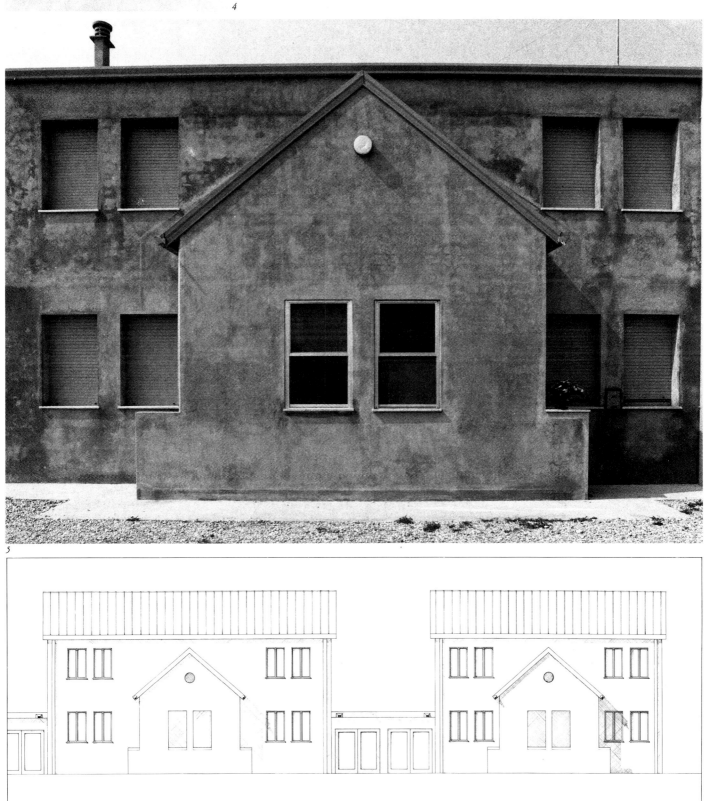

5

6

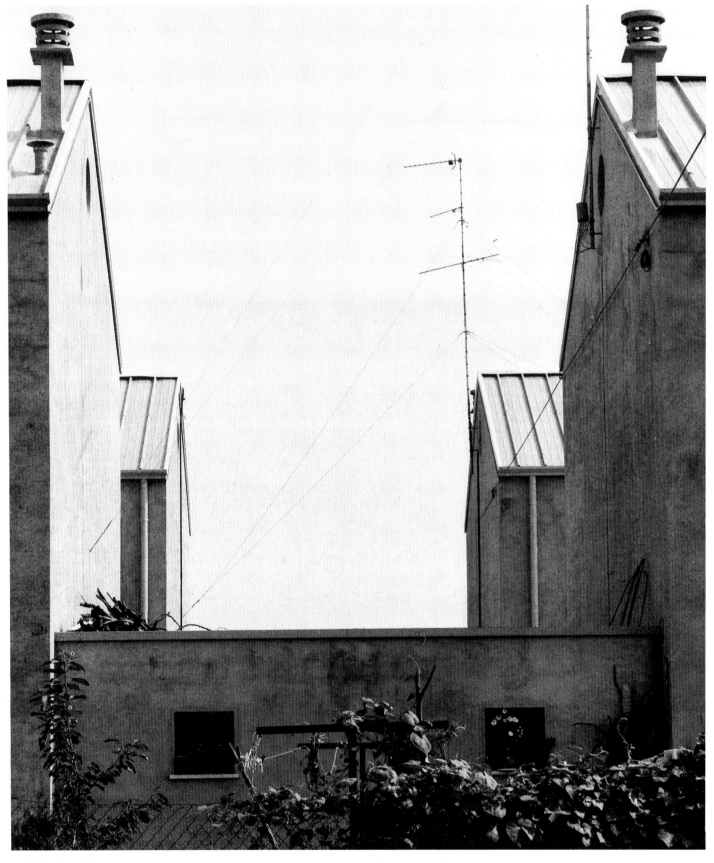

1. Side view of units

Housing Cooperative
Pegognaga, Italy, 1979
With G. Braghieri, COPRAT

In another town near Mantua, a group of houses similar in many ways to those built in Goito were designed for another workers' cooperative. The context and economic conditions were very much like those in Goito; as a consquence, site planning, materials, and unit plans are also similar to those of the earlier project. The housing units are arranged in two blocks, creating a mews. A lower block of garages closes the mews on one side. The housing blocks themselves are modeled on the traditional farmhouses of Lombardy and Emilia, particularly upon the porticoes of country houses. Entrances to the housing units are beneath double-height porticoes that run the length of each housing block behind square piers.

1. View of the double-height portico along the main façade 2. Side view 3. Study sketches

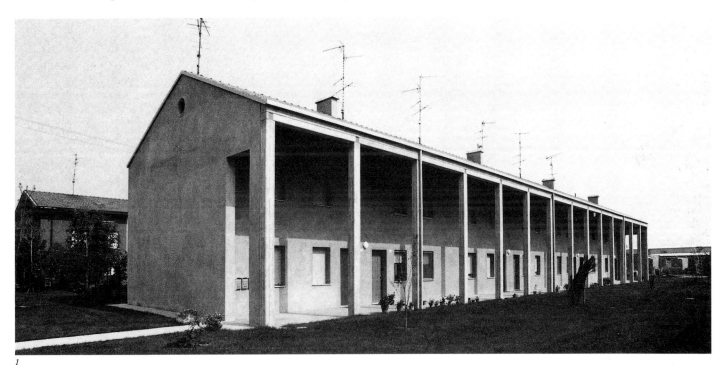

1

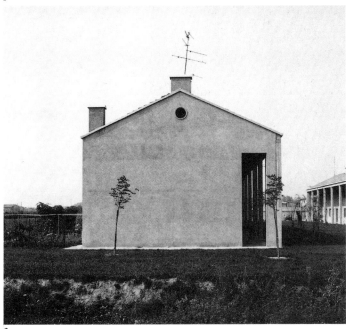

2

3

1

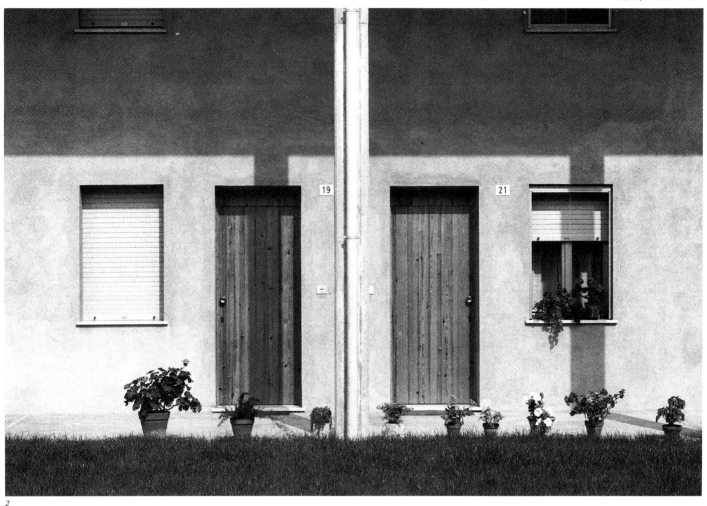

2

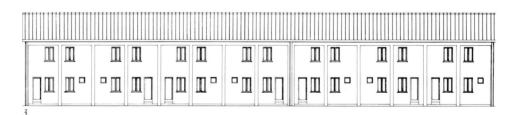

3

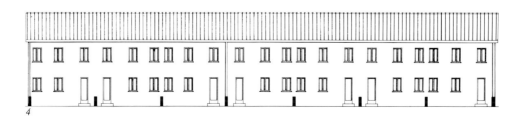

4

1. Study sketches 2. Entrance doors on the portico 3. Building A – front elevation 4. Building A – back elevation 5. The double-height portico 6. The roof of the portico 7. Building B – front elevation 8. Building B – back elevation

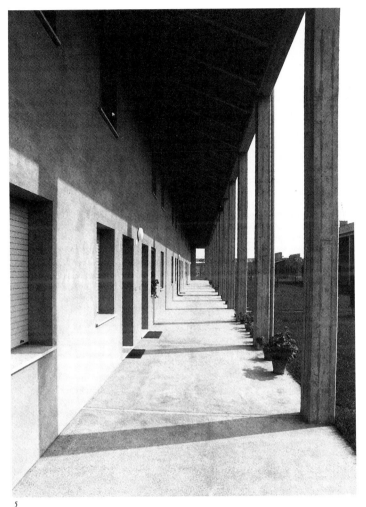

5

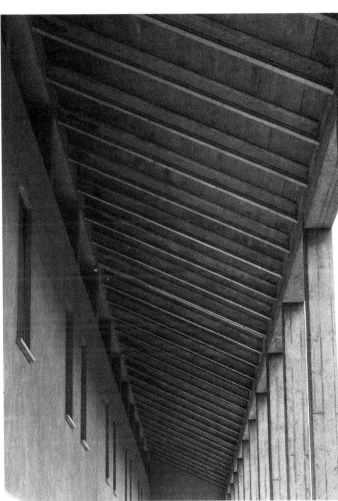

6

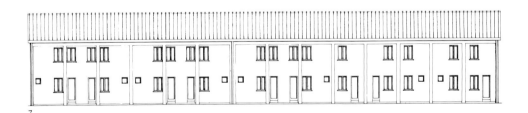

7

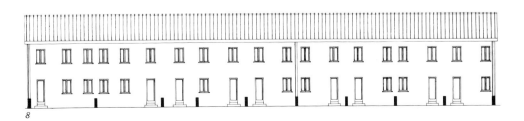

8

1

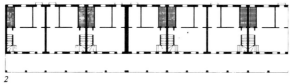

2

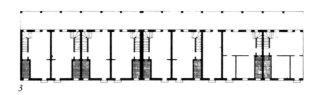

3

Civic Center Tower
Pesaro, Italy, 1979

The tower was designed as part of Carlo Aymonino's Pesaro Civic Center. The height and location of the tower are mathematically determined in relation to the series of buildings that constitute the Civic Center. The tower is comprised of three parts—in plan, each part is a square of diminishing dimensions. In the base, a stair rises in the area between the exterior wall and an interior ring of piers. The stairs lead to a terrace

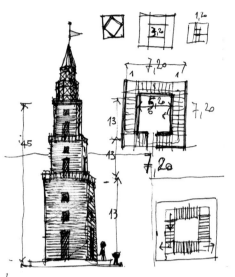

around the base of the middle section and to a second, exterior set of stairs. These exterior stairs lead to an observation deck, which is covered in part by the third section of the tower—a steel structure, which is square in section but sited at a 45 degree angle to the rest of the tower.

1. Study sketches 2. Plans, elevation, and section

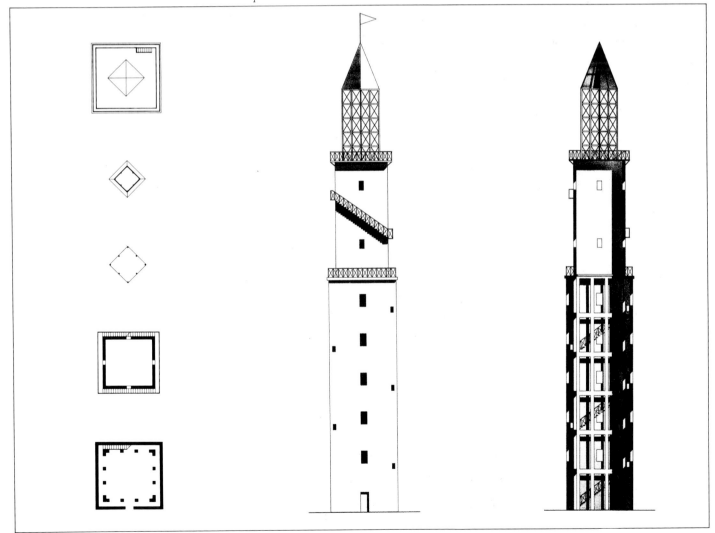

Teatro del Mondo
Venice Biennale
Venice, Italy, 1979

The floating theater was built under a joint commission from the theater and architecture sections of the 1980 Venice Biennale. It was seen as the progeny of sixteenth-century floating pavilions. These *teatri del mondo* were generally in the form of round canopies over ranges of columns, and belonged both to a family of floating "machines" and to the genre of ephemeral festival structures like towers, triumphal gateways, and fountains built for special civic occasions. The Teatro is related both to the tradition of the floating building and to the idea of a structure intended to temporarily alter the landscape of a city.

The Teatro was built of steel scaffolding welded to a barge. The skeletal frame defined a volume 9.5 meters square and 11 meters high, on top of which was an octagon 6 meters high that was capped with a pyramidal metal roof. A little steel flag and sphere rose above the roof as a finial. Two rectangular volumes that contained stairs flanked the body of the Teatro; they also gave access to terraces around the base of the octagon. The steel frame was sheathed on the exterior with wood, clear-sealed except for bands of sky blue paint at the tops of the rectangular and octagonal volumes and on the doors. Inside, the scaffolding was partially

sheathed in wood. The Teatro seated 250 in stepped seats and balconies around a central stage.

The Teatro was built at the Fusina shipyards and towed by sea to the Punta della Dogana, a spot, according to Rossi, that "seemed to me a place where architecture ended and the world of the imagination or even the irrational began." It was anchored there through the duration of the Biennale. Afterward it traveled by sea to the Dalmatian coast of Yugoslavia, calling at coastal towns like Dubrovnik that were originally Venetian colonies. It was later dismantled.

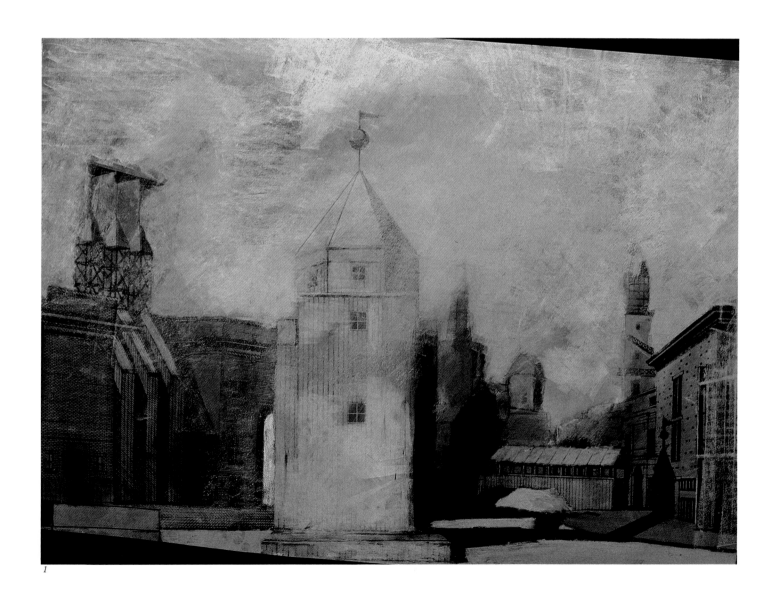

1

1. *Composition* 2. *"Study for the Teatro del Mondo, Biennale, Venice"* 3. *Shakespearean theaters* 4. *Jan Sadeler,* The Flood (*sixteenth century*) 5. *Giovanni Grevernbrach,* Floating Performance 6. *Athavasius Kircher,* Noah's Ark (*seventeenth century*)

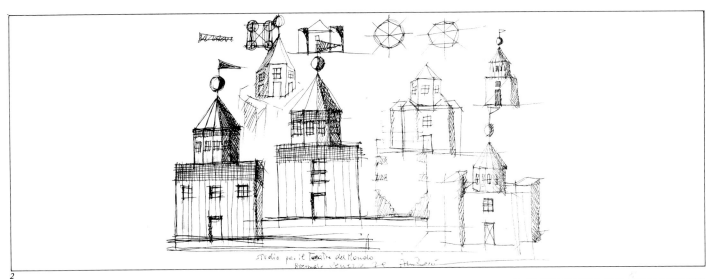

2

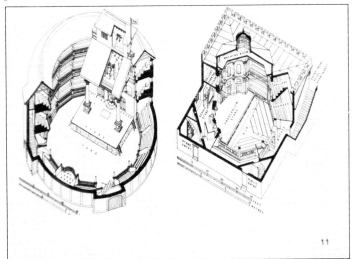

3

4

6

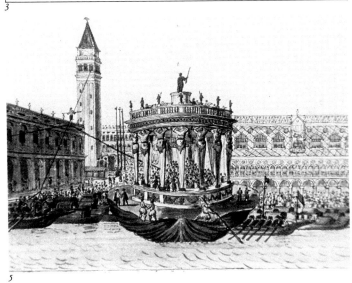

5

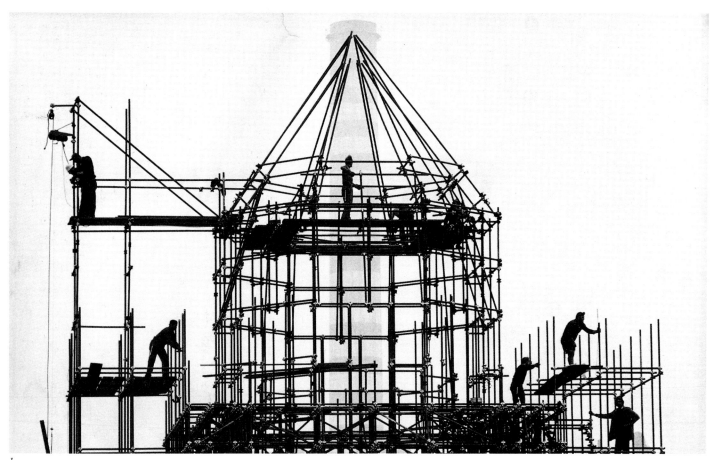

1

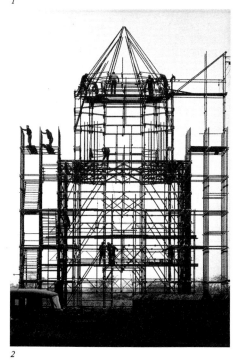

2

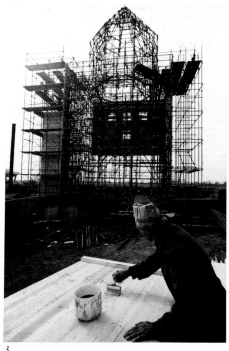

3

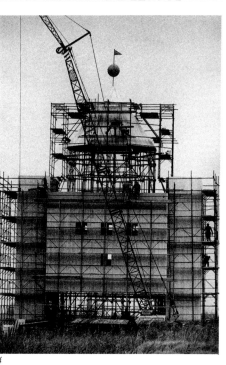

4

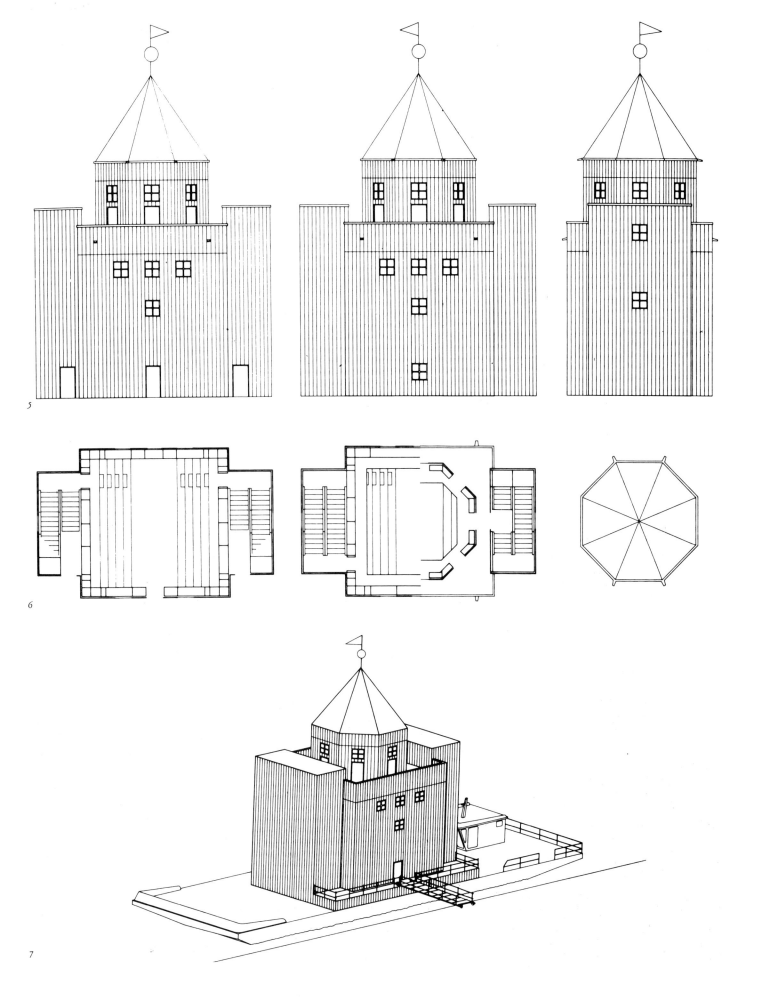

5

6

7

1. The Teatro against the factory 2. The Teatro's skeleton 3. Interior view during construction, looking up

2

3

1. The beginning of the trip to Venice
2. Rossi and Portoghesi 3. Boat towing the
Teatro 4. 5. The Teatro at Punta della
Dogana, Venice

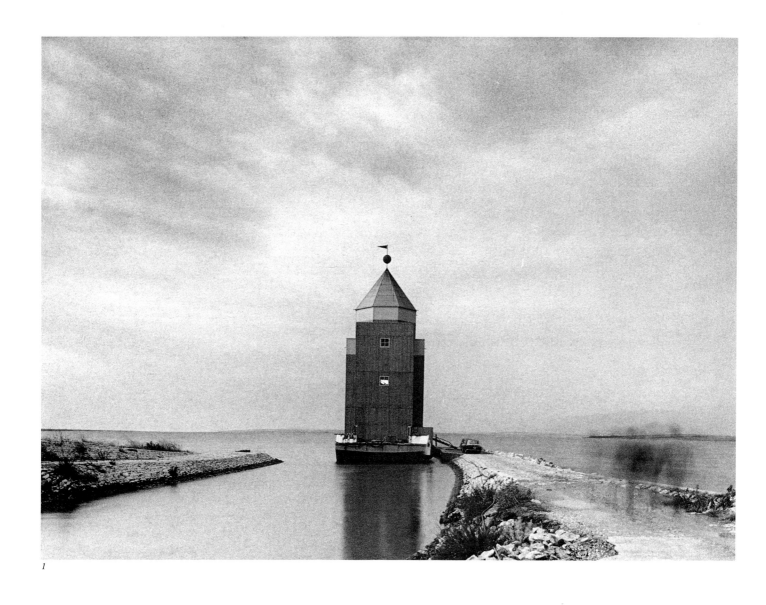

1

226

2

3

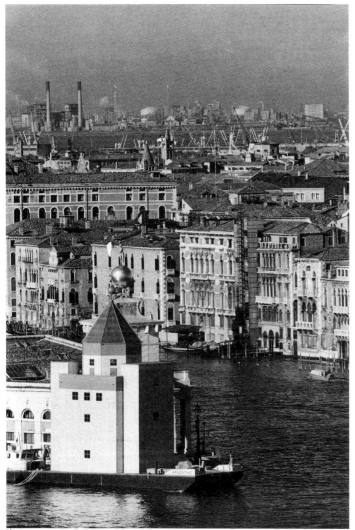

4

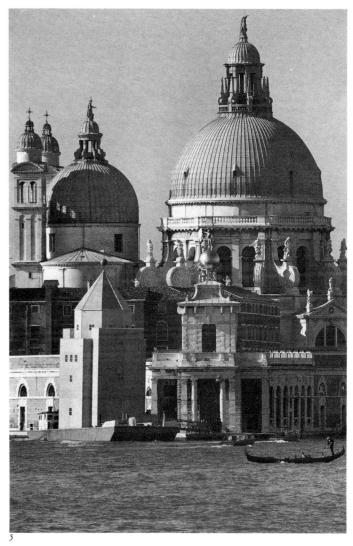

5

1. Dogana and Teatro 2. 3. 4. 5. 6. 7. The
Teatro in the Venice lagoon

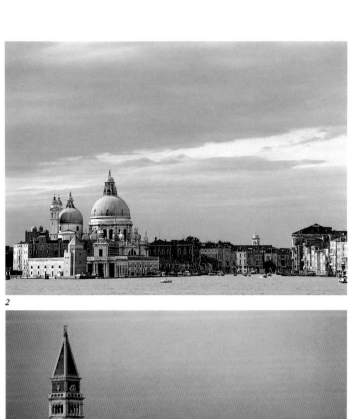

2

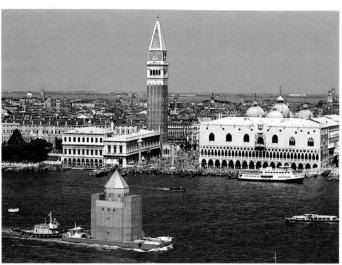

3

4

5

6

7

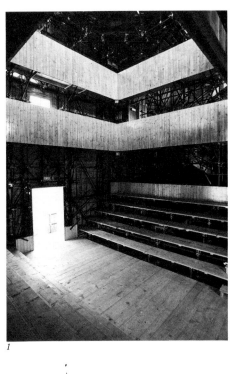

1

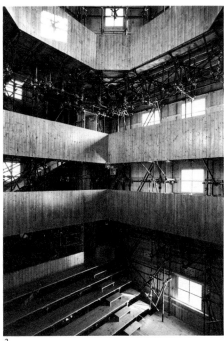

2

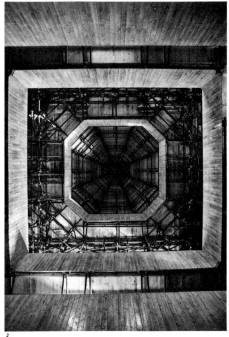

3

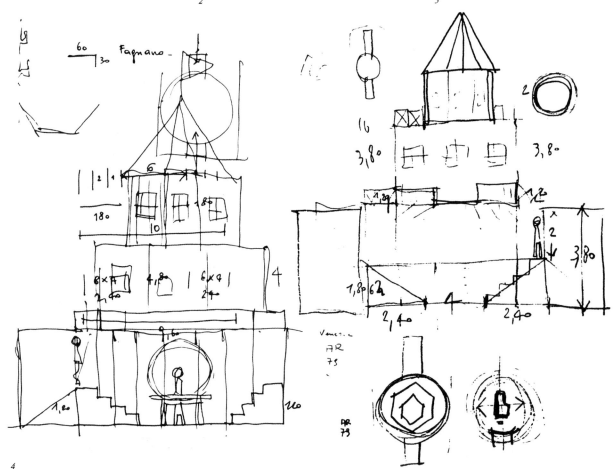

4

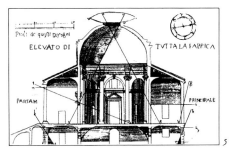

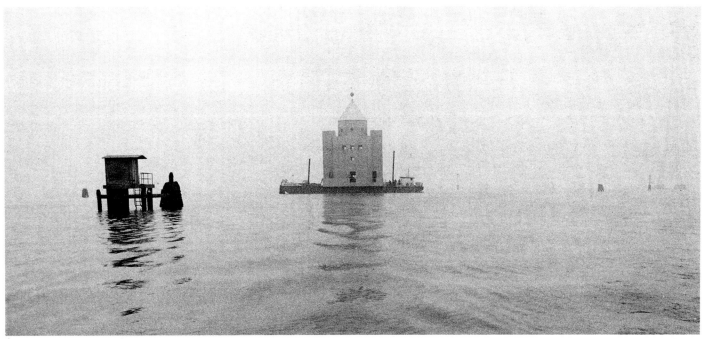

6

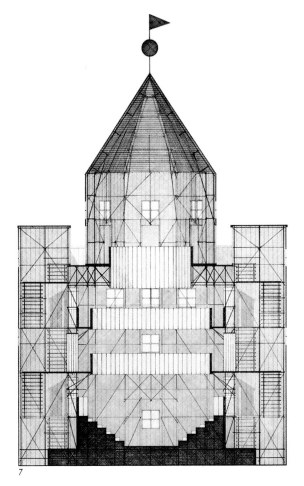

7

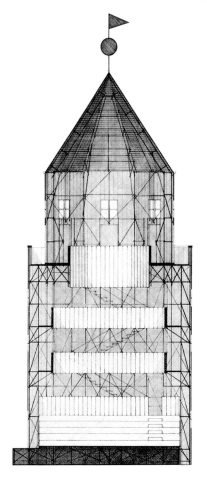

231

1

1. *The Teatro sailing toward Dubrovnik*
2. *Skyline with Dogana, Redentore, and Teatro*

2

1

2

234

1. From Venice . . . 2. . . . to Dubrovnik
3. 4. The travels of the Teatro

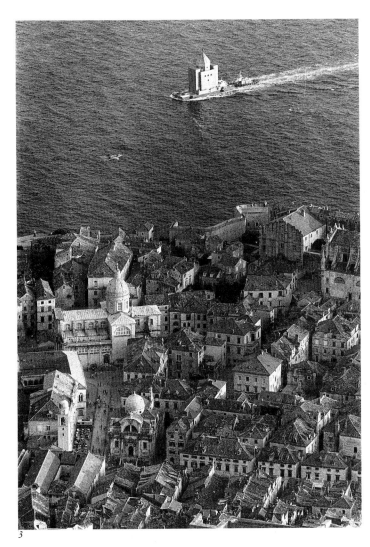

3

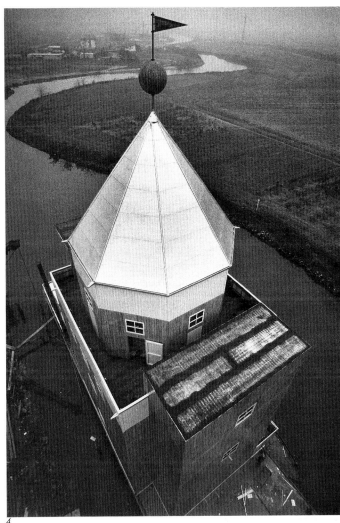

4

235

1. *Teatro reaching Dubrovnik* 2. *Side*
façade

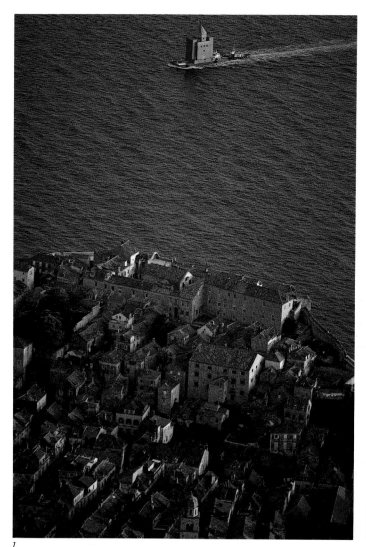

1

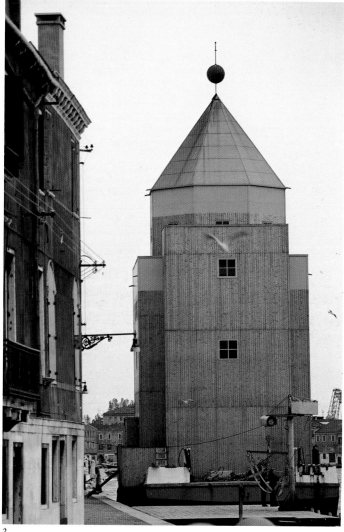

2

236

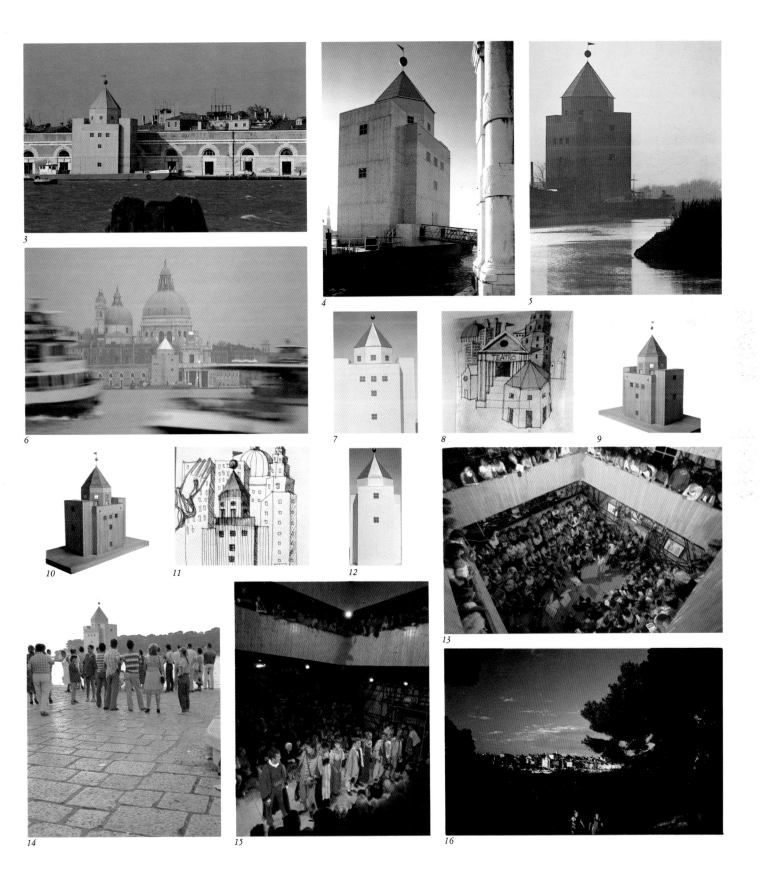

3

4

5

6

7

8

9

10

11

12

13

14

15

16

A Landmark for Melbourne
Competition Design
Melbourne, Australia, 1979
With G. Braghieri

The competition called for a construction whose sole function was to be a landmark in and a symbol of Melbourne. The site was over the tracks of a railroad yard. Rossi saw the competition as an opportunity for participating architects to explore their diverse interests; he himself enjoyed the competition as an imaginative exercise and as a chance to focus on the craft of drawing. As the city and the site were unkown to him, he concentrated on designing a pure synthesis of other towers

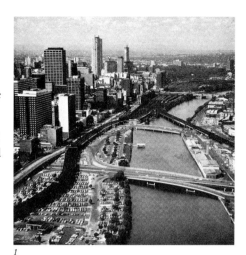

1

he and others had imagined and sketched. He developed the design with little consciousness of the actual architectural context in which the landmark was ostensibly to be sited; rather, according to Rossi, the landmark "is an almost anonymous object in which can be seen a constructive possibility."

1. Aerial view of Melbourne 2. Plans and front elevation 3. Axonometric projection 4. Study

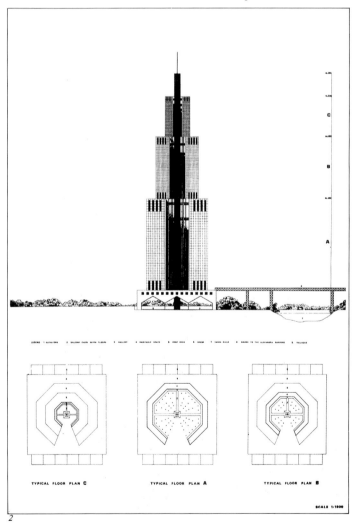

2

3

238

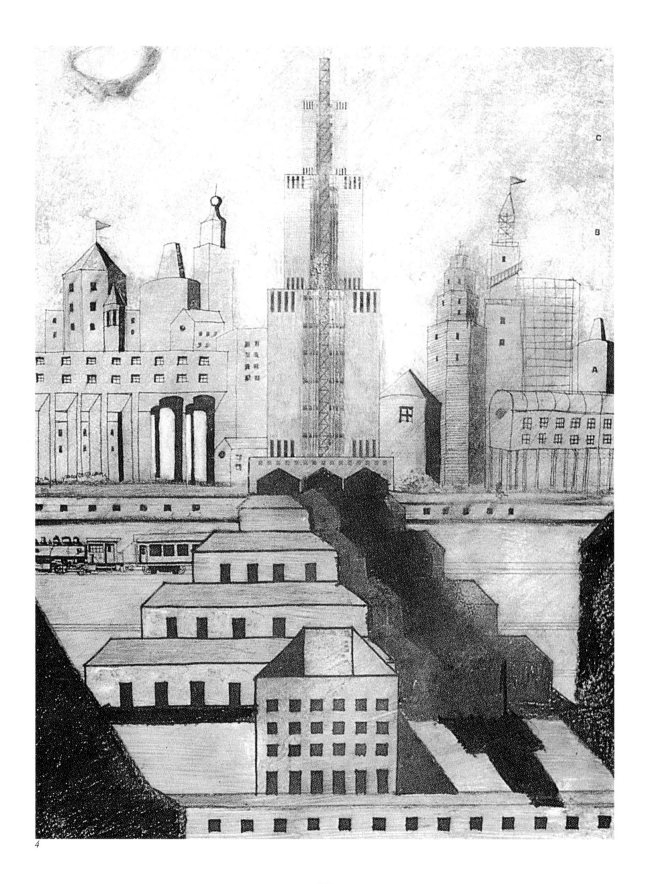

4

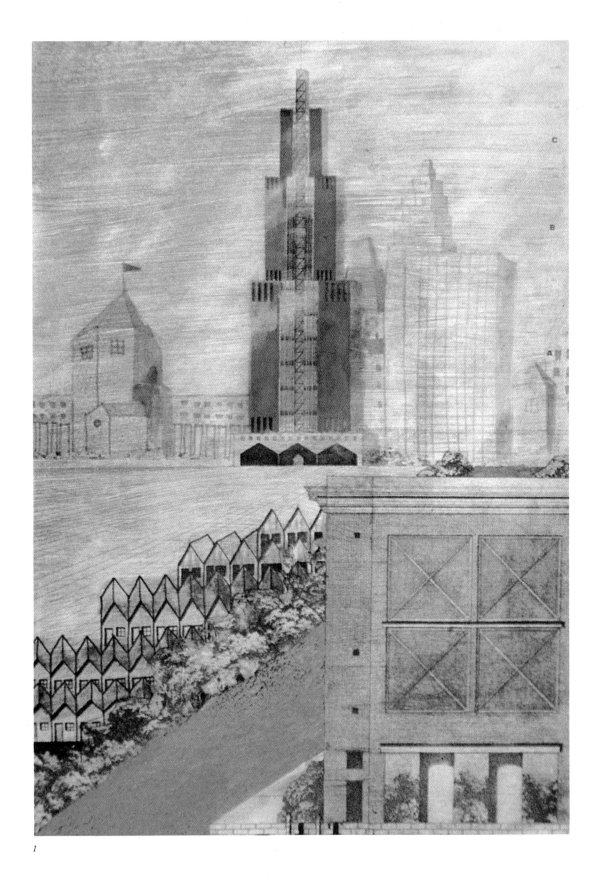

1

The architecture section of the Venice Biennale was held in the Corderie, a part of the Arsenale complex that is reached by a long, narrow street. The portal was erected at the entrance to the street from the canal, between the Arsenale wall and an adjacent building. Toward the canal, a series of windows and doors was cut through the depth of the two primary planes of the portal; the two planes were joined by shed roofs. Three pilasters were similarly joined to the tallest plane with shed roofs. Above the pilasters were three towers of steel scaffolding surmounted by pyramidal roofs and flags. All

1

roofs and flags were of reflective sheet metal. The main structure was of wood, clear-sealed except for a band of blue paint below the roofs. The design recalled old city gates and the tradition of temporary structures built for special events. The wood and scaffolding construction referred not only to such temporary structures, but also to Venice's historic relation to maritime life.

1. Study sections and elevations 2. Front façade on the canal 3. Back façade—detail 4. Back façade 5. Model—front view 6. 7. Model—side views

2

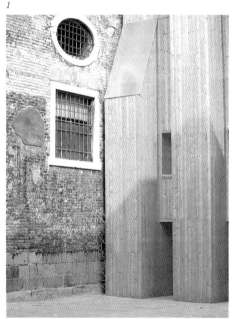

3

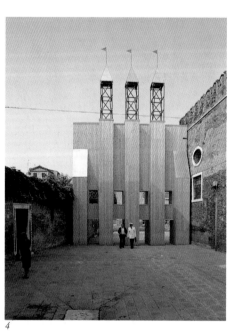

4

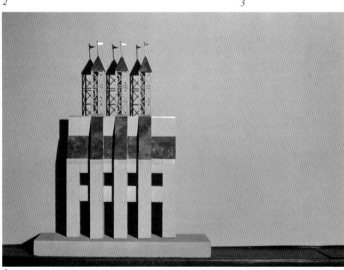

5

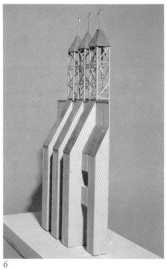

6

7

Cannaregio West
Project
Venice, Italy, 1980
With G. Dubbini, A. de Poli, M. Narpozzi

Projects proposing ideas about the form of Venice were solicited by European and American architects for an exposition. This project represents a meditation on the problem of access to Venice. It proposes that vehicular access to Venice from the mainland be prohibited. Instead a slaughterhouse would be rehabilitated and enlarged to serve as a ferry station. With incoming traffic limited to ferry passengers and pedestrians, area would be available for new buildings on the west part of the Cannaregio and for a new monumental building on the Grand Canal. A great large building would glorify the architecture of port warehouses.

Rossi said of the project, "When I was making a cornice for the plans for Cannaregio, I looked at the designs for the cornices of Palazzo Farnese, to copy them and to make them as alike as possible, because I think that architecture is something that carries continuity, something that relates to what preceded it." In keeping with this view, the drawings show in the background Palladio's unbuilt design for the Rialto Bridge. "I think the great danger, the great mistake brought on by the architects of the modern movement was to have introduced a moralistic tone of a sociological and religious kind into architecture as well as into the profession, and this tone continues today. That is, the very word *premodern* or *postmodern* is just another form of the moralism applied by the modern movement, a form of dishonesty, of distortion of the problem. Recently I was asked in an interview if architecture should improve or change man: architecture is architecture. I wrote that if two people love each other, they love each other in an ugly room just as they do in a room by Le Corbusier or Schinkel, and if they are unhappy they would be unhappy in any room with any architecture. I believe that there is a moment when, reading Montale or living in a Palladian villa, one may get a kind of bonus, but there are things that are quite outside architectural controversy."

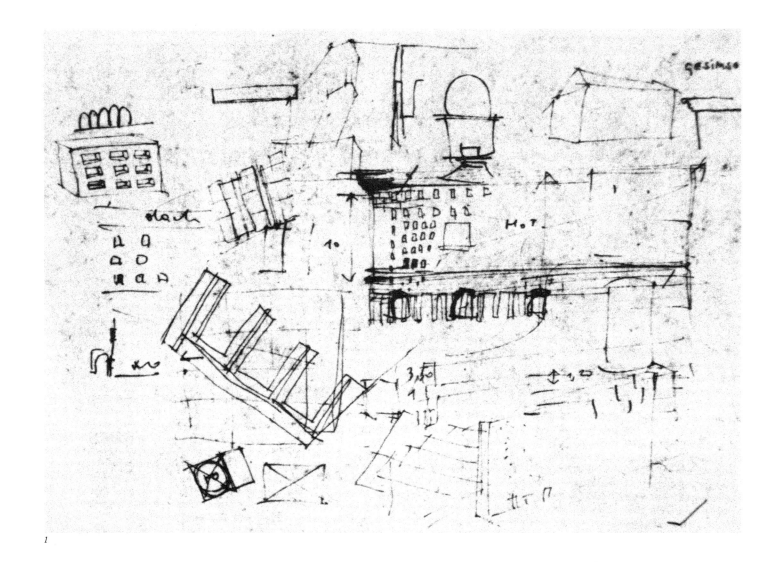

1

2

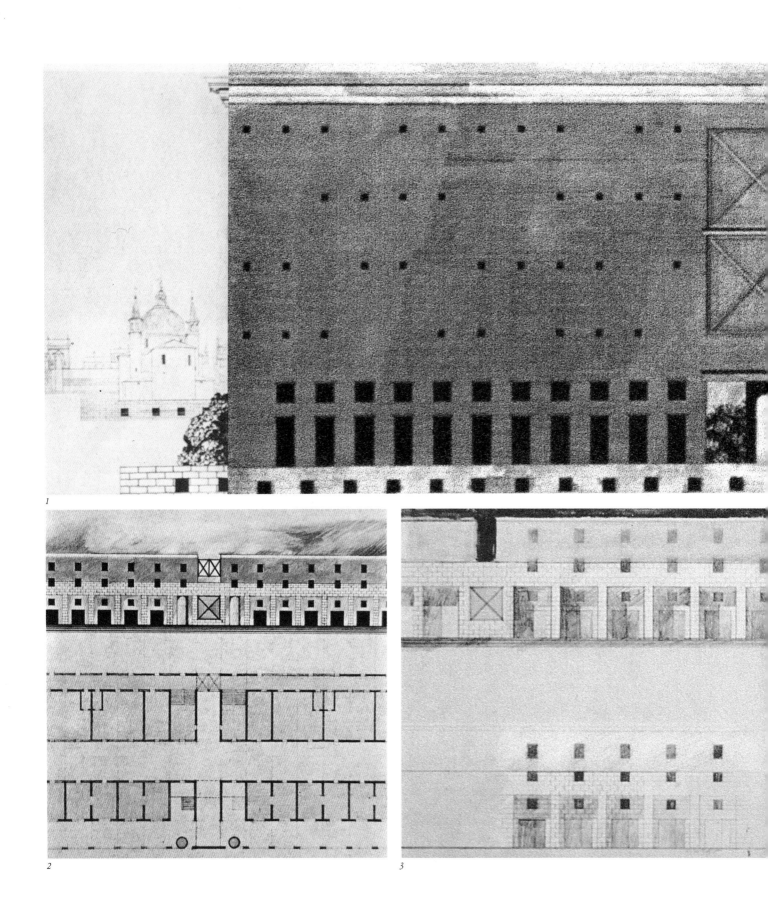

1. Hotel on Grand Canal—front elevation, with Venice in the background 2. Office building on the new station square—front elevation and details of typical and ground-floor plans 3. Office building—elevation studies and detail of ground-floor plan 4. Hotel—ground- and typical floor plan 5. Hotel—preliminary sketches

1

2

3

244

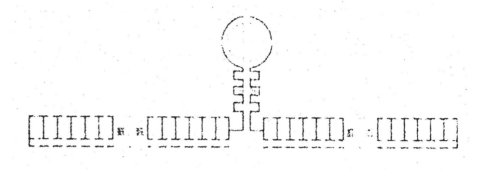
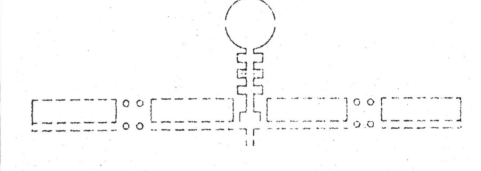

4

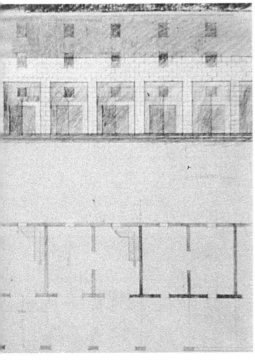

5

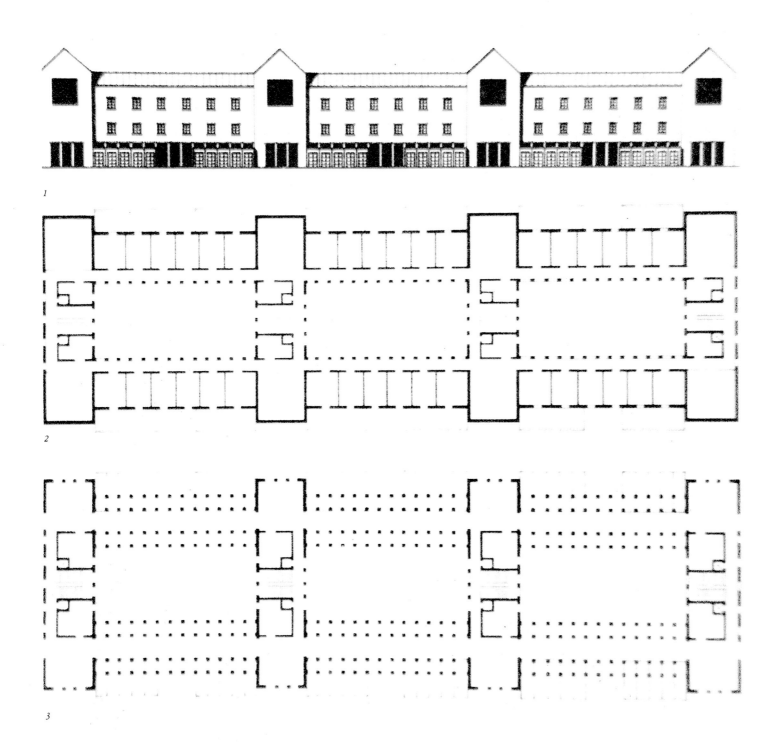

1

2

3

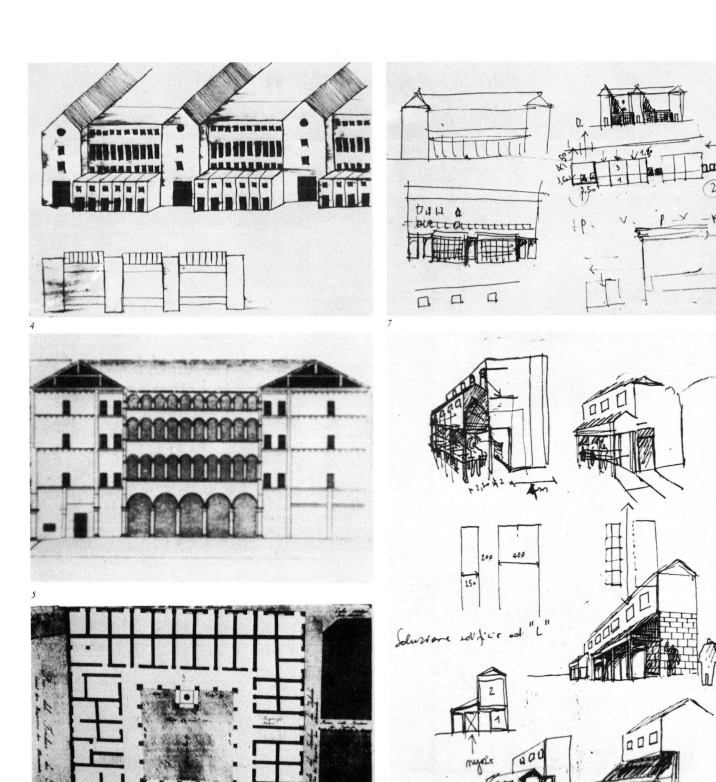

4

7

5

6

8

1

Alessi, an Italian manufacturer, commissioned eleven designers—mostly architects—to design tea services and coffeepots. As it happened, Rossi had been interested in the design properties of such objects since an early age. He explains, "I have always been very interested in objects, instruments, gadgets. Unintentionally, I often lingered for hours in the large kitchen at S., Lake Como, drawing the coffeepots, pans, and bottles. I especially loved the strange shapes of the coffeepots, enameled red, blue, and green. They were miniatures of the fantastic architectures I would encounter later. I still love to draw these large coffeepots, which to me are like brick walls, like structures that can be entered."

The service design also includes a cylindrical silver pitcher 8.5 centimeters in height, a

1. 2. Studies

1

2

22.5-centimeter-high cylindrical sugar bowl with a spherical quartz finial on its domed lid, and a plated spoon 17 centimeters in length. The bodies of both the teapot and the coffeepot are truncated cones above which is a cylindrical band enameled sky blue. The pots' conical lids are surmounted by spheres of quartz. The coffeepot is 26 centimeters high, the teapot 22.5. As part of the service, a storage unit was designed. Its base is black iron, its frame brass. Glass doors are opened with a quartz knob. The pitched roof is of copper. The pediment and flag are silver plate that is glazed sky blue; within the pediment is a battery-operated clock.

1. Prototype

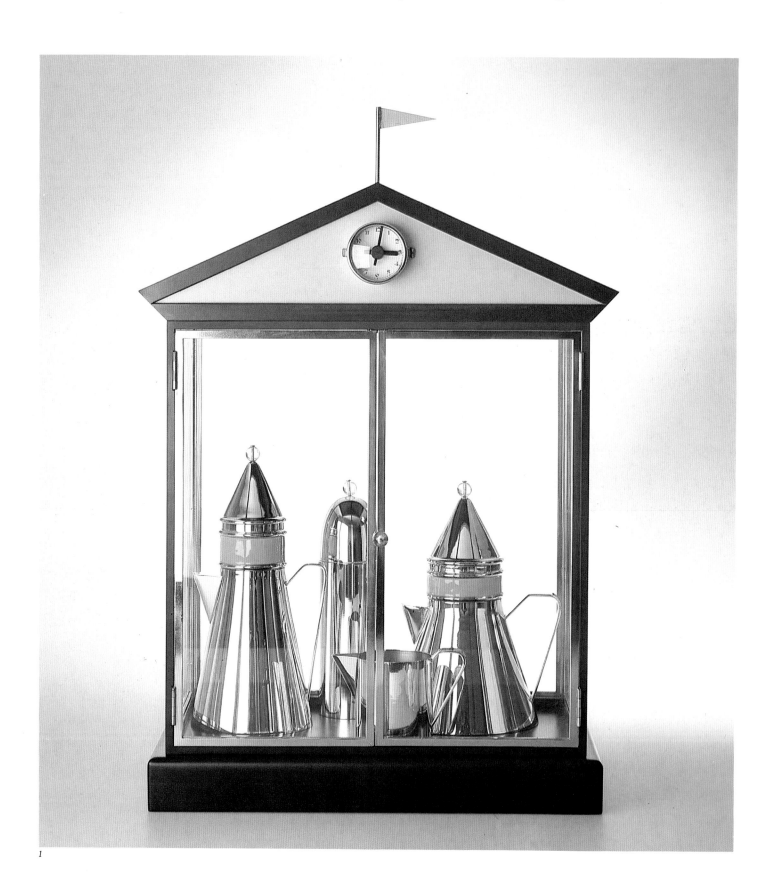

1

250

Zitelle Complex
Restoration and Addition
Venice, Italy, 1982

Located on the Giudecca Canal, the Zitelle complex was built as a home for indigent women (*zitelle* means "spinsters"). Following a design by Palladio, it was constructed in the late 1500s. The complex consists of a church and rooms arranged around a cloister. The church, the volume of which is embedded in the housing block, is marked on the front with a double Corinthian order crowned by a pediment and two small belfries; its dome and lantern are identical to that of the Redentore. The project is a study and proposal for converting the complex for use by a university. Dormitory space is increased by extending the two lateral wings of the existing cloister to form a new three-sided court with the rear wing of the old cloister. Partially closing the fourth side is an octagonal building. Rossi refers to the proposal as "The Venetian Frame."

1. Model—back view 2. Model—corner view 3. Model—front view 4. Palladio, Le Zitelle—main façade

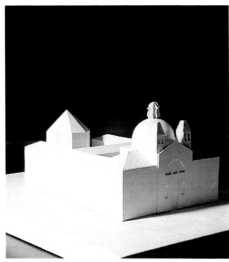

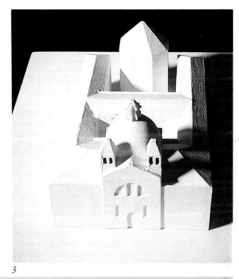

1

2

3

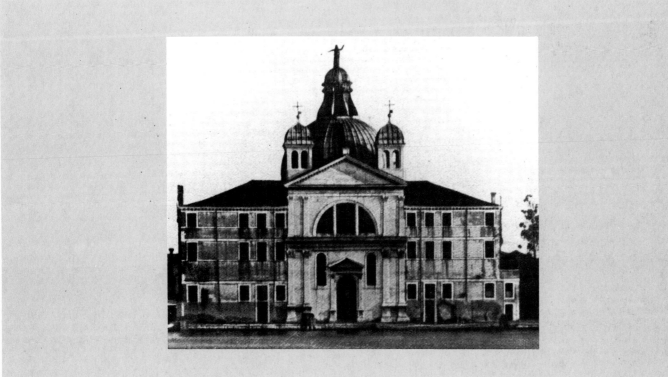

4

Südliche Friedrichstadt
Closed Competition Design
Berlin, West Germany, 1981
With G. Braghieri, C. Stead, J. Johnson

I.B.A. 84 is a concerted program to develop those areas of Berlin still unreconstructed from the ravages of World War II. Specific city areas were the subject of independent, closed competitions. The district studied in this entry, which won the competition, is the southern Friedrichstadt area. The principal proposal of the project is the reinstatement of the perimeter of the block—a lesson taken from the failures of modernist urban buildings. Existing buildings were incorporated into the street-front building line and left in place where practical in the area at the center of the block. The center is conceived of as a planted area. Openings along the perimeter provide views into this court, making it part of the public domain. Between some gaps in the perimeter, trees are planted within the zone along the street. Residential buildings have colonnades along the ground floor and are open to the court at the rear. The perimeter buildings are composed of a series of brick towers alternating with curtain-walled blocks, crowned by a sloped copper roof. Facing the block's interior, the perimeter buildings are marked with freely spaced trussed cages. The stairs and elevators within these cages lead to a *ballatoio* on each floor, screened by a sort of façade—detached from the main body of the building—envisaged in white plaster with a yellow tile cage. At the corner buildings along the Wilhelmstrasse, two giant columns are intended, like Filarete's Column in Venice, to serve as landmarks in the district and as a promise of the area's redevelopment. That redevelopment was only sketched for the adjacent blocks. The principle of perimeter buildings of a fairly regular height intermittently interrupted by visible greenery was considered a sufficient framework within which the designs of individually commissioned architects would create a varied but coherent district.

1. General plan 2. 3. 4. Study sketches
5. Ground-floor plan

1

2

3

4

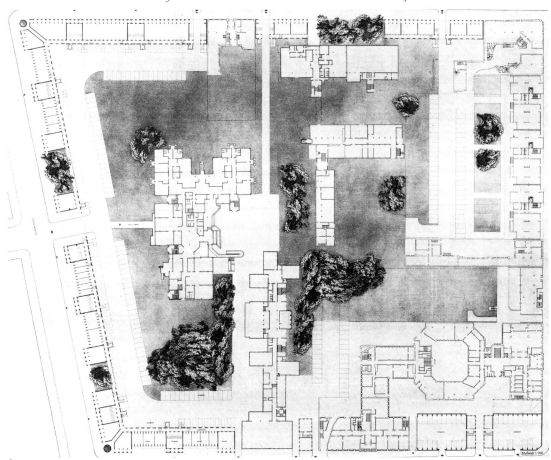

5

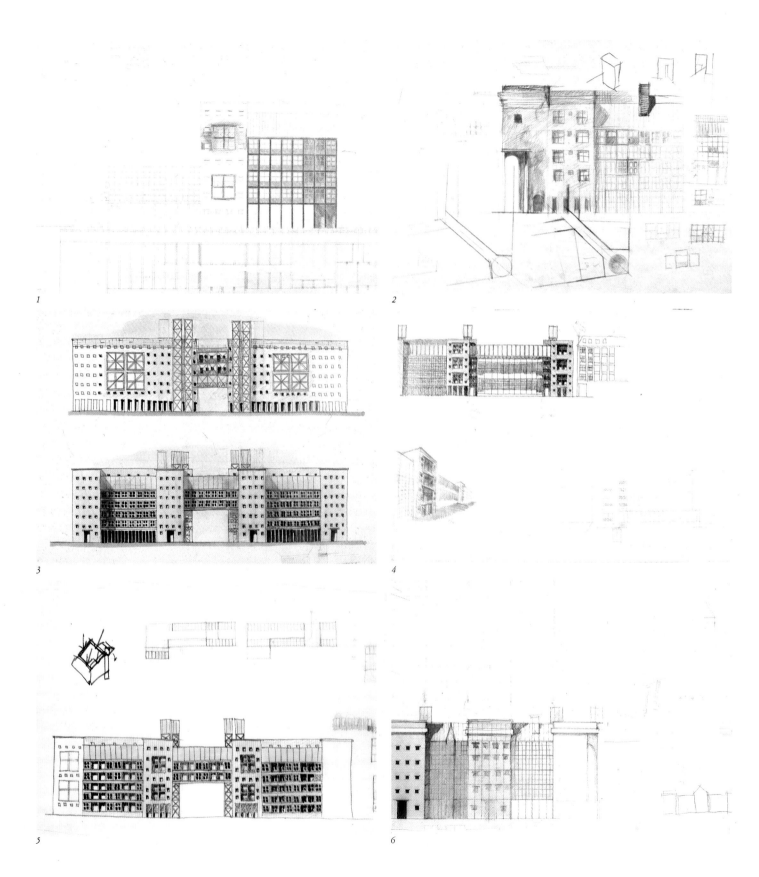

1

2

3

4

5

6

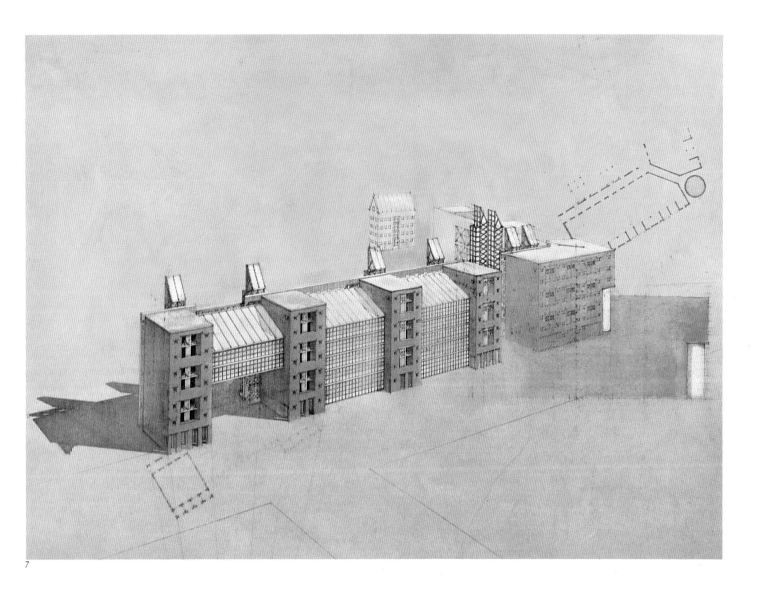

7

255

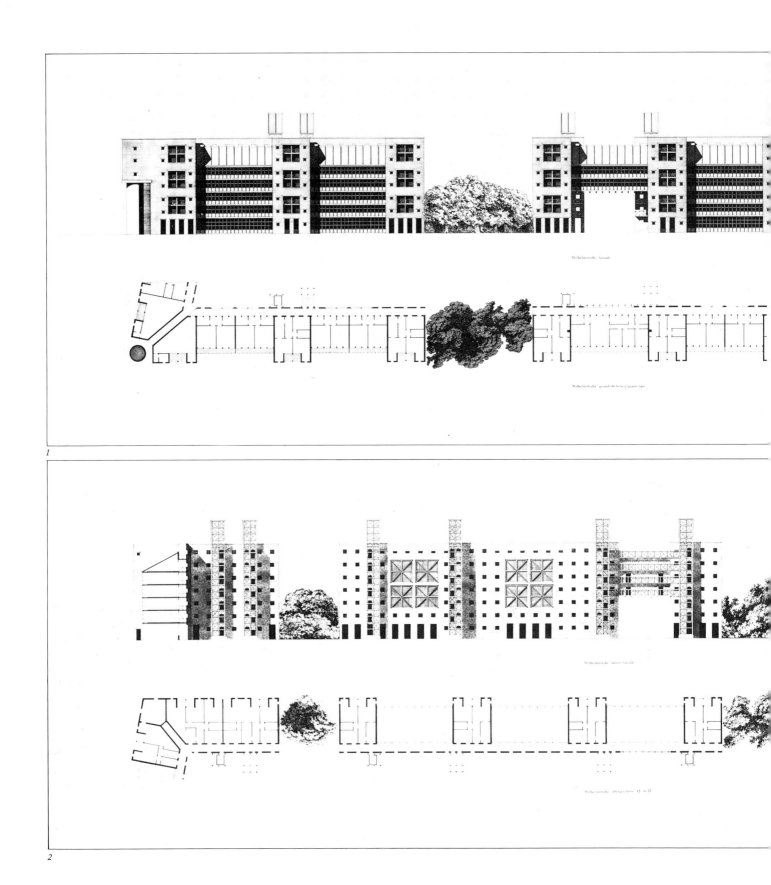

Wilhelmstraße Fassade

Wilhelmstraße grundriße beine/parter lage

Wilhelmstraße innere Fassade

Wilhelmstraße obergeschoss 13 m 29

1

2

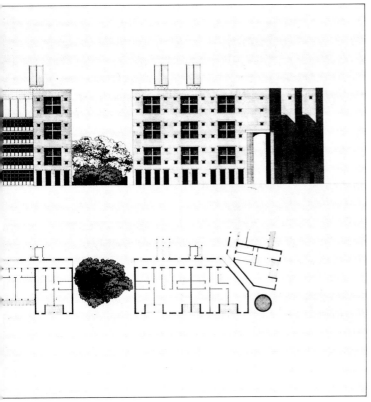

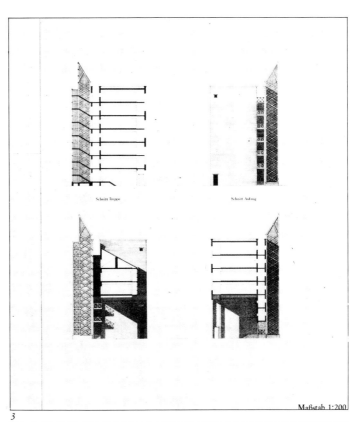

3

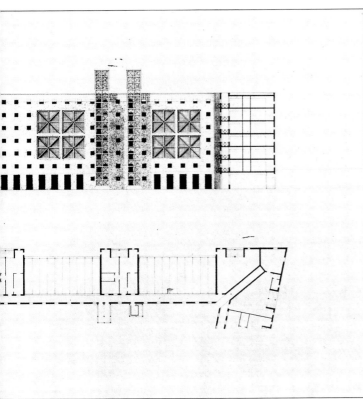

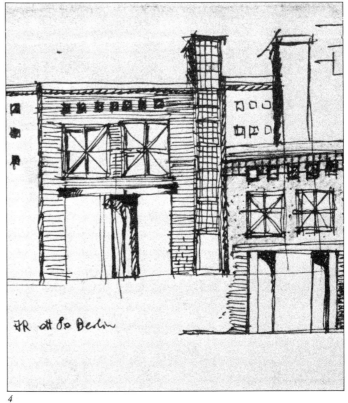

4

1. 2. *Study model—courtyard* 3. *Block
elevation on Kochstrasse* 4. *Block elevation
on Friedrichstrasse* 5. *Block elevation on
Puttkanerstrasse* 6. *Model—detail of*

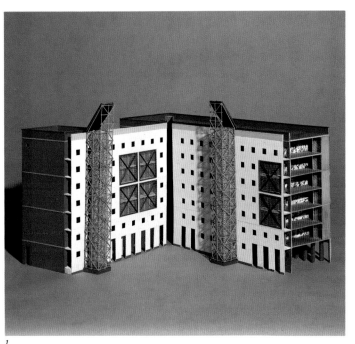
1

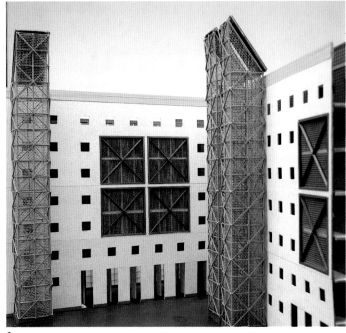
2

3

4

5

column at the corner 7. Filarete's Column
8. 9. Model—corner of Wilhelmstrasse at
Kochstrasse 10. 11. Studies for column at
corner

6 7

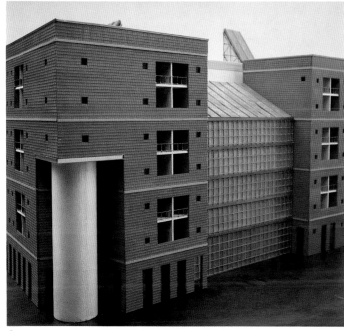

8

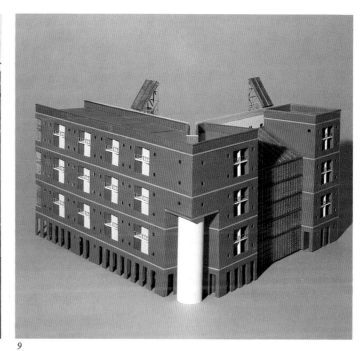

9

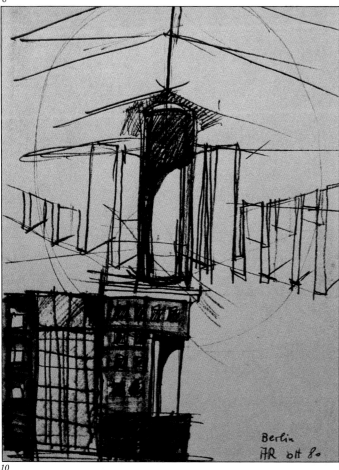

Berlin
AR ott 8.

10

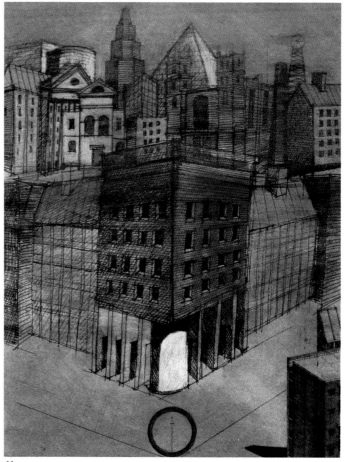

11

Funerary Chapel
Brianza, Italy, 1981
With C. Stead

The chapel and family tomb are formed by a high brick prism on a stone base. The base is almost entirely subterranean, forming a hypogeal hall that is lit by high windows and by an opening in its ceiling. The hall is reached by a side stair. The brick tower above contains a reconstrution of the Porta dei Borsari at Verona. The roof is formed by steel trusses; the tower is continued as a parapet to conceal the trusses on the exterior.

Rather than an exploration of romantic images of mourning, the project was seen as a design for a monument, in keeping with the historic continuity and identity of tombs and memorials in urban architecture. The exactitude of the classical orders was taken as a model of architecture as a collective enterprise, communicable by the precise codes of the discipline. The precision and rigor of the brick and steel structure is intended to extend the precision and rigor of the interior architecture.

1

2

3

1. Section and side and front elevation of the of the façade 3. Study for the orders
"contained" façade 2. "Study for a Museum" 4. Section

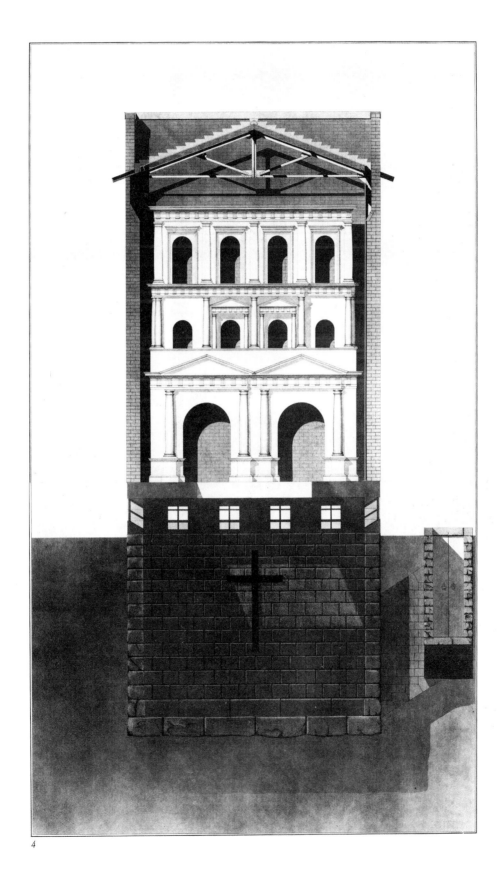

4

The striped cabanas recurrent in Rossi's drawings have been proposed as prefabricated, freestanding closets. According to Rossi, "The cabins, as little summer houses, recur in my drawings because I have always found in them a sort of summary or a reduction of architecture—I like the idea of their becoming an interior landscape. . . . One can also think that the closet, the cupboard, or the bookcase can suggest a discreet mystery in the interior life of the house."

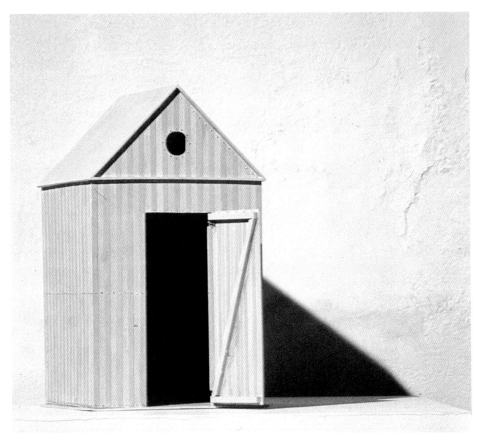

1

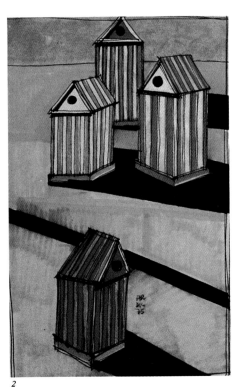

2

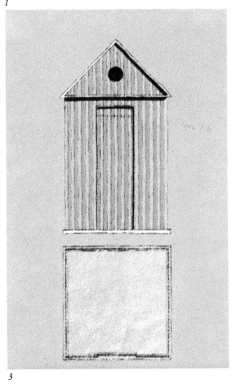

3

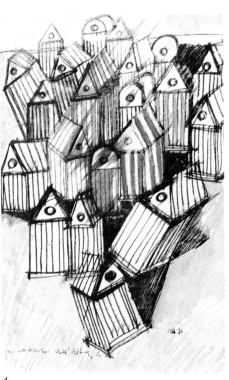

4

1. Model—front view 2. 3. 4. Studies
5. Prototype

5

Capitolo Sofa
1979
With L. Meda

The design of the sofa is based on a reflection upon the relationship between architectural forms and the forms of objects of everyday use. A system of cylindrical columns, "wall" planes, and lintels is used less for its tectonic properties than for the universality of that combination as a design convention and as a general device in the composition of forms. This system of posts and lintels, expressed in simplified form, forms the structure of the sofa. Over the structure a soft pad upholstered in brightly colored stripes comfortably accommodates the human form.

1. 2. Study sketches 3. Side elevation of fountain at Segrate 4. Study for axonometric 5. Front view of easy chair and couch (by L. Meda)

1

2

3

4

5

Klösterliareal
Competition Design
Bern, Switzerland, 1981
With G. Braghieri, C. Stead

This competition for Bern addressed a relatively commonplace situation—an ancient, densely settled historic area attracts a sufficient number of visitors so that parking becomes a problem. One typical solution—underground parking—was rejected as never sufficiently hidden and therefore destructive of the existing city it is intended to preserve. Instead, it was suggested that a single, large parking garage in the form of a steel cube be placed on an unbuilt area across the Aare River from the town center. The location serves the town—on the assumption that it is reasonable to make tourists walk into the city in order to preserve it from automobiles—as well as the adjacent Bärengraben, a sort of zoo in which bears (the symbol of Bern) are kept. The project report stresses the special attributes of Bern, such as its unusually close relationship between town and countryside and its pre-Roman history. On top of the cube is a piazza, imagined with paving overgrown like the stones of a cathedral; the solidity of the form itself is likewise seen as evocative of an ancient cathedral. Its steel sheathing is seen as representative of both modern industry and ancient armor. Rossi says its form, which both towers over the city and offers views of the countryside, "will, like the Solothurn

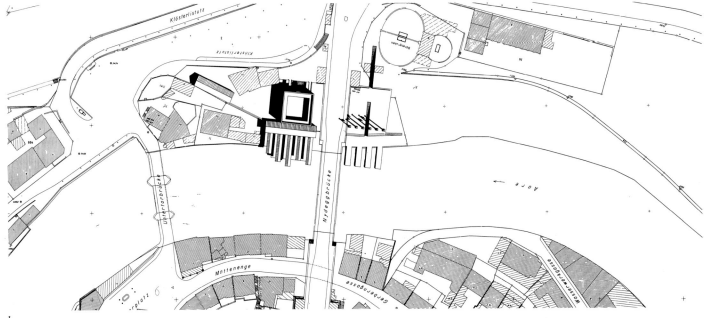

1

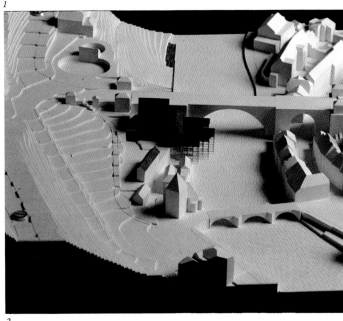

2

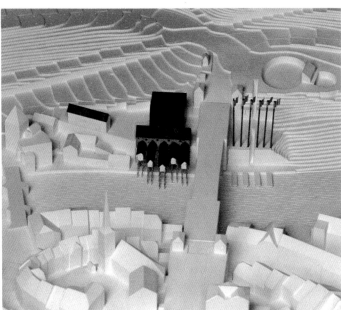

3

Towers, eventually appear to be a natural event." Across the street from the cube is a platform overlooking the river, on which stand a number of flagpoles; a stair "notched" in the ground leads to the Bärengraben. According to the project report, "Buildings, as modest as the huts of Alpine workmen or like the humble wooden shacks that used to spring up around cathedrals, encircle the cube. These buildings do not clearly belong to the city or the country, either; they're like the flags in the wind."

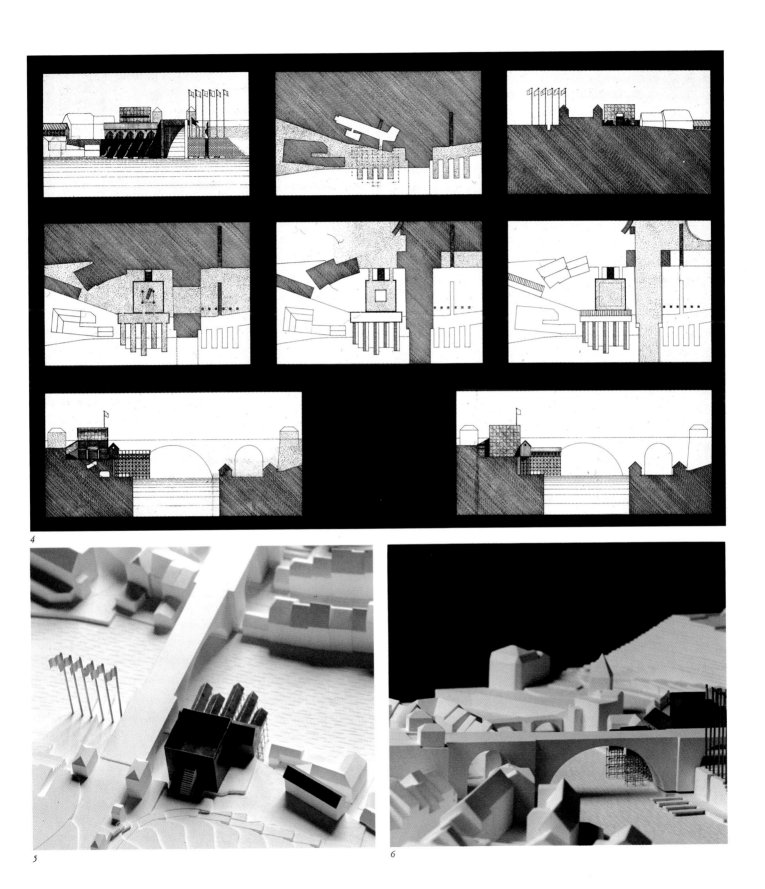

4

5

6

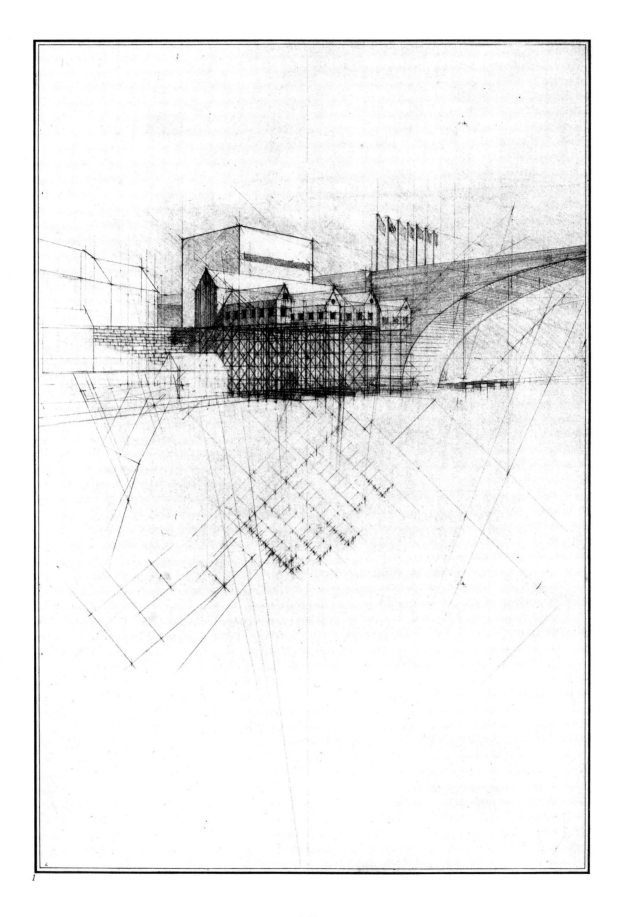

1

Kop van Zuid
Competition Design
Rotterdam, the Netherlands, 1982
With G. Braghieri, F. Reinhart

A competition soliciting master-planning proposals for sectors of Rotterdam was taken by Rossi as a forum for discussion, through design, of the role and efficacy of large-scale plans by architects for cities. The design for the Kop van Zuid (literally "Head of the South") area is intended to advance an argument against large-scale redevelopment

alternative organizations are both presumptuous and fruitless. The report instead draws attention to the structure and quality extant in the area; the design, with polemical consistency, supports and extends that structure.

Kop van Zuid is a harbor area with isolated neighborhoods between port facilities.

consistency, archetypicality, and endurance. There are no formal distortions of their patterns—only occasional small-scale park squares—making the areas seem like miniature Dutch cities.

The design proposed shows the area growing along existing patterns. The area is seen as a nodal center, like the Vieux Carré in New

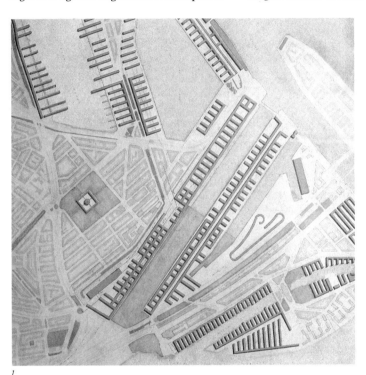

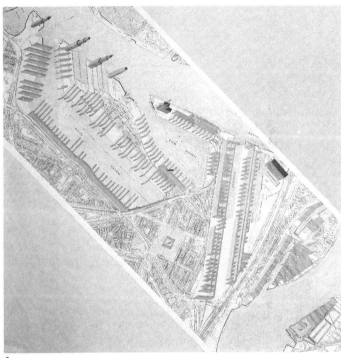

1

2

designs that ignore existing urban structures. The project report cites the aesthetic and social failure of the modernist ideal of the Ville Radieuse (notwithstanding its success with speculative developers as a model for inexpensive buildings); the hope of social and urban transformation through grand, formal plans now seems to have been a fruitless demagoguery destructive of the physical forms developed by specific cultures over years in specific environments. The conclusion drawn is that developed urban structures should be followed and that proposals for

Development has followed the lines of the docks: streets, railroad lines and trestles, shipping company buildings, warehouses, and other industrial buildings respect their geometries. Some of the buildings aspire to architecture; others repeat formulas for inexpensive industrial buildings. The composite has a certain urban beauty, with the cranes and docks as the civic monuments. The buildings of the residential neighborhoods conform to regional traditions—repetitive rows of sturdy buildings, unique and admirable for their

Orleans, which patterns the growth of surrounding areas. The buildings are suggested as reference points—like New York's Empire State Building—that reinforce the structure of a city. The summary of the design and report states: "If, absurdly, the Kop van Zuid should be transformed on the basis of functional or economic criteria, or even as a realization of an architect's design—be it ugly or beautiful—it would lose its irreplacable character."

1. General plan 2. General axonometric

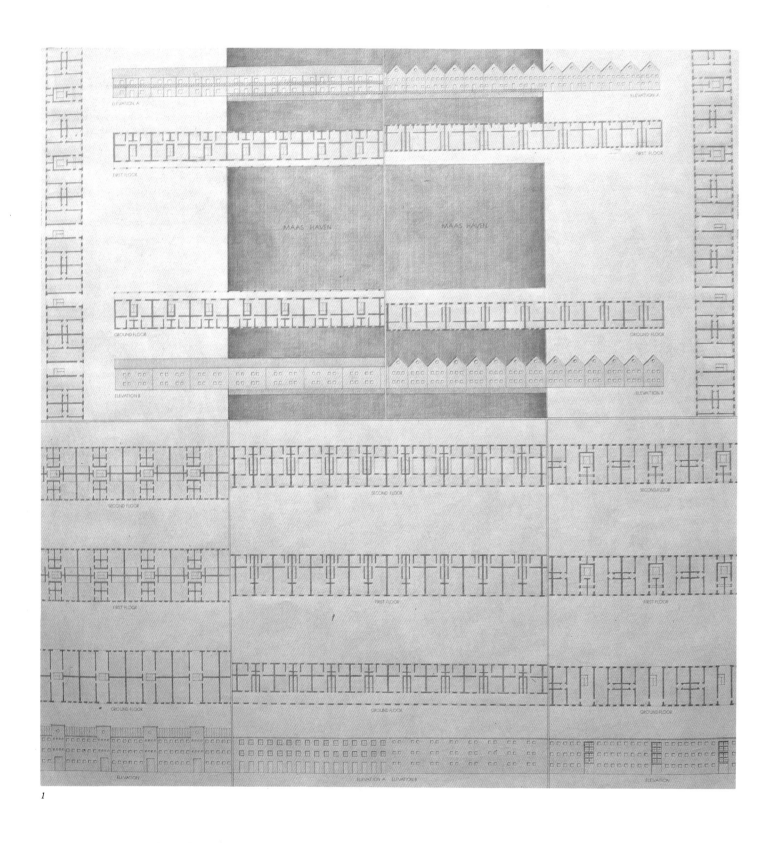

1

Santini and Dominici Exhibition
Bologna Shoe Fair, Italy, 1982
Santini and Dominici Shop
Latina, Italy, 1982
With G. Braghieri

For a temporary exhibition within a larger interior space, the square exhibition area was surrounded by a partition on which were outlined a series of cabana façades. The cabanas were suggested by molding describing the peaks of gabled roofs, painted stripes demarcating the cabanas' façades, and a series of suggested doors and windows. (Originally the lunettes were to provide glimpses of the merchandise from outside the display area; however, the necessity of safeguarding design secrets from competitors dictated that they be closed.) The square exhibition area was divided by two gray slablike walls that created entrances. In both halves of the exhibition area stood raised, stagelike platforms on which shows were held.

The shoe shop in Latina, for the same company, was built in a long, narrow, and high space. In the design, the space is turned into a streetlike arcade. Its architectural elements—piers defining a galleria, a façade with windows, a bridge-*ballatoio,* street lights, and porphyry block paving (black marble was substituted in the executed design)—create a sort of interior urban landscape. The second floor, built within the volume of the shop, houses storage and display of shoe boxes in a series of square shelving cases. Access is along the *ballatoio,* which, like the stair leading to it, is made of steel grating over steel framing.

*1. Exterior view of the pavilion at the shoe fair (shoeroom) 2. Interior view of the store's upper-level deck and bridge
3. Ground-floor plan of the store 4. First-floor plan of the store*

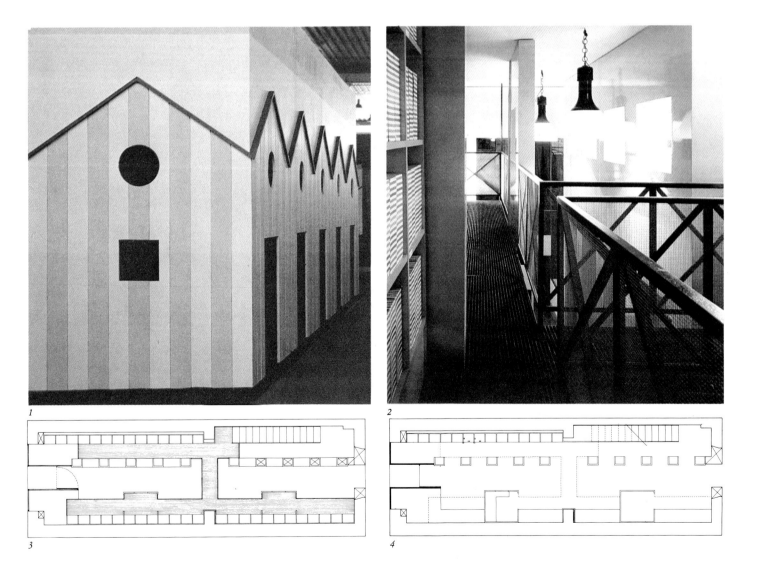

1

2

3

4

1. Plan, pavilion 2. 3. Elevations, pavilion
4. Axonometric of pavilion

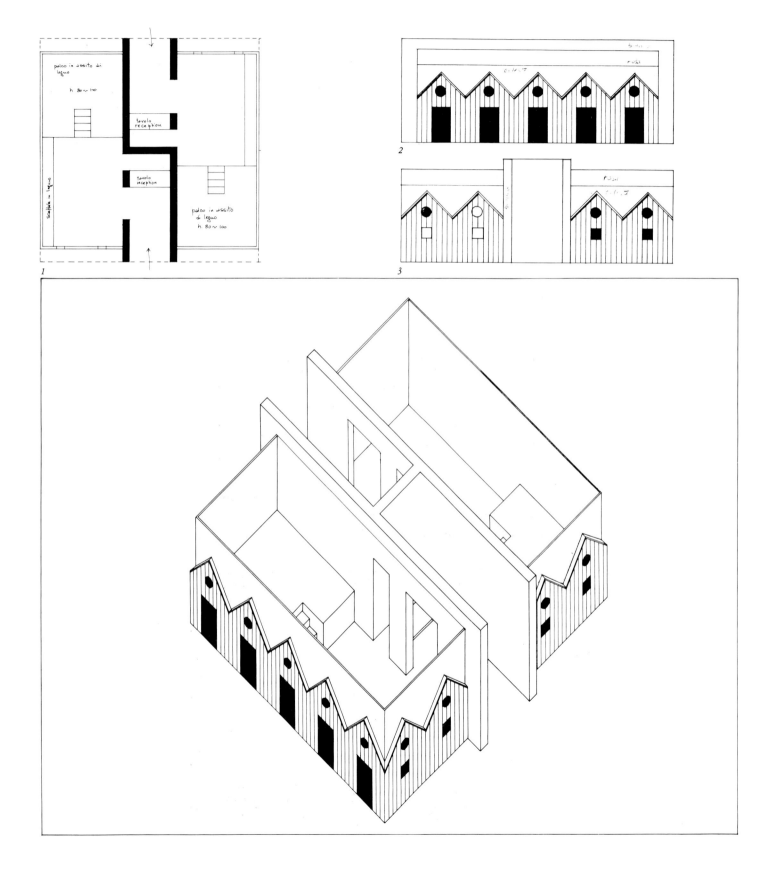

Interior with Theater
Alcantara Exhibition
Milan, Italy, 1982
With G. Braghieri

Alcantara, a textile manufacturer, commissioned six architects to create designs using its new synthetic fabric. The "theater" uses the material as upholstery, as theatrical backdrop, and as a ceiling cover. The project consists of a volume, apparently broken open, in an area where two large cylindrical columns flank the stage; it is this area that is also the primary exhibition route through the construction. To one side of the route stand two raised levels on which sit black lacquered chairs (designed by Rossi and Luca Meda) upholstered in red Alcantara fabric. These two levels are also accessible by pairs of doors in the sides of the structure. Interior blue surfaces are wood-clad; the ceiling is covered in blue Alcantara fabric. On the stage, against a backdrop (also of the blue fabric), is a model of the shrine at Modena Cemetery.

1. Interior perspective and plan

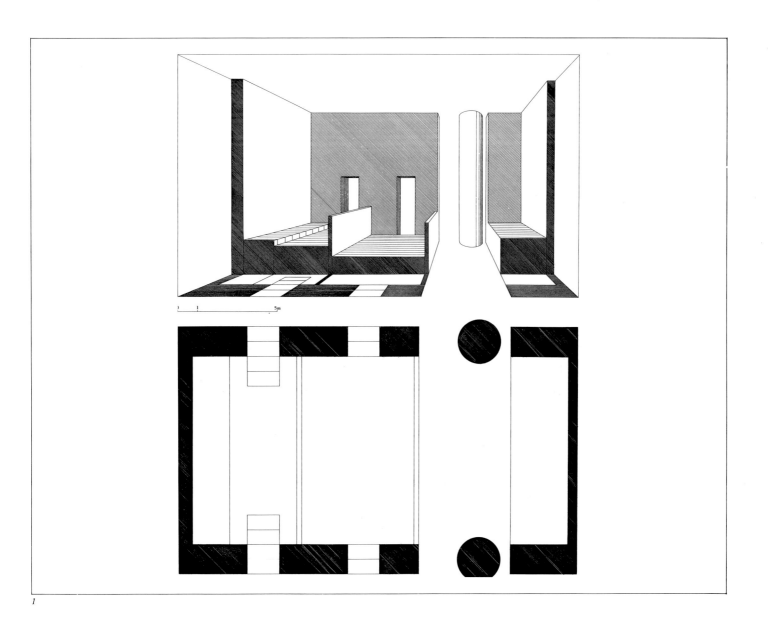

1

273

1

2

3

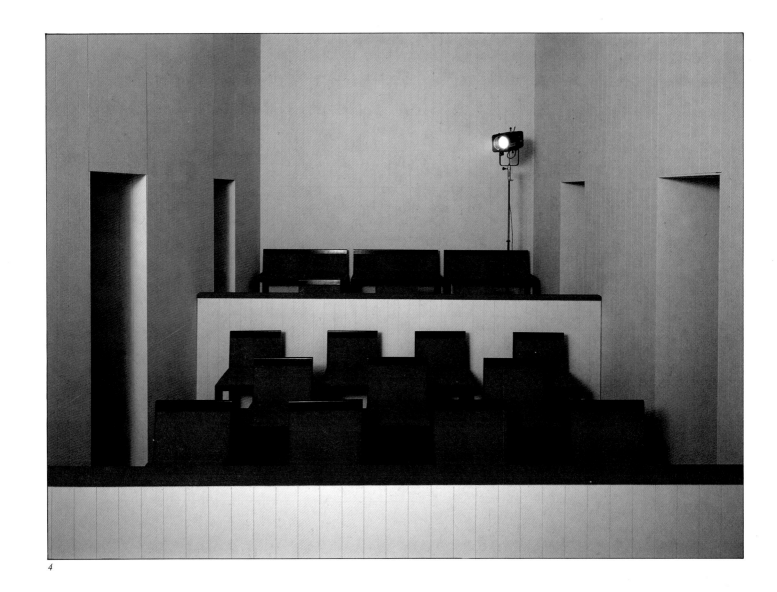

4

1. *Section looking toward seats* 2. *Section through entrance doors to back seats* 3. *Section looking toward stage* 4. *Interior view looking toward seats* 5. *Side elevation* 6. *Section through stage and seats* 7. *Interior view looking toward stage*

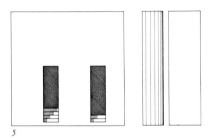

5

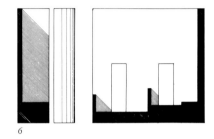

6

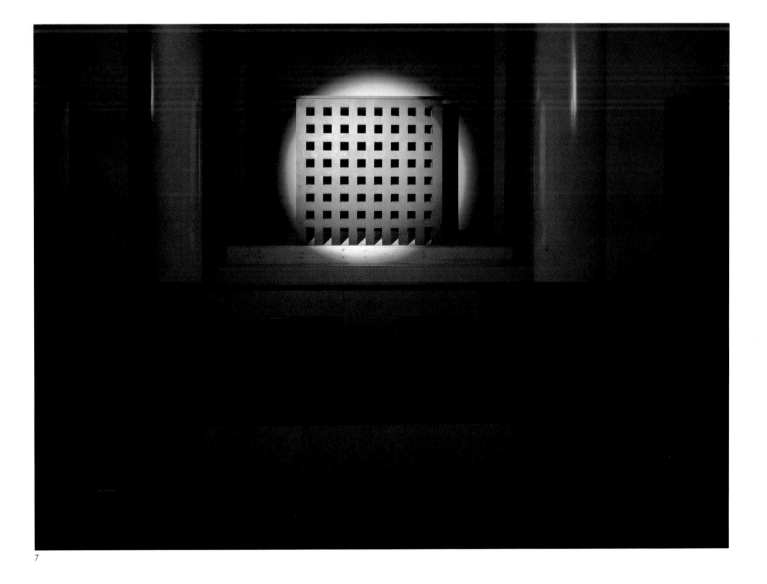

7

1

"Idea and Knowledge" was the subject of a double exhibit at the XVI Triennale in Milan. The design of the Idea section was generated by two images: that of Raphael's *School of Athens* and that of a corridor with many doors. The largest room was made at the center of the exhibition hall; in it, on a wall behind a large model of Palladio's Villa Emo, a full-scale reproduction of Raphael's cartoon for the painting was hung. In the cartoon, surrounding the figures of Plato and Aristotle and the allegorical figures of Art and Science determining Architecture, stand the figures of many philosophers. Analogically, in the exhibition, numerous doors along a 50-meter-long wall opened onto exhibits of the work—on the theme of the representation of ideas—of individual architects. As at the exterior construction at the XIII Triennale, the doorways opened onto rooms of varying dimensions. Some of the doors gave access directly to rooms; others opened onto a funneling, secondary corridor that in turn opened onto exhibit areas. Corridor walls were sponge-finished with a sky blue paint.

1. "Enclosed Space, Interior" 2. Preliminary sketches

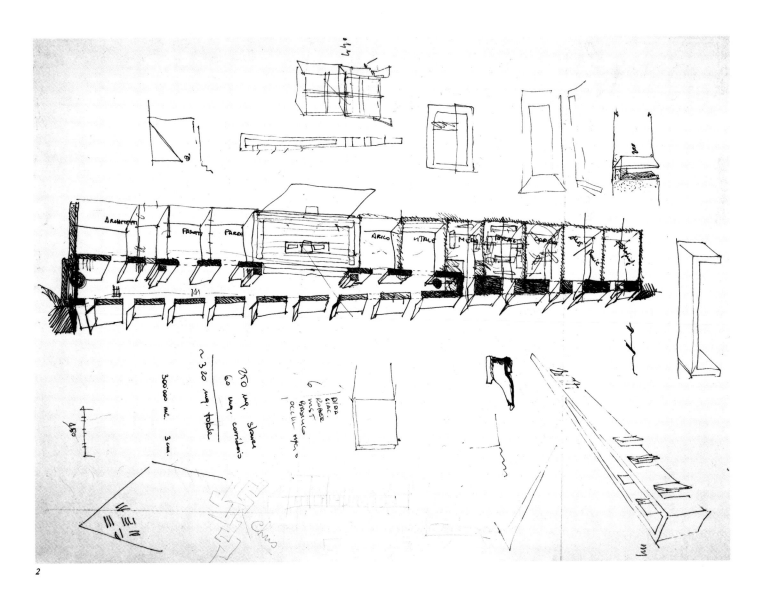

2

1

2

3

278

1. *At one end of the corridor*, Substance of Architecture, *by Giovanni Sacchi—geometric elements, wooden model* 2. *Monument to* the Resistance at Cuneo, *sectioned wooden model by Giovanni Sacchi* 3. *Perspective of* corridor on which the rooms open 4. *"Architecture/Idea"* 5. *Axonometric*

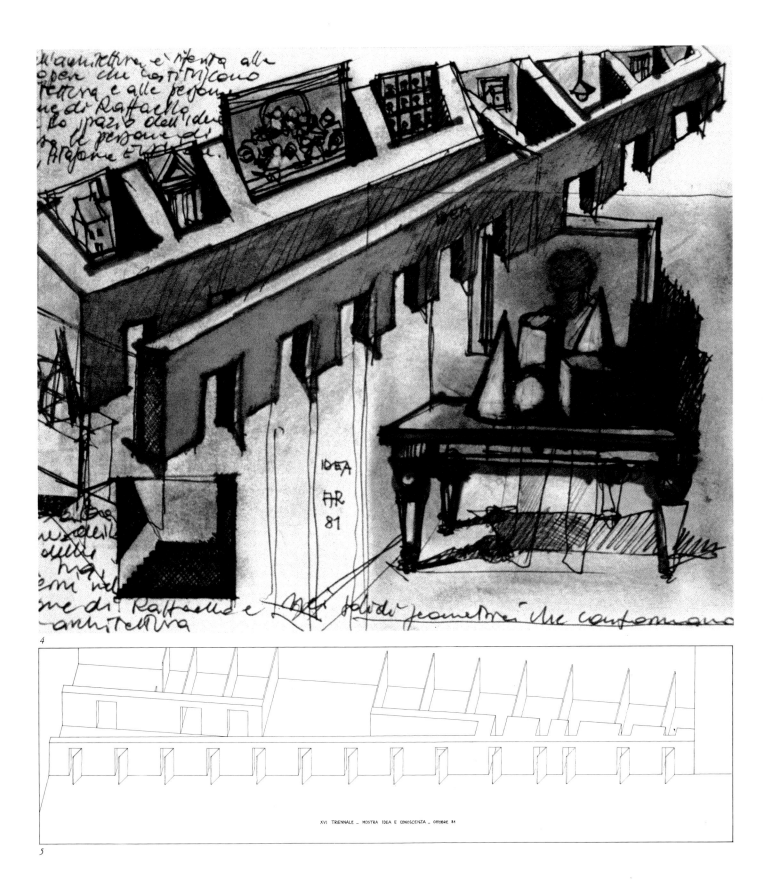

4

5

Villa in the Roman Countryside
1981
With C. Stead

The villa as designed is square in plan, with an atrium of vertical proportions at its center. Following classical tradition, the main floor is one level above grade, atop a podium that, in this case, contains the garage. Access to the *piano nobile* is gained by a large, double flight of stairs; a smaller exterior stair is located at one side. On the *piano nobile* the floor of the atrium is several steps below that of the surrounding rooms, giving it a subtly theatrical quality. Four large piers at each

1

corner of the atrium are, like the walls they support, faced in stone, suggesting an open-air atrium. Windows cut in the upper atrium walls provide views from the top floor's hall, which surrounds the atrium. Above it are two glass and steel skylights, each defining a differently proportioned gable—a superimposition suggesting that of different pediments on the façades of some Palladian churches.

2

3

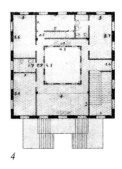

4

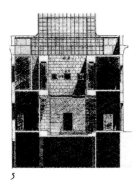

5

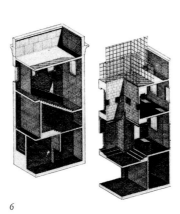

6

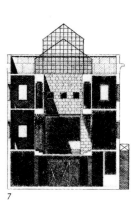

7

1. "The House of Life" 2. Basement-level plan (garage) 3. Ground-floor plan 4. Bedroom-floor plan 5. Section through interior covered courtyard 6. Sectioned axonometrics showing corners of house 7. Section through interior covered courtyard 8. Axonometric with corner cut away 9. Side elevation 10. Front elevation 11. Side elevation 12. Back elevation

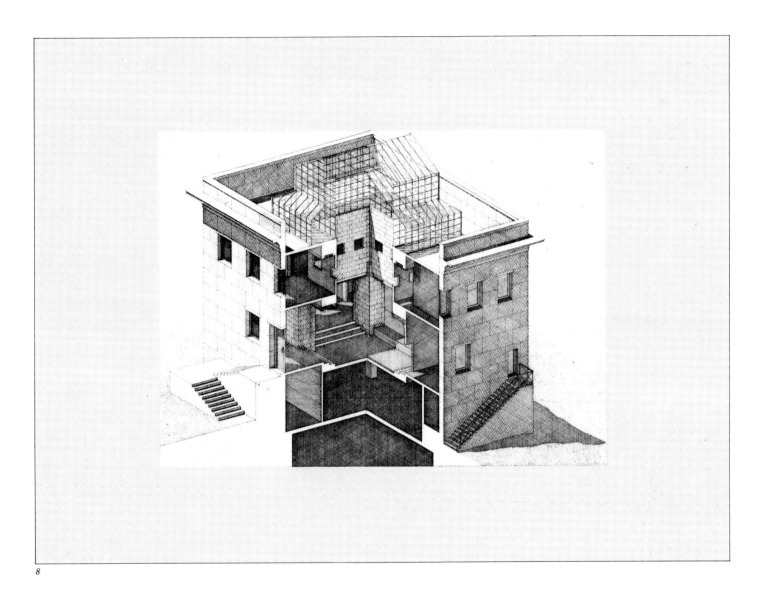

8

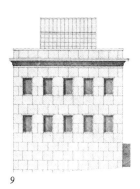

9

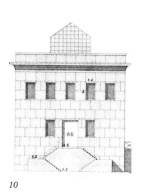

10

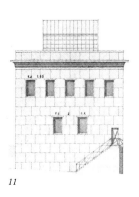

11

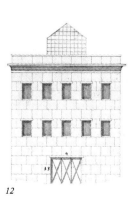

12

Apartment House
Viadana, Italy, 1982
With G. Braghieri, A. Gozzi, A. Medici, C.
Castagnoli

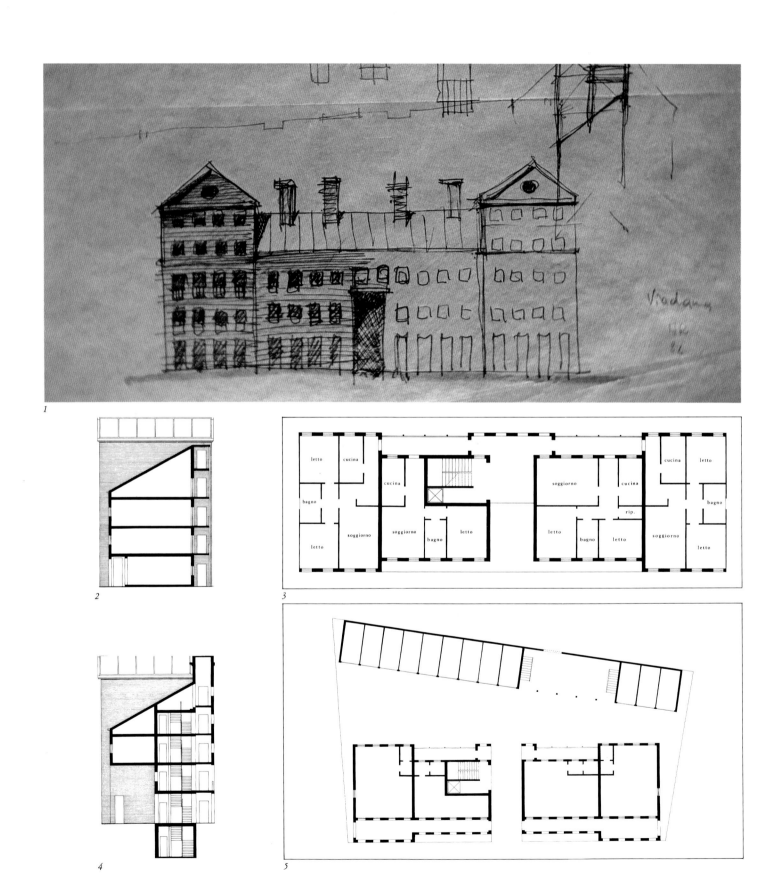

1

2

3

4

5

For a site in a town near Mantua, a five-story apartment house was built at the street's edge. A garage and storage building is at the rear of the property, creating a court at the interior. The apartment building is comprised of a central block flanked by two taller, projecting pavilions. All are of brick. The great copper roof over the central block is pierced by four chimneys; the pavilions have gabled ends to the street, detailed as pediments and circular attic vents. A third, central pavilion is apparent only from the court. At the street along the ground floor is a continuous arcade opening onto shops. A high central portal leads through to the court, as well as to the stairs and elevator toward the rear of the building. In the long, low building, access to the small storage room over garage bays is by means of an open-air corridor overlooking the court.

1. Preliminary studies 2. Section through apartments 3. Typical floor plan
4. Section through stairs 5. Ground-floor plan with garages and storage room annex
6. Elevations.

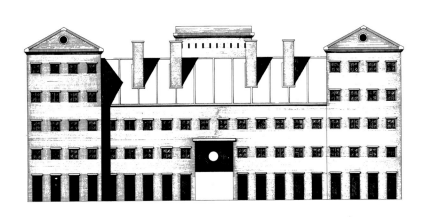

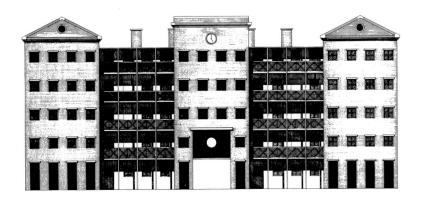

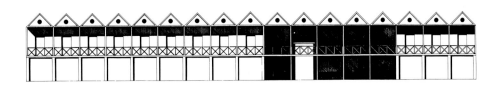

EDIFICIO IN VICOLO S.ROCCO A VIADANA

6

Fiera-Catena Area
Competition Design
Mantua, Italy, 1982
With G. Braghieri and COPRAT

While the port area of Mantua (for which this master plan was developed) has both undistinguished and impressive existing buildings, it is urbanistically diffuse, having no real discernible borders; even the embankment along the water is ill defined. In the design, all existing buildings are preserved and are taken, together with the embankment, as the generators and boundaries of the project. Four major elements dominate the design: a meadow around a lagoon enclosed by an amphitheater; a large courtyard structure made in part by existing buildings; the existing ceramics factory, rebuilt and enlarged; and a series of small buildings along a new grid of streets. The project was developed under the slogan "The Death of Virgil," after a novel by Hermann Broch that takes Virgil's death as a metaphor for the slow disappearance of a world in which urban and rural values are the same. The design takes the half-rural and half-urban site and tries to evoke architecturally a sense of the cultural transformations that have occurred there. For example, at the amphitheater, modern ideas of space for separate leisure activities are not accommodated: the amphitheater seats (imagined as overgrown with plants) provide views of a crescent-

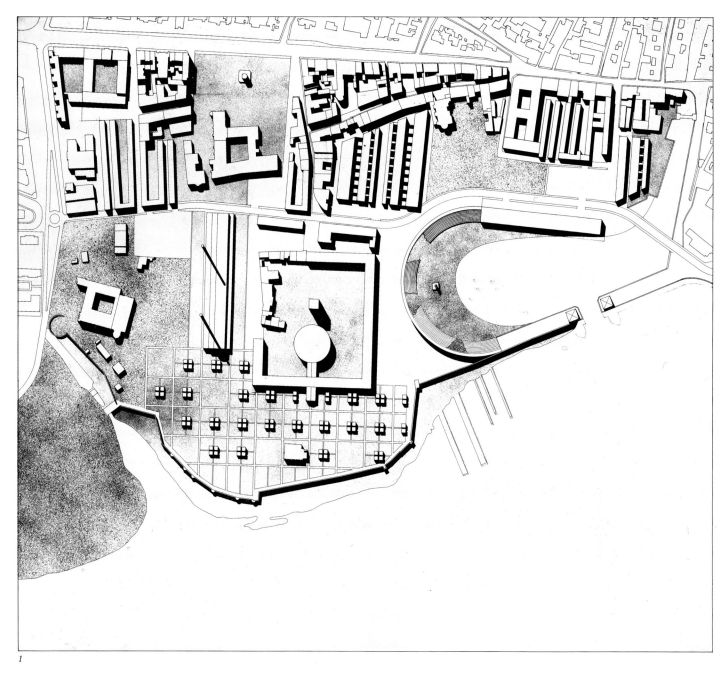

1

shaped meadow (imagined as hardly distinguishable from the lake), at the center of which is a statue of Virgil.

Behind the amphitheater is a paved area on which sits the courtyard with its partially preexisting edges. In the court are evenly planted trees and a cylindrical building intended for meetings and exhibits; the court also serves as entry to a hotel proposed to accommodate tourists drawn to the area's traditional crafts fair. The existing buildings are surrounded by trees. To the south of the hotel is the grid of streets along which are small buildings, either motel units or sports facilities. The grid is truncated at the south by a wall along the water. The old ceramics factory, currently in ruins, is restructured as a gallery and office building. Also envisioned, according to the proposal report, are the renovations of existing buildings and "construction of buildings for artisans with a particular typology that refers to the old buildings for commerce and crafts."

1. General plan 2. Possible alternatives for the lower sector of the plan

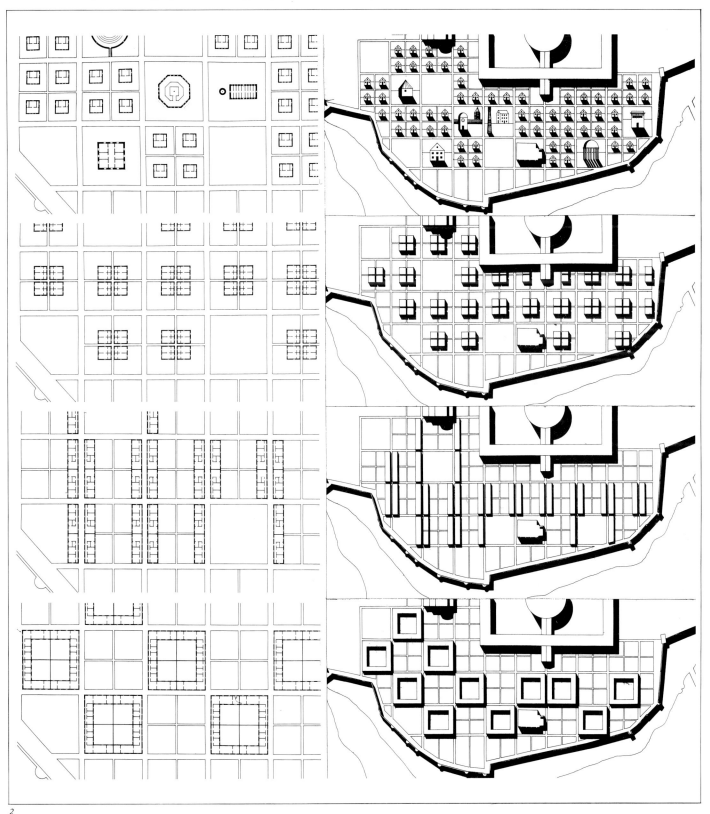

2

285

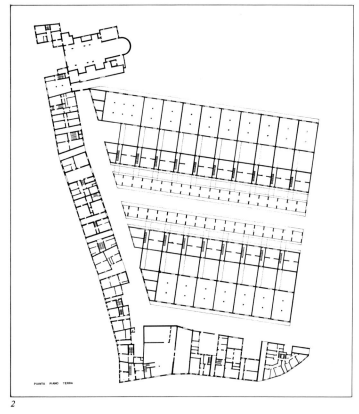

PIANTA PIANO TERRA

2

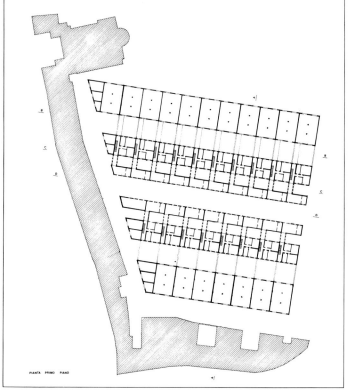

PIANTA PRIMO PIANO

3

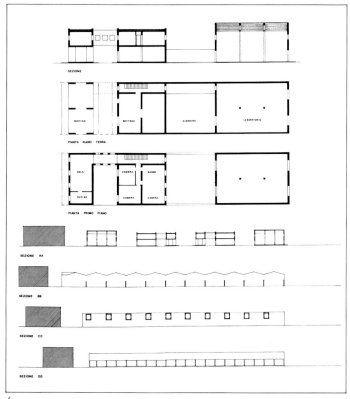

4

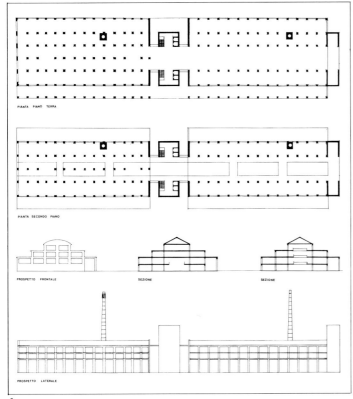

5

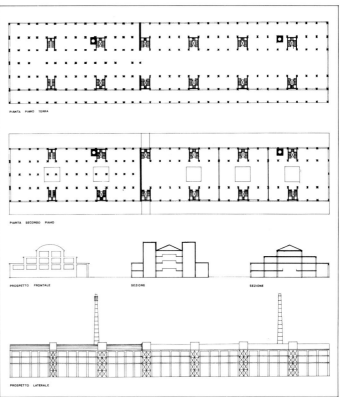

6

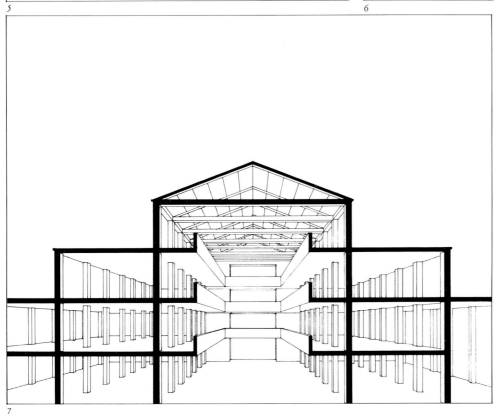

7

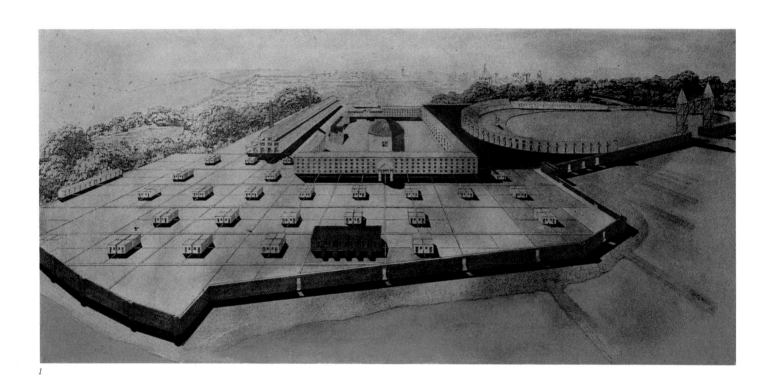

1

Congressional Palace
Preliminary Plans
Milan, Italy, 1982
With M. Adjini, G. Geronzi

The palace was conceived of as a new part of the city which connects different activities of urban life. There are three elements in the design, which is sited on a podium containing parking and storage. The congress hall is housed in a cube-shaped building. It consists of three halls, one above the next, the uppermost of which is lit by a glass roof. Leading from the hall is a skylit galleria passing through blocks containing a hotel and housing units. Beyond the galleria is a tower containing a museum, meeting halls, and a planetarium. In addition to proposing a new sector of Milan, the project provides an analogical re-creation of three of Milan's civic structures: La Scala, the Victor Emmanuel Gallery, and the spires of the Duomo.

1. Composition with section through tower

1

1. *Site plan* 2. *Ground-floor plan*
3. *Linear section through tower and*
auditoriums and elevation of office building
4. *Plan of first level of main auditorium*

1

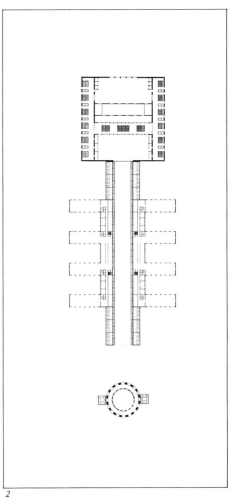

2

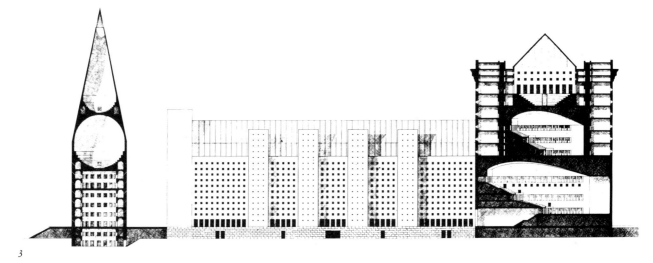

3

290

5. *Plan of main auditorium and offices*
6. *Plan of smaller auditorium at the top*
7. *Perspective*

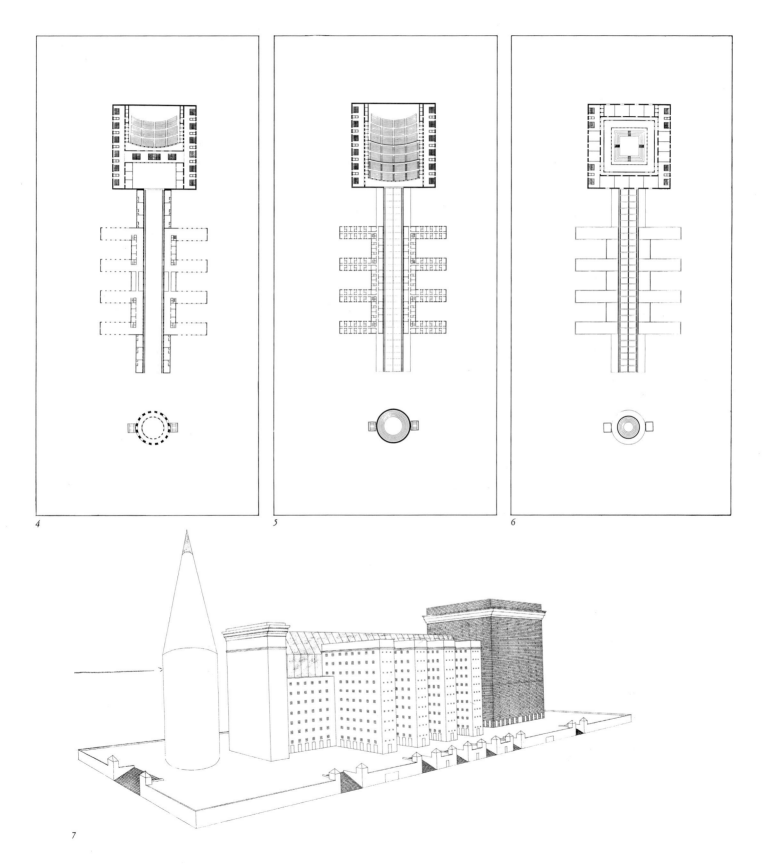

4

5

6

7

291

1

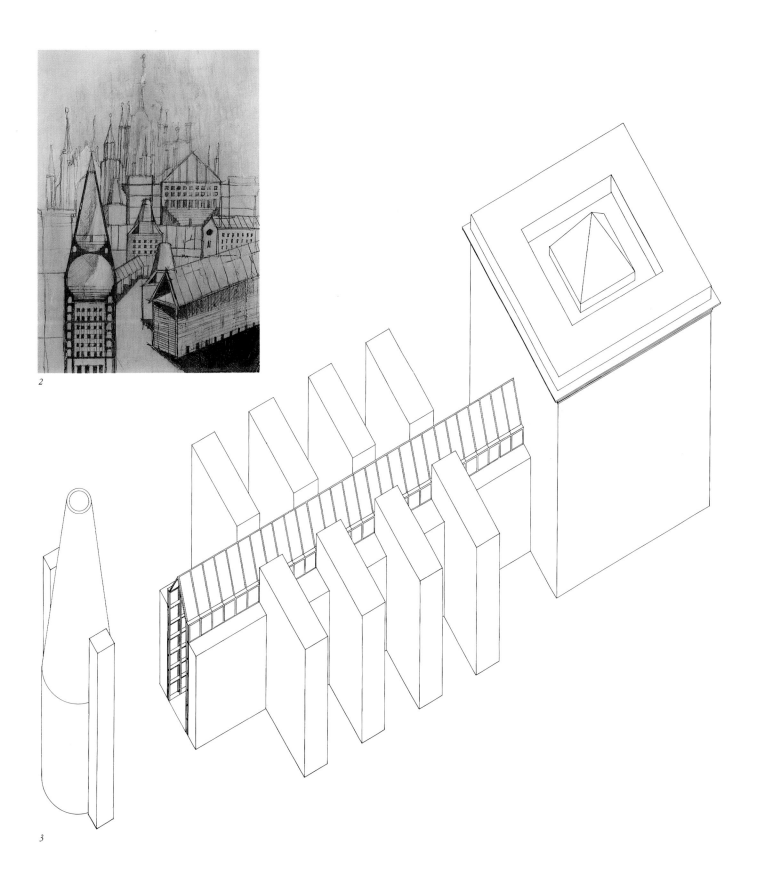

1. 2. Compositions with the tower and the
Duomo 3. Axonometric

2

3

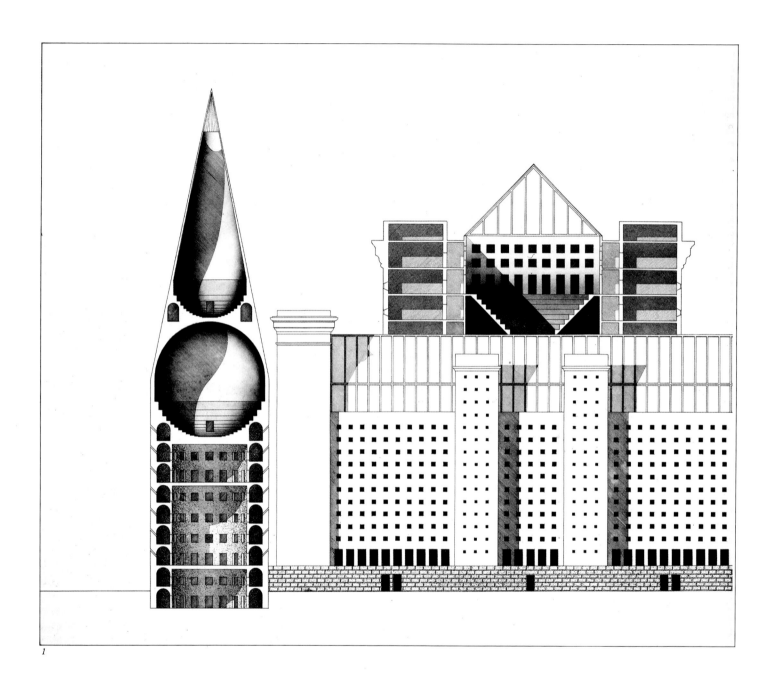

1

Carlo Felice Theater
Competition Design
Genoa, Italy, 1982
With S. Cardella, G. Braghieri, F. Reinhart

This design for a reconstruction of Genoa's Carlo Felice Theater was generated by consideration of its singular historical, architectural, and cultural importance. Barabino's original theater, set in front of the Ducal Palace, was a new middle-class insertion in an urban fabric that was previously a weave of only plebeian and aristocratic buildings, and is thus an important symbol of the emergence of a new, middle-class city. Like its contemporaries— Milan's La Scala, the Paris Opéra, the Bolshoi in Moscow, and the Stadtheater in Vienna—the theater represented and has continued to represent this part of urban history. Like these theaters and similar theaters in other Italian cities, the Carlo

Felice Theater has also continued to foster life and culture in the city and exert a strong physical and architectural presence; it is both a symbol of and a tessera in the urban environment. The decision to reconstruct the building's exterior was based on the belief that this confluence of values could not be evoked in any substitute; consequently, to not reconstruct it was a political act of destruction.

Following an earlier proposal by Scarpa, there are three main parts of the project—the conservation of Barabino's neoclassical theater, the interior *cavea*, and the

1. Ground-level plan of site area
2. Model—view from the piazza

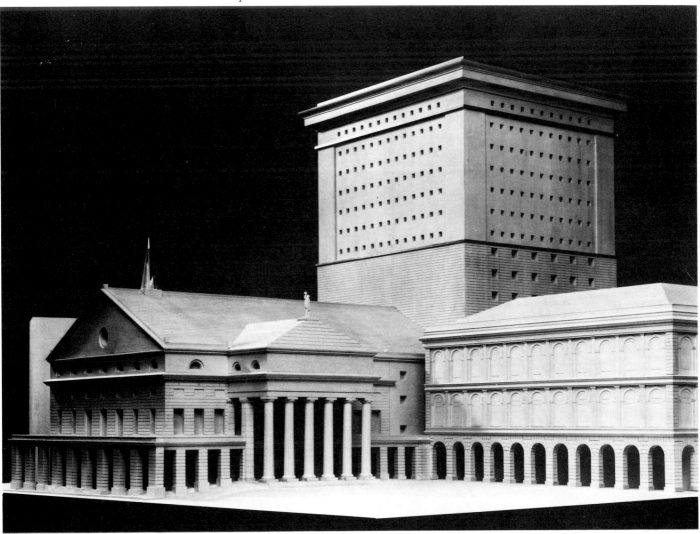

295

enlargement of the stage tower. Preserving the masonry mass of theater, the interior section and exterior massing reflect the dense urban fabric into which the theater has been inserted. A conical opening over the entrance foyer cuts up through the building like a great chimney, bringing light down from above the building mass; the intermediate floors through which it cuts overlook "this

unique dome, the zenith light of which streams down to throw a circle of sky on the entrance square." Its polygonal lantern is intended as a "small and precious element that overlays the philological reconstruction of Barabino's building." The so-called entrance square is open to the city, acting as a kind of filter between the theater and the city. The hall itself holds two thousand spectators in a

cavea occupying the old building in its entirety. Its fly-loft and backstage production areas serve as a kind of factory for the theater that is housed in the simple, taller building to the rear; its gray Genoa stone and steel stairs and bridges suggest a workplace like the city's shipyards.

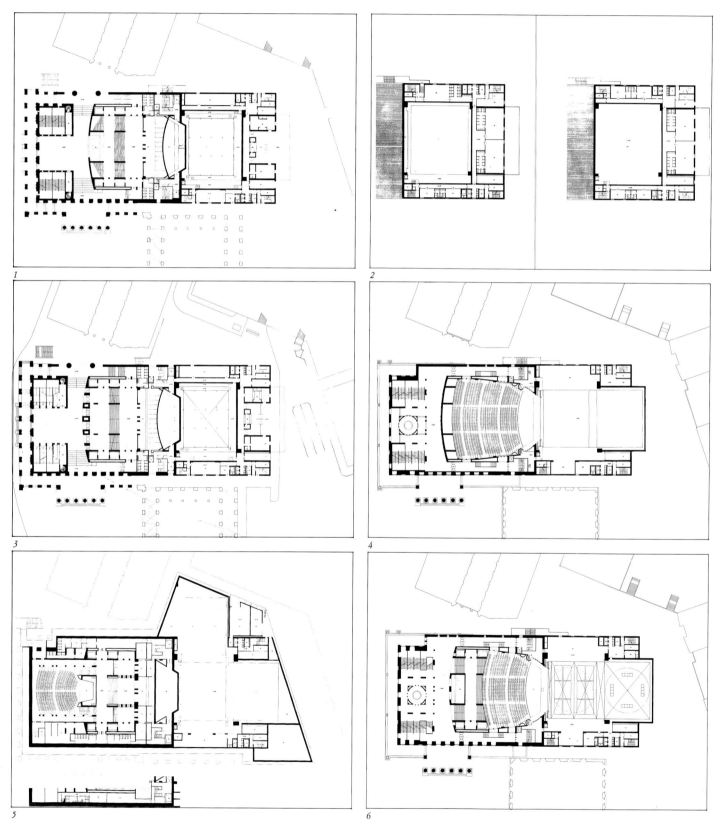

1

2

3

4

5

6

1. Plan of entrance and stairs to auditorium seats 2. Plans of studios 3. Entrance-level plan 4. Auditorium plan 5. Underground auditoriums and basement floor plan 6. Stage-level plan 7. Side elevation 8. Side elevation on the piazza 9. Front elevation 10. Section through entrance space and skylighted cone 11. Back elevation

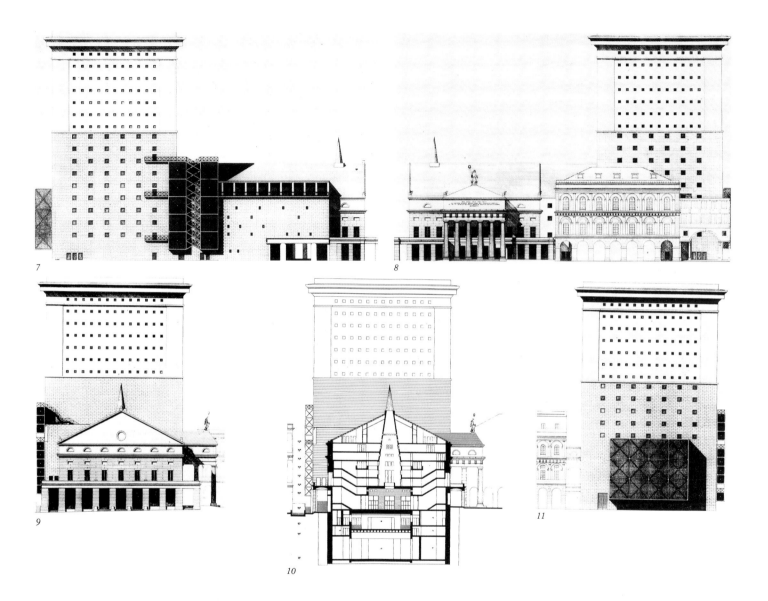

7

8

9

10

11

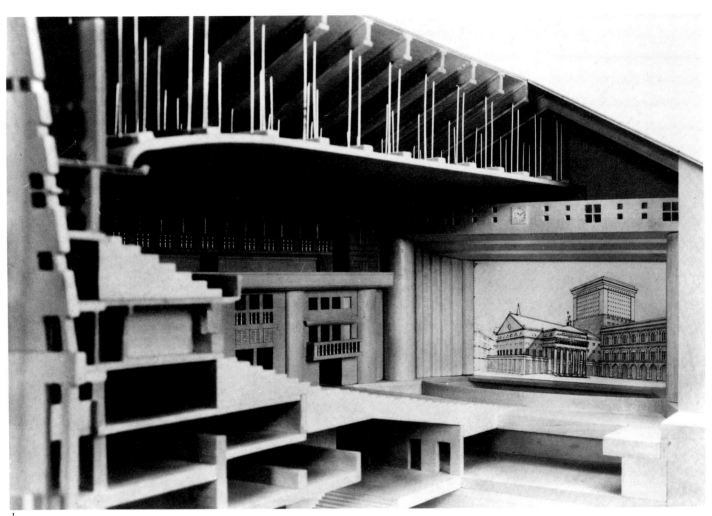

1

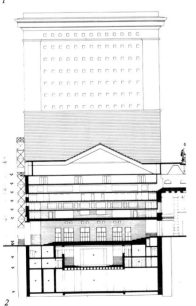

2

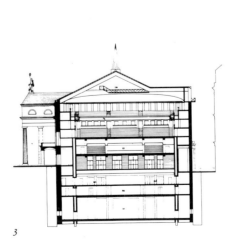

3

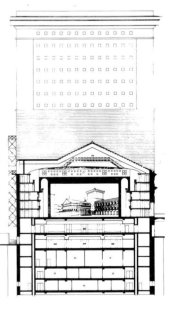

4

298

1. Model—section through auditorium
2. Section through entrance from the piazza
3. Section through auditorium looking
toward the entrance 4. Section through
auditorium looking toward the stage
5. Model—section through entrance spaces
and skylighted cone 6. Model—back view
7. Linear section

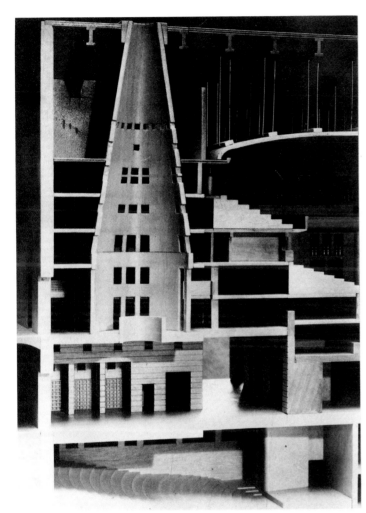

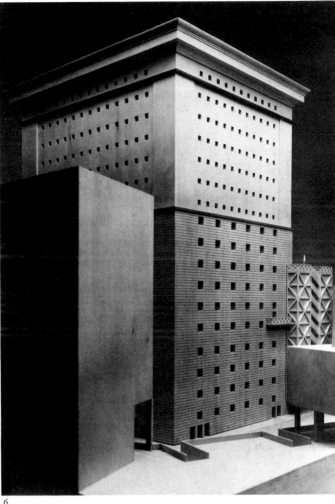

5

6

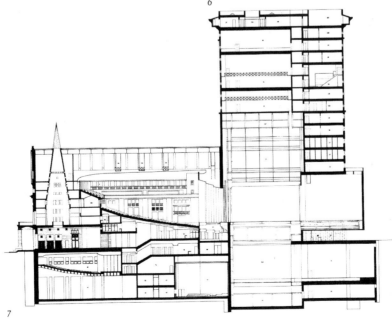

7

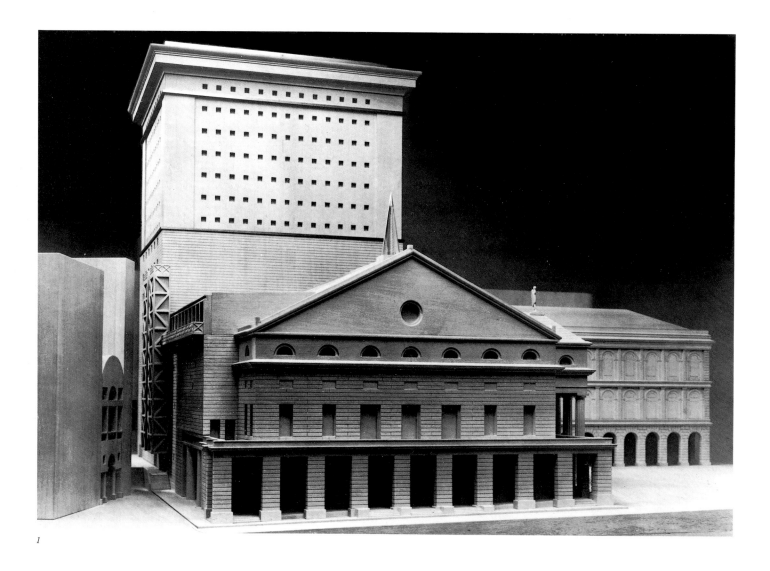

1

1

2

3

4

The site of the new complex is an old industrial area of Fontivegge between the historic center of Perugia and the modern expansion of the city. The program requires housing, offices, and facilities for stores and a number of public services. The project has at its center a long, sloping piazza. On one side is a block of housing, articulated with a rusticated base and a series of towers.

Opposite the housing is a big public building, following the tradition of the *broletto*—a civic building usually completely arcaded at ground level. The *broletto* is a block surrounding an approximately square courtyard. A glazed gallery bisects the court, connecting it to the piazza; the gallery itself is conceived of as an interior space open to the public. At the top of the piazza's slope is

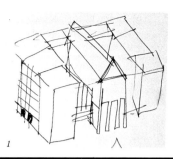

1

2

3

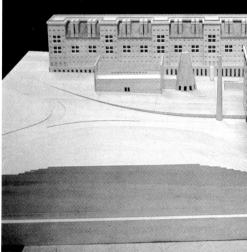

4

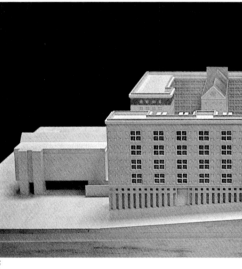

5

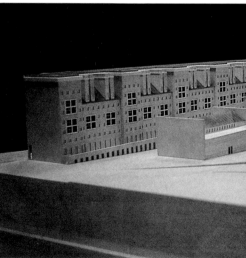

6

a theater and cultural center in the shape of a rectangular block connected to a conical tower. A fountain, like that at Segrate, is on the brick and stone piazza; its water flows through a channel to a basin on the axis of the *broletto*'s gallery. At one side of the *broletto*, an extant smokestack is preserved; it is the focus of a tree-lined promenade that bridges a highway running through the site.

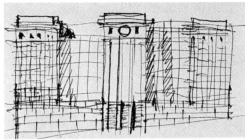

1. 2. *Studies* 3. *Model*—broletto 4. 5. 6. *Views of model* 7. 8. *Studies* 9. *Model*— *theater and cultural center* 10. *Study of housing Overleaf. Study*

7

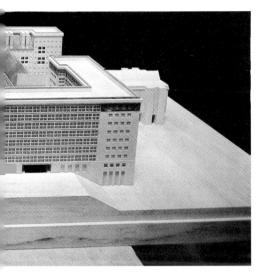

8

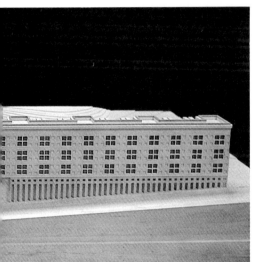

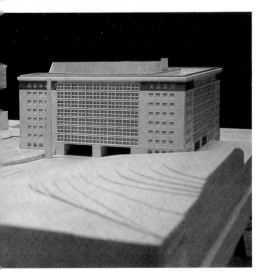

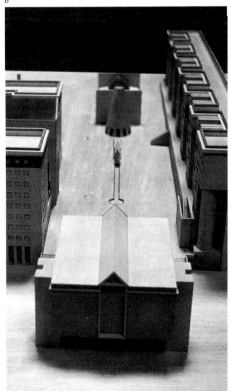

9

10

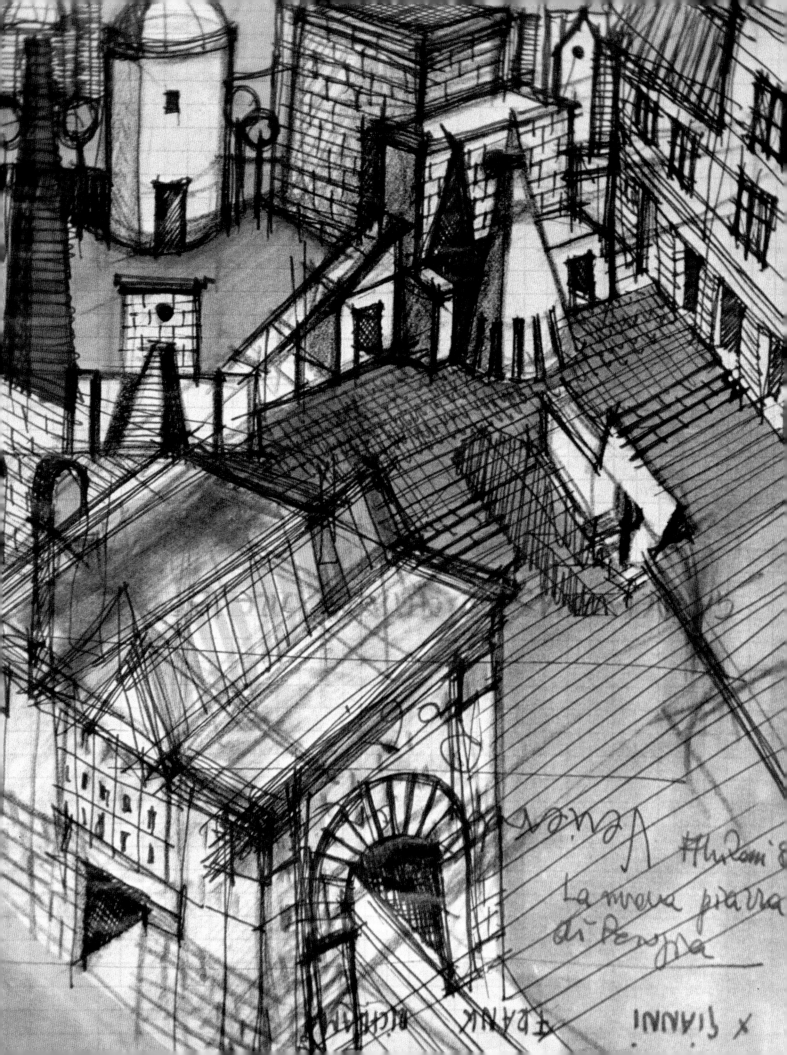

Architektur des Rationalismus
ALDO ROSSI

MARSILIO EDITORI PADOVA
INCONTRO CON L'AUTORE
IL PROF. ARCH. ALDO ROSSI DEL-
L'ISTITUTO UNIVERSITARIO DI
ARCHITETTURA DI VENEZIA PAR-
LERA' MARTEDI' 16 MARZO ALLE
ORE 21.15 PRESSO LA SEDE DEL-
L'UNIVERSITA' POPOLARE (G.C.)
VIA E. FILIBERTO 1 SUL TEMA
L'URBANISTICA E LO STUDIO
DELLA CITTA' NELLA CULTURA
ITALIANA

Il Gruppo d'Iniziativa
Culturale Sedese

presenta un ciclo di conferenze-dibattito
su problemi dell'URBANISTICA
che saranno lungo nei locali della
Società "LA VETTA" (g.c.)
via Sesto n. 88-A.

2° conferenza

Venerdì 4 marzo, ore 21

Prof. Arch.
ALDO ROSSI

parlerà sul tema:

Urbanistica
e Politica

ALDO ROSSI

ARCHITEKTURABTEILUNG

ETH

2c CONSTRUCCION
ALDO ROSSI 2 Parte

DE LA CIUDAD n.5

ALDO ROSSI

Colexio de Arquitectos de Galicia

ALDO-ROSSI + 21

ESPOSICION - HOSTAL

Carlo Aymonino Aldo Rossi
con
Gianni Braghieri

UN PROGETTO PER FIRENZE
1977

A L D O R O S S I
+21 ARQUITECTOS ESPAÑOLES

ALDO ROSSI

ALDO ROSSI

ROSSI

ALDO ROSSI
TEORIA DE ARQUITECTURA

ALDO ROSSI
la città analoga

aula magna scuola tecnica logano-trevano
giovedì 5 maggio '77 ore 20.30 ass.studenti sts

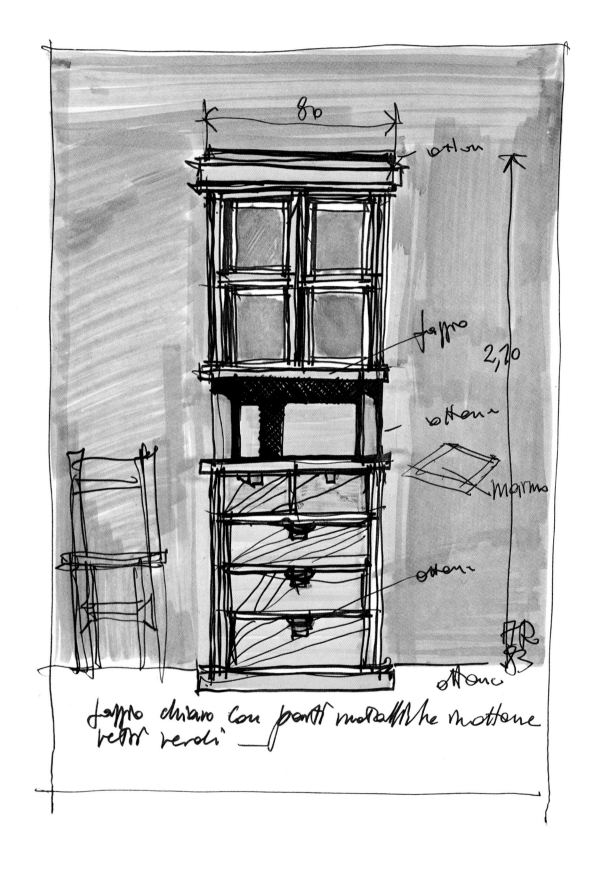

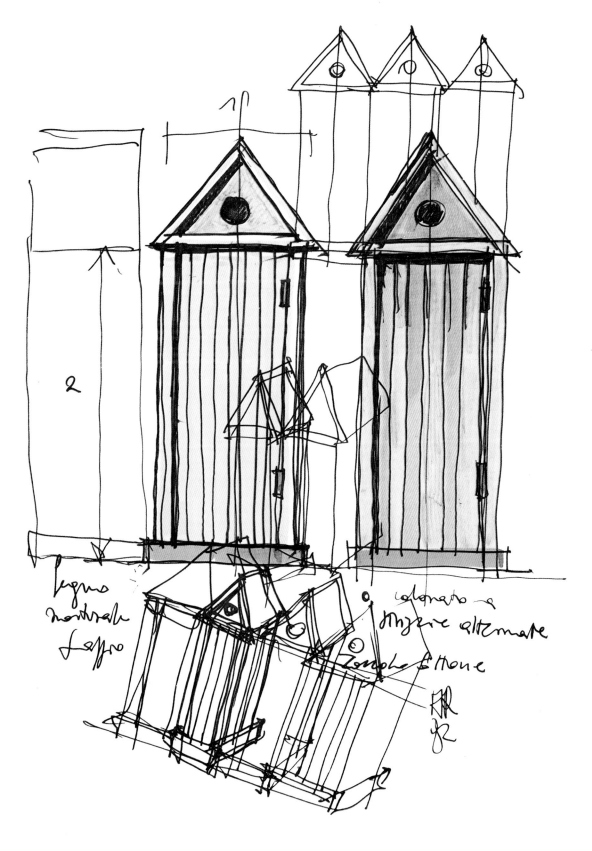

To confront the complete work of an architect is an unsettling task for a critic. A global consideration of work accomplished over a long period of time greatly adds to the methodological difficulties inherent in analyzing architectural works.

One approach would be to study the evolution of the architect and his work over the years, indulging in the pleasure of exploring how influences and circumstances have manifested themselves in his career. Thus, in the case of Aldo Rossi, the study of the period before 1966 would lead us to an evaluation of projects within the specific circumstances in which they were produced, such as the Peugeot Skyscraper competition with Magistretti and Polesello; the villa at Versilia with Ferrari; the Monument to the Resistance in Cuneo with Meda and Polesello; the Monumental Fountain for Milan with Meda; and ending with the project for the competition for the *centro direzionale* of Turin, Locomotiva 2, with Meda and Polesello. This first period of his career is marked by very diverse influences: a certain interest in technology in the Peugeot Skyscraper; an unquestionable admiration for Loos in the Versilia villa; a debt to the Russian constructivist way of understanding rationality in the Iron Bridge for the Triennale park in Milan; a desire to amplify and extend the investigations of contemporary avant-garde artists in his projects for monuments and fountains; and finally, in projects such as the Turin business area, an undeniable curiosity for the work of those explorers of the theme of scale—the megastructuralists. It would be advisable, in any case, to point out how all these projects maintained an evidently critical position vis-à-vis the interpretation of the modern made by the majority of his Italian colleagues. Rossi did not share their interest in organic architecture. Furthermore, he held an openly critical attitude toward those who sought an alternative in more elaborate design. To better appreciate the aloofness manifest in the work of Aldo Rossi, we need only to compare the powerful and decisive structure of Locomotiva 2 with the winning project in that competition—the submission of Quaroni and his collaborators [1].

Another approach would be to read the work of Aldo Rossi from the standpoint of his being a theoretician. Today no one doubts the weight that his opinion has had in defining an alternative answer to the dramatic situation of an architecture that, thinking itself faithful to so-called modern principles, had reduced the discipline to a simple linguistic exploitation. With the conviction that, after years of exacerbating the singular, the time had come to assert the primacy of a discipline whose salient characteristic was an autonomous permanence, Rossi offered the result of his investigation of the relationship between city and architecture in a now classic book, *L'architettura della città*. In order to establish that relationship, Rossi described the formation of the city, coming to the conclusion that architecture is the discipline that makes possible its construction. The definition of concepts such as element, plan, type, morphology, and monument assumed a special meaning in his description of the city. One should not be surprised, therefore, that such concepts can easily be identified in his work and thus that an analysis of Rossi's projects between 1966 (the year in which he published *L'architettura della città*) and 1972 (the year in which he won the competition for the

Modena Cemetery) establishes his designs as illustrations for the book in the most literal sense [2].

The ideas of element and place are thus manifest in projects such as the City Hall Square in Segrate and the Pilotta Square in Parma, while the San Sabba school in Trieste and the City Hall in Scandicci would serve to illustrate the concepts of type, monument, and composition.

A special mention should be made of the project for residential housing in San Rocco, Monza, in collaboration with Giorgio Grassi. This is in effect a compendium of Rossi's theoretical work during those years, since here he gives the broadest answer to the problems presented by designing under the aegis of ideas of urban morphology and type, without reference to the existing city and without the support of the environment [3].

But the mature work of Aldo Rossi, beginning with the projects for Gallaratese and Modena—work exemplified by so many drawings and the unusual, if quite beautiful, photographs I now have before my eyes—resists such analysis. It demands a more radical and synthetic opinion, a key to understanding, once and for all, the compass that has guided his long pilgrimage through the kingdom of architecture.

His work—the work published in this book as his complete work through today—is marked by a rigorous unity. To penetrate his mysterious and obsessive career, this unitary character of his work must be explained. Towers, houses, villas, cemeteries, theaters—all of these appear before our eyes with forms that seem identical, and with good reason: Rossi the architect always infuses real life into the same object, architecture.

It has been some time since Rossi has shown interest in the design of a concrete building, as he did, for instance, when he thought of the Scandicci City Hall or the Pilotta Square. Nowadays Rossi insists that everything he designs—be it the student housing in Chieti, Melbourne Tower, or the theater in Genoa—embody the essence of architecture in the making of the building. Architecture is the sole protagonist of his work and it is architecture that he presents us with again and again, whatever the program or the circumstances in which it is produced.

Rossi does not design schools, hospitals, theaters. He is not at the service of different programs, nor does he produce diverse artifacts whose end is merely utilitarian. For Rossi, building does not mean giving material entity to an object whose ulimate raison d'être, at least regarding form, is in his hands; instead, to build is to continually give birth, whatever the occasion, to the reality of that discipline through which all other realities become manifest for him—architecture.

Therefore one may consider as identical the images of the schoolyard in Fagnano Olona and the porticoes in the houses at Mozzo. Both are endowed with that synthetic quality always attached to Rossi's works,

a quality that evokes all the problems implied by the exercise of the discipline. The unity in Rossi's work is thus derived from the will to bring together the common origins of all architecture, origins that spring from the womb of the discipline. He leads us by the hand to the discovery of these origins through desperate, unusual situations.

The manner in which Rossi frequently assumes his condition of architect is by helping us understand architectures other than his own—marginal, degraded, forgotten, broken architectures in which the imprint of the discipline has nevertheless been indelibly marked. Some houses in the delta of the Po reflect the instrumental condition of housing in a milieu propitious to fishing: the rationality of their disposition is sublimated until it reaches the category of disciplinary, until it turns into architecture. A patio in Seville turns its shady environment into a defense against climate at the same time that it encourages contact among those who live around it: the spatial order in its architecture (insofar as its structure) is inevitable. A balcony overlooking Lake Maggiore speaks to us of the exactitude of sensation and of the intense reality generated around it. Rossi's own words strongly reveal the mood in which he confronts these architectures: "I have always known that architecture was determined by the hour and the event; and it was this hour that I sought in vain, confusing it with nostalgia, the countryside, the summer: it was an hour of suspension, the mythical *cinco del la tarde* of Seville, but also the hour of the railroad timetable, of the end of the lesson, of dawn" [4].

This will toward a synthetic architecture, alluding to the discipline as a totality without renouncing its individuality, becomes more evident when a work is placed within the global environment, within the unavoidable frame of all that has been built. Rossi always situates a new work in the context—the landscape—of his own complete work; it has become a sort of framework for an architecture of desire, which, on the other hand, maintains the attributes of anonymity and generality that belonged to the architecture of the past. This explains why Rossi draws the entire built environment with a frequency that cannot be labeled as simply repetitive. He draws all the architecture known by him, which is the same as saying all the architecture loved by him and all that he would like to build some day. In memorable drawings Rossi accumulates all his designs as if in a fantastic city: towers, houses, chimneys, bridges, cranes, the image of San Carlone, the porticoes of Gallaratese, the cabins at Elba, and the roofs of Trieste.

Let me quote Rossi in order to emphasize this idea of totality as the setting in which he embeds his designs:

> But the question of the fragment in architecture is very important since it may be that only ruins express a fact completely. Photographs of cities during the war, sections of apartments, broken toys. Delphi and Olympia. This ability to use pieces of mechanisms whose overall sense is partly lost has always interested me, even in formal terms. I am thinking of a unity, or a system, made solely of reassembled fragments. Perhaps only a great popular movement can give us the sense of an overall design; today we are forced to stop ourselves at certain things. I am convinced, however, that architecture as totality, as a comprehensive project, as an overall framework, is certainly more important and, in the final analysis, more beautiful. But it happens that historical obstacles—in every way parallel to psychological blocks or symptoms—hinder every reconstruction. As a result, I believe that there can be no true compensation, and that maybe the only thing possible is the addition that is somewhere between logic and biography [5].

Although it may seem obvious, the unity we detect in the work of Rossi is neither the fruit of linguistic coherence, nor the application of a common syntax to architecture; it is instead arbitrary. In Rossi's work—contrary to what happens in academic architecture—there is no room for the notion of arbitrariness as a fundamental idea on which to base the characteristic traits that define a particular style. Arbitrariness, at best, is a leftover from the past, a notion that no longer makes sense in these times of plenitude—the plenitude of a rationality that dates back to the Enlightenment and of which Rossi thinks himself an intellectual heir. Architecture will be what it must be, over and above any vicarious or circumstantial obligation, serving a categorical imperative located at the very root of the discipline, and that becomes the specific way of knowing and possessing achieved by man when he builds.

However, the architecture of Rossi does not present us with the occasion to explain the role played in the discipline by compositional mechanisms or by formal recourses. In my understanding, for Aldo Rossi architecture is not the elaboration and development of a formal convention. We must resist applying to his work those criteria and parameters of critics who have based the interpretation and evaluation of architectural works strictly on the investigation of formal mechanisms. While we could perhaps speak of some formal criteria in his first works (in which there was still a certain interest in unveiling mechanisms of composition), we must establish the fact that right from the beginning Rossi has rejected any architecture that would find justification either in composition, as paradigm of the arbitrary, or in sensory experiences [6]. Renouncing an architecture that is controlled by the senses, Rossi also rejects the possibility that the discipline might be simply the acceptance of custom as norm, because he does not want to transfer to other spheres those responsibilities that he thinks should be assumed by concrete and sharply defined faculties. To say on the contrary that architecture is a mental operation would be, in my understanding, just as ambiguous and wrong: the distance Rossi establishes between the senses and all other faculties falls flatly into an area one might label as ethical, given the important place held in his work by feelings that are woven into memory and recall.

For Rossi, architecture is not subscribing to a language, elaborating a figurative formal convention; architecture exists not so much in material appearance as in the very reality of things, a reality that is immediately translated into images through a complex personal process that Rossi himself has frequently described. Rossi's explanation of how Boullée conceived his library is particularly eloquent in this respect and reveals to us the path Rossi has followed in so many designs, a path that has allowed him to reach the

material image for his intuited reality:

In the origin of this design there is an emotional point of reference that defies analysis; this point of reference is associated to the theme from the beginning of the design project and will grow with it throughout the entire process. . . . At first he sees the Library as the physical setting for the spiritual inheritance of the great men of our cultural past, for it is they, with their works, who constitute the Library. . . . This first item of emotional data, which is also the last insofar as it is deprived of any possibility of development, is associated to a figurative solution, to a form apparently remote and that by itself is not architecture. Here Boullée declares himself profoundly struck by the sublime conception of Raphael's *School of Athens* and makes explicit his desire to build it. . . . Raphael's *School of Athens* is more than a symbol; the great men of the past mixed with and personalized in the contemporaries constitute a unity between the ancient and the modern and the choice of a humanistic culture. But this reference is not alien to composition; the great space of *The School of Athens,* the dynamics between the individual figures, the immensity of the space, the technical mastery in sum which is typical of a composition such as this. This technical mastery is typical of Boullée's interests, for he is always looking for an architectural solution that goes beyond the personal nucleus that gives it birth and beyond the system itself of the design project to a magisterial construction which is authentically architectural, autonomous in its substance, within the above mentioned limitations, from the contents addressed by the project [7].

This long quotation is absolutely indispensable to an understanding of Rossi's modus operandi, for in describing Boullée's attitude, he discreetly conceals any revelation of his own thought through the interpretation of Boullée's work.

There is no allusion to style in his words. Style, for Rossi, is the circumstantial, the ephemeral, all that in which he is least interested. Rossi's effort as an architect is to abandon and to consign to oblivion all that could be labeled stylistic, because for him architecture is not accessory, nor that which can be added. On the contrary, architecture is all those things that man builds in his absolute defenselessness [8].

The window, the door, the cover — in other words the elements — reach their condition as such only after they have shed the superfluous. For Rossi, the superfluous is any individual accent. The world that Rossi exhorts us to discover is the world of all hidden silent architecture, an architecture in which form and construction reside without fuss. The houses in which men live, the buildings that shelter their institutions, the constructions that help their work — in sum, architecture — have the same instrumental value as the utensils that accompany man and that by the sheer force of their immediacy, their very presence in everyday life, have become another landscape, a landscape so natural and well integrated that it goes practically unnoticed. Rossi would like for his works to be incorporated into this landscape and to fulfill their condition as artifacts — a condition in which it is difficult to separate form and function, since they are complementary concepts that obtain their undisputed reality when the builder, the architect, gives them life.

Rossi believes that there is a singular affinity between his attitude and that of another architect, Adolf Loos. For both, architecture is before anything else this effort to capture the authentic reality of an object, aided by the instruments of the discipline. Both see issues such as ornament, the relationship between architecture and society, and the sense of history and tradition in identical ways. This attitude presumes for Rossi an authentic sense of modernity, understood as a new stage of history: a stage in which we may know things as they are, devoid of all that culture had deposited on them before they were made to disappear by turning into other things. The new, therefore, has meaning only when it is radically so; things, utensils, architecture, have no need to be subjected to continual change just for the sake of respecting stylistic evolution. Rossi celebrates Loos's explanation of how the harness maker cannot, must not, modify the saddle unless there is a change in either the horse or the rider. Architects should also learn this important lesson: "style and technique are only an occasion" [9].

But how can we accurately understand what things are really like? How should a country house, or a place of work, or a space be prepared for a ritual? On the one hand, Rossi will claim the continuous assistance of reason, which is why he has not refused to have his architecture characterized as "rational." On the other hand, he asserts the presence of history, which is why he has always valued the exercise of memory. Reason and memory are the backbone of the discipline and the foundations of any architecture; their interplay is evident everywhere in Rossi's work.

Reason makes it possible for construction to become transparent, leaving the work in total nudity and investing it with paradoxically candid purity. In Rossi's architecture everything is evident. A roof will accept its condition as a roof without a care, without asking if its presence could have been done away with for the sake of a presumed vision of architecture as affected volumetrics: let us think of the houses at Mozzo or Pegognana, or of the monumental structure of student housing in Trieste, all works in which the simplicity of the cover is entrusted with giving character to the construction. A window — such as one at the school at Fagnano Olona, the housing cooperative at Goito, or Gallaratese — is not a matter of design: in its elementariness it seems to recognize the impossibility of being otherwise. A portico, as in the Modena Cemetery, or a gallery, as in the Corral del Conde in Seville, relies on its presumed vulgarity; yet the sensibility of the architect can, with a simple gesture, transform what started as a mere acceptance of the norm into a subtle and attractive exaggeration. Transparency and exaggeration versus concealment and moderation. Intensity and passion as antidotes to tepidity.

Rossi deliberately provokes, ready to spread terror among those who thought their efforts had led them to an understanding of the evolution of the recent history of architecture. He allows for such immediacy in the production of the elements that his attitude may easily be taken for clumsiness. Nothing could be farther from reality: Rossi minimizes his participation in the design in order to reveal the

rational and obvious principles on which his architecture rests. Without a doubt, he who demands clarity for all construction stands among the first of his kind, for clarity is an attribute that always accompanies reason. The will to have reason be the compass and the guide of his work is a constant throughout Rossi's entire oeuvre: his adherence to the concept of type to explain the growth of the city and to understand the problems of architecture that are formulated by it is more proof of the primacy of reason over strictly formal compositional criteria. It is thus that Rossi propagates a logic of form, not as abstraction, but as a direct link to typology. He will use this logic to plan his design projects, and it is not difficult to detect in them a respect for a geometry derived from the knowledge the architect has of the structures that are used in defining type [10].

Rossi's thirst for clarity leads to extreme proposals in which he purports to offer type in its most radical condition. However, we need not be surprised by the supposed naïveté expressed in Rossi's incursions into domestic architecture. He accepts the reality of domestic architecture without succumbing to the temptation of forgetting the environment in which the dwellings will be inscribed—in other words, without fear of accepting what they really are: suburban houses. Truthfulness accompanies reason in the architecture so beloved by Rossi [11].

Rossi's most intense praise has always been reserved for architects whom he has unhesitatingly labeled as rationalists. Loos, Tessenow, Hilberseimer, and Meyer are for him, above all, mirrors of reason. In Tessenow he finds an absolute fidelity to things, a fidelity that reaches the desirable extreme of making the architect disappear, dissolved in his architecture. In Hilberseimer and Meyer he appreciates the will to resolve the problems that architecture has with society. In Loos he admires the courage to do without all that; being without substance does not impact authentic architecture. For Rossi, to be rational is to accept the limitations imposed by reality, by facts—be they the facts of technique or those of use; to respect what things are, with the implication that the collective has supremacy over the private as a satisfying counterpoint. Architecture disappears into building when it accepts the reality of the public realm. This reality is usually denied by those architects who choose to exalt the singular and the private, but architectural discipline seems to exclude all personalism, so these are not necessarily appropriate.

Rossi has discovered with surprise that the man-made environment is the materialization of memory and that it is where we may learn what things want to be. Reality, the world of all that has been created by those who preceded us, is a patrimony that we share with all those who have lived the same hours, the same shadows. Reality speaks to us then of the past, of other men coming to life in the image of memory that is the man-made environment—the city. It is the city that teaches us what a house is, how a temple should be, how to lay a bridge. It is reason that helps us understand the permanence of the memorable.

Men die and disappear: things, however, make us feel their presence.

In *A Scientific Autobiography* Rossi gives an exacting description of the relationship between man and things and, in passing, of the possible attitude we may take in front of the built environment, in front of architecture: "I have always claimed that places are stronger than people, the fixed scene stronger than the transitory succession of events. This is the theoretical basis not of my architecture, but of architecture itself" [12]. The architect sees that, in the final instance, it is the city that possesses time, that the life given to us will be deposited in the city and will thus contribute to consolidating its condition of perpetual scenery. Is there a point in attempting to change its face? Rossi's answer is categorical: "But at times the theater is closed; and cities, like vast theaters, sometimes are empty. While it may be touching that everyone acts out his little part, in the end, neither the mediocre actor nor the sublime actress is able to alter the course of events" [13].

Neither the city's being nor the faculty of memory can be fragmented if we are to understand the architecture of the city. We may not have recourse to the diversity claimed by style; instead, we need to return to a vision and a theory of the city, a global theory such as was described above. Rossi devotes his energy to an attempt to see reality denuded of all that could be considered superfluous, of all that we call circumstantial or specific; therefore Rossi does not want to be forced by circumstances, be they place or materials, time or people. He clearly sees that face of the city which is hidden from all other mortals, and his architecture is a faithful recording of the world he sees. When mystics have attempted to describe their experience in the presence of God, they have spoken of self-absorption. Rossi, especially the Rossi of these last years, has given us proof of his self-absorption, which results from his confrontation with the face of architecture. His work is nothing else but a testimony of what he sees and of his frame of mind when confronted with that vision.

But what is the scope of Rossi's illuminated vision of architecture? Is there room for description, for the picture of his experience of unity? In trying to situate Rossi's work within the framework of his diagnosis of the present situation, Peter Eisenman has written:

Architecture, on the other hand, it can be argued, can only exist in a pre-linguistic universe unencumbered by history. And it is through the particular imagery of collective death that Rossi attempts to suggest the presence of this atemporal universe of architecture—one which is outside man. In this way Rossi attempts to escape from an architecture reduced to the inconsequential hermeticism of individual intellectual work. But the images of collective death also become the sign of Rossi's own anxiety about his reality. They represent Rossi the romantic poet, faced with the inexorable reality of the survivor, yearning for the return to the possibility of the hero. The drawings represent the dilemma of Rossi the humanist confronted with a modernism that is not offered to him as a condition of choice [14].

It is true that Rossi's architecture, Rossi's drawings—especially those in the series of "L'architecture assassinée" and of the "Cedimenti"—present us with an image of a world that is

fragmented and crumbling. But it is just as true that even more frequently there are works in which one breathes the atmosphere of an analogous city, stable and secure, in which the images of the Rossian architecture emerge from a world that appears happy in its rationality. Rossi would thus become the painter of reality's utopia, of architecture's utopia, offering us a world that takes pleasure not so much in natural beauty as in the satisfaction of knowing itself governed by reason and assisted by memory [15].

This principle of analogy, so strongly vindicated by Rossi, gives way to mimesis as a natural consequence of the exercise of memory. At the same time it demands for architecture the independence to establish identical forms in situations as diverse in time as in place, without any other help than what may be furnished by the principles of a discipline that has reason as a warranty. It is not by chance that in one of his drawings, "Domestic Architecture," architecture and things are found coexisting. As if they were the elements of a still life, a cup, a coffeepot, a fork, and a bottle are mixed on the same plane with images of Gallaratese, with towers, with chimneys, with factories, without time, without place. Architecture is installed anyplace by virtue of the principle of analogy. Mimesis and analogy thus enter into an intimate and fertile contact, populating the world of architecture, the world of all those artifacts we designate as houses, schools, temples, bridges, or factories and that constitute the environment for man's business as a builder. The mimesis of the known allows for an infinite display of architecture, and I might even say that in admitting the concept of analogy, mimesis is better understood insofar as it is a reproduction of that which already exists. It is hard to think of mimesis, even in classical terms, without being aware of the existence of a world of recognized and conscious fiction, a world not very different from that which Rossi labels analogical.

But in speaking of mimesis we must ask ourselves an inevitable question, a question that in the analysis of Rossi's work is of singular importance: what is the sense of talking about realism in architecture? What reality is taken as the point of reference by those who claim to practice mimesis in architecture, using architecture?

In the desire not to reduce mimesis to a simple representation of that which already exists, we might think that artisans—potters, carpenters, blacksmiths, the builders of all those artifacts and utensils that men, and therefore architects, make use of—give life through their works to a pallid reflection of authentic reality.

If we lay out the issue in these terms we are inclined to think, at least for the first moment, that the work of Rossi is that of a disciple of Plato, because he curiously attempts to capture the image of the first ideas with his architecture. But Rossi's debt to Aristotelian thought becomes evident as soon as we notice that the representation of ideas he pretends to achieve through his architecture is the product of his forcing the exterior world of the built environment through the filter of memory. In other words Rossi "sees" the primary ideas in the world we all share before our eyes in a mental exercise that may be placed within the purest Aristotelian tradition, and this

is why Rossi's intention is to represent the authentic reality of the built, the first ideas, types. Etienne Gilson has written that "art would reveal to nature the true type that nature is eternally trying to achieve without ever completely succeeding" [16].

Rossi's ambition is to offer to architecture—the discipline he so loves—the image of type, something that architecture has anxiously searched for without success. Mimesis for him is not a mere repetition, but rather the effort to represent the common, the generic, that which implicitly carries an abstraction. It is my understanding that Rossi's wish has always been to be able to represent architecture in its primary and original condition. For Rossi, seeing things, representing them, is knowing them.

Conscious of these premises and dauntless before any circumstance, Rossi has made an enormous effort, especially in recent years, to give testimony of his architecture through drawing and this has led his drawing to a true anticipation of his work.

We cannot be surprised by this, for if we admit that architecture is nothing but representation, then a building is the same as a drawing. But to admit that architecture is representation radically modifies the traditional use of drawing by architects. Traditionally, drawings have been a foreshadowing of what would be the reality of the built work; the architect thinks, designs, a reality that will be built later, and produces drawings as a simple representation of that later reality, in an attempt to facilitate for others the image of something that for him is no longer mysterious. Rossi uses drawing in quite a different way: since they are both representational, for Rossi drawing is on a par with building—it is the other face of the same reality. Thus the operation of building serves, if we reverse the terms, to materialize the drawing, to "make it real" [17].

We may therefore understand some of the photographs of his recent work as if they were mere representations of a reality that had already become manifest through his drawings. What could we say, for instance, of that one in which a trellis defines its symmetrical condition using the chimney as a point of reference? Even the chimney, in unfortuitous disarray, seems to insist on looking like the texture of his drawings' backgrounds. How could we otherwise understand the violence in the sketch of a staircase: the harshness of the bannister, the puritanical and provoking exhibition of its construction? It can be explained only by accepting the submission to an intentional distortion imposed by the drawing. Do not the schoolchildren of Fagnano Olona look like inhabitants of a world not their own? The children inhabit a time that already alludes more to what will become their own past than to the present that seems arrested by the photograph, thus advancing the idea of the atemporality of the construction, the indifference of architecture toward those who inhabit it.

The images given us by the drawings turn into reality, and yet they do so without losing their look of images. Construction does not bind the architect: Rossi has withstood the trial by fire implicit in the

building of any work and has emerged from it with proof that the images that had been foreseen and drawn were strong images—so strong, so determining, that there was no other way out for reality. The resulting image is not the reflection of another reality, the image is reality itself, the only reality to which we have access.

In wishing to make architecture visible, to turn it into the object of our attention, Rossi turns to theater. Its condition as a window open to another reality allows him the distance that turns the vision of the represented into a conscious act of the mind, not an automatic gesture. Representation thus becomes an epistemological exercise: reality is, before anything else, knowledge.

In this way one phase of his career becomes clear for us, an episode that may seem minor but has, I think, great significance. The Little Scientific Theater will be a window open to all known architecture, just as the Theater of Memory of Guilio Camillo was a window open to the global and complete knowledge of all that existed. We will see how all the Rossian iconography already familiar to us takes shape on the stage: columns from Gallaratese, San Carlone, chimneys, industrial constructions, coffeepots à la Morandi, fences with the cross of Saint Andrew, palm trees, bathing cabins as in Chieti, infinite truncated octagonal towers. The architecture on the stage is confused with others that support the action, with others that surround it, thus including the theater in a broader space that is presented as an incomplete portrait of the city and its history. The Little Scientific Theater would be the paradigm of the city as it becomes its representation, as it materializes its memory. Theater of Memory, Theater of Architecture [18].

Is this surprising when Rossi has been so adamant about his idea of the city as memory? Rossi builds or draws—it is the same thing—various scenes for his theater: a complete city; the interior of a room with a saint's image at one end; "la piazza di un villaggio pedano"; the levee of a beach with bathing cabins and the sea as background. Those who have followed his career would not be surprised to see in the scene so many well-known characters with the author among them—a way of telling us that only theatrical fiction allows us to understand reality. This is the way one can make architecture—things become alienated, distant, and are seen through optics that make them lose any possible relationship to the everyday quality that constantly trivializes them. We see reality as fiction and it, in turn, becomes the tool with which to build new realities.

But as I see it, the Little Scientific Theater is not an occasion to privately satisfy the passions of an architect who feels forgotten and despised. This is in the end the synthesis of all Rossi's work, for in it coexist, as Tafuri has accurately written, the space of representation and the representation of space [19]. All roads lead to the Rome of architecture and no one can be surprised that the inventor of the machine, Rossi, has disposed its mechanisms in such a way that the stage is always showing the same drama. Rossi himself says:

I have always claimed that places are stronger than people, the fixed scene stronger than the transitory succession of events. This is the theoretical basis not of my architecture, but of architecture itself. In substance, it is one possibility of living. I liken this idea to the theater: people are like actors; when the footlights go up, they become involved in an event with which they are probably unfamiliar, and ultimately they will always be so. The lights, the music, are no different from a fleeting summer thunderstorm, a passing conversation, a face. But at times the theater is closed; and cities, like vast theaters, sometimes are empty. While it may be touching that everyone acts out his little part, in the end, neither the mediocre actor nor the sublime actress is able to alter the course of events [20].

Rossi sees things at a distance, the same distance at which one contemplates theater. In fact, this obsession with seeing architecture as the only possible authentic stage appears again and again in *A Scientific Autobiography*.

But we must not confuse Rossi's vision of the world as theater with that of the classical authors of the baroque, for whom men fulfilled their roles in life by attending to the social and historic framework in which they lived. Nothing could be further from this than the Rossian theater, in which the protagonists are none other than all those beings to whom the history of architecture has given life. The theater of the world is the theater of architecture, perceived as if it were the only reality to which man has access. All other realities—from those scientists insist upon describing to the one we believe we possess when we think ourselves owners of our immediate being, of our corporeal experience—escape us, are dissolved by time and end up losing the truthful profile they had at first appearance. Men, our lives, are the shadows that populate authentic reality, the one we have been taught to see by painters such as de Chirico, where time and place seem to coincide. Yet this coincidence can only take place, as we have been saying, in architecture [21].

In the work of Rossi the confident artist of the turn of the century disappears before the necessity of recognizing the image of authentic reality. What is left today of those artists who thought they could project the private and personal reality of their own consciousness onto the exterior world, as they transferred to the work of art, to the picture, the most immediate and automatic of their gestures? The modern sensibility has been described as the result of the transformation suffered by man while he denied the value of any experience other than the strictly personal, turning into what Schorske has called the *Homo psicologicus*. Today's situation, which is so clearly manifest in Rossi's work, reflects a profound desire to go beyond the strictly personal and private. There is a painful nostalgia for an architecture that expresses the institutions that allow the life of man in society, an architecture that can be once again a universal and public discipline [22].

Rafael Moneo

Notes

1. The sources and texts for the study of the history of Italian architecture during the formative years of Aldo Rossi and the beginning of his career are numerous and varied. Among those supplying a more synthetic overview are: Vittorio Gregotti, *Orientamenti nuovi nell'architettura italiana* (Milan, 1969); C. de Seta, *L'Architettura del Novecento* (Turin, 1981); M. Tafuri, "Architettura Italiana 1944–1981," in *Storia dell'arte italiana*, part 2, vol. 3 (Turin, 1982), pp. 425–628. Another interesting book is E. Bonfanti and M. Porta, *Città, museo, e architettura* (Florence, 1973); although devoted to a discussion of the Gruppo BBPR, it contributes data and opinions on the Italian architectural climate of those years, which are immensely valuable.

With regard to the work of Aldo Rossi one can look at V. Savi, *L'Architettura di Aldo Rossi* (Milan, 1975); and the articles of E. Bonfanti, "Elementi e Costruzione. Note sull'architettura di Aldo Rossi," *Controspazio*, no. 10 (1970): pp. 19–28; Eugene J. Johnson, "What Remains of Man. Aldo Rossi's Modena Cemetery," *Journal of the Society of Architectural Historians* 41 (March 1982); M. Scolari, "Avanguardia e nuova architettura," in *Architettura Razionale* (Milan, 1973), pp. 153, 189; M. Tafuri, "L'architecture dans le boudoir," in his *La sfera e il labirinto* (Turin, 1980), pp. 323–54; M. Tafuri, "Architettura italiana, 1944–1981," in ibid., pp. 541–45; D. Vitale, "Inventions, Translations, Analogies: Projects and Fragments by Aldo Rossi," *Lotus International*, no. 25 (1979). Bibliographies on the work of Aldo Rossi can be found in Aldo Rossi, *Scritti scelti sull'architettura e la città 1956–1972*, ed. R. Bonicalzi (Milan, 1975 [1st edition, 1972]); Savi, *L'architettura di Aldo Rossi*; F. Moschini, *Aldo Rossi, Progetti e Disegni* (Rome, 1978); IAUS, *Aldo Rossi in America: 1976 to 1979* (New York, 1979).

2. The writings of Aldo Rossi in which he expounds his theoretical thinking are: *L'architettura della città*, (Padua, 1966); *Scritti scelti*, important because it gathers together the majority of his writings; *A Scientific Autobiography* (Cambridge, Mass., 1981), with a postscript by Vincent Scully, enormously important for the understanding of the sentimental atmosphere that surrounds his thinking. The articles of R. Moneo, "Aldo Rossi: The Idea of Architecture and the Modena Cemetery," *Oppositions* 5 (1976): pp. 1–30; and M. Scolari, "Un contributo per la fondazione di una scienza urbana," *Controspazio*, no. 7–8 (1971), pp. 4, 47, can be used as an introduction to and discussion of the concepts proposed by Rossi.

3. As a complement that helps clarify aspects of Rossi's thought one can see the book written at that time by Giorgio Grassi, *La costruzione logica dell'architettura* (Padua, 1967).

4. *A Scientific Autobiography*, p. 80.

5. Ibid., p. 8.

6. It seems useless—or at least irrelevant—to attempt a description of the composing mechanisms Rossi uses, since his theoretical thinking today is pointed in a different direction, a fact that can be confirmed through a reading of *A Scientific Autobiography*. At any rate, in his first designs one can notice greater attention to the instrumental, to composing elements, while new preoccupations have become apparent in the later designs.

7. *Scritti scelti*, p. 355.

8. Rossi's extreme rejection of the stylistic might explain the liberties he takes in his design projects when he introduces, without prejudice, elements from the past. The section of the theater at Genoa clearly shows the meaning that Rossi gives to the use of elements derived from classical architecture.

9. See also Rossi's prologue to the book by Benedetto Gravagnuolo, *Adolf Loos, Teorie e Opere* (Milan, 1981), pp. 11–15. See also Aldo Rossi, "Adolf Loos, 1870–1933," *Casabella-continuità*, no. 233 (1959): pp. 5–12 (also included in his *Scritti scelti*).

10. Rossi's compositional schemes are based on a profound knowledge of types, and the most trivial elements acquire in their essence the condition of the singular and the specific.

11. Rossi's houses are comfortably installed on the suburban periphery without fuss. There is in their radical imagery an entirely provoking identification with the environment into which they are fitted.

12. *A Scientific Autobiography*, p. 50.

13. Ibid. p. 51.

14. Peter Eisenman, "The House of the Dead as the City of Survival," in IAUS, *Aldo Rossi in America*, p. 6.

15. For Tafuri, the world described by Rossi is an impossible world, voluntarily maintained, completely alien from the reality into which it interjects itself. "Especially in the latest projects, drawings and engravings Rossian words assume the dignity of alchemic signs. In the Cabine dell'Elba (1973), in the Città Copernicana, in the Souvenirs de Florence, an esoteric alphabet is manipulated by an obstinate magician determined in his refusal to look through Galileo's telescope." M. Tafuri, "Il 'caso' Aldo Rossi," in *Storia dell'arte italiana: Il Novecento*, p. 544.

16. Etienne Gilson, *Painting and Reality* (Princeton, N.J., 1968).

17. See Rafael Moneo, "La obra reciente de Aldo Rossi: dos reflexiones," *Construcción de la ciudad-2C*, no. 14, 1975.

18. Ibid.

19. Tafuri, "Il 'caso' Aldo Rossi," p. 544.

20. *A Scientific Autobiography*, pp. 50–51.

21. The study of the figurative sources present in Rossi's work would lead us to pay attention to other Italian painters. In this respect one should see P. Fossati, "Pittura e sculture fra le due guerre," in *Storia dell'arte italiana: Il Novecento*, pp. 187–230. The iconographic contacts between de Chirico and Rossi have been examined in Johnson, "What Remains of Man."

22. Carl E. Schorske, *Fin-de-siècle Vienna: Politics and Culture* (New York, 1980).

The majority of the illustrations in this book have been provided by the office of Aldo Rossi. The exceptions are listed below. The publisher and editors wish to thank those below, as well as Mr. Rossi, for their kind permission to reproduce the illustrations.

The first figure in each pair refers to the page number; the figure or figures in parentheses refer to the illustration number.

Peter Arnell: 100 (2), 101 (3–6).

Aldo Ballo: 250 (1), 274 (4), 275 (7); also, frontispiece.

Maria Ida Biggi: 72 (1–3), 89 (2–3), 96 (1), 104 (1–3, 5), 159 (4–5), 237 (3), 241 (2–7).

Gianni Braghiere: 208 (3–4), 209 (5–6).

Sergio Fornasetti: 58 (1), 122 (1), 123 (3), 124 (1–3).

Ezio Frea: 65 (1).

Roberto Freno: 59 (2).

Alfredo Gambaro: 43 (3).

François Halard: page 16.

Heinrich Helfenstein: 86 (1), 120 (1).

Giacinto Manifredi: 109 (5), 175 (4–5).

Antonio Martinelli: 222 (1–4), 224 (1), 225 (2–3), 226 (1), 227 (2–5), 228 (1), 229 (2–7), 230 (1–3), 231 (6), 232 (1), 233 (2), 234 (1–2), 236 (1–2), 237 (4–6, 13–16).

Roberto Schezen: 68 (1), 70 (1–3), 74 (1), 78 (1), 79 (2–6), 80 (1), 81 (3–4), 83 (2–4), 84 (1), 92 (2), 93 (4), 95 (4), 96 (2), 97 (5–6), 98 (1–2), 99 (9–12), 110 (1), 111 (2), 113 (2–3), 114 (1–2), 115 (3–4), 116 (1), 117 (2–4), 143 (2–4), 174 (1), 175 (2), 192 (1–2), 193 (4), 194 (1–5), 195 (6–7), 196 (1), 197 (2, 4–7), 198 (1), 199 (2–5), 200 (1), 203 (2), 204 (1), 205 (3–4), 210 (3–4), 211 (5–8), 212 (2), 213 (4–5), 214 (1), 215 (1–2), 216 (2), 217 (5–6), 259 (7).

Leo Torri: 263 (1).

Cino Zucchi: 52 (1–3).

Aldo Rossi was born in Milan in 1931. He studied at the Faculty of
Architecture at the Politecnico there. Even before graduating in 1959,
he began contributing to the journal *Casabella-continuità* and served
as an editor from 1961 to 1964. He has taught at the Milan
Politecnico and at the Eidgenossische Technische Hochschule in
Zurich, and is currently professor of architecture at the University of
Venice. He has lectured widely in the United States, including at
Cooper Union, Cornell, Harvard, Rice, Tulane, Yale, and the
University of California at Berkeley. Among his most prominent
writings are *The Architecture of the City* and *A Scientific
Autobiography*. His architectural practice is in Milan, where he works
with Gianni Braghiere.

Peter Arnell and **Ted Bickford**, who were educated at PS 225 in
Brooklyn and at Princeton University respectively, are partners in the
New York advertising and design firm of Arnell/Bickford Associates.
Their recent publications include monographs of the work of Robert
A. M. Stern, Michael Graves, James Stirling, Charles Gwathmey and
Robert Siegel, and Frank O. Gehry, as well as David Hockney's
Cameraworks and a collection of essays by Robert Venturi and Denise
Scott Brown, *A View from the Campidoglio*. In addition they are the
senior editors of an ongoing series documenting architectural
competitions.